AMY DEMPSEY

DESTINATION ART

Thames & Hudson

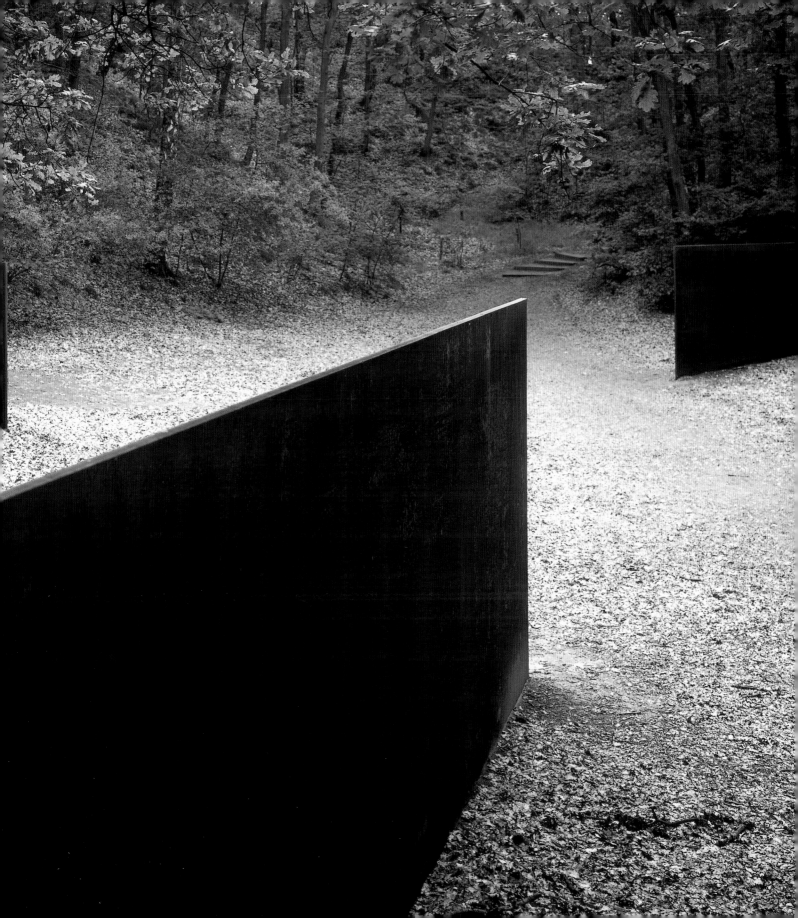

Il Castello Incantato

Christ the Redeemer of the Open Arms

Left Torres de Satélite
Above La Frénouse

DEDICATED TO JUSTIN SAUNDERS

First published in the United Kingdom in 2006 by
Thames & Hudson Ltd, 181A High Holborn, London WC1V 7QX

Revised and expanded edition 2011

© 2006 and 2011 Amy Dempsey

British Library Cataloguing-in-Publication Data
A catalogue record for this book is available from the British Library

ISBN 978-0-500-28880-1

Printed and bound in China by Toppan Leefung

To find out about all our publications, please visit **www.thamesandhudson.com**.
There you can subscribe to our e-newsletter, browse or download our current catalogue,
and buy any titles that are in print.

INTRODUCTION: ART AS DESTINATION 8

ONE: MONUMENTS FOR THE MODERN AGE 12

CONTENTS

Cadillac Ranch

Yorkshire Sculpture Park

Skulptur Projekte

Above Urban Configurations
Left The Fields Sculpture Park

Above A13 Artscape
Inset The Land of Evermor

FOUR:
DESTINATION ART COMES OF AGE 142

Sculpture in the Parklands

FIVE:
INTO THE FUTURE 212

Above Parco Sculture del Chianti
Inset Montenmedio Arte Contemporaneo

INTRODUCTION:
ART AS DESTINATION

A powerful work of art can take you on a journey. It can take you to another dimension and provide insight into another world, time, place or way of thinking. The more than two hundred works in *Destination Art* transport you in a more tangible, literal sense. For these are not works that will be coming to a museum near you – they are works that you have to travel to and meet in their own space and on their own terms, for they must be seen on site. 'Destination Art' is art that must been seen *in situ*, and the term recognizes the impact of the art's context, that the location is an important part of experiencing and understanding the work. It also acknowledges and explores the often reciprocal dynamic that the art and its place exert on each other. Thus, it is the art in its particular setting that is your destination. Some Destination Art requires a committed pilgrimage to see it, while other works may be hidden gems in a city near you.

The sites featured in this book are predominantly from the twentieth and twenty-first centuries and from around the globe. Massive land and environmental works, extensive sculpture parks, magnificent architectural follies, site-specific installations and even whole towns turned over to the display of art are just some of the treasures featured. They are by a variety of makers – from artists to postmen, architects to preachers – and are the results of a wide range of motivations. Some are very private, introverted projects, while others are the results of public commissions and are responses to important public issues, whether political, such as conflicts and the state of the environment, or sociological, such as the role of art in public spaces and art as a tool for regeneration. Most of the works from the first half of the twentieth century were private initiatives – either personal endeavours that later received wider interest or works for individual patrons. More recent projects have tended to be more public and larger in scale and are often undertaken with either civic, corporate or charitable support.

A number of factors – artistic, social, legislative – encouraged the flourishing of Destination Art in the second half of the twentieth century. To begin with, from the 1950s, some artists sought to blur the line between art and life by bringing art out of the museums and galleries and putting it into everyday environments. Others wanted to make art that specifically engaged with its location or that explored its physical context – be that gallery, city square or hilltop – to the extent that the site became an integral part of the work. The phrase 'site-specific' became increasingly popular in the 1960s to describe such art. Throughout that decade, there was also a growing 'community arts' movement, which gave rise to a belief that art should be available to more than just a privileged few. This democratic view led in the 1970s to many local and national governments funding public art projects. Although not all such schemes were related directly to their sites, artists' interest in location and context resulted in a shift from the idea of public art as monument towards the notion of art as transforming an anonymous or neglected 'space' into a significant 'place'. Special emphasis was put on the collaborative nature of these projects, as artists, architects, patrons and the public joined forces to realize them.

During the 1980s, numerous public art agencies were established to facilitate negotiations between artists, architects, regulating and funding bodies, and to consult users of public spaces. 'Percentage for art' legislation, which stipulated that a certain amount of funds from the budgets of new buildings or new public spaces had to be allocated to art, was increasingly enacted throughout the West. This growth in governmental patronage led to public sculpture and site-specific works becoming common in cities in many countries.

Almost two decades earlier, a parallel development had taken place. In the late 1960s, Earth Art – also known as Land Art – emerged as one of the many artistic trends that rejected the restrictive traditions of painting and sculpture and sought to expand the boundaries of art practice in terms of materials, disciplines and places to operate. Earth artists explored the potential of landscape and environment as both material and site for their art. Rather than representing nature, they utilized it directly in work that took the form of immense sculptures in the landscape or monumental forms

Below One of the seventy-eight large sculptures in Alois Wünsche-Mitterecker's *Figurenfeld* (1958–75) – 'a memorial to peace and Liberty against War and Force' – installed in a valley in Germany.

made from the earth itself. Examined through the broader sensibility of the 1960s, Earth Art developed during a period of growing interest in ecology and an awareness of the dangers of pollution and the excesses of consumerism on the fate of the earth and, therefore, humankind. By drawing attention to this debate, Earth artists make an appeal to us to see the 'art' in nature, or to respect and value nature as highly as we do art. As a psychoanalyst quoted in an article on Earth Art in *Art in America* in 1969 noted:

The works of these innovators are an attempt to be as big as the life we live today, the life of immensity and boundless geography. But it's also the manifestation of a desire to escape the city that is eating us alive, and perhaps a farewell to space and earth while there are still some left.

There is also a preservation impulse in much Earth Art, for if a piece of land is consecrated as art it can be saved from commercial development. There is an implied desire to protect, or salvage, not only the environment but also the human spirit; some works explicitly evoke the forms, and by association the spirituality and mystery, of such anthropological wonders as Native American burial grounds, Stonehenge and the giant chalk figures etched into the hills of England – past interventions in the landscape by unknown individuals for unknown reasons.

The remote location of much early Earth Art means that these works have, in a sense, existed only in the memories of those who participated in them or in documentation. Lack of maintenance has left others in a state of disrepair, making them equally intangible to viewers. Most art books have not helped much, for they often use the same old photographs and do not provide information as to whether the works still exist and, if they do, where they might be found. Correcting this situation is one of the motivations for this book.

Since the 1990s there have been many new initiatives that draw on and further the debates of the 1960s and 1970s. New works are often located not in the major cosmopolitan cities, but in more culturally,

Below Steven Brower, Lunar Excursion Module
(LEM) (2004–05) in *The Fields Sculpture Park*, USA
Right Kenneth Payne, *First Light* (2003) in
Pirkkala Sculpture Park, Finland
Right below Maya Lin, 11 Minute Line, (work in
process) in the *Wanås Foundation*, Sweden
Far right Kozo Nishino, *It Is Breezing*, (1999) in
the *Kirishima Open-Air Museum*, Japan

industrially and politically challenging areas where the art is used very deliberately as an agent for regeneration and social change. At the same time, new Earth Art pieces are being created, and efforts are being made to preserve earlier ones and to provide facilities that make them more accessible.

The works in *Destination Art* are located in deserts, forests, city centres and churchyards, on farmland and mountains, and alongside highways and railways. They can be found on nature reserves and former military land, and in ghost towns, gardens, artists' backyards and abandoned quarries. Many works are functional and blur the line between sculpture and architecture, becoming what British sculptor Sir Antony Caro dubbed 'sculpitecture'. Some sites are spread over acres and acres, while others measure no more than a few metres. Some are site-specific, and even when they are not, their location remains an important factor. It lends a very distinctive flavour to the work, such that even when it is by an artist you have previously encountered, you know that you are experiencing it in a very specific place, country or environment. The art is often a way into a different culture.

Fifty-four sites are featured in detail, with accounts of their histories and descriptions of the works. They come from all over the world, from several cultures and traditions, and have been selected to highlight some of the many different types of Destination Art that can be found, often in the most unexpected of locations. Visiting information and resources for further research are supplied for each featured site; descriptions and essential information for an additional 150 sites are also included. The sites are presented chronologically, with the practical information listed in alphabetical order by site name at the back, where you can also find a conversion table for metric and imperial measurements. Indexes of people, places and sites are also included to help you find your way. Whether you are an intrepid art explorer or an armchair traveller, *Destination Art* is the perfect companion for a journey around the world of art.

ONE:
MONUMENTS FOR
THE MODERN AGE

LE PALAIS IDÉAL

HAUTERIVES, FRANCE
Ferdinand Cheval
1879–1912

It has to be seen to be believed. FERDINAND CHEVAL

The small rural village of Hauterives (population *c.* 1,300), in the Rhône Valley in southeastern France, is home to one of the most impressive works of outsider art: *Le Palais Idéal* (Ideal Palace). The bizarre monumental structure covering six hundred square metres was built single-handedly by Ferdinand Cheval (1836–1924), a country postman (*facteur* in French), known as 'Le Facteur Cheval', over the space of thirty-three years.

In 1869 Cheval was assigned to a postal route based out of Hauterives. It stretched thirty-two kilometres, often taking him two days to cover on foot, during which time he would sleep in barns along the way. It was a solitary existence, and years later he wrote:

What else is there to do when one is constantly walking in the same setting, apart from dreaming? To entertain my thoughts, I built in my dreams a magical palace....

Ten years later, as the dream was beginning to fade, Cheval tripped on a stone. He wrote:

I wanted to examine it closely, my stumbling block: its shape was so bizarre that I picked it up and took it away with me. The following day I went back to the same place and I found more beautiful stones which, gathered on the spot, looked so pretty and filled me with enthusiasm. Then I said to myself: 'Since Nature provided me with sculptures I shall become an architect and a mason.'

And so, at the age of forty-three, Cheval began to turn his vision of a palace in which 'all the styles from all the countries and from all the times meet and are mingled' into a reality. He began to collect oddly shaped stones, fossils and shells that he found on his rounds, and took them back to the plot of land he owned in Hauterives. Working at night, he fashioned the massive structure by building

Main picture As you approach *Le Palais Idéal*, near the rural village of Hauterives in France, the stunning moss-covered, highly ornamented and intricately carved palace emerges from the ferns and trees surrounding it.
Above Just a few of the many amazing features and sculptural details that adorn every surface of *Le Palais Idéal*, including the giants from the east façade which look down on visitors from a ten-metre-high turret.

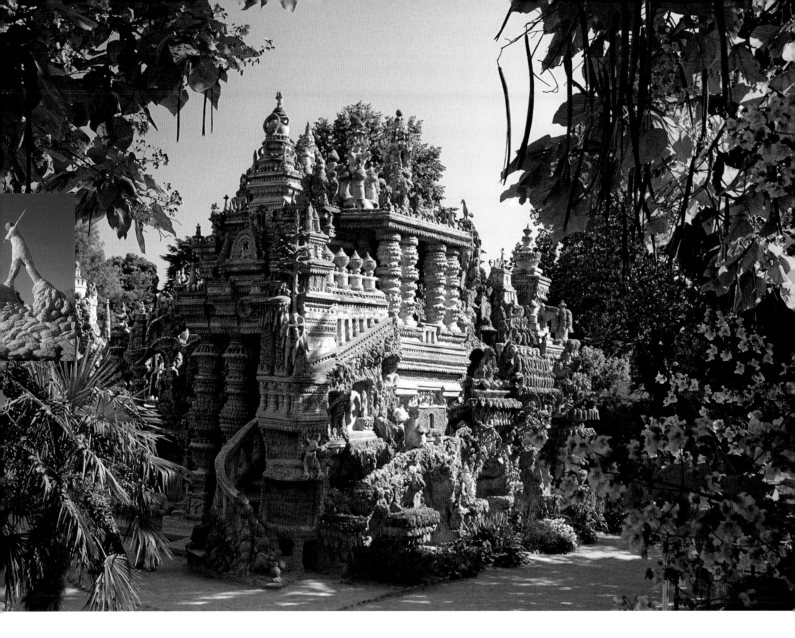

a skeleton of wire, covering it with a mixture of wet cement and lime and pressing his treasures into it.

Cheval's neighbours thought he was 'an old fool who fills his garden with stones', but did not think him dangerous or his condition 'contagious', so they left him to it. He recorded that:

I was the first to agree with those who called me insane; I was not a builder, I had never handled a mason's trowel; I was not a sculptor. The chisel was unknown to me; not to mention architecture, it was a field in which I remained totally ignorant.

By the time he completed the palace in 1912 it was twenty-four metres long by fourteen metres wide and around ten metres high. The self-taught builder and sculptor created a labyrinthine structure of turrets, caves, corridors, grottoes, waterfalls and spiral stairways that featured sculptured figures and animals, tombs, mummies, giants, cement trees, a Hindu temple, a medieval castle, a mosque, a Swiss chalet and the White House, amongst others, encrusted with elaborate ornamentation. As he had hoped, visitors 'start wondering if ... [they] have not been carried away into a fantastic dream with boundaries beyond the scope of imagination'. There are also

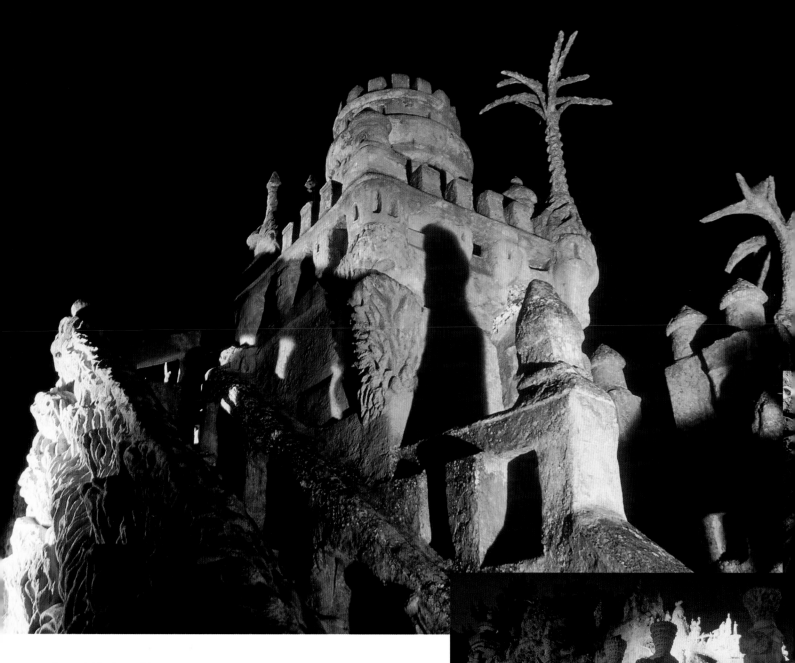

Above and right Some of the many
sculptures and fantastical towers and
stairways of *Le Palais Idéal* illuminated
at night. The inscriptions chiselled into
it proclaim Le Facteur Cheval's thoughts
on the power of art and dreams and his
belief in the merits of hard work and
commitment: *In creating this rock, I wanted
to prove the power of will* (below right).

hundreds of poems and inscriptions chiselled into the monument, mostly Cheval's thoughts on the power of art and dreams and the merits of hard work and commitment, such as:

Everything you can see, passer-by
Is the work of one peasant
Who, out of a dream, created
The queen of the world

I wanted to prove what
Willpower can achieve

1879–1912
10 thousand days
93 thousand hours
33 years of effort

Despite the ridicule of his neighbours, Le Palais Idéal became a tourist attraction in Cheval's lifetime. It was also embraced by the art world. Many Surrealists made pilgrimages to it in the 1930s and it was a major source of inspiration for many of the following generation of artists, such as Jean Tinguely (see *Le Cyclop*, p. 76) and Niki de Saint Phalle (see *Giardino dei Tarocchi*, p. 126; *Golem*, p. 138; *The Grotto*, p. 222; *Noah's Ark Sculpture Park*, p. 266; *Queen Califia's Magical Circle*, p. 268). In 1969 it was listed by André Malraux, Minister for the Arts, as the 'only example of primitive architecture' in the world.

In the Hauterives cemetery you can also see Cheval's extraordinary *Tomb of Silence and Eternal Rest* (1914–22), which he began building for himself at the age of seventy-eight after having been refused permission to be buried in a vault under the palace. He spent eight years working on it and was laid to rest there less than two years after completing it.

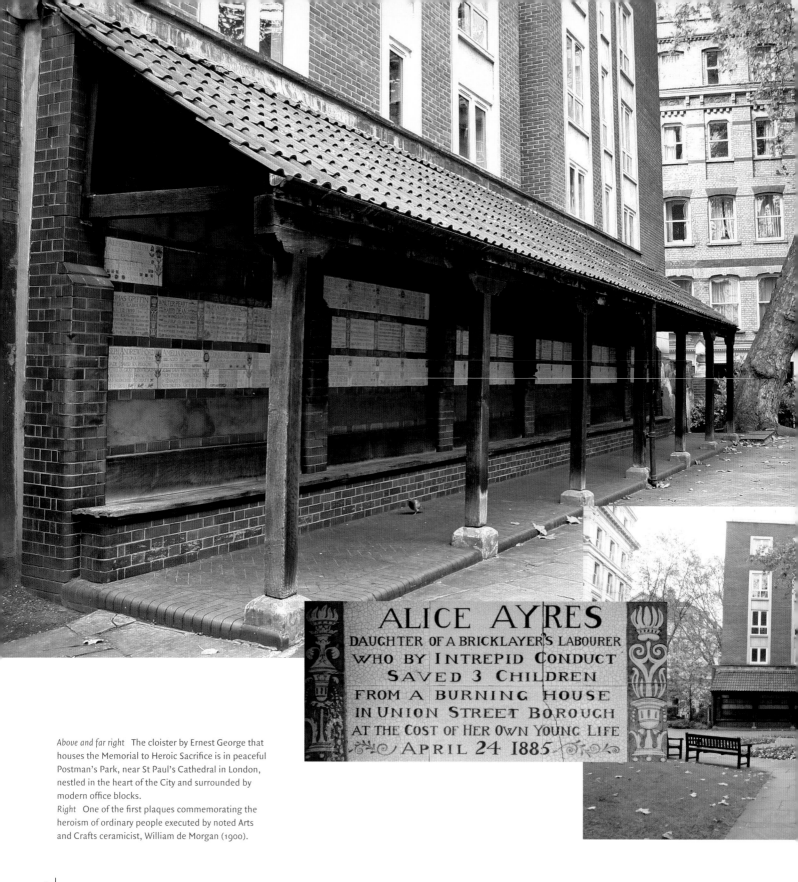

ALICE AYRES
DAUGHTER OF A BRICKLAYER'S LABOURER
WHO BY INTREPID CONDUCT
SAVED 3 CHILDREN
FROM A BURNING HOUSE
IN UNION STREET BOROUGH
AT THE COST OF HER OWN YOUNG LIFE
APRIL 24 1885

Above and far right The cloister by Ernest George that houses the Memorial to Heroic Sacrifice is in peaceful Postman's Park, near St Paul's Cathedral in London, nestled in the heart of the City and surrounded by modern office blocks.

Right One of the first plaques commemorating the heroism of ordinary people executed by noted Arts and Crafts ceramicist, William de Morgan (1900).

MEMORIAL TO HEROIC SACRIFICE
(INCORPORATING THE MEMORIAL TO G. F. WATTS)

POSTMAN'S PARK, LONDON, ENGLAND
G. F. Watts, T. H. Wren, William de Morgan
and Doulton & Co.
1899–1930

A monument to the faithful who are not famous. GEORGE ELIOT

The Memorial to Heroic Sacrifice, better known as Postman's Park, is one of London's hidden gems. The charming memorial consists of fifty-three glazed ceramic plaques recording heroic acts of self-sacrifice, which are displayed along a wall in a purpose-built lean-to, or cloister, in tiny Postman's Park in the City of London. The park is a few minutes walk north from St Paul's Cathedral and is well worth the detour.

This memorial was the brainchild of the Victorian painter and sculptor George Frederick Watts (1817–1904), one of the most celebrated British artists of his day. Inspired by the passage above from George Eliot's novel *Felix Holt*, published in 1866, Watts became obsessed with the idea of erecting a monument to the heroism of ordinary people and proposed the idea in a letter to *The Times* in 1887. After campaigning unsuccessfully for sponsorship, he decided to undertake the project at his own expense.

For the site, he chose the old churchyard next to St Botolph-without-Aldersgate, which had been made a public garden in 1880, and the fifteen-metre 'covered way' to house the plaques was erected in 1899 by the architect Ernest George (1839–1922). The first batch of twenty-four tributes was executed by the celebrated Arts and Crafts ceramicist William de Morgan (1839–1917), and dedicated in 1900. The plaques feature the hero's name, date and act of heroism painted in teal and decorated with a flaming incense burner, symbolizing prayers ascending to God.

Alice Ayres, daughter of a bricklayer's labourer who by intrepid conduct saved 3 children from a burning house in Union Street, Borough, at the cost of her own young life. April 24 1885.

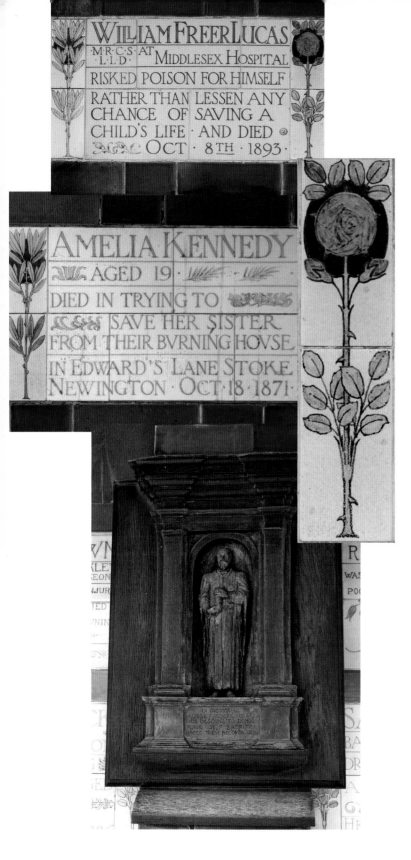

Henry James Bristow, aged eight at Walthamstow on December 30, 1890 saved his little sister's life by tearing off her flaming clothes but caught fire himself and died of burns and shock.

Watts had hoped that he and his wife would be able to bear the full cost of the project and that they would be able to fill the whole wall, but it was not to be. He allowed the Heroic Sacrifice Memorial Committee from St Botolph's to be established in 1904 to help select those to be commemorated. Watts died shortly afterwards and the sculptor T. H. Wren, a student at the School of Arts and Crafts established by Watts and his wife, was commissioned by the new committee to make a memorial to Watts. The wooden memorial by Watts was installed at the centre of the Memorial to Heroic Sacrifice and it was unveiled at a memorial service on 13 December 1905.

Around 1907, with de Morgan no longer available, Doulton & Co. was hired to make twenty-four new tributes. These have more of an Art Nouveau flavour, with flowers instead of incense burners, and occasional references to the nature of the heroic deed. They are painted in a light-blue glaze and form the second row of the memorial.

Soloman Galaman, aged 11 died of injuries Sept 6 1901 after saving his little brother from being run over in Commercial Street 'Mother I saved him but could not save myself'.

Samuel Lowdell, bargeman, drowned when rescuing a boy at Blackfriars Feb 25 1887. He had saved two other lives.

It was not until 1930 that further commemorative plaques were installed. In the interim, Mary Watts admitted that she was finding it difficult to finance the project and agreed to let others help raise money. B. A. G. Norman, a churchwarden, raised enough money from private and public sponsors, including the General Post Office (whose workers used the park, hence its name), to commission five more plaques. These were unveiled by the Bishop of London on 15 October 1930 at a ceremony to celebrate the fiftieth anniversary of the opening of the park.

Alfred Smith, Police Constable, who was killed in an air raid while saving the lives of women and girls. June 13 1917.

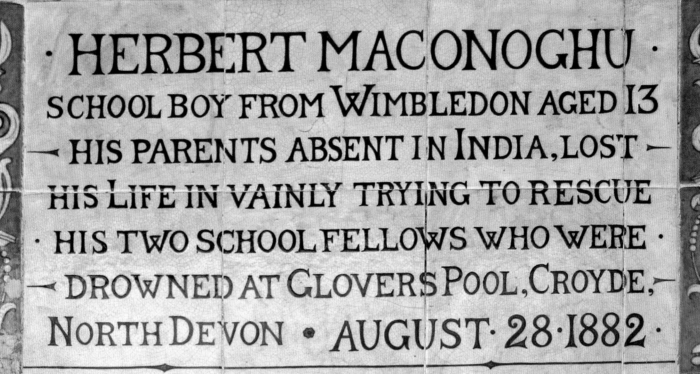

· HERBERT MACONOGHU ·
SCHOOL BOY FROM WIMBLEDON AGED 13
— HIS PARENTS ABSENT IN INDIA, LOST —
HIS LIFE IN VAINLY TRYING TO RESCUE
· HIS TWO SCHOOL FELLOWS WHO WERE ·
— DROWNED AT GLOVERS POOL, CROYDE, —
NORTH DEVON · AUGUST · 28 · 1882 ·

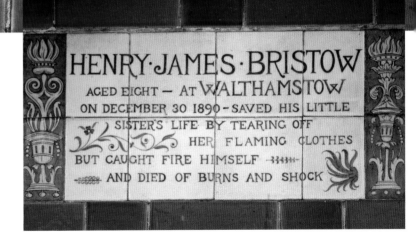

HENRY · JAMES · BRISTOW
AGED EIGHT — AT WALTHAMSTOW
ON DECEMBER 30 1890 – SAVED HIS LITTLE
SISTER'S LIFE BY TEARING OFF
HER FLAMING CLOTHES
BUT CAUGHT FIRE HIMSELF
AND DIED OF BURNS AND SHOCK

Watts's memorial has enshrined some of those events that appear in newspapers or on the news as brief human-interest stories and then are usually forgotten. As he had hoped, the memorial is a poignant and thought-provoking tribute to the extraordinary acts of those people. There has been renewed interest in the memorial since it featured in Patrick Marber's play *Closer* (1997, subsequently made into a film) and it has since been voted one of Londoners' favourite sites.

Opposite, top Some of the more Art Nouveau-type plaques by Doulton & Co. (c. 1907)
Opposite, bottom *Memorial to G. F. Watts* by T. H. Wren (1905)
Above Other plaques by William de Morgan

PARK GÜELL

BARCELONA, SPAIN
Antoni Gaudí
1900–14

Colour in architecture must be intense, logical and fertile....
ANTONI GAUDÍ

Antoni Gaudí (1852–1926) – whose fantastic architecture has become synonymous with Barcelona itself – was the outstanding figure of Modernisme, the Art Nouveau-like movement in Spain's Catalonia region between c. 1880 and c. 1910. Influenced by English Arts and Crafts architects, Gaudí insisted on designing every aspect of his buildings himself. He also drew on the structural theories of the French medieval-revival architect Eugène Emmanuel Viollet-le-Duc (1814–79), in particular his recommendations of using direct metal construction and employing new technologies in Gothic reconstructions. Gaudí's interest in natural forms as a source of inspiration was added to this mix of medievalism, romanticism and rationalism to create his highly individual dynamic, organic, visionary structures.

In 1882 Gaudí met the textile manufacturer and shipping magnate Count Eusebi Güell (1846–1918), who shared his socialist and progressive beliefs. Güell quickly became one of the architect's best friends and an important patron. In 1888, he asked Gaudí to design his home in Barcelona, the Palau Güell; this was followed in 1891 with a commission to build the Colonia Güell, a workers' community near one of Güell's textile plants, and then, in 1900, with the *Park Güell*, which would become one of the most influential examples of Gaudí's work.

Güell was inspired by the English Garden City movement, which advocated small, economically self-sufficient landscaped suburbs as an alternative to the overcrowding of industrial cities. In response to the rapid urban-industrial growth of Barcelona, Güell hired Gaudí to design such a development for fifteen hectares of his land on the Muntanya Pelada, a hilly area overlooking the city (now a part of Barcelona itself). Gaudí and his collaborators, including Francesc Berenguer (1866–1914) and Josep María Jujol (1879–1949), set to

Gaudí's extraordinary ornamentation, attention to detail and interest in natural forms are evident on the entrance sign to the park (*above*), the viaducts that span the site (*right*), the salamander that forms part of its drainage system (*right, below*) and the grand staircase (*opposite*) that leads you up to the planned community's covered market and roof-terrace plaza.

work on the infrastructure for the new community – the walls, gatehouses, staircases and pavilions. In these structures, Gaudí's undulating sculptural rhythms are to the fore, as is his imaginative use of materials and decoration, and his sense of architecture as a living organism. He insisted on working with the hilly terrain instead of levelling it, bringing art and nature together.

At the main entrance to the walled park you are greeted by two fantastic pavilions, which were to have been the porter's house and an administrative building. The wacky rubblework buildings with tall towers feel like something out of the Brothers Grimm or Dr Seuss and aptly herald the other world you are about to enter. Once inside there is a grand stairway leading up to what was

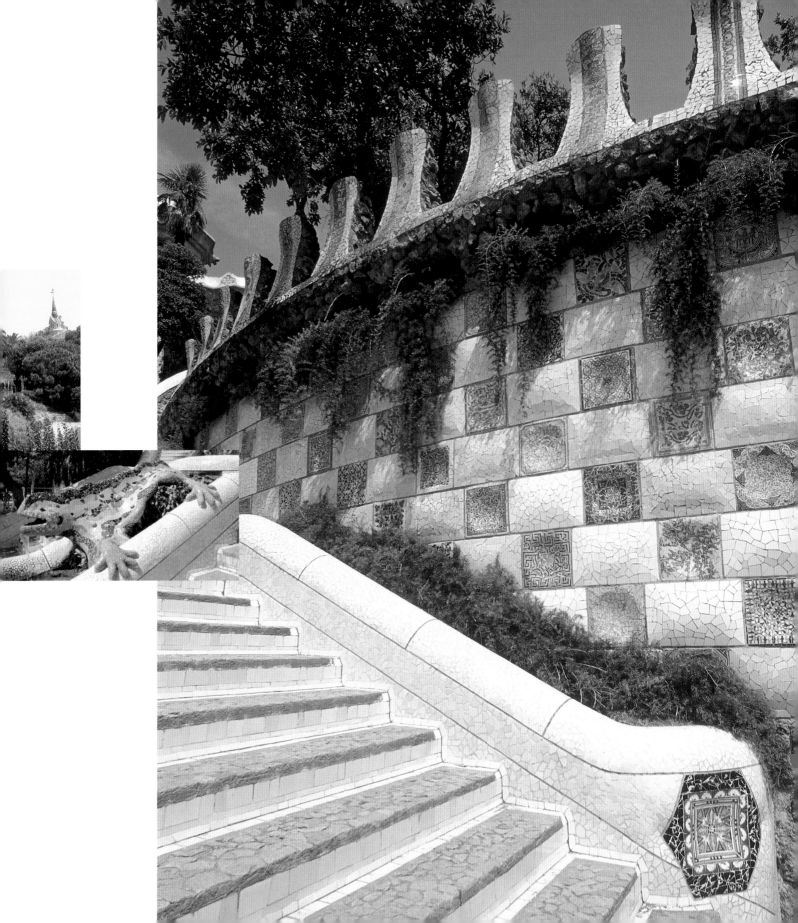

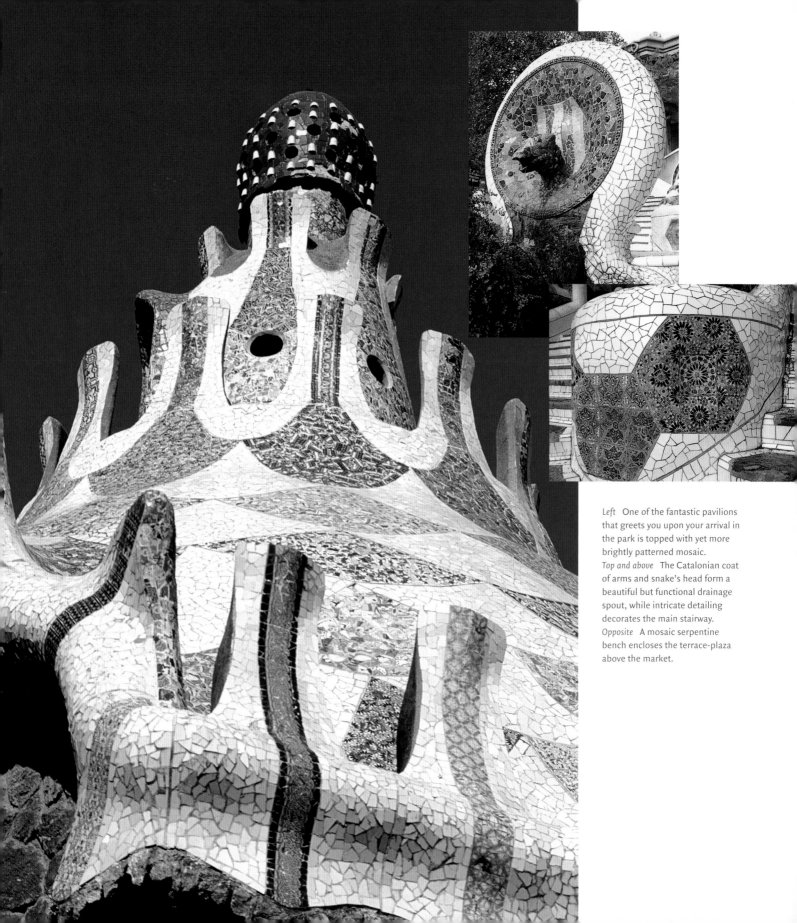

Left One of the fantastic pavilions that greets you upon your arrival in the park is topped with yet more brightly patterned mosaic.

Top and above The Catalonian coat of arms and snake's head form a beautiful but functional drainage spout, while intricate detailing decorates the main stairway.

Opposite A mosaic serpentine bench encloses the terrace-plaza above the market.

intended as the covered market for the new community. The undulating vault is supported by Doric-like columns, which resemble a forest of trees holding up the clouds or sky with a number of colourful mosaics appearing on the ceiling like sunbursts.

The roof of the marketplace serves as part of the support for the splendid terrace-plaza above, which provides amazing panoramas over the city and sea. The terrace is encapsulated in a stunning mosaic serpentine moulded wall with a bench incorporated into it. At the back of the terrace there are stairs leading to walkways through the park itself. Elsewhere there are weird tree-like pillars supporting roads and viaducts, and throughout the magical environment there is lush mature vegetation and extraordinary detail and ornamentation.

The original plan for the development included plots for sixty single-family homes on the perimeter of the park. Berenguer built a fairytale-like pink chalet as a showhome on one plot. Gaudí himself lived in it between 1906 and 1926 and it is now the Casa Museu Gaudí. Only two of the other plots had been sold when the First World War halted the project in 1914. After 1914 Gaudí devoted himself solely to his work on the Church of the Sagrada Familia, also in Barcelona, until his untimely death in June 1926, when he was run over by a tram. Güell died in 1918 and his heirs sold the site to the city. It was opened as a public park in 1923.

Although Güell and Gaudí's utopian living environment was a commercial failure, the jubilant park has since become one of the world's most beloved urban spaces and a Barcelona landmark. Gaudí's use of colour, texture and movement in architecture and his example at *Park Güell* of harmonizing art and architecture with nature was an inspiration to many artists and architects of the twentieth century and continues to be a source of inspiration today.

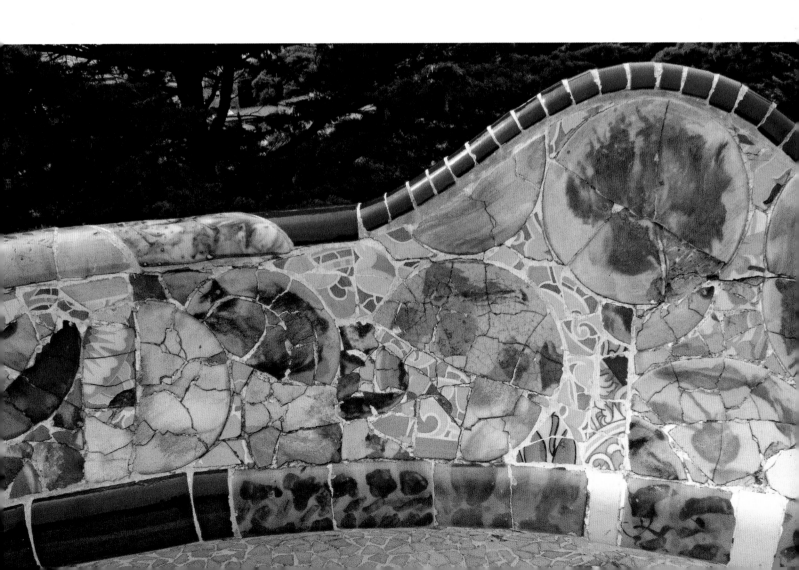

WATTS TOWERS

LOS ANGELES, CALIFORNIA, USA
Simon Rodia
1921–54

I had it in my mind to do something big and I did. SIMON RODIA

In 1921 Italian immigrant labourer Simon Rodia (1879–1965) purchased a triangular plot of land in the Watts district of south-central Los Angeles. He built a wall around it and began work on what he called 'Nuestro Pueblo' (Our Town), now known as the *Watts Towers*. Rodia spent every evening and weekend of the next thirty-three years working on his monumental complex. It features three soaring spiralling towers (two reaching almost one hundred feet high) and six shorter ones, surrounded by a walled garden with fountains, walkways, arches and pavilions, all on his one-tenth of an acre site.

Rodia worked alone on his hand-built towers of steel pipes and rods wrapped with wire mesh that are covered with cement and decorated with found objects – mostly shards of glass and mirror, seashells, broken pottery and tiles. His novel construction method did not require welding, bolts or rivets – or scaffolding. Once a section had dried he would climb up a tower using its interlocking rings as a ladder and harnessed to it with a window washer's belt, continue to build higher.

Perhaps understandably, most of his neighbours thought him insane and he was subject to their abuse and his towers to vandalism. While now the web-like towers look like some sort of delightful fantasy dreamed up by Roald Dahl, during their construction many saw them as something much more sinister – some believed that the towers were being used to transmit secrets to the Japanese during the Second World War and then later to the Communists. By 1954 Rodia had had enough. Weary of the taunts and suspicion, the seventy-five-year old labourer-artist turned over the deed to his property and the Towers to the only neighbour who had not been abusive. Rodia left the city and never returned, declaring 'there's nothing there'.

In 1957 the city of Los Angeles declared the Towers 'an unauthorized public hazard' and ordered that they be demolished. Controversy ensued and a committee was formed to campaign to save the Towers. 'The Committee for Simon Rodia's Towers in

Watts' eventually managed to convince the city to perform a stress test on the structures, a test they passed with flying colours to the point that the testing equipment began to buckle rather than the Towers. The Towers were saved, but their future was still uncertain.

In 1961 Rodia's Towers received considerable attention in the catalogue accompanying the landmark exhibition, 'The Art of Assemblage', held at the Museum of Modern Art in New York. This had a twofold effect. It brought the work to the attention of many artists working in the 1960s for whom it was very inspirational, such as Niki de Saint Phalle and Jean Tinguely. The Towers' inclusion in the catalogue was also extremely valuable for the ongoing battle to preserve and conserve them for the public. The first exhibition devoted to the Towers was held in Los Angeles in 1962 and the Towers were subsequently placed on the National Register of Historic Places. The complex was designated a National Historic Landmark in 1985.

Rodia's extraordinary folly survived derision, a demolition order, riots and earthquakes to become a much-loved landmark and an important source of inspiration for artists as varied as Edward James (see p. 64), Noah Purifoy (see p. 202), Saint Phalle (see pp. 126; 138; 222; 266; 268), Tinguely (see p. 76) and James Turrell (see p. 184).

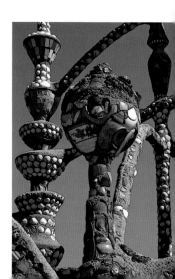

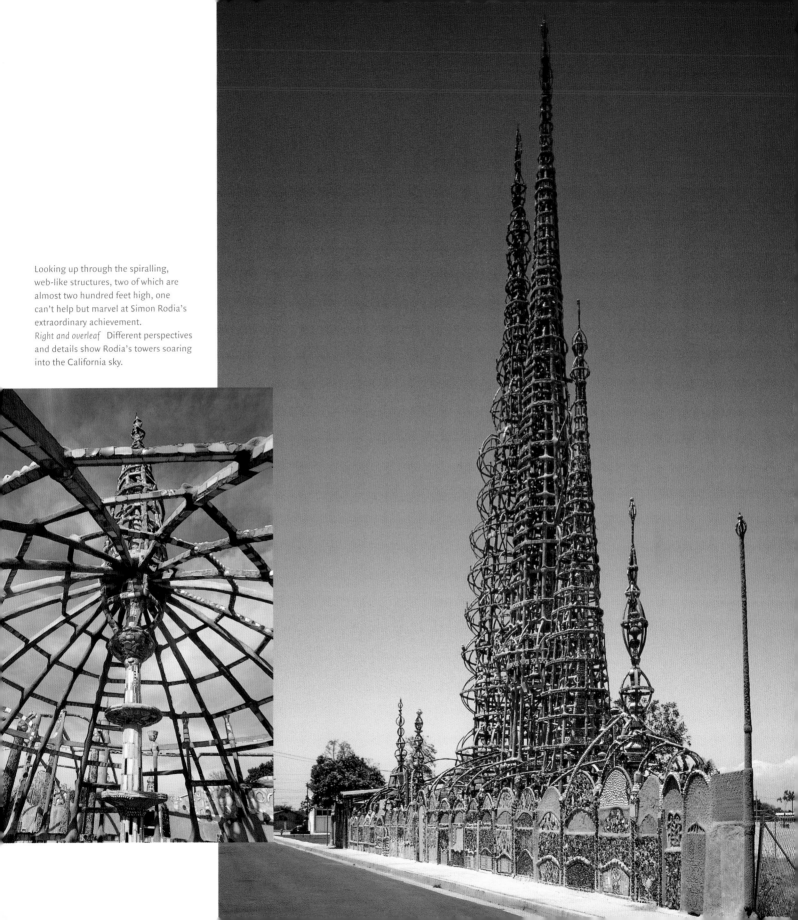

Looking up through the spiralling, web-like structures, two of which are almost two hundred feet high, one can't help but marvel at Simon Rodia's extraordinary achievement.
Right and overleaf Different perspectives and details show Rodia's towers soaring into the California sky.

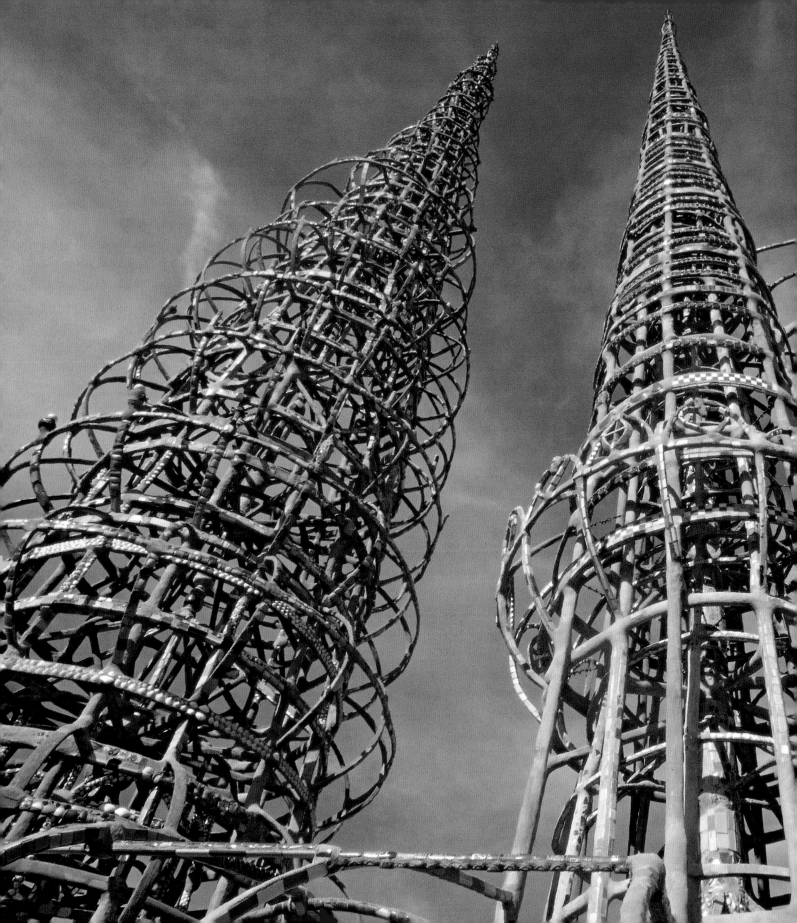

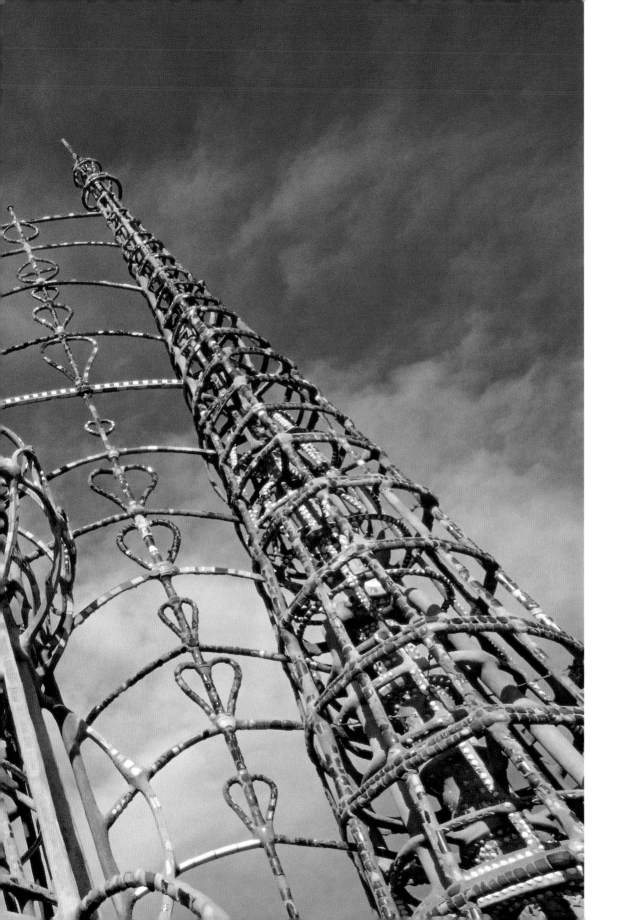

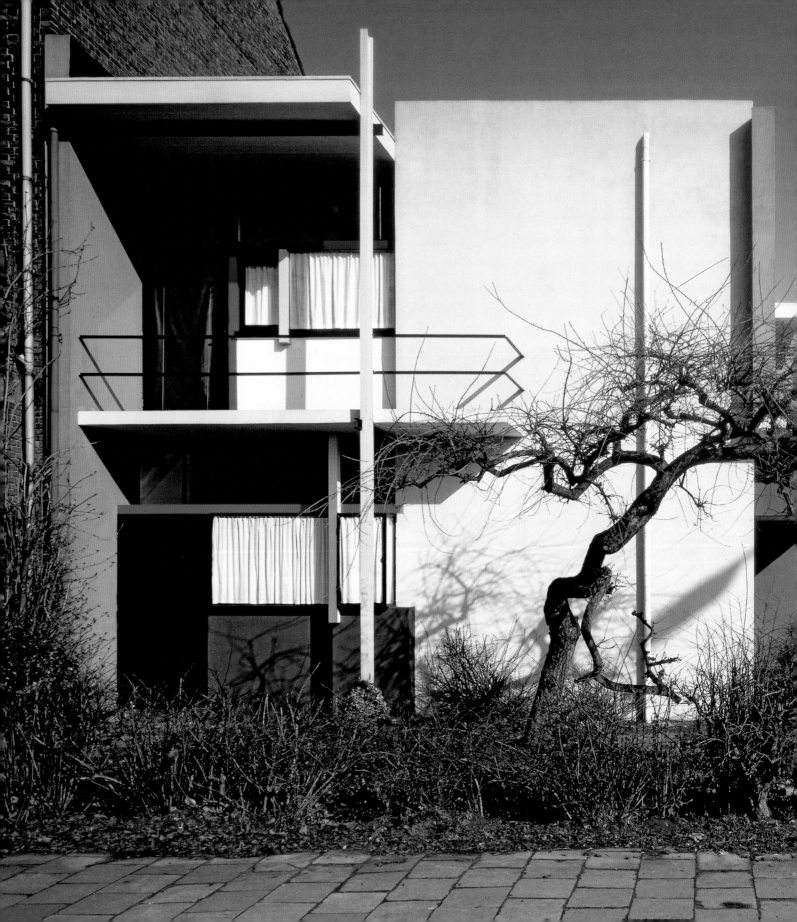

RIETVELD SCHRÖDERHUIS

UTRECHT, NETHERLANDS

Gerrit Rietveld

1924

We didn't avoid older styles because they were ugly, or because we couldn't reproduce them, but because our own times demanded their own form, I mean, their own manifestation. GERRIT RIETVELD

The *Rietveld Schröderhuis* (Rietveld Schröder House) in Utrecht in the Netherlands was designed by architect-designer Gerrit Thomas Rietveld (1888–1964) in collaboration with his client, interior designer Ms Truus Schröder-Schräder (1889–1985) in 1924. Both Rietveld and Schröder were associated with De Stijl (The Style), an avant-garde movement of artists, architects and designers in the Netherlands in the 1920s, and the house they created together stands as perhaps the most complete expression of the ideals of the group.

The De Stijl group's mission was to create a new, international art that would lead to the creation of a better society by integrating art and life. They felt that the horrors of the First World War had discredited the cult of personality, and sought to replace it with a more universal and ethical culture. The means to do this was the reduction – the purification – of art to its basics (form, colour and line). They believed that a simplified and ordered art would lead to a renewal of society and they developed an abstract visual vocabulary based on the use of horizontal and vertical lines, right angles, and rectangular areas of flat colours, which they sought to put to practical purposes. Eventually their palette was reduced to the use of the primary colours, red, yellow and blue, and the neutral colours of white, black and grey.

Rietveld was originally a furniture maker, moving on to interior design and then architecture as his career progressed. When Truus Schröder's husband died in 1923, she turned to Rietveld for help in finding a smaller, more intimate home for herself and her three children. When no suitable home could be found, Rietveld proposed the idea of building one. The plot they selected was at the end of a row of traditional terraced houses, originally surrounded on three sides by a low-lying area of landscape. Features which gave a sense

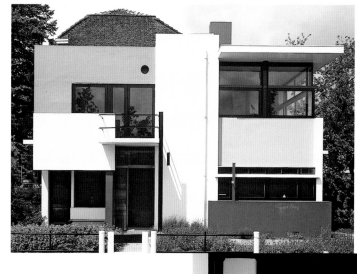

Opposite The simple yet striking street frontage of the *Rietveld Schröderhuis*. The adjoining row of terraced houses can be seen at the left.
Above The front entrance of the house, which faces and interacts with the surrounding landscape rather than the street. The front door is under the balcony.
Right One of the downstairs rooms being used as a study, with Rietveld's brightly coloured furniture and minimalist design.

of inside spaces flowing seamlessly into outside ones, and vice versa, were crucial to the design of the house. The house was cut off from the spectacular landscape in 1964 when a four-lane motorway over a viaduct was constructed in front of it. Rietveld thought this damaged the spatial relationship of the house so much that he suggested demolishing it. Fortunately, he did not get his way and instead trees and shrubs were planted to soften the effect and protect the house.

From the outside the building reads as an abstract, almost sculptural, composition of interlocking planes with projecting roofs and balconies. Inside, there are many delights in store, from ingenious solutions such as a speaking tube that allows communication with deliverymen while upstairs, to a device that allows the sliding door on the ground floor to be opened and closed from the upper floor. The upstairs living space has integrated furniture and fittings and walls that move at right angles to allow the space to change from a single large room into a collection of smaller ones. Due to building restrictions, the ground floor has fixed walls, but Rietveld installed windows at the top of them, which, together with the clever lighting and application of colour, connects the rooms and creates the sense of a much larger space. The overall effect of the play between the lines, angles and colours is that of living in a De Stijl painting.

There is extraordinary attention to detail, with seemingly every eventuality considered. Storage is integrated into the design and everything that moves has a bespoke storage space so that it doesn't interfere with the design of the room or the flow of the living space. Although space, light and airiness are paramount, the need for privacy was also taken into account. Various devices are included which allow, for instance, a bit of solitude or a private telephone conversation. The De Stijl goal of creating a total living environment was certainly achieved in this remarkable house.

The flexibility integral to the design anticipated and accommodated the way the composition of a household and the needs of its occupants change throughout an owner's lifetime. For example, each room was fitted with a handbasin, drainage, space for a bed, storage and a door to the outside, should a room need to be rented out. This foresight allowed the house to meet not only the needs of the immediate family, but also to adapt as circumstances changed. At various times Ms Schröder rented out parts of the house to students, single mothers, and an infant school. Rietveld himself had a studio on the ground floor for awhile, in what was to have been a garage.

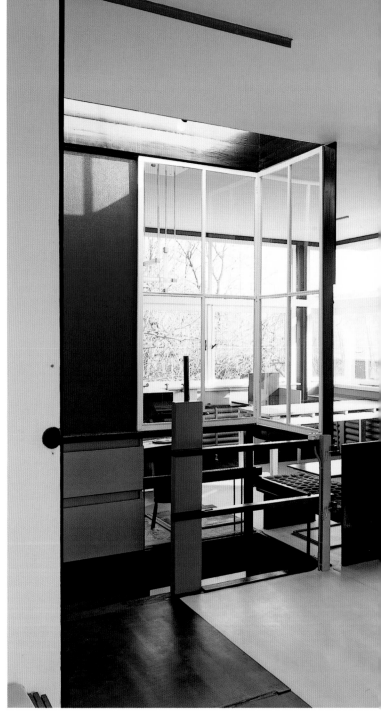

Glimpses into De Stijl living on the top floor, with built-in furniture and storage, moving interior walls and large windows.
Above Looking into the living/dining area from the bedroom areas across the stairwell in the middle. To the right is one of the dividing walls pushed partially back.

Right Looking from the living/dining room across into one of the bedroom areas with Rietveld's famous Red-Blue chair in the background.

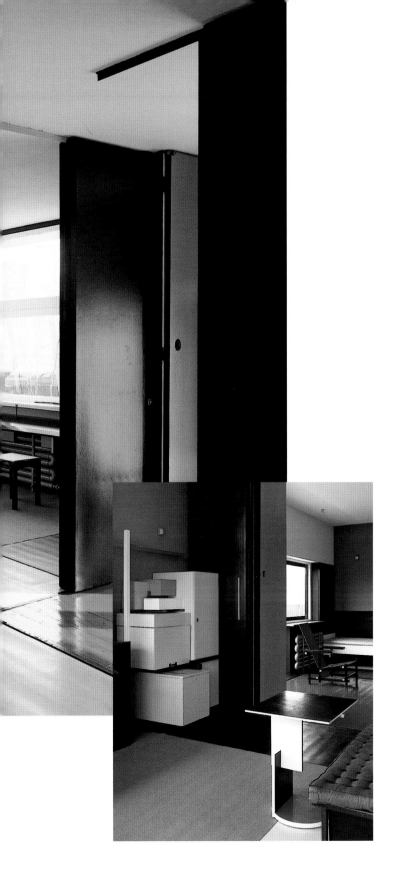

Although many in the local community were outraged by the appearance of the house, it was admired and visited by an international circle of avant-garde architects throughout the 1920s. It was also visited by students from the local technical college, whose teachers used it as an example of how not to build, believing that it would surely tumble like a house of cards. Despite those misgivings, the house withstood the test of time and family living – Truus Schröder lived there until her death in 1985. The importance of the house was recognized in 2000 by UNESCO, which placed it on the World Heritage List, calling it a 'masterpiece of human creative ability'.

While many of Rietveld's innovations are now familiar, particularly aspects of his furniture and storage design, I was struck by how fresh and radical the house still seemed eighty years on. As you come up to it on the street you can imagine the uproar from the neighbours when it was built, and ponder how little things have changed.

Just beyond the *Rietveld Schröderhuis* on Erasmuslaan are two housing blocks built by Rietveld in 1931 and 1935 with the help of Truus Schröder. Unlike the colourful *Rietveld Schröderhuis*, these houses are exercises in white, glass and steel, reflecting Rietveld's move to the minimalist palette of the functionalist architecture of the 1930s. Similarities to his earlier work, however, include the overriding interest in light, air, a connection with the outdoors and the flexibility of living spaces. Initial viewers of the homes were baffled by the lack of prescribed functions for the spaces, so an exhibition of a model home designed by Rietveld and Schröder was held in October 1931 to showcase the possibilities of this new way of living. The response to the exhibition was overwhelmingly positive. Rietveld's career as an architect was established and he went on to build 934 houses in Utrecht alone.

Both the *Rietveld Schröderhuis* and the model home at Erasmuslaan 9 have been restored to their original states and are open to the public. Visits must be arranged in advance due to demand. They are overseen by the Centraal Museum, home of the world's largest Rietveld collection.

MOUNT RUSHMORE

KEYSTONE, SOUTH DAKOTA
USA
Gutzon Borglum
1927–41

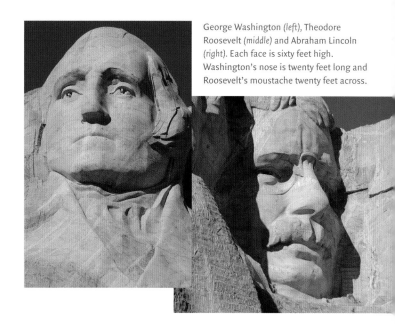

George Washington (*left*), Theodore Roosevelt (*middle*) and Abraham Lincoln (*right*). Each face is sixty feet high. Washington's nose is twenty feet long and Roosevelt's moustache twenty feet across.

There is something in sheer volume that awes and terrifies, lifts us out of ourselves. GUTZON BORGLUM

Mount Rushmore was the vision of South Dakota state historian Doane Robinson (1856–1946), who heard reports of tourist interest in the mountain-carving-in-progress of Confederate heroes in Stone Mountain, Georgia (see p. 47). He believed that such a project could help put his state on the map. He kept talking about his dream until it captured the imagination of state Senator Peter Norbeck (1870–1936) who promised his support if he could find the right sculptor for the project.

In 1924 Robinson wrote to Gutzon Borglum (John Gutzon de la Mothe Borglum, 1867–1941), the American sculptor on the Stone Mountain project, to see if he would be interested in producing mountain carvings of Western heroes in the Black Hills – and if he thought it was possible. After nine years on the Stone Mountain project, which was beset by many delays and inadequate funding, Borglum was constantly at loggerheads with his patrons, frustrated by its lack of progress and they with his 'ungovernable temper'. Borglum was ready for a new challenge and went to South Dakota to meet Robinson. The ambitious sculptor agreed to the project, but thought that national heroes would be a bigger draw than regional ones and suggested four presidents – George Washington, Thomas Jefferson, Abraham Lincoln and Theodore Roosevelt. Robinson agreed and he and Norbeck began raising money.

Meanwhile, the confrontations between Borglum and his patrons in Georgia came to a head and in 1925 he was fired from the Confederate Memorial project. Although furious, Borglum was able to turn his full attention to the Black Hills project. He chose the site – the craggy cliff of Mount Rushmore, for its height, the consistency of the granite and for the direct sunlight its southeastern exposure would provide for most of the day.

On 10 August 1927 *Mount Rushmore* was formally dedicated by President Calvin Coolidge and work on the 5,725-foot mountain commenced. Borglum's workforce was drawn from the pool of local unemployed miners. While originally these men were just happy for work during the Great Depression, most were eventually caught up in Borglum's infectious vision and the incredible challenges they faced to bring about what became their shared dream. As Red Anderson, one of the workers, commented: 'More and more we sensed that we were creating a truly great thing, and after a while all of us old hands became truly dedicated to it and determined to stick to it.' Around four hundred men worked on *Mount Rushmore* during the fourteen carving years. On average, a crew consisted of thirty to fifty men at a time. Incredibly, there were no deaths during the project, an amazing safety record considering the work involved using dynamite and heavy machinery while dangling from a cable down the face of the mountain.

In March 1941, as the four sixty-foot faces were nearing completion and a final dedication was being planned, Borglum died of complications following surgery. His son, Lincoln Borglum (1912–86), carried on throughout the summer, finishing the details on the carving. With the artist dead and funding depleted, carving ended on 31 October 1941. The monument was declared finished, although Borglum might have argued otherwise – he calculated that

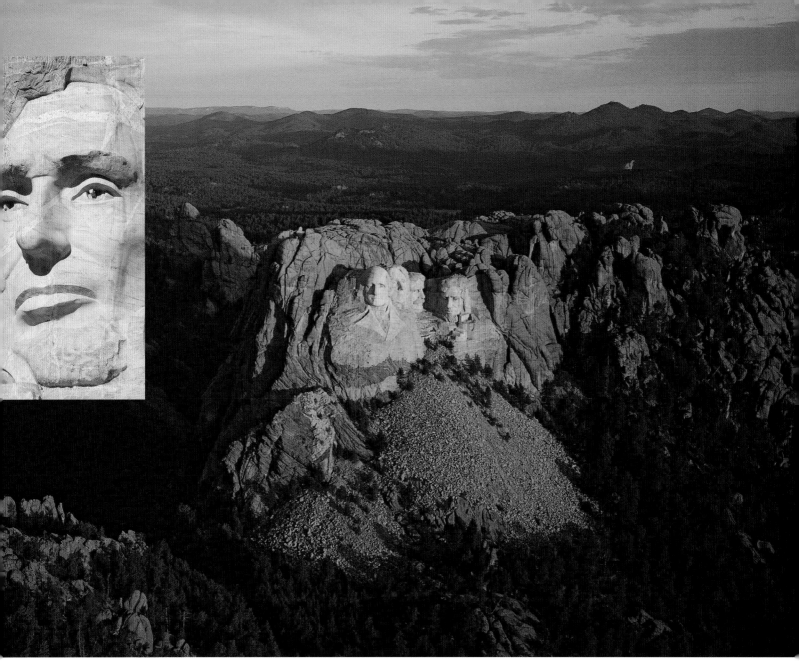

the granite would erode one inch every 10,000 years and added three inches to all the figures' features, such that the work will eventually be completed by nature in 30,000 years! Will future civilizations be as baffled by these massive mountain carvings as we are by such ancient wonders as Stonehenge and the Pyramids?

Mount Rushmore functions as a monument to the first 150 years of the USA and to the ideals of its early founders, but also stands testament to the audacious vision and determination of Borglum, Robinson and Norbeck and to the men who toiled to make it

happen. As familiar as its image is, it is still an awesome sight to behold. As President Franklin Roosevelt commented in 1936 upon seeing it in person for the first time: 'I had seen the photographs, I had seen the drawings, and I had talked with those who are responsible for this great work, and yet I had no conception, until about ten minutes ago, not only of its magnitude, but also its permanent beauty and importance.'

Another massive mountain carving in progress, *Crazy Horse Memorial* is just 17 miles southwest of *Mount Rushmore* (see p. 83).

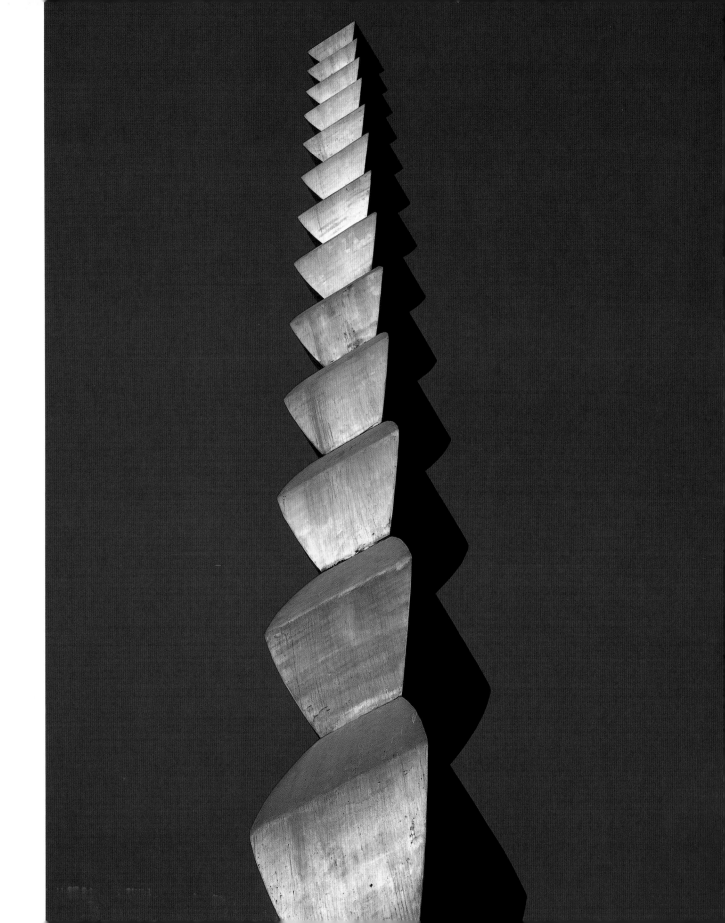

BRANCUSI ENSEMBLE

TÂRGU-JIU, ROMANIA
Constantin Brancusi
1937–38

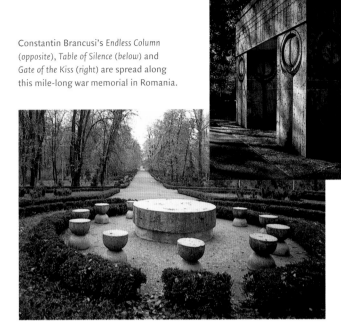

Constantin Brancusi's *Endless Column* (opposite), *Table of Silence* (below) and *Gate of the Kiss* (right) are spread along this mile-long war memorial in Romania.

Simplicity is at bottom complexity, and one must be weaned on its essence to understand its significance. CONSTANTIN BRANCUSI

In 1935 Romanian sculptor Constantin Brancusi (1876–1957) was commissioned to create a monument to commemorate the twentieth anniversary of the end of the Great War for Târgu-Jiu in the Gorj region (where he was born) in southwestern Romania. He responded with an ambitious war memorial complex that is a complete environment. Its main components are three monumental sculptures – *Table of Silence*, *Gate of the Kiss* and *Endless Column* – which are spread along the *Alley of the Heroes*. This mile-long axis of the ensemble stretches from the western edge of the town at the River Jiu, where the *Table* is located, through the town to higher ground at the other end where the *Column* is sited.

The 98-foot-high *Endless Column* can be seen from miles around while the others are encountered on foot in the city park. *Table of Silence* is a round stone table with twelve stools surrounding it. This apparently simple composition has been read as symbolizing many things – from the universal – the cycle of life and eternal time (twelve hours, twelve months, twelve astrological signs, etc.) and a space for quiet reflection – to the more specific, with the empty seats representing those lost in battle. It also calls to mind the site of a Last Supper – be it that of Jesus and his twelve disciples or of the city's soldiers before battle. Or perhaps it represents the 'round table discussions' necessary to prevent or resolve conflicts?

The massive stone *Gate of the Kiss* is an archway with a stylized vision of embracing lovers. It too has been interpreted in many ways – as a symbol of peace and hope, and of love conquering death. Like the *Table*, its context as war memorial also lends more poignant readings – of last goodbyes before battle, the kiss at the station. The park also features stools and benches by Brancusi, along the *Alley of Chairs*.

The most impressive component of the complex is the magnificent modular *Endless Column*, connecting Earth and sky from a clearing on a small hill. It is made of seventeen rhomboidal cast-iron modules threaded onto a steel spine, clad with zinc and brass to achieve the 'very pure golden-yellow' Brancusi specified. A report by UNESCO many years later described the column as 'not only a masterpiece of modern art, but also an extraordinary feat of engineering'. Brancusi referred to it as 'the Endless Remembrance' and described it as a way to 'sustain the vault of heaven'. It certainly has a transcendent aura, rising skywards and overlooking the village, seeming to protect it. One of Brancusi's main preoccupations was the relationship between his sculptures and the space around them. Here not only do the sculptures themselves rise as you encounter them – from table to arch to column – but so does the land on which they sit, such that the whole experience is one of literally ascending to the heavens.

The complex was dedicated in 1938 and was donated to the Municipality of Târgu-Jiu. It was badly neglected during the Communist era and local authorities even attempted to demolish the *Endless Column* in the 1950s. With the return of democracy in 1989, the Romanian government took a renewed interest in the complex, declaring it to be of 'public utility and national interest'. In 1996 *Endless Column* was placed on the World Monuments Watch List of 100 Most Endangered Sites. The World Monuments Fund and the Romanian Government formed a partnership with the World Bank in 1998 to renovate the complex. *Endless Column* was restored to its former glory in 2000 and conservation of the stone monuments was completed in 2004.

KRÖLLER-MÜLLER MUSEUM

OTTERLO, NETHERLANDS
Various artists
From 1938

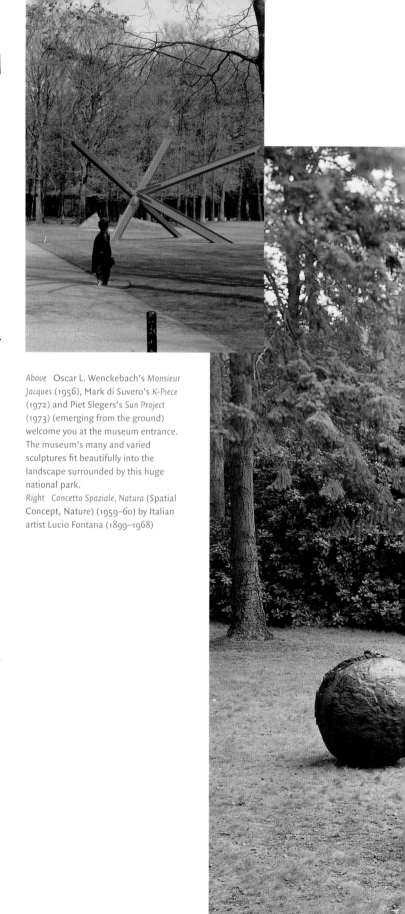

Art is always seeking and yearning, art never stands still.
HELENE KRÖLLER-MÜLLER

The Kröller-Müller Museum is an extraordinarily beautiful museum and sculpture garden in the Netherlands. It is situated in the Hoge Veluwe, the country's largest national park, which covers 5,500 hectares. Both the museum and the park are the legacy of Anton Kröller (1862–1941) and his wife, Helene Kröller-Müller (1869–1939). Helene began collecting art in 1907 and the family's wealth allowed her to amass a vast collection in a relatively short time. Anton, meanwhile, began buying land in the Veluwe region for hunting and riding and the two began to consider it as a site for a museum-house. They commissioned Belgian architect Henry Van de Velde (1863–1957) to design a museum for their Veluwe estate. Although begun in 1920, economic problems prevented its completion.

In 1935 Helene presented her collection to the state. A small museum by Van de Velde opened to the public in 1938. Helene considered her collection to be a completed entity, and after she died in 1939, her successors respected her wishes and focused on collecting modern and contemporary sculpture, which has resulted in a museum with two high-quality, distinct but complementary collections. Helene Kröller-Müller's highly personal collection of outstanding works from the nineteenth and early twentieth centuries is particularly noted for its paintings by Vincent van Gogh (1853–90). The comprehensive sculpture collection, both indoor and out, traces the development of modern sculpture, from Auguste Rodin (1840–1917) and Medardo Rosso (1858–1928) to contemporary practitioners such as Dan Graham (b. 1942), Giuseppe Penone (b. 1947), Richard Serra (b. 1939) and Chen Zhen (1955–2000).

To accommodate this new direction, in the 1950s Van de Velde added a sculpture gallery to the museum. Its large windows allow the works to appear as if set in the natural surroundings. This concept was taken further with the establishment of a permanent

Above Oscar L. Wenckebach's *Monsieur Jacques* (1956), Mark di Suvero's *K-Piece* (1972) and Piet Slegers's *Sun Project* (1973) (emerging from the ground) welcome you at the museum entrance. The museum's many and varied sculptures fit beautifully into the landscape surrounded by this huge national park.
Right *Concetto Spaziale, Natura* (Spatial Concept, Nature) (1959–60) by Italian artist Lucio Fontana (1899–1968)

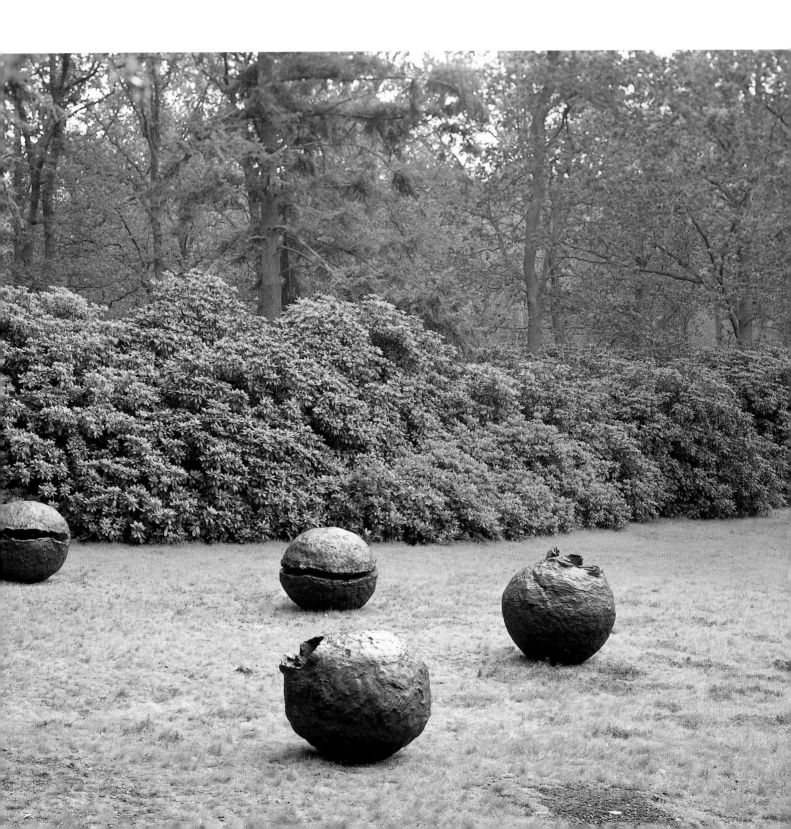

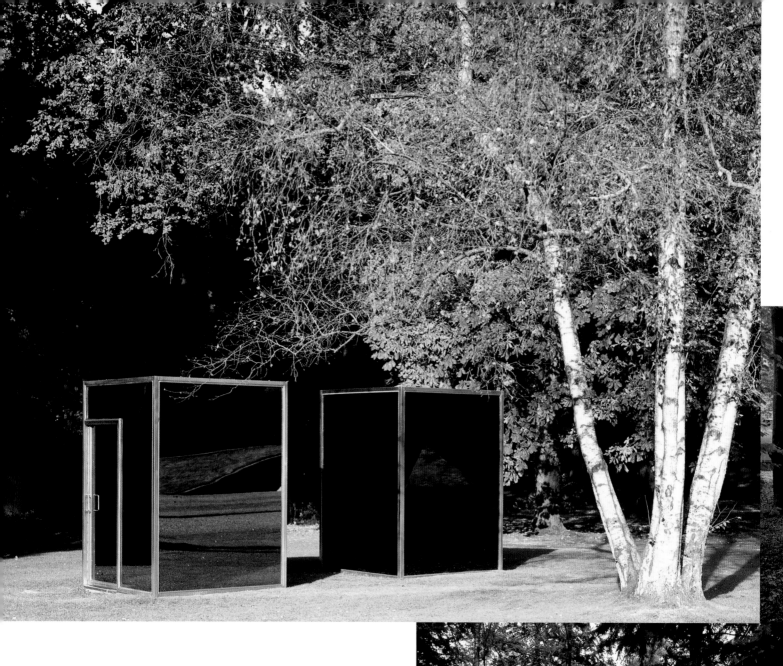

sculpture garden in 1961. As the collection expanded, so did the building and sculpture garden – a new museum wing was added in 1970–77 by Dutch architect Wim Quist (b. 1930) and the sculpture garden is now one of the largest in Europe, covering twenty-five hectares. Noted Dutch landscape architect Adriaan Geuze (b. 1960) of West 8 designed the extension to the garden, which now includes parkland, woodland, open spaces, new paths and an activity area. The whole has been beautifully choreographed to facilitate the experience of different types of art in a variety of contexts.

The road leading to the museum and sculpture garden is announced by an apt beacon, Claes Oldenburg (b. 1929) and Coosje van Bruggen's (1942–2009) massive blue trowel, *Trowel I* (1971–76). In the front garden of the museum you are greeted by works as varied as Mark di Suvero's (b. 1933) massive red steel construction, *K-Piece* (1972), Oscar L. Wenckebach's (1895–1962) *Monsieur Jacques* (1956), Dan Graham's *Two Adjacent Pavilions* (1978–81), glass constructions which reflect the surroundings and viewers, and an earthwork, *Sun Project* (1973) by Piet Slegers (b. 1923). Bruce Nauman's (b. 1941) *Window or Wall Sign* (1967) beckons from the end of the path through the trees, drawing you to the entrance of the museum.

Once inside, the sculpture garden is reached from the museum foyer. It features numerous different environments, from manicured lawns which use the landscape as an outdoor gallery, to open spaces in which nature is a backdrop for large sculptures that can only ever be outdoors, to areas with work which engages directly with nature – either as the subject of the work or as an active ingredient in its making.

There is a whole variety of site-specific works, from Jean Dubuffet's (1901–85), *Jardin d'émail* (Enamel Garden) (1972–73), an enormous black-and-white installation in which he created an artificial garden within the natural one, to those more directly involved with nature – and harder to find – such as Ian Hamilton Finlay's (1925–2006) *Five Columns for the Kröller-Müller Museum* (1980–82), Giuseppe Penone's *Otterlo Beech* (1987–88) and Luciano Fabro's (1936–2007) *La doppia faccia del cielo* (The Double Face of the Sky) (1986).

With such an exemplary collection, it is difficult to single out highlights, but one would have to be Richard Serra's (b. 1939) *Spin Out (for Robert Smithson)* (1972–73), his first large-scale commission for a site-specific work (see illustration on title page). He chose a dell in the park ringed by a ridge around 150 feet high. Three huge steel plates push into the sloping terrain, seeming to

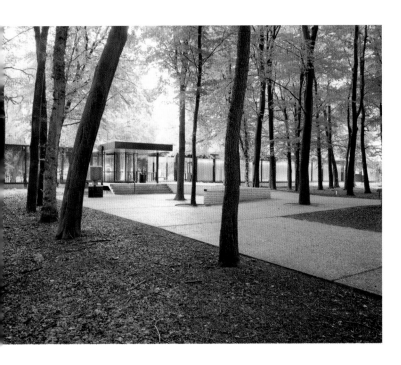

Above left Dan Graham's *Two Adjacent Pavilions* (1978–81) reflecting Piet Slegers's *Sun Project* (1973) in its gleaming surfaces.
Above Dutch artist André Volten's (1925–2002) sculpture *Cubic Construction* (1968) in the foreground stands beside Wim Quist's new wing of the museum (1970–77).
Below Luciano Fabro's suspended marble sculpture, *La doppia faccia del cielo* (The Two Faces of the Sky) (1986).

meld into the landscape. Walking around and through the work, there is a slightly eerie sensation that the plates are moving and when you are in the centre there is a sense of spiralling movement. When seen from above it looks a bit like a propeller, which in light of the dedication, makes the work particularly poignant, for Serra's friend Smithson was killed in 1973 in a plane crash while overseeing the building of his site-specific Land Art piece in Texas, *Amarillo Ramp* (see p. 138).

Behind and above Serra's piece you catch sight through the trees of an enormous sculpture on a hill. R. W. van de Wint's (1942–2006) *View* (1999–2002) draws you up the wooden stairs to it. The massive steel plant-like sculpture is amazing enough in its own right, but it also beckons you to a spot where you get panoramic views over the park. As you follow the ridge around you also get great aerial views of the Serra and other works below, including Kenneth Snelson's (b. 1927) *Needle Tower* (1968) and Carel Visser's (b. 1928) *Cube and its Piling Up* (1967).

The Kröller-Müller Museum's sculpture garden is a place which would reward return visits, as it is difficult, if not impossible, to find and see all the works in one trip. Helene Kröller-Müller's vision of creating an environment in which art, architecture and nature interact in a harmonious fashion has certainly been achieved. Those subsequently entrusted with that vision have created and sustained a fitting, living, evolving tribute to the desire of its patron.

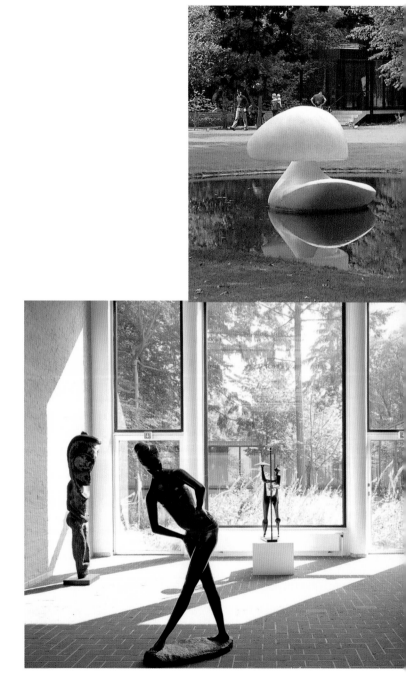

Top Hungarian-born French artist Marta Pan (1923–2008) designed the first section of the permanent sculpture garden in 1961. Her contribution included the lake, path, lawn and this amazing floating sculpture, *Sculpture Flottante 'Otterlo'* (Floating Sculpture 'Otterlo') (1960–61).
Below The museum's sculpture gallery was specially designed by Henry Van de Velde in the 1950s. Connecting the building with its natural surroundings began the museum's process of integrating art and nature.

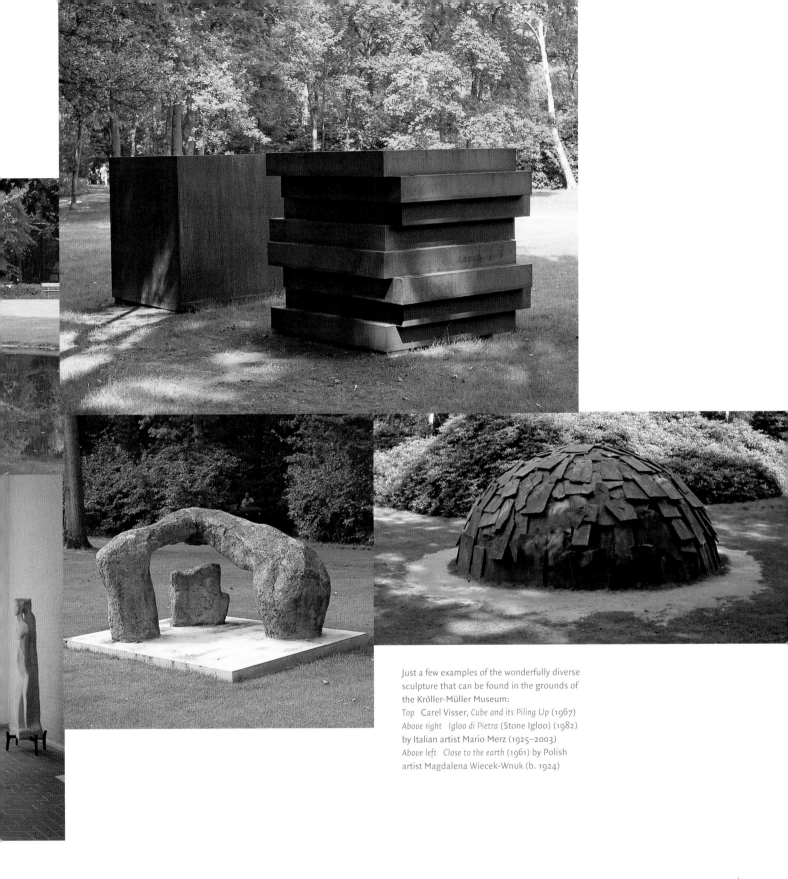

Just a few examples of the wonderfully diverse sculpture that can be found in the grounds of the Kröller-Müller Museum:

Top Carel Visser, *Cube and its Piling Up* (1967)
Above right *Igloo di Pietra (Stone Igloo)* (1982) by Italian artist Mario Merz (1925–2003)
Above left *Close to the earth* (1961) by Polish artist Magdalena Wiecek-Wnuk (b. 1924)

OPUS 40

SAUGERTIES, NEW YORK, USA
Harvey Fite
1939–76

One of the largest and most beguiling works of art on the entire continent.
BRENDAN GILL

Saugerties, New York is on the west bank of the Hudson River, one hundred miles north of New York City. In 1938 American Harvey Fite (1903–76), a sculptor and art teacher, found an abandoned bluestone quarry in the middle of the woods in the tiny hamlet of High Woods, New York, near Saugerties village, in the foothills of the Catskill Mountains. He bought the twelve acres from the last quarrymaster's widow, built his house and studio on the lip of the quarry and in 1939 began clearing the rubble and overgrown brush on the site.

Originally drawn to the quarry as an endless source of raw material for his sculpture, Fite began fashioning pedestals for his sculptures out of the stone and creating ramps to reach them. Before long, however, Fite realized he was involved in something much more all-encompassing than simply making stands on which to display his carved sculptures, that he was in fact, creating a complete sculptural environment. He had begun his monumental earthwork, *Opus 40*, a planned forty-year project that would be cut short by three years because of his accidental death in 1976.

Opus 40 is a labyrinth of sweeping ramps and terraces, steps, alcoves and pools, built using an ancient construction method known as 'dry keying', which relies on the precise fitting of stones and their mass to create stability, rather than mortar or cement. Fite had become familiar with the technique while helping to restore Mayan sculptures in Copan, Honduras in 1938.

At the apex of the six-acre composition is a massive (nine-ton) monolith, which Fite found in a creek bed nearby. He had originally planned to carve it, but once it was in place he was struck by the stone's beauty and decided to leave it as it was. It had such a commanding presence that he even moved his other carved sculptures into the woods on the periphery and let it hold court on its own.

Walking around the site, the beauty of the stone shines through as does that of the surrounding countryside, as you are guided to arresting vistas on different levels. In addition to *Opus 40*, a small museum is also open to the public. Fite built it during the 1970s to house the traditional quarryman's tools that he used to create his hand-built stone wonderland. Although the result of one man's dream and hard work, *Opus 40* stands as a fitting monument to all those involved in what was once a major industry in the region.

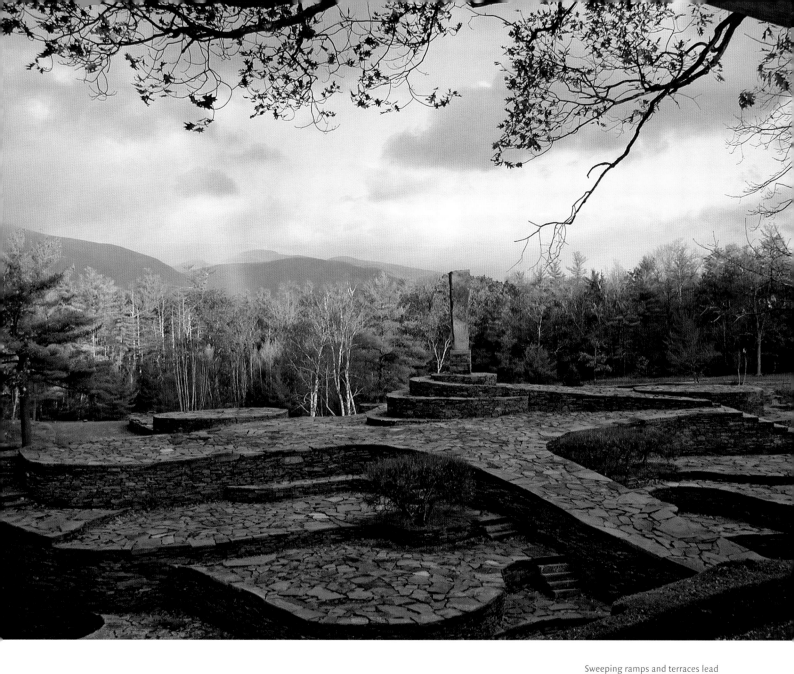

Sweeping ramps and terraces lead up to the monolith and to stunning views of the surrounding countryside in Harvey Fite's *Opus 40*, which he worked on for thirty-seven years. Set in the middle of the woods, the distant mountains create a natural frame for *Opus 40*, while the stone carvings suggest a strong connection to the quarry which provided the raw material for this unique earthwork.

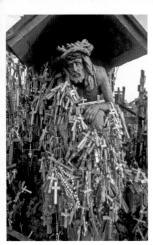
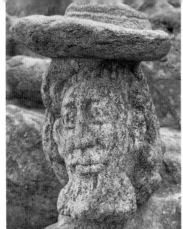
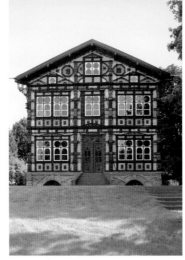

Kryžių Kalnas (Hill of Crosses) (1)
Siauliai, Lithuania
Anonymous, ongoing

In northern Lithuania near the Latvian border, is the Hill of Crosses, an amazing spontaneous folk art monument to the Lithuanian people's continual fight against religious and political oppression. Crosses have been planted on the small hill by anonymous pilgrims for hundreds of years as a sign of faith and as an act of defiance against the country's numerous invaders – the Teutonic Knights of the fourteenth century, Russia during the seventeenth and eighteenth centuries, Germany in the Second World War and the Soviet Union after the war. Throughout this time it has evolved from a site of purely religious significance into a focus for expressions of pain, hope, memory and identity. During the Soviet occupation (1944–91) the Hill of Crosses took on an even more charged symbolic function. In 1961, 1973 and 1975 the Soviets desecrated the monument, removing and destroying the crosses, razing the site, the covering it with sewage and digging a ditch around it to prevent access. Their efforts were

unsuccessful, however, as each time new crosses appeared almost immediately. They finally gave up in 1985 and the monument is now covered with hundreds of thousands of crosses, crucifixes, rosaries and statues of Lithuanian heroes.

Les Rochers Sculptés (The Carved Rocks) (2)
Rothéneuf, France
Abbé Fouré, 1870–early 1900s

When country priest Adolphe-Julien Fouré (1839–1910) was forced to resign after a stroke which left him partially paralyzed and unable to hear or speak, he turned his attention to carving. With the aid of an elderly assistant he spent more than thirty years carving over three hundred sculptures into the granite Brittany coastline on the edge of the village of Rothéneuf, near Saint-Malo. The sprawling work tells the legendary adventures of the Rothéneuf family of pirates.

Das Junkerhaus (Junker House) (3)
Lemgo, Germany
Karl Junker, mid-1880s–1912

Das Junkerhaus in Lemgo, near Hannover, represents the whole career of, and only building by, schizophrenic architect Karl Junker (1850–1912). His obsessively carved and decorated total work of art includes the exterior and interior of the house and its fixtures and fittings.

The Garden of Eden (4)
Lucas, Kansas, USA
S. P. Dinsmoor, 1907–28

Civil War veteran and retired teacher Samuel Perry Dinsmoor's (1843–1932) garden is an elaborate maze of concrete trees with over 150 cement sculptures of people, flags and animals in them. It surrounds the house he built of limestone to look like a log cabin. The tableaux illustrate his religious and political beliefs and his version of the history of the world. Dinsmoor himself can be paid a visit in his glass-topped concrete coffin in the mausoleum he built on site.

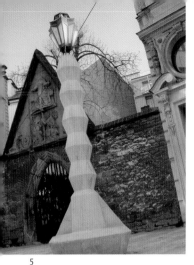

5

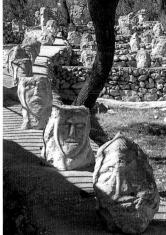

6

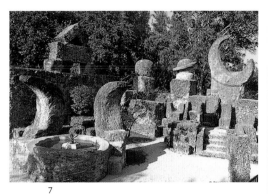

7

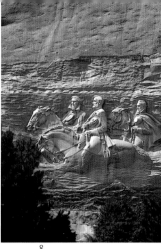

8

Cubist Lamp Post (5)

Prague, Czech Republic

Emil Králícek and Matej Blecha, 1912

Prague is home to the world's only Cubist lamp post (with four seats incorporated into the base), designed by Emil Králícek (1877–1930) and Matej Blecha (1861–1919) in 1912. Cubist architecture is unique to Prague, where the possibilities of Cubism were explored most fully, as a whole way of life. Cubist theories were taken up enthusiastically in Czechoslovakia by artists, sculptors, designers and architects, who translated the characteristics of Cubist painting (simplified geometric forms, contrasts of light and dark, prism-like facets, angular lines) into architecture and the applied arts, including furniture, jewelry, tableware, fixtures, ceramics and landscaping.

Il Castello Incantato
(The Enchanted Castle) (6)

Sciacca, Italy

Filippo Bentivegna, 1920s–67

Filippo Bentivegna (1888–1967) returned to southern Sicily from the USA in 1913 after his heart was broken. After decorating his hut with murals he created a garden filled with thousands of heads carved into the stone and the bark of the trees (see p. 4).

Christ the Redeemer of the Open Arms

Rio de Janeiro, Brazil

Heitor da Silva Costa and Paul Landowski, 1922–31

This massive statue was conceived in 1921 as a way to mark the centenary of Brazilian Independence in 1922. It was designed by Brazilian engineer Heitor da Silva Costa and executed by Polish–French sculptor Landowski (1875–1961). The thirty-eight-metre-high steel and concrete sculpture is covered in a mosaic of soapstone and is located atop the Corcovado Mountain overlooking Rio de Janeiro (see p. 4).

Coral Castle (7)

Homestead, Florida, USA

Edward Leedskalnin, 1923–51

Latvian immigrant Edward Leedskalnin (1887–1951) spent twenty-eight years carving a coral castle complex in Florida. Supposedly, he was driven to do so by unrequited love – his beloved Agnes jilted him the day before their wedding. One of the many mysteries about this monument is how the diminutive self-taught architect, who was about five feet tall and weighed around one hundred pounds, carved, sculpted and installed 1100 tons of coral and rock, working alone with handmade tools.

Confederate Memorial Carving (8)

Stone Mountain, Georgia, USA

Augustus Lukeman and Walker Kirtland Hancock, 1923–72

Sixteen miles east of Atlanta is Stone Mountain Park, home to the world's largest mass of exposed granite which features the world's largest high relief carving of three Confederate heroes of the Civil War, President Jefferson Davis and Generals Robert E. Lee and Thomas J. 'Stonewall' Jackson. The mountain sculpture measures 90 by 190 feet and is 42 feet deep into the mountain. The United Daughters of the Confederacy conceived of the idea of a monumental memorial and hired American sculptor Gutzon Borglum (1867–1941) as carving consultant in 1915 and procured the

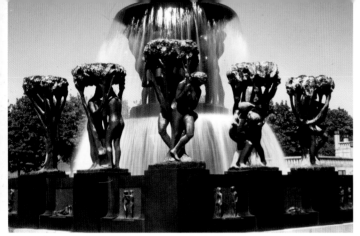

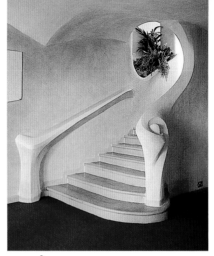

cooperation of the Venable family, owners of the mountain, in 1916. They deeded the face of the mountain for twelve years, after which time if the carving had not been realized ownership would revert to the family. Funding problems and the First World War delayed the start of the project until 1923. Borglum finished the head of Lee in January 1924 but left the project in 1925, destroying his models and sketches, after a dispute with The Stone Mountain Confederate Monumental Association. Augustus Lukeman (1871–1935) took over and Borglum found fame with his next project, *Mount Rushmore* in South Dakota. Lukeman removed Borglum's work and started over, but had not made enough progress by 1928, so the Venable family reclaimed their property. Work did not recommence until 1964 after the State of Georgia had purchased the mountain (1958) and a new sculptor, Walker Kirtland Hancock (1901–98) had been selected from an international competition. The memorial was finally completed in 1972 as part of a larger plan to turn Stone Mountain Park into a state park and tourist attraction.

Vigelandsparken (Vigeland Park) (1)
Oslo, Norway
Gustav Vigeland, 1924–47
The eighty-acre Vigeland Park in western Oslo is the one-man project of Norwegian sculptor Gustav Vigeland (1869–1943). Vigeland designed the architecture of the park, including the bridge and landscaping and peopled it with over two hundred of his bronze, granite and iron sculptures depicting man's cycle of life. Highlights include the monumental bronze fountain and the soaring granite monolith.

Rudolf Steiner House (2)
London, England
Montague Wheeler, 1926–37
The Rudolf Steiner House is the head of the Anthroposophical Society of Great Britain. Its building, designed by Montague Wheeler (1874–1937) of Hoare and Wheeler, is the only example of Expressionist architecture in London. The extraordinary flowing, curving staircase is worth a visit alone.

L'Aubette
Strasbourg, France
Theo Van Doesburg, Jean (Hans) Arp and Sophie Taeuber-Arp, 1926–28
In 1926 Dutch poet, painter and architect Theo Van Doesburg (1884–1931) was commissioned to modernize a number of interiors of the entertainment complex in the eighteenth-century *L'Aubette*. He called his style of painting at the time 'Elementarism'; compositions using right angles and primary colours tilted at forty-five degrees to give them an element of surprise and dynamism. His aim was to fully synthesize painting and architecture, declaring that 'painting without architectural construction (that is, easel painting) has no further reason for existence.' These thoughts were realized in this project, which Van Doesburg worked on with local artist Jean (Hans) Arp (1887–1966) and his Swiss wife, Sophie Taeuber-Arp (1889–1943). Van Doesburg planned the overall scheme and each artist decorated a room. The interior surfaces were covered with boldly coloured, shallow diagonal abstract reliefs, which provide a contrast to the horizontal-vertical lines of its

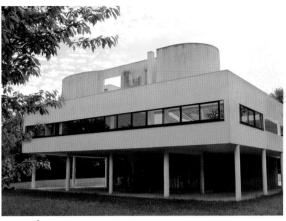

4

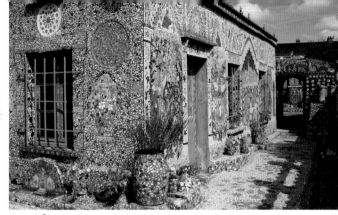

5

construction, and a sense of movement was created by contrasting features, and the integration of colour and lighting. The interiors were covered up in 1938 and rediscovered in 1977. In 1994 the cinema-dance hall was restored, followed by the Festivity Hall, the Foyer Bar and the Staircase, completed in 2006.

The Wharton Esherick Museum (3)
Paoli, Pennsylvania, USA
Wharton Esherick, 1926–66
American painter turned woodworker Wharton Esherick (1887–1970) began work on his studio and home on Valley Forge Mountain in southeastern Pennsylvania in 1926 and proclaimed it finished in 1966. The stone and wood structure, its architectural interiors and sculptural furniture make for an extraordinary work of art. Esherick's sensuous organic forms fuse his knowledge of, and interest in, early modernism with a respect for traditional fine craftsmanship and native natural materials. Working in relative isolation for most of his life, shortly before his death he was finally heralded by the

national art and design community as the 'Dean of American Craftsmen'. His studio and home, now the Wharton Esherick Museum, was declared a National Historic Landmark in 1993.

Villa Savoye (4)
Poissy, France
Le Corbusier and Pierre Jeanneret, 1928–31
In the 1920s Swiss painter and architect Le Corbusier (1887–1965), became famous for his gleaming white concrete houses. The most famous example is the *Villa Savoye* in Poissy, just outside of Paris, which he designed in conjunction with his cousin, Pierre Jeanneret (1896–1967). Experiencing the incredible light, space, green areas, flexible design and attention to detail makes clear the meaning of his famous aphorism: 'The house is a machine for living in.'

La Maison Picassiette (5)
Chartres, France
Raymond Isidore, 1937–64
Raymond Isidore (1900–64), a graveyard sweeper, spent almost thirty years building

and decorating his family home in Chartres. After decorating the outside of the house with mosaics made of broken crockery and glass, he then covered the interior and furniture. Next, he built a complex of courtyards and shrines and a little chapel, all encrusted with elaborate mosaics. Some fifteen tons of crockery were used in the project.

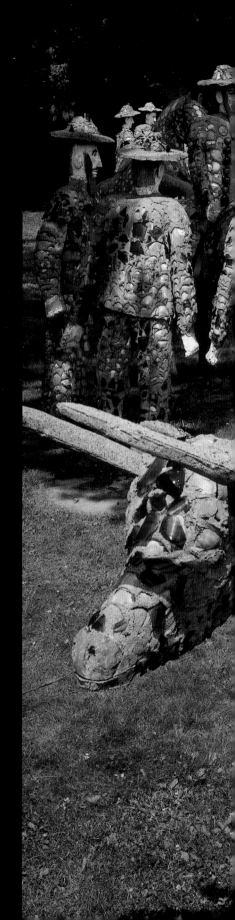

TWO:
PERSONAL VISIONS &
THE RISE OF LAND ART

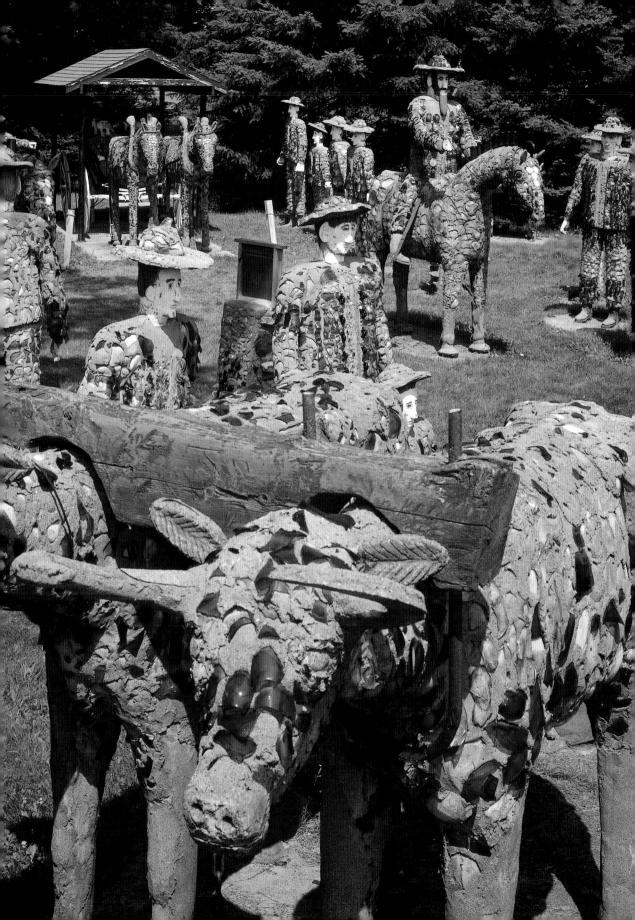

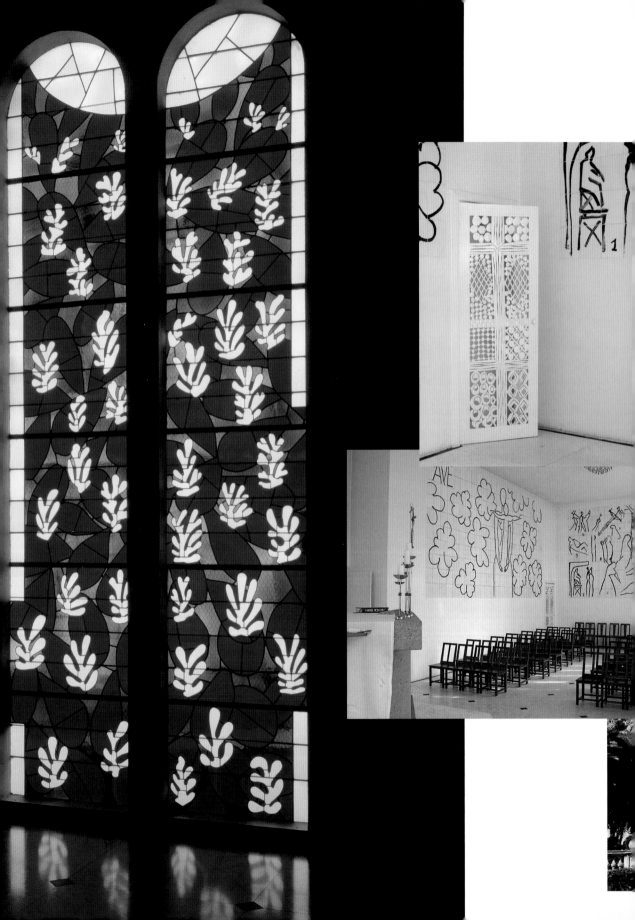

CHAPELLE DU ROSAIRE

VENCE, FRANCE
Henri Matisse
1948–51

The point is to create a special atmosphere: to sublimate, to lift people out of their everyday concerns and preoccupations. HENRI MATISSE

During the Second World War French artist Henri Matisse (1869–1954) moved to Vence from Nice to escape the coastal bombing threats. While there he was reunited with Monique Bourgeois, a young woman who had nursed him back to health after major surgery in 1941. Bourgeois was in the process of becoming Sister Jacques-Marie, a Dominican nun. Despite being nearly eighty years old, Matisse volunteered to decorate the chapel for the nuns' cloister in the village as a gesture of his gratitude. He originally planned to design some stained glass windows, but ended up designing almost the whole chapel.

This complete control lends an extraordinary unity to the whole. From the outside, the Chapelle du Rosaire (Chapel of the Rosary) is a small, austere white building punctuated by soberly coloured stained glass windows and adorned with two simple ceramics depicting the Virgin and Child and Saint Dominic in bold black lines. The blue and white tiled roof provides a flash of colour and its tall wrought-iron arrow makes it soar. Matisse explained his thinking behind the arrow:

It does not crush the chapel but, on the contrary, gives it height.... When you see smoke rising from a cottage roof at the end of the day, and watch the smoke rising and rising ... you get the impression that it does not stop. This is a little like the impression I gave with my arrow.

When entering the chapel, at first the pristine white-tiled interior with its sparse black-and-white wall drawings might seem a strange departure for Matisse, for whom colour was all-important. However, once the light streams through the exquisite floor-to-ceiling stained-glass windows and paints the interior in sumptuous jewel-like colours, you see that colour is indeed a key feature. The windows, with their leaf motifs coloured in the brilliant lemon yellow, bottle

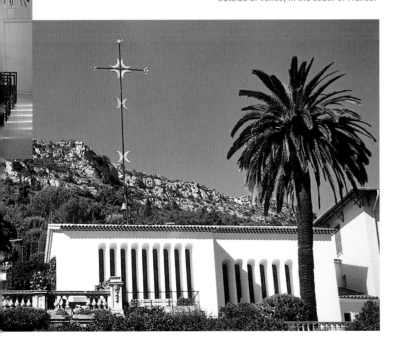

This page and overleaf Henri Matisse designed almost every aspect of the atmospheric Chapelle du Rosaire, including the carved doors (*above left*), the glazed-tile murals (*left*) and the striking colourful window, with its design inspired by the native French cactus, the prickly pear fig (*opposite*). *Below* The bright white chapel is just outside of Vence, in the south of France.

green and ultramarine associated with the region, bring the light and colour of Provence inside. The light and the colour fuse, such that the colours become, in a sense, dematerialized and the light becomes a tangible presence, both effects creating a very serene, spiritual atmosphere. Matisse described his cut-outs of the same period, such as *Jazz* (1947), as 'drawing directly into colour' and on a sunny day the interior of the Chapel is as saturated with colour as they are.

In addition to the stained-glass windows and glazed-tile murals, Matisse also designed the floor pattern, the stone altar, a crucifix, some candlesticks, carved doors and vestments for the priests. Upon completing the Chapel he wrote: 'This work has taken me four years of exclusive and assiduous work and it represents the result of my entire active life. I consider it – in spite of its imperfections – to be my masterpiece.'

Matisse's joyful colourful abstraction has influenced many artists and the Chapel of the Rosary has been a site of pilgrimage for Matisse fans since its consecration in 1951. Other art sites in Vence include the Fondation Émile Hugues in the Château de Villeneuve, which showcases contemporary art, as does the Centre d'Art VAAS. From the Centre d'Art VAAS you also get a good view of the Chapel of the Rosary's roof. There is also a striking mosaic by Marc Chagall (1887–1985) in the eleventh century Cathédrale Notre-Dame de la Nativité in the old town.

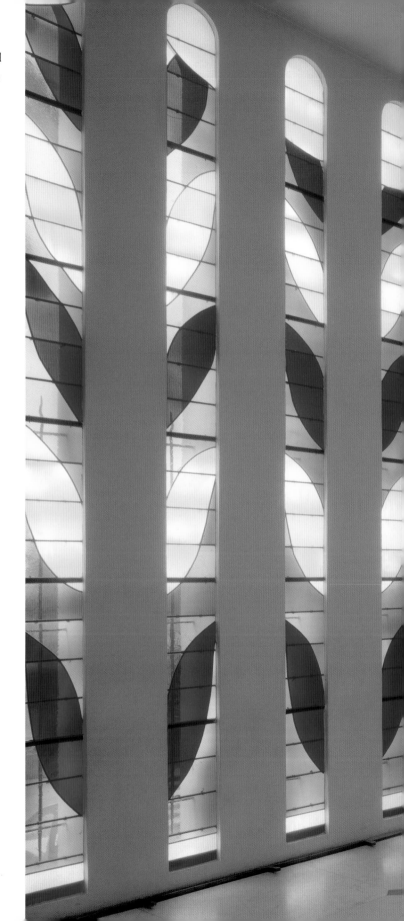

Right The cool interior of Matisse's masterpiece is illuminated by glorious stained-glass windows. The stone altar, the floor and the candlesticks were all designed by the artist.

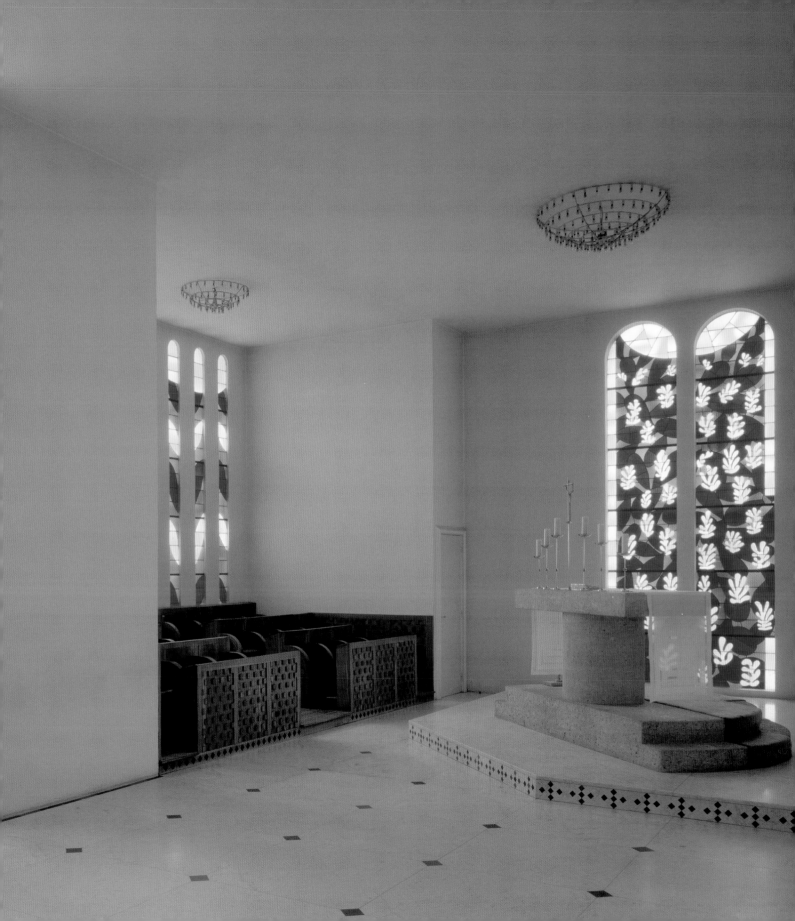

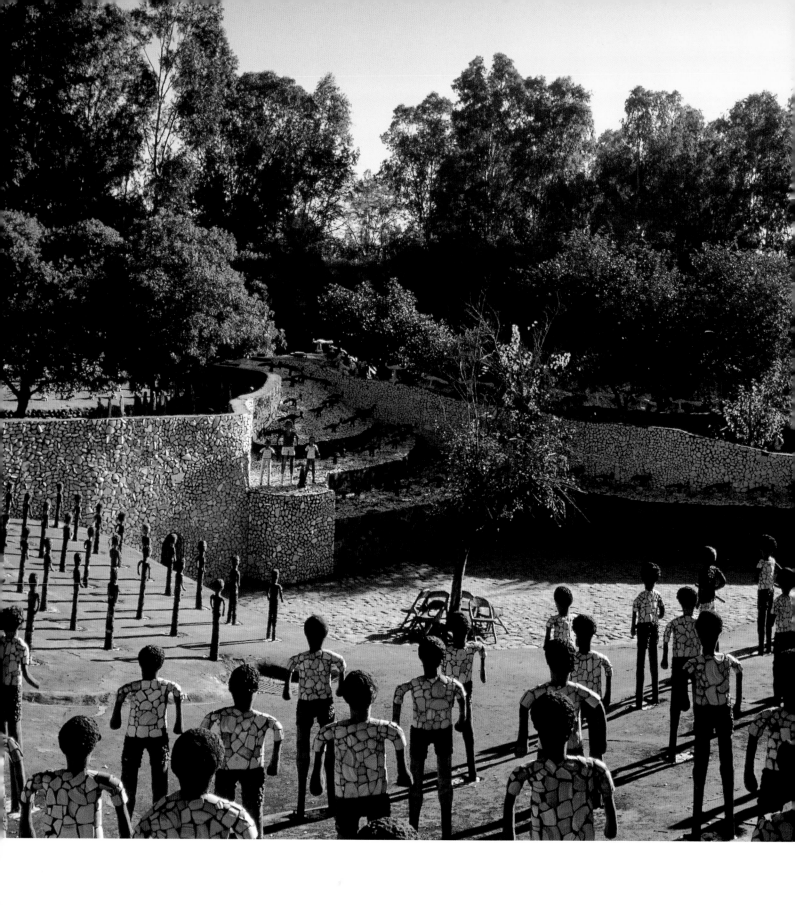

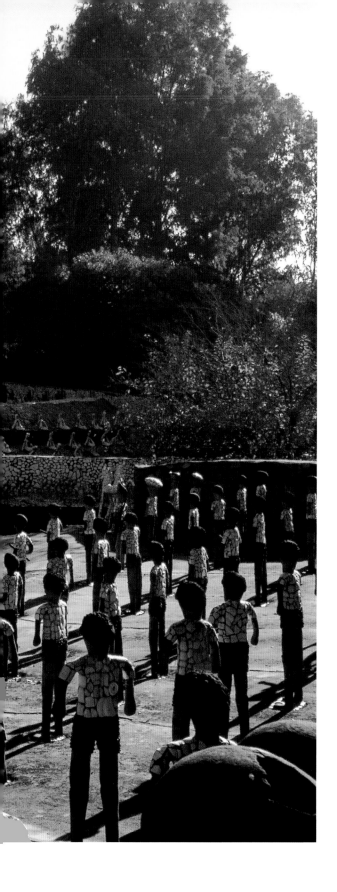

THE ROCK GARDEN
CHANDIGARH, INDIA
Nek Chand
From 1958

My own effort is to explore the aesthetic dimension. The natural environment, trees, water, soil, birds, rocks are the major participants in my work.
NEK CHAND

Indian Nek Chand (b. 1924) moved to Chandigarh in northern India in 1951 to work on the new, utopian modernist city that was being built by renowned Swiss architect Le Corbusier (1887–1965). In 1958, while working as a Roads Inspector for the Engineering Department of Chandigarh Capital Project, Chand began to plan his own magical kingdom at a site in the protected woodlands surrounding the city. He made a small clearing, built a hut and began collecting materials – urban and industrial waste and stones. He began building and sculpting in 1965 and before long had covered several acres with figures and stones.

As the land on which he was working was government-owned and no building work was permitted, Chand worked on his vision alone and in secret.

Every day, after I finished my government job at 5:00, I would come here to work for at least four hours, as I did on almost every holiday. At first my wife didn't understand what I was doing everyday but after I brought her to my jungle hut and showed her my creation, she was very pleased.

Ten years later, when the government authorities discovered Chand's illegal secret garden, they however, were less than pleased and in a quandary as to what to do with the almost two hundred pottery-covered concrete sculptures in a complex of courtyards that they had come across. Fortunately, news about Chand's creation spread quickly and public support helped save it from demolition. Public pressure led city authorities to name Chand 'Sub-Divisional Engineer, Rock Garden' and he was given a state salary and a staff of fifty to help in its building. *The Rock Garden* was opened as a public space in 1976 and it has continued to grow ever since.

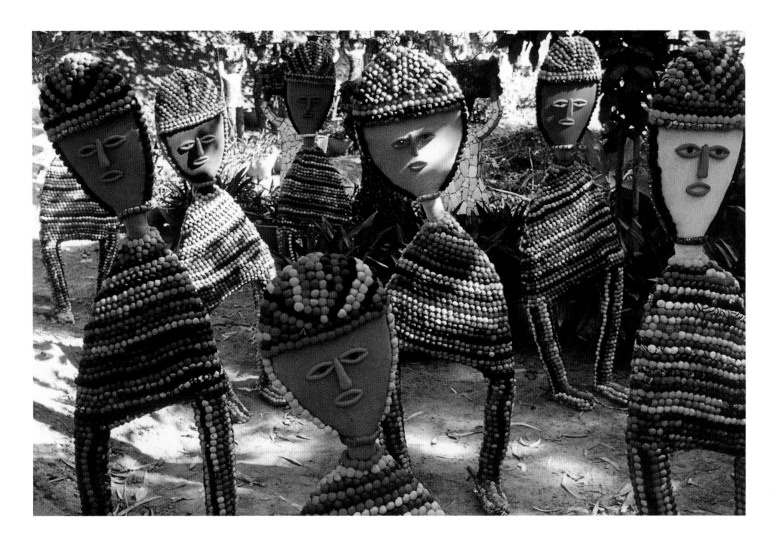

Waste collection centres were established around the city, which both provided material for the newly christened park and helped the city deal with its refuse.

The first part of the garden is a small canyon, which leads on to a series of fourteen chambers. Each is populated by concrete humans and animals, clothed in mosaics of broken crockery and glass. Other sections feature a mountain village, a grand palace complex, an open-air theatre, waterfalls and streams, pavilions and colonnades with swings. Throughout this labyrinthine fantastic environment there are sculptures based on natural rock and tree forms and thousands of Chand's distinctive sculptures of people, deities and animals inhabiting it.

The Rock Garden of Chandigarh now spreads over more than forty acres and receives more than five thousand visitors a day.

What began as one man's secret vision of paradise and belief that urban waste could be recycled into something beautiful evolved into the world's largest visionary environment and India's second most popular tourist attraction after the Taj Mahal.

Above and opposite Many of Nek Chand's extraordinary sculptures are organized into groups of dancers, animals or deities. All of the sculptures in *The Rock Garden* (begun in 1958) were created using local stone and broken ceramics, as well as discarded urban waste. Approaching the figures in bright sunshine, with their expressive faces and intricate decoration, you can almost imagine each one moving and dancing in the shade of the natural rock and tree forms.

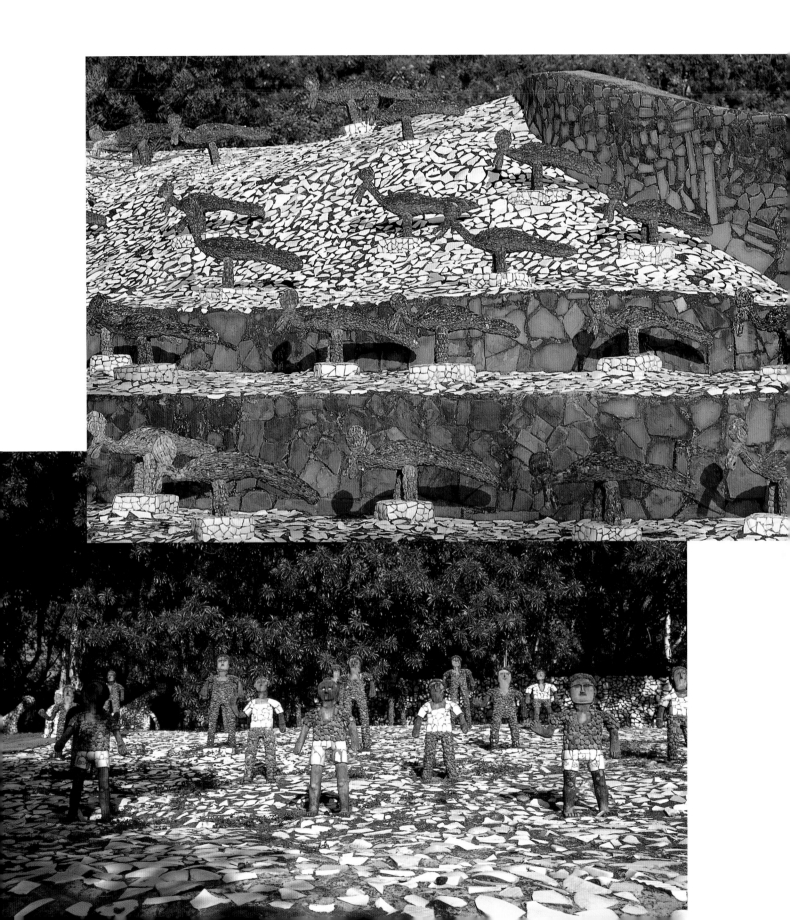

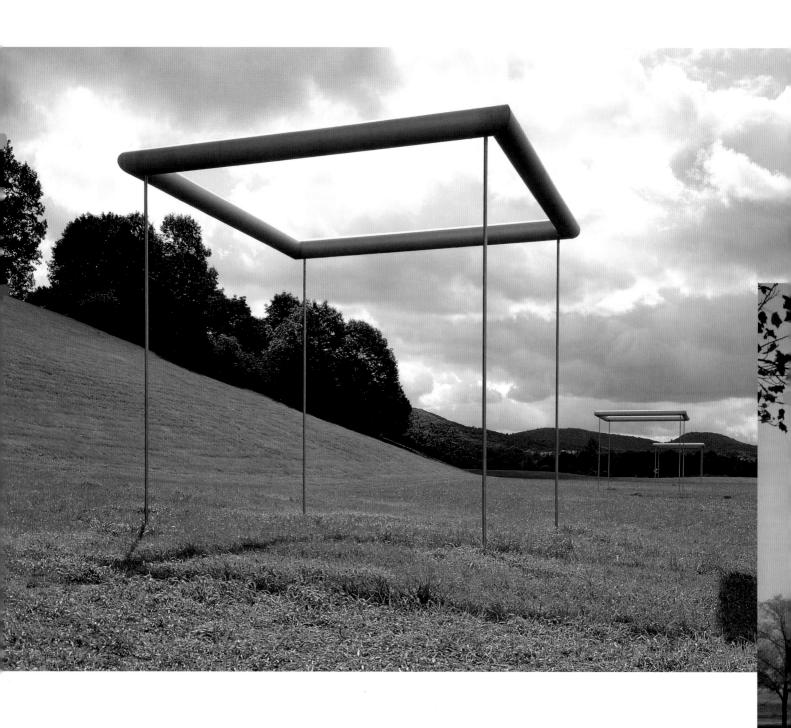

STORM KING ART CENTER

MOUNTAINVILLE, NEW YORK, USA
Various artists
From 1960

The landscape in and around the
Storm King Art Center provides
dramatic settings for its superb
collection of modern sculpture.
Left Untitled (1972) by David von
Schlegell is the first site-specific artwork
that was created for Storm King.
Below Tal Streeter's 'ladder into the
sky', *Endless Column* (1968)

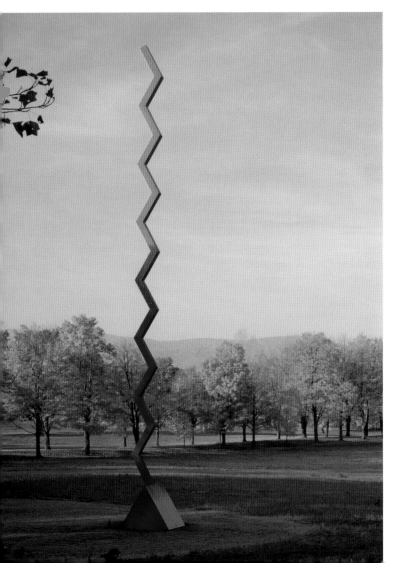

Among sculpture parks of the world, Storm King is King.

J. CARTER BROWN

The celebration of sculpture and nature that is the Storm King Art
Center is in Mountainville, New York, fifty-five miles north of
Manhattan in the lower Hudson Valley. Here a world-class collection
of twentieth and twenty-first century sculpture has been planted in
five hundred acres of landscaped lawns, hills, fields and woodlands
nestled between the Schunnemunk and Storm King mountains. The
grounds are surrounded in the distance by the Hudson Highlands,
a range of low-lying mountains, providing a dramatic panorama for
works displayed against a backdrop of sky and land. The permanent
collection features over 100 sculptures by an international cast of
prominent artists, including Magdalena Abakanowicz (b. 1930),
Alexander Calder (1898–1976), Roy Lichtenstein (1923–97), Henry
Moore (1898–1986), Louise Nevelson (1899–1988), Isamu Noguchi
(1904–88), Ursula von Rydingsvard (b. 1942), David Smith (1906–65)
and Mark di Suvero (b. 1933).

Storm King was founded in 1960 by businessmen Ralph E. Ogden
(1895–1974) and H. Peter Stern, joint owners of Star Expansion
Company. Ogden had originally planned on opening a museum of
the Hudson Valley painters, until his interest in sculpture was piqued
by a visit to a marble quarry in Austria in 1961. This interest was
furthered in 1967 when he visited David Smith's home and studio,
and saw his sculptures in open fields. The idea of Storm King as a
setting for monumental sculptures was born.

Stern explained that, 'we wanted to bring the interrelationship
of a remarkable landscape and great sculpture to its full potential'
and that 'we happened to appear on the scene as these large-scale
sculptures emerged.... Museums did not have room for them.
We had the space and the open-mindedness.' Ogden began
collecting large-scale sculpture while landscape architect William A.
Rutherford began engineering the transformation of the scarred and

neglected site into one that has grand, natural-looking vistas and a variety of terrains as homes for the sculptures.

Storm King began to commission site-specific works in 1972. One of the first was American David von Schlegell's (1920–92) *Untitled*, three giant square frames on thin legs spread over some 300 feet, which when seen from the side seem to be floating over the meadow. From the top of the hill nearby you can see them from above and the squares appear to be sitting on the field. Walking through the work, the landscape is enlivened by the ever-changing shadows and your view is directed up and out to the landscape and the skyscape beyond.

Other site-specific works include American Richard Serra's (b. 1939), *Schunnemunk Fork* (1990–91) and British artist Andy Goldsworthy's (b. 1956) *Storm King Wall* (1997–98). Serra's piece – four giant weathering steel plates inserted into the slopes on a ten-acre field – is named after the mountain nearby and draws attention

to it and to the undulating topography of the site. In Goldsworthy's piece art and nature are literally entwined. The 2,278-foot-long serpentine dry stone wall emerges out of the earth, winds through a line of trees, dips into a pond and comes out the other side, heading straight up the hill to the edge of the property.

Not only are several of the artworks site-specific, but in some cases the land is 'art-specific', having been reconfigured to create the best setting possible in which to plant the sculpture, such that often the sculptures and the sites are, literally, made for each other. In 1997 the Center, which is a nature conservancy as well as a sculpture park, began reintroducing native long grasses and wildflowers as a nod to the land's previous agricultural use and as a way to extend the range of varied landscapes in which to site sculpture.

There is a 'hop-on, hop-off' tram ride available, which is a nice way to get an overview of what is on offer before you set off exploring and discovering. Throughout there are intimate, private spaces as well as the large public ones. Korean-born Nam June Paik's (1932–2006) small three-part work, *Waiting for UFO* (1992), for instance, makes a distinct contrast to the large works. Searching for it is like going on a treasure hunt. On the other hand, American Tal Streeter's (b. 1934) *Endless Column* (1968) is both a homage to Constantin Brancusi's *Endless Column* (1937) in Romania (see p. 36) and a 'ladder into the sky'. Streeter's striking red sculpture does indeed draw your gaze upwards to the heavens and connects the Earth and the sky.

One of the most unnerving works you will encounter is Israeli Menashe Kadishman's (b. 1932) *Suspended* (1977), a huge tilted cantilevered sculpture of weathering steel which appears to have no mode of support. One of the most poetic is British sculptor George Cutts's (b. 1938) *Sea Change* (1996), a kinetic sculpture with gently entwining dancing 'tentacles', and one of the most touching is American Kenneth Snelson's (b. 1927) elegant *Free Ride Home* (1974), which has birds nesting in it.

Overall, an amazing visual tapestry has been created at Storm King by weaving together the glorious landscape and the stellar collection. Another outstanding collection of large-scale sculptures can be seen at Dia:Beacon, which is about a fifteen-minute drive away on the other side of the Hudson River (see p. 232).

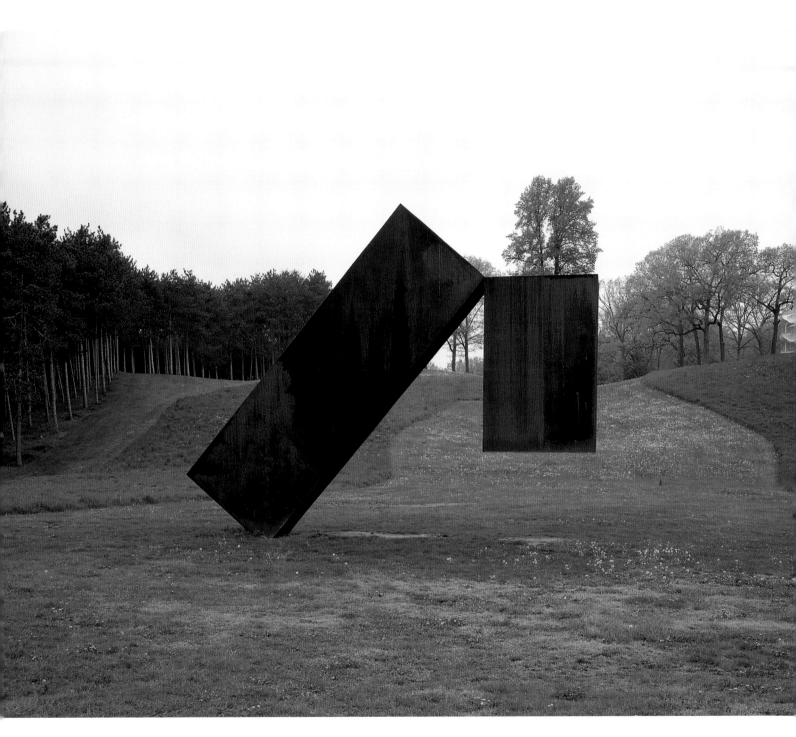

Opposite Sea Change (1996), an undulating
kinetic sculpture by George Cutts
Above Menashe Kadishman's gravity-defying
sculpture *Suspended* (1977)

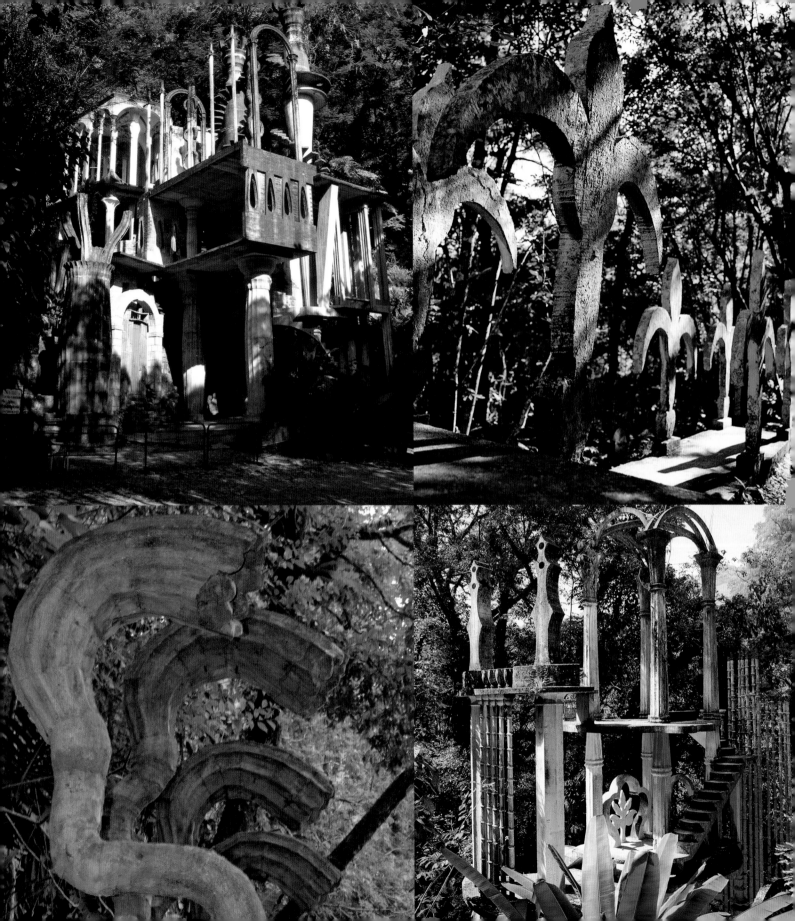

LAS POZAS

XILITLA, MEXICO
Edward James
1962–84

My house has wings and at times, in the depths of the night, it sings.

EDWARD JAMES

Edward James (1907–84) was an extremely wealthy eccentric British aristocrat obsessed with Surrealism. He became an important patron to a number of Surrealist painters, including Salvador Dalí (1904–89) and René Magritte (1898–1967), but longed to become an artist himself. On a trip to Mexico in 1945, he was taken to Xilitla, a small mountain village in the rain forest of the Sierra Madre Orientals, in the northern state of San Luis Potosi.

James fell in love with the remote mountainous region with its cascading waterfalls and pools and decided that this would become his home and the home for his artwork. Inspired by a visit to Simon Rodia's *Watts Towers* (see p. 26) in Los Angeles in the early 1960s, he also determined what that artwork would be – a Surrealist paradise in the jungle. He bought land outside Xilitla on the Las Pozas (the pools) River and in 1962 began to bring his fantasy to life.

James spent over twenty years and over five million dollars building his phantasmagorical city high in the mountains. Some forty full-time local labourers built his designs under the supervision of his friend Plutarco Gastelum. Elaborate wooden moulds were constructed to make thirty-six reinforced concrete structures that were planted in twenty acres of tropical forest.

Like something out of *Alice in Wonderland*, a labyrinth of paths takes you to sculptures inspired by the lush vegetation, some over one hundred feet high. There are colourful gates, unfinished buildings, crazy towers, stairways leading up into the treetops, giant animal and plant forms, platforms, pillars and fountains. The names of some of the pieces – *Stegosaurus Column*, the *Toadstool Platform* and the *House With a Roof like a Whale* – give an idea of the Surreal world that you will enter. The structures in James's paradise are so entwined with their environment that they seem to have grown out of it. The pieces are in varying states of decay, giving the impression that the jungle is gently claiming them for itself.

The Gastelum family took over the running of *Las Pozas* after James died and opened it to the public in 1995. In 2007 the Fonda Xilitla was established to conserve the sculptures and preserve the surrounding environment. The Foundation began running the site in 2008.

Arches, columns and sculptures are beautifully entwined with the lush flowers, plants and forest trees in *Las Pozas*, Edward James's concrete Surrealist fantasy in the Mexican jungle. Sunlight streams through the leaves and highlights features such as (*clockwise from top left*) the entrance to *Las Pozas*, *Puente de la Flor de Lis* (the Lily Bridge), *Palacio de Babu* (Bamboo Palace) and *Las Pozas Cornacopia*.

BIENNALE OF SPATIAL FORMS

ELBLAG, POLAND
Gerard Kwiatkowski and others
1965–73

We will live in the city – painting. GERARD KWIATKOWSKI

Most of the industrial port city of Elblag was destroyed by the Soviet army during the Second World War, particularly the historic city centre. Although the postwar Communist authorities planned for the reconstruction of the Old Town, funding problems kept delaying its realization, and even the demolition of the ruins did not take place until the 1960s and 1970s. For those with a vision for the future of their city, the starting point was pretty much a blank slate.

One of the few buildings to survive the war, although severely damaged, was St Mary's, a former Dominican church built in the thirteenth century. In 1961 artist Gerard Jürgen Blum-Kwiatkowski (b. 1930) applied to the town authorities for permission to convert the ruined church into a studio and art gallery. Kwiatkowski worked at ZAMECH Machine Works, the local industrial plant, and garnered their support for his venture as well as that of the town council and the Socialist Youth Union, and Galeria EL was born. Not content with founding the city's first modern art gallery and starting the process of revitalizing the historic old town, Kwiatkowski and his colleagues went on to change the face of Elblag for ever.

In 1965 Kwiatkowski initiated the first Biennale of Spatial Forms, a citywide open-air exhibition of modern sculpture. With the support of ZAMECH, artists were invited from all over the country to come to the city and work with plant workers to construct public sculptures from scrap metal. This pioneering partnership between art and technology not only transformed the city's urban landscape but also facilitated the development of the work of many artists involved through their partnership with the technical and material experts at ZAMECH.

Four more Biennales were held (1967, 1969, 1971, 1973) before Kwiatkowski moved to Germany in 1974. Each was accompanied by exhibitions and symposiums which brought together avant-garde artists, critics and art historians from all over Poland. The first two Biennales were dominated by the production of three-dimensional metal 'spatial forms' while the later ones explored other experimental art forms such as kinetic art, light art, film, performance and conceptual art.

Magdalena Abakanowicz (b. 1930), Marian Bogusz (1920–80), Zbigniew Dłubak (1921–2005), Wanda Golkowska (b. 1925), Zbigniew Gostomski (b. 1932), Hilary Krzysztofiak (1926–79), Lech Kunka (1920–78), Kajetan Sosnowski (1913–87), Antoni Starczewski (1924–2000), Henryk Stazewski (1894–1988) and Magdalena Wiecek-Wnuk (b. 1924) are among those who created spatial forms in Elblag. There are forty-four spatial forms in Elblag and they can be found in

Through a pioneering partnership of art and industry, Polish artists and workers transformed bleak postwar industrial Elblag into a living, breathing modernist sculpture park:
Top A work by Mieczyslaw Wisniewski (1965)
Bottom Juliusz Wozniak's spatial form (1965)

the park, the grounds of the gallery, alongside streets and paths, in traffic islands and in residential areas. The showcase of Polish Assemblage, Constructivist and Minimalist art adds a distinctive character to this provincial city, where the works serve as a constant reminder of the modernist utopian dream, the possibilities of collaborations between art and industry and the impact that public art can have on a place's identity.

The Galeria EL is still going strong and serving as the cultural hub of the community. A guidebook with information about the sculptures and where they can be found is available there.

Some of the spatial forms you will encounter on a wander around Elblag by artists such as Tihomir Gyarmaty (1965) (*opposite, far left*), Andrzej Matuszewski (1965) (*opposite, top right*), Jerzy Krechowicz (1965) (*opposite, bottom right*) and Marian Bogusz (1965) (*left*).

LITTLE SPARTA

DUNSYRE, LANARKSHIRE, SCOTLAND
Ian Hamilton Finlay
1966–2006

The art of gardening is like the art of writing, of painting, of sculpture; it is the act of composing, and making a harmony, with disparate elements.

IAN HAMILTON FINLAY

Poetry, sculpture, architecture, plants, trees, streams and ponds are some of the disparate elements that British artist and wordsmith Ian Hamilton Finlay (1925–2006) brought together in *Little Sparta*, his celebrated art garden in Scotland. *Little Sparta*, which was voted 'the nation's greatest work of art' by Scottish arts professionals in 2004, started life as a semi-derelict farm in the rather barren moorlands of the Pentland Hills, twenty miles southwest of Edinburgh. Finlay and his wife Sue moved to the farm in 1966 and began fashioning a garden, a project that eventually became Finlay's greatest artwork.

During the 1960s Finlay was known for his concrete poetry, a type of poetry in which the layout, typography and sounds of words and letters play important roles. The reader reacts to the sounds and shapes of letters and words, the ideas they represent and the juxtapositions of sound, image and allusion created by the poet's composition. Finlay's exploration of the visual, aural and symbolic properties of words and of the possibilities of the synthesis of word and image reached its ultimate expression in *Little Sparta*. Through an innovative and effective fusion of poetry, sculpture, architecture and landscape design the garden has become a three-dimensional visual–verbal poem exploring issues of morality, philosophy, history, mythology, culture, beauty and politics. Finlay employed simplified, disciplined modes of expression to convey highly allusive, layered content in which art, man and nature are presented both in tension and in harmony.

This environmental poem is comprised of over 275 wood, stone and metal sculptures installed in a variety of landscapes, such as *The Wild Garden*, *The Roman Garden*, *The Woodland Garden* and *The English Parkland*. In these compositions, Finlay referenced other times and

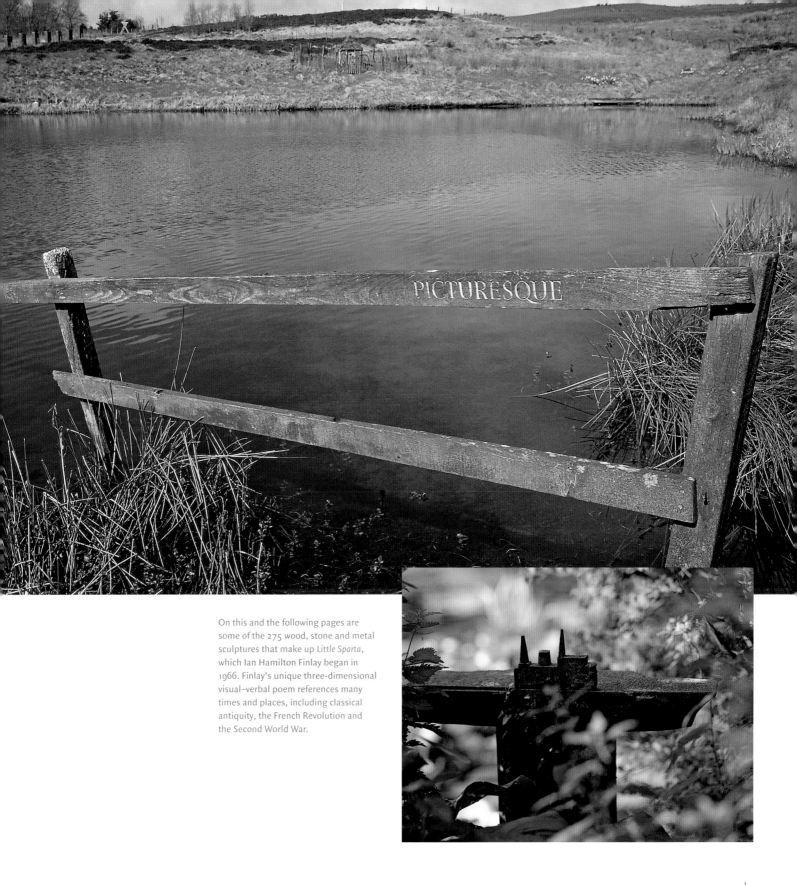

On this and the following pages are some of the 275 wood, stone and metal sculptures that make up *Little Sparta*, which Ian Hamilton Finlay began in 1966. Finlay's unique three-dimensional visual–verbal poem references many times and places, including classical antiquity, the French Revolution and the Second World War.

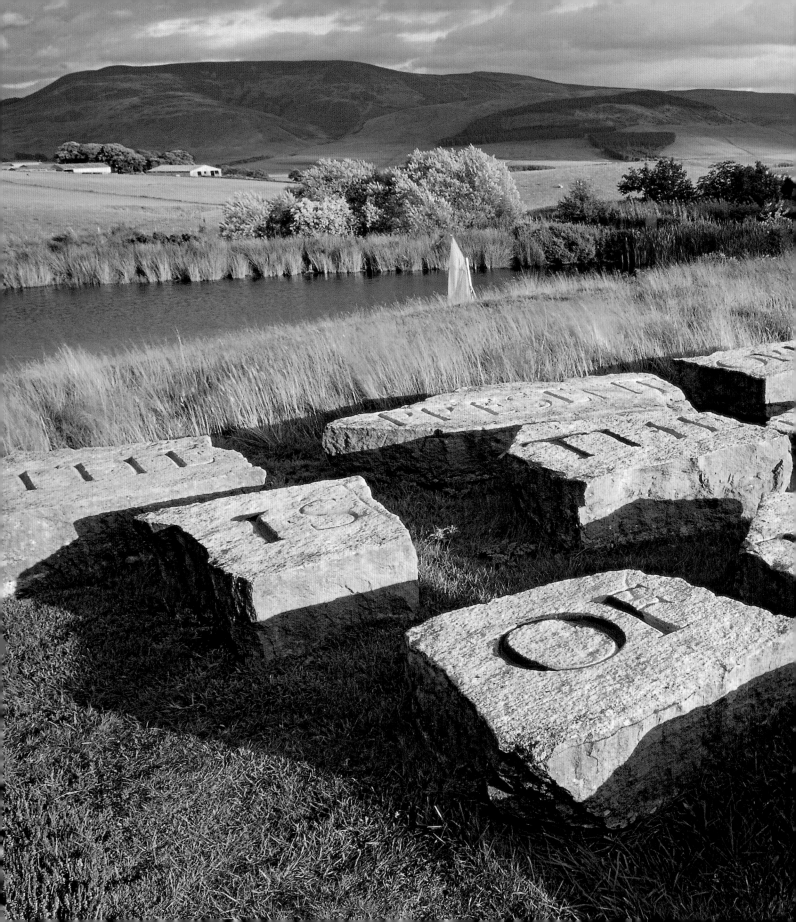

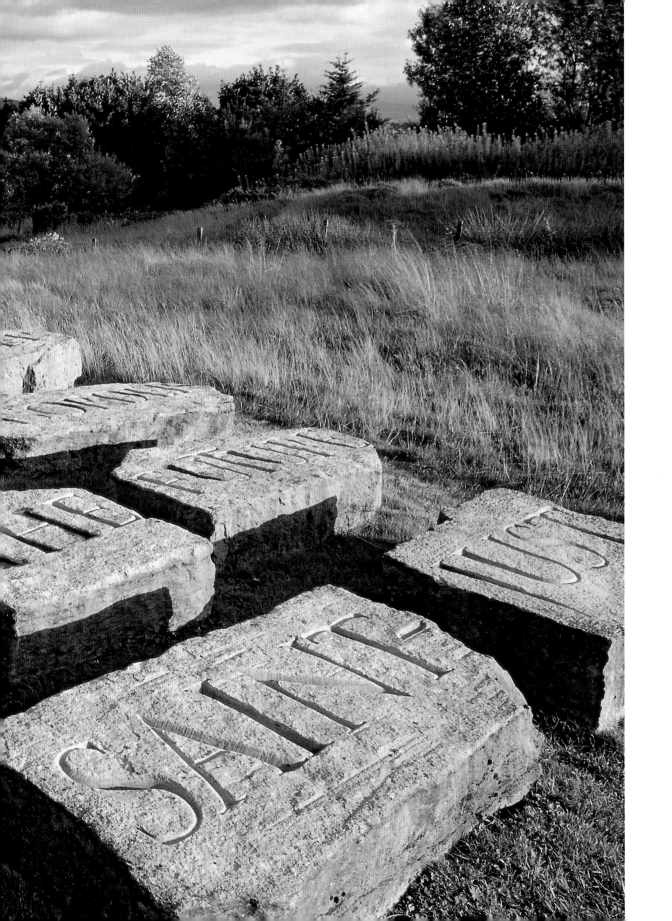

places, such as classical antiquity, the French Revolution and the Second World War, in order to help us reflect upon and understand our own. Although often raising very universal ideas and issues, *Little Sparta* is also very personal – it definitely retains the feeling that it was someone's home and a project that was nurtured throughout the years. As a visitor, you get the feeling of having been invited into someone's mind and life – someone whose love of nature, the sea, language, history and philosophy are very apparent. There are homages and memorials throughout to those Finlay admired, from artists and thinkers of the past, such as Latin poets Virgil (70 BC–15 BC) and Ovid (43 BC–AD 17), French painters Claude Lorrain (1600–82) and Nicolas Poussin (1594–1665), French philosopher Jean-Jacques Rousseau (1712–78) and French revolutionary Louis Antoine de Saint-Just (1767–94), to the family cat (1977–93). It is a work that is at once serious and playful, intellectual and emotional, somber and witty, tender and stark, and one that draws on ideas and images that range from the overly familiar to the wilfully obscure.

Finlay's word and image play are to the fore in the brick gateway in *The Wild Garden*. Its piers are topped with hand grenades instead of the expected pineapple or urn finials – and British hand grenades used during the Second World War were nicknamed 'pineapples' because of their appearance. It also presents two uses of such a gateway, which can be either welcoming or menacing, inviting the visitor to come in or to stay well away. Elsewhere you will come across a stone grotto engraved with an 'A' and a 'D' referring to Virgil's tragic tale of Aeneas, prince of Troy and Dido, Queen of Carthage. While the work seems to celebrate the cave in which they found shelter and love during a storm, the iron railings guarding it bring to mind how easily a shelter can become a prison. Likewise, the contradictory function of lines as connections or boundaries is made clear on a bridge of simple planks in *The English Parkland*. Its inscription reads: 'That which joins and that which divides is one and the same.'

The largest piece in the garden consists of eleven large blocks of stone with a word carved into each:

THE PRESENT ORDER IS THE DISORDER OF THE FUTURE
SAINT-JUST

While giving cause to reflect on Saint-Just's Revolutionary ideals and his damning of the corrupt society of his day, the independence

of each word points to the possibility of their rearrangement into what could be an even more worrying vision of our future.

While knowledge of classical mythology, horticulture, maritime history, art history or political philosophy might provide a useful way to approach many of the pieces, it is far from essential to enjoy a visit to *Little Sparta*. Once you enter into the spirit of the garden and begin seeing and hearing the visual, aural and symbolic play at work, the inscriptions read in a rather 'punny' way. For example, there is a small stone tablet that is engraved:

See POUSSIN, Hear LORRAIN

As an art historian I could certainly understand Finlay referencing the two greats of the ideal landscape tradition in painting. I could also contemplate the enormous influence that Lorrain in particular had in Britain, both in art and in gardening. His work inspired a whole tradition of English gardening in the eighteenth century in which landscapes and gardens were based on his paintings, complete with ruins and rotting trees. Inside *Little Sparta* you can certainly sense that Finlay continued this tradition of making a three-dimensional painting while extending it by incorporating other disciplines, leading to the creation of a multi-sensory, multi-dimensional visual poem. However, as someone with rudimentary French visiting on a drizzling August afternoon, I also couldn't help but read 'See POUSSIN, Hear LORRAIN' as an allusion to the garden's past as a farm (*poussin* is French for chick) and the rain that is common in the region.

These are but a few examples of the scenarios you will encounter in Finlay's arcadian garden. It is a place in which to get lost – to meander, discover and contemplate. There is no fixed route and no indication of whether you've seen it all or not. It is a collection of secret gardens that are fun to explore and comes complete with geese and boats, which add to the sense of wandering through an idyll.

More Destination Art not to miss in the Edinburgh area includes Jupiter Artland (see p. 260) and Charles Jencks's *Landform Ueda* (see p. 266).

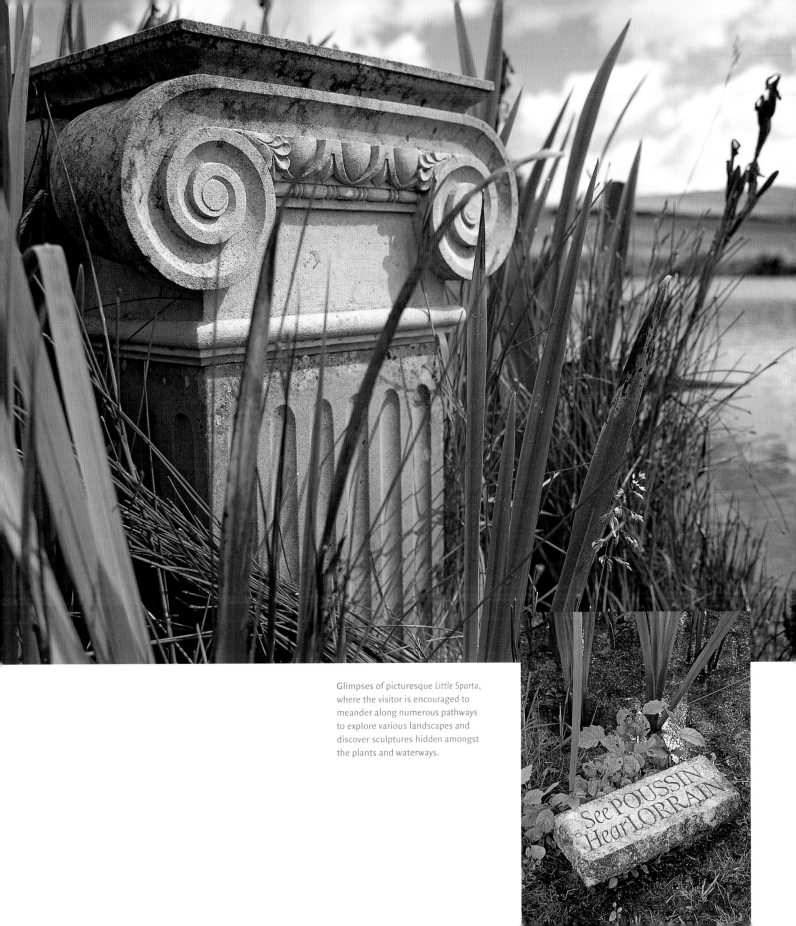

Glimpses of picturesque *Little Sparta*, where the visitor is encouraged to meander along numerous pathways to explore various landscapes and discover sculptures hidden amongst the plants and waterways.

See POUSSIN
Hear LORRAIN

LE CYCLOP

MILLY-LA-FORÊT, FRANCE
Jean Tinguely and friends
1969–89

It's hard work to make people enjoy life. JEAN TINGUELY

Never one to shy away from hard work in the pursuit of art and happiness, Swiss artist Jean Tinguely (1925–91) spent twenty years working intermittently on *Le Cyclop* (The Cyclops), his monumental sculpture in the Fontainebleau forest outside Milly-la-Forêt, France.

Tinguely first came to international attention in the 1950s with his weird and wonderful moving artworks. He became a sensation with his 'meta-matics' – drawing machines that make abstract art. Fountains that sprayed abstract designs followed, as did his famous self-destructing machines, such as *Homage to New York*, which performed and destroyed itself on 17 March 1960 at the Museum of Modern Art in New York, an event that fellow artist Robert Rauschenberg (1925–2008) described 'as real, as interesting, as complicated, as vulnerable, as loving as life itself.'

Inspired by visits to Antoni Gaudí's Park Güell in Barcelona, Spain (see p. 22), Le Facteur Cheval's *Le Palais Idéal* in Hauterives, France (see p. 14) and Simon Rodia's *Watts Towers* in Los Angeles, California (see p. 26), Tinguely began formulating his idea of a giant outdoor sculpture in the late 1960s. When the collectors and patrons John and Dominique De Menil made their plot of land in the Fontainebleau forest available to Tinguely in 1969, *Le Cyclop* was born.

In distinct contrast to his self-destructing works, with their short lifespan and very public finales, this fantastic collaborative work, known variously as *Le Cyclop*, The Head or The Monster of Milly, grew and was nurtured in secret by Tinguely and his main collaborators Niki de Saint Phalle (1930–2002), Bernhard Luginbühl (b. 1929), Rico Weber (1942–2004) and Joseph Imhof over a twenty-year period. Others who contributed to the monumental project included Arman (1928–2005), César (1921–99), Daniel Spoerri (b. 1930), Eva Aeppli (b. 1925), Jean-Pierre Raynaud (b. 1939), Jesus Raphael Soto (1923–2005), Larry Rivers (1923–2002), Giovanni Podestà (1895–1976), Philippe Bouveret (b. 1960) and Pierre Marie Lejeune (b. 1954).

Opposite and right This gigantic twenty-two-metre-high kinetic structure was built by Jean Tinguely and his friends over a twenty-year period. Visiting the sculpture in all its glory entwined in the surrounding trees in the heart of the Fontainebleau forest is a truly magical experience.

The hunt for the sculpture is part of the adventure. After finding and following small signs leading to *Le Cyclop*, you turn off the main road and head into the forest. Another ten minutes or so into the forest and down a dirt path you hear it clanging away, alerting you to its presence. Then you come upon a clearing and there it is – the head of a giant Cyclops buried in the ground up to its shoulders. The massive structure, measuring over twenty-two metres high is covered in a mosaic of mirror, causing it to sparkle and twinkle, disappear into its surroundings and then reappear.

The journey to find it, the sheer size of the Cyclops and the sense of wonder upon seeing it, lend the whole experience the feeling of having adventures like those in *Gulliver's Travels* or *The Odyssey*. The Cyclops has a winking gold eye, a bulbous nose and a lolling tongue, which was once a water-slide, until it was covered in mirror in 1987. Walking around the creature, you encounter towers, crazy stairways, a variety of sculptures, a massive ear and rusting cogs and wheels from long-forgotten, agricultural and industrial equipment. Large trees are entwined in the structure, giving it the air of being the tree house to top all tree houses.

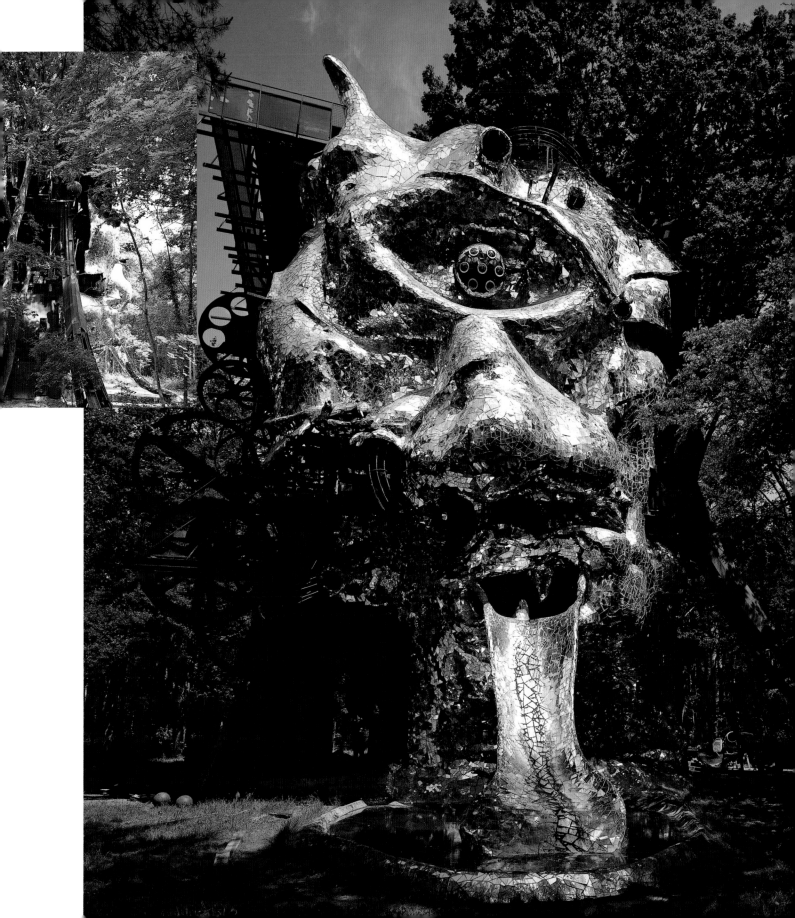

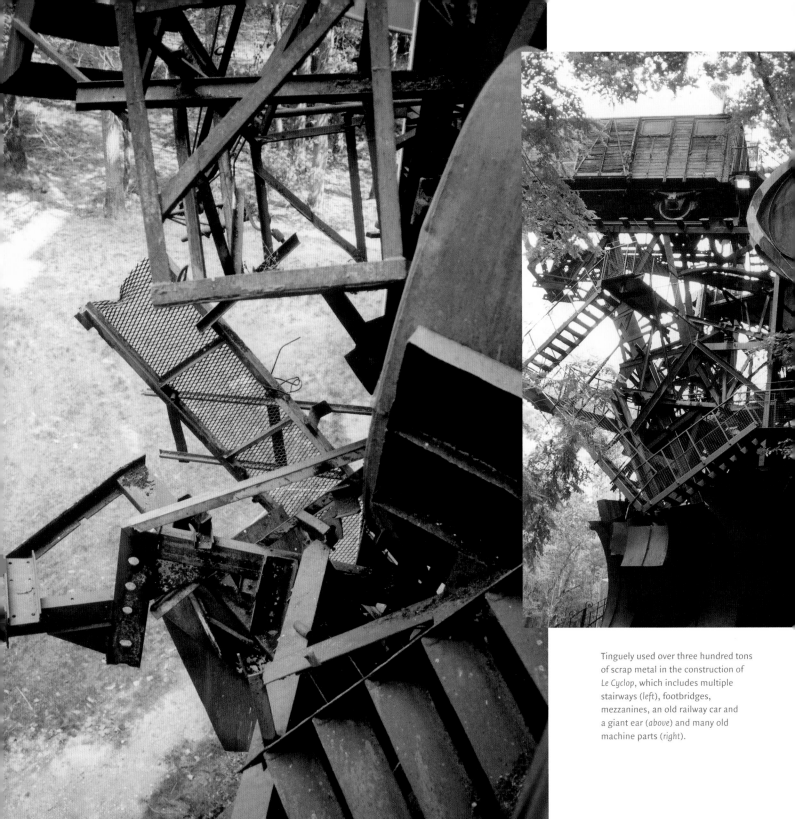

Tinguely used over three hundred tons of scrap metal in the construction of *Le Cyclop*, which includes multiple stairways (*left*), footbridges, mezzanines, an old railway car and a giant ear (*above*) and many old machine parts (*right*).

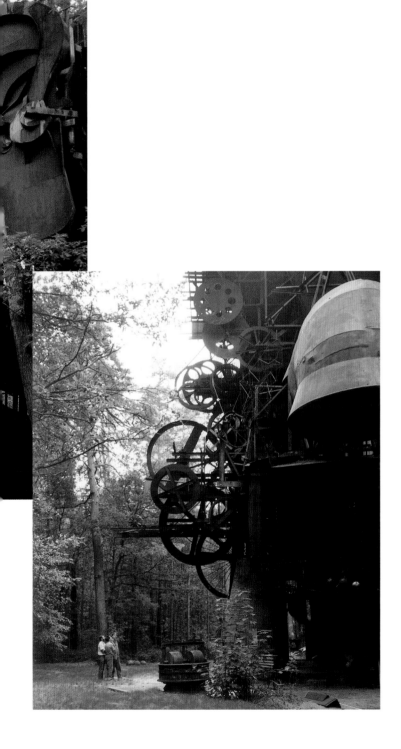

Perhaps most extraordinarily, there is an old railway car perched near the top of the Cyclops's head, as if placed there by a giant, which has you wondering at the determination and ingenuity necessary to get it there. As amazing as *Le Cyclop* is from the outside, you then get to go inside. Ascending the winding stairs leading to different levels with different artworks, environments and machines is a truly magical experience. Nearing the top, you see that the railway car is an abandoned 1930s French carriage filled with figures by Swiss artist Eva Aeppli – an homage to those deported during the Second World War and a poignant reminder of the evil side of human determination and ingenuity.

Movement in art and enjoyment in life were all important for Tinguely, and both are present in great abundance in *Le Cyclop*, which functions as a self-portrait, or indeed, a look inside Tinguely's head. Throughout the head there is a winding gutter-like contraption into which huge ballbearings, representing 'thoughts', fall, bang and clatter around, eventually gathering enough momentum to drop and roll around and down. To me, it was an effective and humorous presentation of the way ideas roll around your head. It also makes you feel like you are inside a massive pinball machine.

The inside of *Le Cyclop* is filled with Tinguely's work and that of his friends – there are tributes to heroes, friends and mentors, such as Marcel Duchamp (1887–1968), Kurt Schwitters (1887–1948), Louise Nevelson (1899–1988) and Yves Klein (1928–62). The names of artists who participated and those he admired are inscribed on the switches in the 'control room', furthering the sense of having privileged access to the inner workings of Tinguely's mind.

In 1987 Tinguely and Saint Phalle donated *Le Cyclop* to the French State, and the following year the Association le Cyclop was established to promote and care for the sculpture. With the cooperation of the De Menil family, *Le Cyclop* was officially opened to the public in 1994 and has been delighting visitors ever since.

After visiting *Le Cyclop*, take a spin around Milly-la-Forêt, an almost obscenely beautiful medieval market town, known for its medicinal herbs and for its most famous resident, artist and writer Jean Cocteau (1889–1963). Cocteau decorated the Chapelle Saint-Blaise-des-Simples on the outskirts of the village, a twelfth-century chapel originally built to care for lepers. Cocteau's tomb and a bust by Arno Breker (1900–91) are housed in the chapel.

DOUBLE NEGATIVE

OVERTON, NEVADA, USA
Michael Heizer
1969–70

I go to nature because it satisfies my feeling for space. MICHAEL HEIZER

American artist Michael Heizer (b. 1944) abandoned painting in 1967 to head West, because, as he explained: 'In the desert I can find that kind of unraped, peaceful, religious space artists have always tried to put into their work.' With the backing of Virginia Dwan, his adventurous New York gallerist, he began to make artworks out of the earth, using the American desert as his raw material. A desert mesa (an isolated, flat-topped natural elevation with steep sides) in southern Nevada is home to his seminal monumental earthwork, *Double Negative* (1969–70).

Double Negative is located on the rim of the high Mormon Mesa, also known as the Virgin River Mesa, which overlooks the Virgin River Valley, about five miles east of Overton, Nevada. The spectacular work consists of two giant rectangular trenches cut into the cliff edges of the mesa. The two cuts face each other from the cliffs on either side of a wide gap in the eroded edge of the mesa, such that the invisible space between the trenches connects them and becomes a part of the work. The two cuts, or negative spaces, are fifty-feet-deep by thirty-feet-wide and the whole work, including the space in between, measures 1500-feet-long. Dynamite and bulldozers excavated 240,000 tons of sandstone and rhyolite in order to make the piece.

Heizer was born into a family of geologists and anthropologists and spent time during his childhood visiting numerous ancient sites in Egypt, Peru, Bolivia and Mexico. He acknowledges that these experiences inform his work, but stresses that he is more interested in evoking the impact – the sense of awe – of these ancient sites than their actual forms.

It is interesting to build a sculpture that attempts to create an atmosphere of awe…. Immense, architecturally sized sculpture creates both the object and the atmosphere. Awe is a state of mind equivalent to religious experience, I think if people feel commitment they feel something has been transcended….

Double Negative is a collection of empty spaces, made by displacing material rather than accumulating it, a type of work which Heizer calls 'un-sculpture' or 'sculpture in reverse'. Despite the work being a void, or absence, it has an incredible presence and a very tangible quality to it as you walk through it. As with visiting *Spiral Jetty* (see p. 90) by Heizer's contemporary, Robert Smithson, the journey itself increases the sense of adventure. The ascent up the mesa on gravel and dirt roads is almost impossible without a four-wheel drive vehicle and there are no barriers to prevent you from driving off the edge once you've arrived. After finding it – the work is barely visible until you are almost in it – you descend into one of the open-top tunnels, and take a trip through time. The geological history of the mesa is exposed by the cuts, as is the future appearance of the area as these layers reveal what will be exposed again through continued erosion. You then emerge from the steep enclosures into the vast, open, dramatic landscape. The overwhelming sensations are of solitude, smallness and indeed, awe. Dwan described it as 'rather like being in a cathedral in reverse' and that:

Absence was the prevailing sensation…. It was empty…. I was not apart, looking at it. I was in it. I was in a hole in the ground, on a mesa, in the state of Nevada, in the United States, of the world, in the universe. These were the only reference points.

Much of the impact of Heizer's work comes from the elegant interplay of opposites, such as mass and void and positive and negative. This can be seen not only within individual works but also in between pieces. For instance, Heizer sees *Double Negative* as related to his other project in the Nevada desert, *City*, a gigantic multi-part earth and concrete sculptural complex that he has been working on since 1970:

Both are paired in location and time – the one a void in the earth, a negative space, the other a positive, above ground sculpture – as if Complex One [of City] evolved from the chasm created by the Double Negative.

Originally sharp and pristine, *Double Negative* has deteriorated over the years. It has ragged surfaces, dislodged boulders and plant life growing in its enclosures – all of which imbue it with the romance of ancient architectural ruins. It feels like a somewhat nostalgic homage to both man and nature – to the achievements of the lost civilizations of the past and to the natural wonders of the West with its extraordinary canyons, caverns and rock formations.

While in southern Nevada, it is certainly worth a trip to the Goldwell Open Air Museum (see p. 148) to see some other sculptures in the desert. It is a two to three hour drive away.

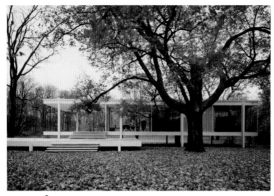

2

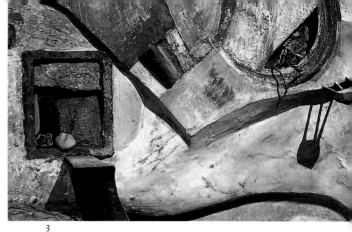

3

The Owl House (1)
Nieu-Bethesda, South Africa
Helen Martins, c. 1945–76

Having decided one day that her life was dull and grey, Helen Martins (1897–1976) set about adding some light and colour to her surroundings in Nieu-Bethesda, a remote village in Great Karoo. The transformation began with her house and then grew into a total environment, with over three hundred statues and towers of cement and glass. This includes sixty-five cement owls, which lent the site its name. The local village did not share her enthusiasm for her project and she became increasingly reclusive and depressed. When her eyesight began to fail she committed suicide by drinking caustic soda. Her home is now a museum and the lifeblood of the community.

Farnsworth House (2)
Plano, Illinois, USA
Ludwig Mies van der Rohe, 1946–50

German architect Ludwig Mies van der Rohe's (1886–1969) extraordinary steel-and-glass Farnsworth House is located fifty-eight miles southwest of Chicago on the Fox River just south of Plano, Illinois. The small, temple-like building looks like an elegant minimalist sculpture in its meadow setting.

Merzbarn (3)
Newcastle upon Tyne, England
Kurt Schwitters, 1947–48

German Kurt Schwitters (1887–1948) was a painter, sculptor, poet and one of the pioneers of modern art. He named his output 'Merz', from part of a word he noticed in one of his early collages made primarily of found objects. He was soon taking his work into three dimensions, which he called *Merzbau* (Merz constructions). In these, Schwitters integrated his work into its surroundings in order to create a total environment. He built three *Merzbau* throughout his life. The first was constructed in his house in Hannover over a period of fourteen years from 1923, until he was forced to flee Germany by the Nazis, and it was destroyed in air raids during the Second World War. The second was built in Norway between 1938 and 1940 – this version was destroyed by fire in 1993. The only surviving *Merzbau* is the last, which Schwitters created on a friend's farm in Cumbria in northeast England between 1947 and his death a year later. The work consists of plaster and found objects embedded directly into the stone walls of the barn. It is now on permanent display at the Hatton Gallery in Newcastle upon Tyne, where it was painstakingly moved and reconstructed in 1966.

Tour d'Eben-Ezer (Tower of Eben-Ezer) (4)
Eben-Emael, Belgium
Robert Garcet, 1948–63

The seven story, twenty-metre-high stone tower just outside the small Belgian town of Eben-Emael, ten kilometres from Maastricht, was erected by former quarryman and pacifist Robert Garcet (1912–2001) as a monument to peace. It is topped with large sculptures that symbolize the four Evangelists – Matthew (a man with wings), Mark (a lion with wings), Luke (an ox) and John (an eagle).

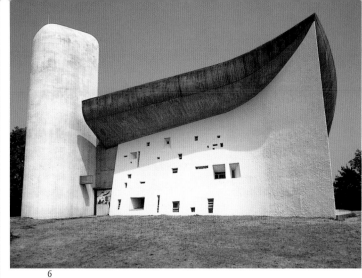

4

5

6

Crazy Horse Memorial

Crazy Horse, South Dakota, USA

Korczak Ziolkowski, from 1948

Crazy Horse Memorial is being carved into and out of Thunderhead Mountain in the Black Hills near Custer, South Dakota. Located seventeen miles southwest of the world's most famous mountain sculpture, *Mount Rushmore*, when (if?) completed, *Crazy Horse Memorial* will be the largest sculpture in the world, measuring 563 feet high by 641 feet long. This colossal project began in 1939, the year the head of President Roosevelt on *Mount Rushmore* was dedicated. The same year American sculptor Korczak Ziolkowski (1908–82) won the first prize for sculpture at the New York World's Fair. This award brought him to the attention of Chief Henry Standing Bear, who invited him to create a sculpture in the Black Hills of the great Sioux warrior Crazy Horse (c. 1845–77). He explained: 'My fellow chiefs and I would like the white man to know that the red man has great heroes, too.' Ziolkowski was intrigued and began researching the life of Crazy Horse and learning valuable skills by spending the summer as Gutzon Borglum's assistant on *Mount Rushmore*. Ziolkowski decided to accept the commission and he and Standing Bear settled on the site in 1947. In 1948 work began on the monumental sculpture in the round of the warrior on horseback. Ziolkowski died in 1982 at the age of seventy-four. His wife Ruth and their ten children subsequently dedicated themselves to continuing his dream of creating a fitting tribute to Crazy Horse and the Native Americans of North America. The family and the Crazy Horse Memorial Foundation unveiled and dedicated Crazy Horse's ninety-foot face in 1998 on the fiftieth anniversary of the memorial's dedication. Work is now underway on the two hundred and nineteen-foot horse's head.

Greenwood Park

Des Moines, Iowa, USA

Various artists, from 1949

The picturesque city-owned Greenwood Park in Des Moines, Iowa is home not only to the Des Moines Art Center but also to a select collection of impressive outdoor sculptures by artists such as Americans Mary Miss (b. 1944), Bruce Nauman (b. 1941) and Richard Serra (b. 1939) as well as Briton Andy Goldsworthy (b. 1959). Miss's *Greenwood Pond: Double Site* (1989–96), a wood, steel, cement and granite installation, poetically reclaimed a neglected pond and brought it back to life.

Wisconsin Concrete Park (5)

Phillips, Wisconsin, USA

Fred Smith, 1950–64

Retired lumberjack Fred Smith (1886–1976) created over two hundred concrete sculptures ornamented with broken crockery, glass and coloured stones on his property in the northwoods of Wisconsin. The life-size and larger-than-life figures and scenes record events from local and national history and legend (see pp. 50–51).

Chapelle Nôtre-Dame-du-Haut (6)

Ronchamp, France

Le Corbusier, 1950–55

From the late 1940s, Swiss architect and artist Le Corbusier (1887–1965) moved away from his earlier precisionist style towards an anti-rational architecture that

1

2

3

was both expressive and fantastic, exemplified by his sculptural concrete pilgrimage chapel in Ronchamp. Perched on a hill above the village, it commands attention with its silo-like white tower and floating curving brown roof.

Casino Knokke (1)
Knokke, Belgium
René Magritte and others, 1953
The Casino in Knokke, a seaside resort town in West Flanders, Belgium, is a find for art-lovers as well as gamblers. Its interior includes tapestries by Frenchman Jean Lurçat (1892–1966), wall paintings by American Keith Haring (1958–90) and Belgian Paul Delvaux (1897–1994) and sculptures by Franco–American Niki de Saint Phalle (1930–2002), amongst others. The highlight however is *The Enchanted Realm* (1953), by Belgian Surrealist René Magritte (1898–1967) pictured above. The seventy-metre-long panoramic fresco cycle is painted on the circular walls of the dining room.

Grass Mound
Aspen, Colorado, USA
Herbert Bayer, 1955
Austrian immigrant artist Herbert Bayer (1900–85) helped transform Aspen into a cultural centre after moving there in 1946. An advocate of total design, Bayer believed that art, technology and nature should, and could, work together. The former Bauhaus teacher's environmental earthwork, *Grass Mound*, was a source of inspiration for the first generation of Land Artists. *Marble Garden* (1955) and *Anderson Park* (1973–74) are other outdoor works by Bayer in Aspen.

Brasilia (2)
Brasilia, Brazil
Oscar Niemeyer and Lúcio Costa, 1956
Brazilian President Juscelino Kubitschek appointed Oscar Niemeyer (b. 1907) chief architect for the design of the new administrative capital of Brazil. The result is that Brasilia (1956), planned by Lúcio Costa (1902–98) with main government buildings by Niemeyer, looks like a massive sculptural installation or still life.

Pasaquan (3)
Buena Vista, Georgia, USA
Eddie Owens Martin (St EOM), 1957–86
When Eddie Owens Martin (1908–86), the self-proclaimed St EOM, inherited his family's farmland in Georgia, he began transforming it into the land of *Pasaquan*, a mystical culture that came to him in a dream. The fortune-telling hippy artist turned the four-acre site into a personal temple to his one-man faith before shooting himself in 1986.

Atelier Brancusi (4)
Paris, France
Constantin Brancusi, 1957
Romanian Constantin Brancusi (1876–1957) spent much of his life living and working in Paris. In 1956 he bequeathed the contents of his studio in the Impasse Ronsin to the French State on the condition that it be reconstructed exactly as it was on the day he died. It includes sculptures, furniture, tools, drawings, photographs and letters.

4

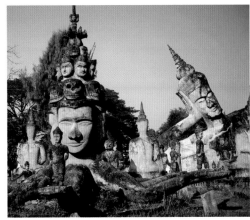

5

6

7

Torres de Satélite (Satellite City Towers)
Mexico City, Mexico
Luis Barragán and Mathias Goeritz,
1957–58
Painting, sculpture and architecture fuse
in the freeway monument, Satellite City
Towers, designed by Mexican architect
Luis Barragán (1902–88) in collaboration
with German sculptor Mathias Goeritz
(1915–90). The five painted concrete towers
outside Mexico City soar to heights ranging
from 160 to 190 feet and are also known as
the 'Towers without Function'. The boldly
coloured towers were designed as an
entranceway to Cuidad Satélite Naucalpan,
then being built to the northeastern side
of Mexico City (see p. 4).

UNESCO
Paris, France
Various artists, from 1958
The headquarters of UNESCO in Paris is
well worth a visit. They have an outstanding
collection of modern and contemporary art
displayed both indoors and out. Sculptures
by American Alexander Calder (1898–1976),
Briton Henry Moore (1898–1986) and Swiss

artist Alberto Giacometti (1901–66) were
incorporated into the original building
plans. *The Garden of Peace* (1956–58) by
Japanese–American artist Isamu Noguchi
(1904–88) is a particular highlight, as are
the more recent additions by Japanese
architect Tadao Ando (b. 1941), *Meditation
Space* (1996), and Israeli artist Dani Karavan
(b. 1930), *Square of Tolerance in Homage to
Yitzhak Rabin* (1996).

Xiang Khouan (Buddha Park) (5)
Near Vientiane, Laos
Luang Pu Bunleua Surirat, 1958–75
This garden of massive concrete sculptures
is on the Mekong River, about twenty-five
kilometres from Vientiane. It was created
by Luang Pu Bunleua Surirat (1932–96),
an eccentric holy man, who saw it as a tool
to share his religious philosophies. It is
dominated by a colossal reclining Buddha
and features numerous statues of Hindu
and Buddhist deities.

Louisiana Museum Sculpture Park (6)
Humelbæk, Denmark
Various artists, from 1958
The Louisiana Museum of Modern Art is on
the shore of the Øresund in Humlebæk,
about 35 kilometres north of Copenhagen.
Its sculpture garden, with works by artists
such as modern masters Alsatian Jean
(Hans) Arp (1887–1966), American
Alexander Calder (1898–1976) (see above)
and Briton Henry Moore (1898–1986), is in
a beautiful setting overlooking the sea.

Figurenfeld (Figure Field) (7)
Hessental, Eichstätt, Germany
Alois Wünsche-Mitterecker, 1958–75,
installation completed 1979
In the beautiful Hessen valley near the
Bavarian town of Eichstätt is a startling
anti-war installation by sculptor Alois
Wünsche-Mitterecker (1903–75). Seventy-
eight concrete figures inhabit a field in this
'Memorial to Peace and Liberty against War
and Force'. Like a scene out of Kurt
Vonnegut's 1969 novel *Slaughterhouse 5*,
it resembles a battleground, with figures in
various states of life and death. The idyllic

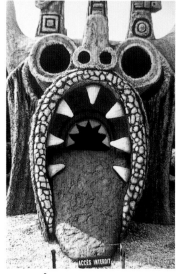

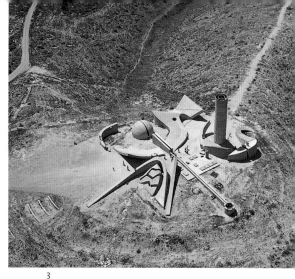

setting only heightens the impact of the work and its stark reminder of man's inhumanity to man as well as the force of the human will to survive.

Park-Museum of Alexey K. Tolstoy
Bryansk, Russian Federation
Various artists, from 1960
In the late 1950s the hundred year-old elms in Bryansk Park in the centre of the city began to die. In 1960 a couple of local youths, Igor Zhdanov and Victor Mikhailov, decided to reincarnate the dead trees as sculptures, beginning the collection of wood sculptures for the park, which has continued to grow ever since.

Paradise Gardens (1)
Summerville, Georgia, USA
Howard Finster, 1961–2001
The Reverend Howard Finster's (1916–2001) *Paradise Gardens* is one of the most famous folk art environments in America. In the gardens and in his paintings, Reverend Finster used a powerful combination of text and image to communicate his visions with an evangelical zeal.

La Frénouse (2)
Cossé-le-Vivien, France
Robert Tatin, 1962–83
French painter, sculptor, architect and ceramicist Robert Tatin (1902–83) travelled the world before returning to Laval in western France in 1962. He bought a derelict farmhouse about thirty kilometres south of Laval near the village of Cossé-le-Vivien, *La Frénouse*, which he and his wife, Lise, turned into a home, museum and mystical, concrete and cement environment. You enter the large temple-like complex via the *Avenue of Giants* – lined with totemic representations of Tatin's heroes, such as Picasso and Lautrec – before encountering a large open-mouthed dragon guarding the entrance to a courtyard. Seeking to create an artistic and philosophical bridge between East and West, the Tatins used ancient Chinese, Celtic, Hindu, Aztec and Breton symbolism in the sculptures and structures in the extraordinary walled compound (see p. 4).

Negev Monument (3)
Beersheba, Israel
Dani Karavan, 1963–68
Israeli Dani Karavan's (b. 1930) monument dominates the desert plain around the city of Beersheba with a surface of one hundred square metres and a twenty-metre-high tower. This site-specific environmental sculpture is made of concrete as well as elements of nature and memory which include: desert acacias, text engraved in the concrete, sound created by the wind, forms made by the sunlight and lines drawn by the water.

Time Landscape (4)
New York, New York, USA
Alan Sonfist, from 1965
Time Landscape, by American Alan Sonfist (b. 1946), is one of the earliest – and most accessible – Land Art pieces. In 1965, Sonfist planted a mini forest of trees and plants in Greenwich Village which were native to Manhattan prior to European settlement, instigating a dialogue between the natural and social history of the city.

4

5

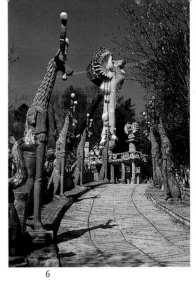

6

Bernhard Luginbühl Stiftung

Mötschwil, Switzerland

Bernhard Luginbühl, from 1966

Swiss sculptor and graphic designer
Bernhard Luginbühl (b. 1929) has lived
and worked in a farmhouse in Mötschwil,
a small town northeast of Bern since 1966.
He has turned the land surrounding it into
a sculpture park where the public is invited
on certain days to see around sixty of his
giant iron sculptures.

Amargosa Opera House and Hotel (5)

Death Valley Junction, California, USA

Marta Becket, from 1968

New York dancer and artist Marta Becket
(b. 1925) and her husband got a flat tyre
near the abandoned town of Death Valley
Junction, California in 1967 while on tour.
Becket was captivated and decided to move
there. She renovated the Opera House,
painted murals on its ceiling and walls,
and decorated those of the adjacent hotel.
Since 1968 the former Broadway dancer
has been performing regularly in her own
productions at her own Opera House in
her ghost town in the desert.

Ruta de la Amistad (Friendship Highway)

Mexico City, Mexico

Various artists, 1968

As part of the celebrations for the XIX
Olympiad held in Mexico City in 1968,
an international cast of sculptors were
invited to create monumental, abstract,
concrete sculptures for a 'route of
friendship' leading to the Olympic Village.
Nineteen brightly painted sculptures were
installed along the Anillo Periferico,
the superhighway circling the capital.

Bruno Weber Skulpturenpark (6)

Dietikon, Switzerland

Bruno Weber, from 1969

Bruno Weber (b. 1931) and his wife
Mariann Weber-Godon (b. 1946) have been
at work on this constantly growing and
evolving 20,000 square metre sculpture
park cum visionary theme park since 1969.
It is located above Dietikon, a suburb
of Zürich, where an array of fantastic
structures – bridges, fountains, houses,
pavilions and exotic mythical creatures –
await you in the *Forest Garden*, *Love Garden*
and *Water Garden*.

Bishop Castle

Rye, Colorado, USA

Jim Bishop, from 1969

Jim Bishop has been working on his one-
man work of art in the Rocky Mountains
in southcentral Colorado since 1969. What
began as a small family cottage has evolved
into a massive granite, concrete and iron
castle, complete with towers, walkways
and a fire-breathing dragon for a chimney.

THREE:
MONUMENTAL ART &
THE ENVIRONMENT

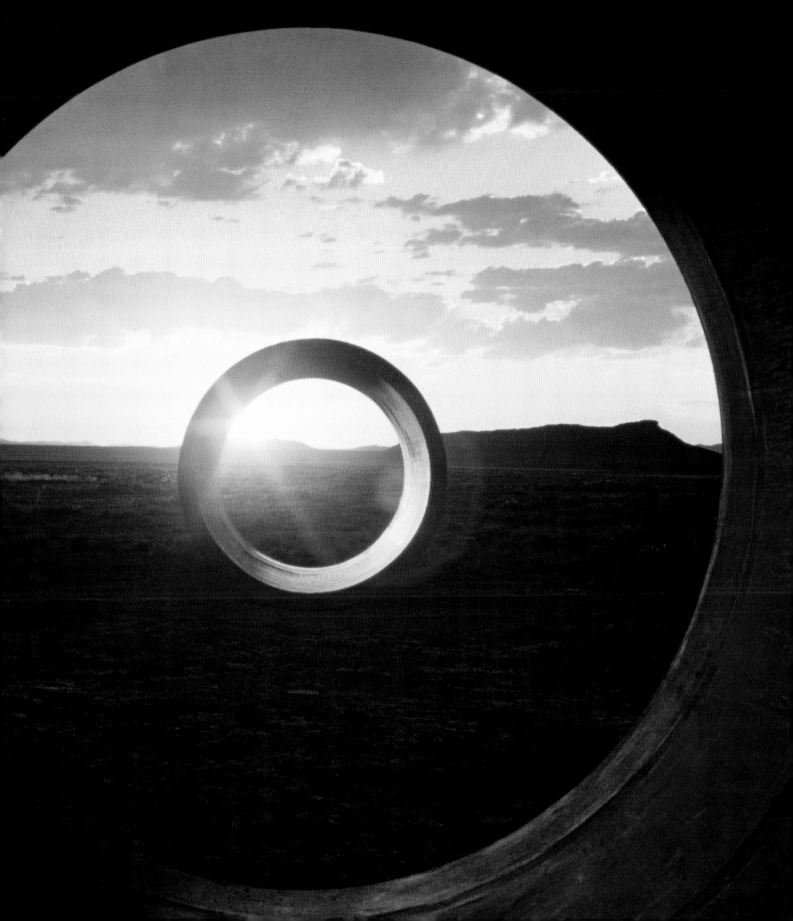

SPIRAL JETTY

GREAT SALT LAKE, UTAH, USA
Robert Smithson
1970

... a vortex that draws in everything in the landscape around it. NANCY HOLT

American Robert Smithson (1938–73) was a pioneering Earth artist who created some of the movement's seminal earthworks prior to his premature death in a plane crash in 1973. In his paintings, sculpture, films, photographs, writings and earthworks, Smithson explored his 'fascination with the coming and going of things', the nature of sculpture and the relationship between a work and its site. In 1969 he began his most famous work, *Spiral Jetty* (1970), by taking out a twenty-year lease on an abandoned industrial site on the Great Salt Lake in Utah. With funding from gallery owner Virginia Dwan, an early supporter of Earth Art projects, he transformed the industrial wasteland, destroyed by oil prospectors, into perhaps the most famous and romantic earthwork of all – a spiral road of black basalt stones and earth projecting into the water of the lake, which was reddened by algae, bacteria and brine shrimp.

The piece is located at Rozel Point on the uninhabited north shore of the Great Salt Lake. Smithson was drawn to the site because of the amazing blood-red colour of the water and its composition as industrial wasteland and spectacular landscape. In an essay about the project, entitled 'Spiral Jetty' (1970), Smithson wrote of the site as 'desiccated, lunar-like, middle-of-nowhere West in its "uncanny immensity"'. Bob Phillips, the local contractor Smithson hired to build the jetty, also commented on the eerie, otherworldly landscape: 'There's no life here. This is the saltiest, deadest lake in America. There's only the brine shrimp that survive around the lake edges, but nobody harvests them any more. See the sand? It's all fossilized brine shrimp.'

Having found the perfect site, Smithson recounted how it suggested to him the form of the artwork:

We drew near to the lake, which resembled an impassive violet sheet, held captive in a stony matrix.... It was as if the mainland oscillated with waves and pulsations, and the lake remained rock still.... As I looked at the site, it reverberated out to the horizons only to suggest an immobile cyclone while flickering light made the entire landscape appear to quake. A dormant earthquake spread into the fluttering stillness, into a spinning sensation without movement. This site was a rotary that enclosed itself in an immense roundness. From that gyrating space emerged the possibility of the Spiral Jetty.

Spiral Jetty was built in six days in April 1970. It is made of 7,000 tons of black basalt rock and earth taken from the hillsides nearby. The spiral is 1500 feet long and 15 feet wide. Bob Phillips recalled the experience:

I'd never heard of earth art before. And suddenly here we are, shipping our dump trucks into the middle of nowhere ... while this manic guy in chest-high waders runs around planting wooden stakes in the water and personally rearranging each rock as it falls.

The causeway was made to sit just above the shallow water so that people could walk on it like a pier. According to Phillips, 'He wanted it to look like it was a growing, living thing, coming out of the centre of the earth.' What Smithson did not realize was that the water levels of the lake were unnaturally low that year and by 1976 *Spiral Jetty* was completely submerged. The remote location of the work and the fluctuating water levels of the lake have meant that for most of its lifetime *Spiral Jetty* has been engulfed in water, and until recently, has been known almost entirely through photographs and a film made by Smithson early in its life.

After only making the occasional cameo appearance in the intervening years, *Spiral Jetty* resurfaced forcefully in 2002 after years of drought in Utah. The work had a new look – it was no longer

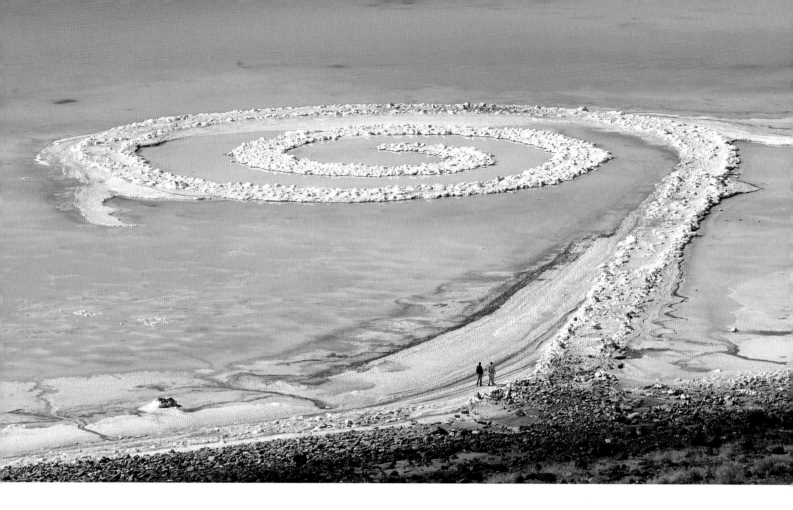

a black stone and red water composition, but a white-on-white relief. The receding water levels left the rocks encrusted in glittering white salt crystals lying in a bluish-white salt bed, with the pale pink shallow water lapping at its edges. The work is now so white that it looks more like snow and ice than stones and salt. Although perhaps not as dramatic as its original incarnation, the new-look *Spiral Jetty* is absolutely stunning.

There is a rocky hill that overlooks Rozel Point, which provides a good vantage point for a birds-eye view of *Spiral Jetty* and the lake. While the work looks massive from above, it feels surprisingly intimate when walking on its exposed causeway – a similar sensation that occurs when walking around Smithson's *Broken Circle/Spiral Hill* in the Netherlands (see p. 96).

Smithson was fascinated with the physical concept of entropy, or 'evolution in reverse', the self-destroying as well as self-regenerating processes of nature and the possibilities of reclamation. These interests inform his landscape interventions, including *Spiral Jetty*, a work in which nature was reclaimed for art and which, without intervention, will eventually be reclaimed through erosion or salt encrustation by nature. Smithson's Estate bequeathed *Spiral Jetty* to the Dia Art Foundation in 1999, and plans are under consideration to add to the height of the work to increase its visibility, an idea mooted by the artist before his death at the age of thirty-five.

The extraordinary effort needed to visit *Spiral Jetty* has certainly added to its mystique over the years. As Smithson's widow, artist Nancy Holt said: 'The trip to see the artwork brings people to a place they wouldn't normally experience.' High summer (August to October) is the safest time to visit to avoid being wrong-footed by the weather and getting marooned on the dirt and gravel roads that lead to it. The water was 4195 feet above sea level when *Spiral Jetty* was built. Current levels can be checked on the US Geological Survey's website (www.usgs.gov). Holt's *Sun Tunnels* (see p. 100), in the Great Basin Desert, is a two to three hour drive away from *Spiral Jetty*.

STAR AXIS

CHUPINAS MESA, NEW MEXICO, USA
Charles Ross
From 1971

The point of this art is to bring star geometry down into physical form and human scale. CHARLES ROSS

Star Axis is an enormous granite, sandstone, concrete and stainless steel astronomy-based architectonic sculpture being constructed by American artist Charles Ross (b. 1937). It is located on a small desert mesa (plateau) in northern New Mexico. Ross, who studied mathematics and physics before turning to art, has been creating work exploring the properties of light, particularly sunlight and starlight, since the 1960s. In 1971 he conceived of a naked eye observatory that frames star alignments on a human scale. After searching for an appropriate site, in 1975 he purchased Chupinas Mesa in New Mexico. He has described what drew him to the site:

I realized that the powerful spirit of this land gave me a feeling of standing on the boundary between Earth and Sky. Here both elements have equal weight and you can see the curvature of the Earth as you look out to the ocean of light that plays across the plains.

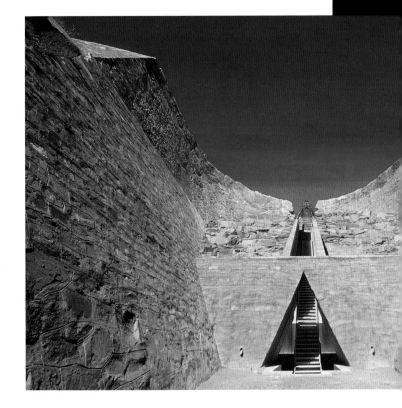

Building began in 1976 and continues today. The extraordinary sculpture is truly astronomical – in both meanings of the word. When completed it will be eleven stories high and one tenth of a mile wide, its design having been dictated, or indeed drawn, by the stars themselves, as Ross explains:

Each element of Star Axis, every shape, every measure, every angle, was first discovered by astronomical observation and then brought down into the land – star geometry anchored in earth and rock.

For me, maths and physics became sculpture tools for looking into light in order to discover its qualities and forms. This art, this architecture, is an instrument for perception – a place to sense how the earth's environment extends into the space of the stars.

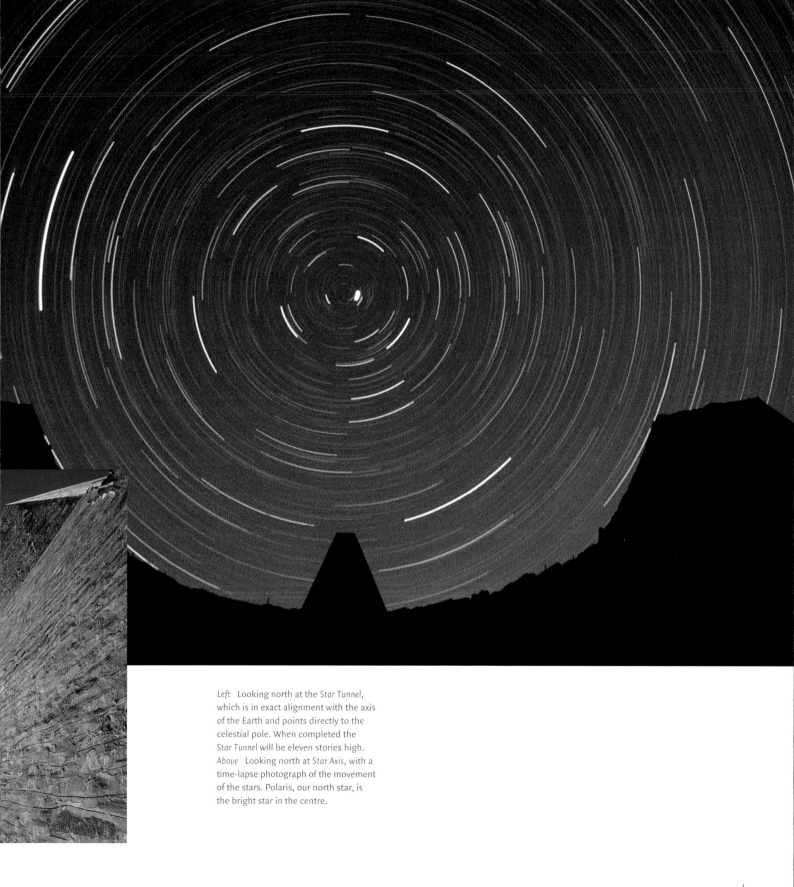

Left Looking north at the *Star Tunnel*, which is in exact alignment with the axis of the Earth and points directly to the celestial pole. When completed the *Star Tunnel* will be eleven stories high. *Above* Looking north at *Star Axis*, with a time-lapse photograph of the movement of the stars. Polaris, our north star, is the bright star in the centre.

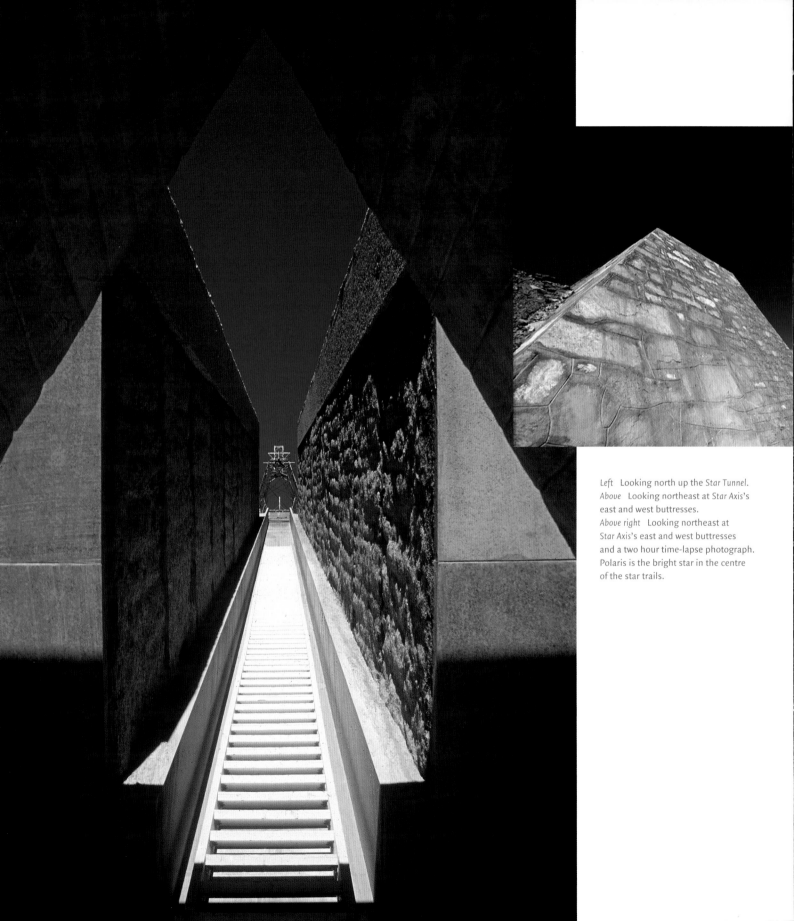

Left Looking north up the *Star Tunnel*.
Above Looking northeast at *Star Axis*'s east and west buttresses.
Above right Looking northeast at *Star Axis*'s east and west buttresses and a two hour time-lapse photograph. Polaris is the bright star in the centre of the star trails.

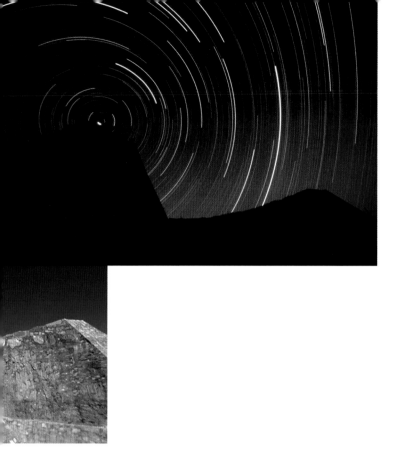

The *Hour Chamber* is another element of *Star Axis*. From inside, viewers will be able to watch an hour of the Earth's rotation, marked by the stars' movement across the sky seen through the triangular opening in the chamber's wall. Outside, the fifty-two-foot-high pink granite *Solar Pyramid* functions like a massive sundial, its shadows marking the sun's daily and seasonal movements.

Star Axis frames the sun and star alignments so you can experience and enjoy your relationship with them in a unique and dynamic way without having to understand the mathematical and astronomical complexities that give it form. It manifests the relationship between the Earth and the sky, maps the dance of the Earth and the stars and provides a place to perceive our interconnectedness with the Earth and the universe. It also beautifully states the role that art can play in helping us to see and understand the world around us as well as our place in it. As Ross puts it:

Star Axis provides a place of heightened focus where we can experience the movement of the Universe in relation to ourselves. It suggests a time when Art, Science and the spiritual are joined again in a creative vision of the Cosmos.

Once completed (hopefully in 2012), *Star Axis* will be open to visitors by reservation. As the most spectacular effects take place at night, small groups of visitors will arrive around sunset, spend the evening with *Star Axis* and the stars and stay overnight in a cabin on site. While in the area, it is also well worth a visit to see Ross's solar spectrum work in the Dwan Light Sanctuary at the United World College in Montezuma, New Mexico, which is about an hour's drive away (see p. 206).

Visitors will enter *Star Axis* via the *Equatorial Chamber*, which showcases the stars seen at the Earth's equator, then move into the *Star Tunnel*. The *Star Tunnel* has a sixty-metre-long staircase that rises up through the mesa, part-open to the elements and part-encased in granite. It runs exactly parallel to the Earth's axis and points to the celestial pole. The journey towards the open circle at the top of the tunnel reveals the expanding and contracting circumpolar orbits of Polaris (the current north star of the northern hemisphere) from 11,000 BC to AD 15,000.

Ross was inspired to build *Star Axis* when he realized that the enormity of time and space that Polaris covers during Earth's 26,000-year cycle of precession was correlative with our field of vision; our perception of Polaris's circumpolar orbit ranges from the perimeter of a dime held at arm's length (viewed from the bottom stair), to that of our entire field of vision (viewed from the top stair). Thus, walking through the structure makes visible 26,000 years of celestial time and the Earth's changing alignment with the stars. Dates engraved into the stairs identify the era you are experiencing along the way.

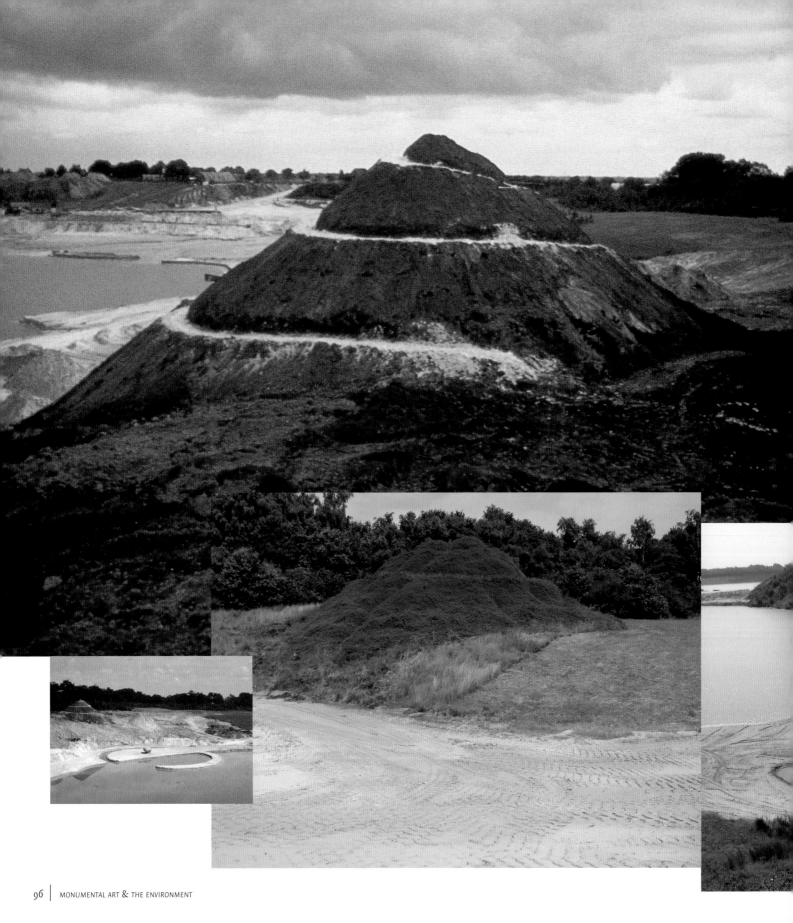

BROKEN CIRCLE/SPIRAL HILL
EMMEN, NETHERLANDS
Robert Smithson
1971

... a visit to BC/SH is something of another sort altogether. A spiritual reunion. A confirmation of things known and unknown. LEE RANALDO

Created a year after his best-known work, *Spiral Jetty* in Utah, USA (see p. 90), American Earth Artist Robert Smithson's (1938–73) sole piece in Europe – *Broken Circle/Spiral Hill* – in the Netherlands, remains largely unknown and rarely visited, even though he considered it a major work.

Emmen is the chief industrial centre of the rural province of Drenthe, a region renowned for its natural beauty. Its landscape is of great geological interest, with massive prehistoric boulders from Scandinavia deposited in the area by slow-moving glaciers during the ice age some 200,000 years ago. Smithson was introduced to the area when he was invited to participate in 'Sonsbeek '71', subtitled 'Buiten de Perken' (Out of Bounds). Curator Wim Beeren had expanded the exhibition's remit from that of a sculpture exhibition in Sonsbeek Park in Arnhem into one that included work sited around the country. Smithson was shown the sand quarry late one evening at sunset. He fell in love with its orange crags, white sand and blue-green water. The combination of this magical landscape with the heavy machinery that exposed its geological layers captured Smithson's imagination. He arrived at the idea of a two-part piece situated on the edge of the lake.

Broken Circle is made from sand and water. One edge of the circle is formed by a sand jetty arising from the water and leading into the other half which seems to have been cut out and flipped over from the other side. The jetty seems to be protecting the sand disk, which has a large boulder on it. Smithson originally wanted to remove the boulder, thinking it too dominant a feature, but it was too heavy to move with the available machinery. He even pondered hiring the Dutch army to remove it, but time and money weren't available to explore this option so the boulder stayed. Knowing that it is one of the prehistoric boulders deposited during the ice age brings other

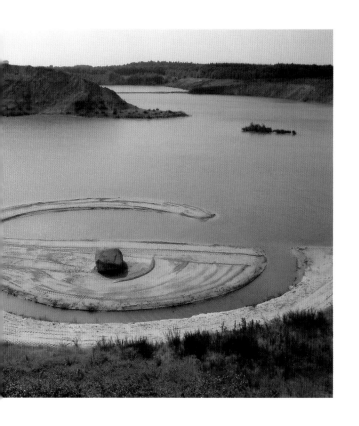

Far left below Robert Smithson's *Broken Circle/Spiral Hill* was built in 1971 on a working sand quarry. Like many earthworks, its appearance has evolved over time and changes with the seasons. *Left and below left* *Spiral Hill* shortly after completion and some thirty years later, respectively. *Below* Looking down on *Broken Circle* and its prehistoric boulder from the top of *Spiral Hill*.

associations to the work – the sand semicircle suddenly seems to appear as a glacier depositing its wares and draws attention to the natural and man-made aspects of the land and the artwork. The huge boulder's stubborn presence also asserts that it will outlast us all. Smithson was eventually won over by the stone, describing it as the 'eye of a hurricane' and 'a warning from the ice-age'.

Spiral Hill sits on the shore above Broken Circle. The hill has a spiral path cut into it winding around and up to the top. The path was originally of white sand which stood out against the hill covered with dark brown peat. The hill was subsequently planted with shrubbery to prevent wind erosion. When I visited in 2004 the hill was covered in bushes and looked like a big green mound. The path was still there though not as prominent. While not as visually striking, I liked this evolution, for the path is now like a secret trail – find the entrance at the back and spiral up to the top for a great view of Broken Circle and the surrounding landscape. Unexpected sensations included seeing how much bigger Broken Circle appeared when viewed from the top of Spiral Hill than when walking on it and also the marvellous childhood thrill of being 'king of the mountain' and on 'top of the world'.

The difficulty in photographing the whole piece has meant that Broken Circle and Spiral Hill usually appear as separate, unrelated works and are often discussed as such. Viewing the work in person, especially from the side opposite the one you first see upon arriving – the viewpoint that Smithson took in his drawings – you really get the sense that they were conceived as parts of a whole. From this angle in particular, the work really calls forth notions of creation, evolution, growth, entropy, erosion, transformation – or as Smithson put it, 'the coming and going of things' in the universe.

Another misconception about Broken Circle/Spiral Hill is that it no longer exists. While the work has certainly had its ups and downs in terms of preservation and maintenance, it most certainly exists and a foundation has been established to care for it. Probably because of Smithson's well-documented interest in working with derelict industrial sites, Broken Circle/Spiral Hill is often described in such literature as having been built on an abandoned quarry. This is incorrect – Broken Circle/Spiral Hill was built on a working sand quarry. At first this may not seem important, but it is, for this quality is an important component of the piece and one of the factors that influenced Smithson's choice of site.

Smithson was drawn to multi-faceted sites, ones where he could contribute an art dimension to a dialogue in which natural and industrial forces had already had their say. This quarry was of geological, industrial and social interest to Smithson – created by one force, disrupted by another and home to all aspects of human life – habitat, work and leisure. This dynamism was one of its attractions, perhaps because of the distinct contrast it made to the isolated, remote Spiral Jetty.

Smithson explained his fascination for such challenging locations in 1972, 'I like landscapes that suggest prehistory. As an artist it is interesting to take on the persona of a geological agent and actually become part of that process rather than overcome it.' Smithson did indeed take on the 'persona of a geological agent' or a choreographer here, imposing works of abstract, geometrical beauty on a site created by chaos and entropy. Or, as Smithson explained in an interview with Gregoire Müller in 1971:

In a very densely populated area like Holland, I feel it's best not to disturb the cultivation of the land. With my work in the quarry, I somehow re-organized a disrupted situation and brought it back to some kind of shape.

Broken Circle/Spiral Hill was originally open to the public on weekends and was popular with the local community. Unfortunately, a group of drunken teenagers put an end to this arrangement when they trashed the area and destroyed the quarry's machinery. Since then, access has been by appointment only, since it is on the site of a working quarry and you need to be escorted through it. Plans are underfoot to build a visitors' centre which would allow greater access to the site, but until then it is only open during normal working hours, so you would need to plan your visit accordingly.

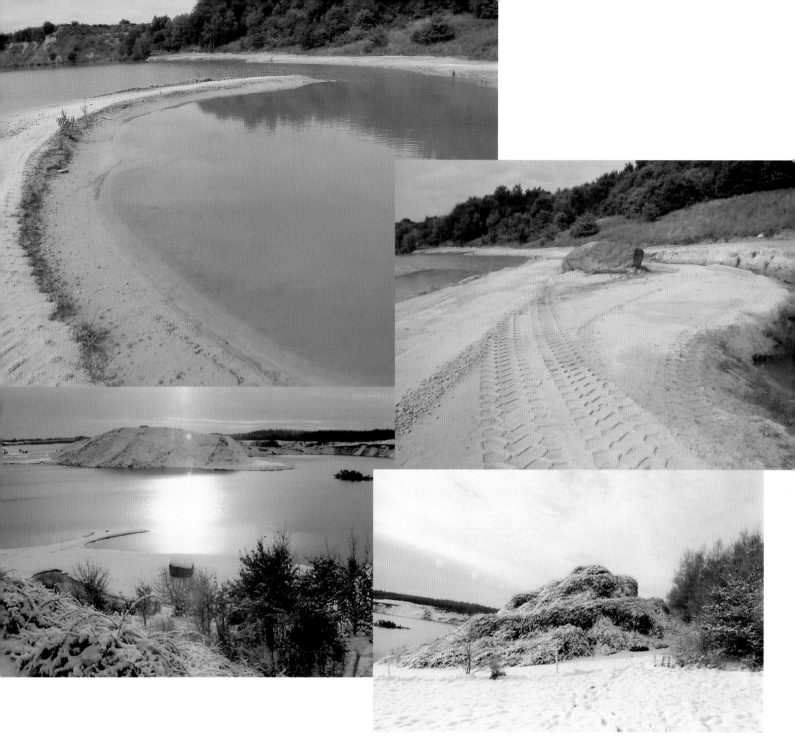

Views of different aspects of *Broken Circle/Spiral Hill*, highlighting its changing state throughout the seasons.

SUN TUNNELS

GREAT BASIN DESERT, UTAH, USA
Nancy Holt
1973–76

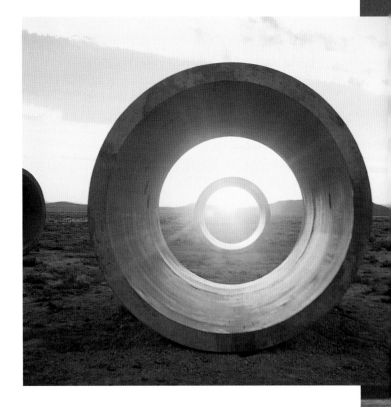

The feeling of timelessness is overwhelming. NANCY HOLT

American artist Nancy Holt (b. 1938) began formulating the idea for a major Land Art piece in 1973 while she was in Amarillo, Texas working on *Amarillo Ramp* (see p. 138) with her husband, Robert Smithson (1938–73). She searched in New Mexico, Arizona and Utah for the terrain that she wanted – a flat desert valley ringed by low mountains. In 1974, Holt found the right site in northwestern Utah, near the abandoned railroad town of Lucin, close to the Nevada border.

Locals thought the land in this large, flat valley of the Great Basin Desert with its sparse vegetation was useless; to Holt the remote area was perfect. She bought forty acres of land and set to work on her astronomical installation, *Sun Tunnels*. Working with an astrophysicist, an astronomer, surveyors, engineers and a range of contractors, Holt turned her vision of an artwork that would be an instrument for reading the sky and marking time into a reality.

Sun Tunnels consists of four large (nine feet, three inches in diameter, eighteen feet long) concrete cylinders, laid out in the desert in an open X configuration that measures eighty-six feet long on the diagonal. The installation marks the sun's position on the horizon; the tunnels are aligned with each other and with the angles of the sun's rising and setting on the summer and winter solstices (around 21 June and 21 December). On those days the sun is centred in the tunnels. Even when it is not a solstice, the tunnels frame their striking surroundings beautifully. They frame a section of the vast landscape and bring it down to a more human scale and provide reference points in the expansive panorama.

The upper half of each twenty-two-ton tunnel is pierced by holes of 7, 8, 9 and 10 inches in diameter. The configuration of the holes in the walls of the tunnels corresponds to the arrangement of stars in the celestial constellations of Draco, Perseus, Columba and Capricorn. The size of the holes varies according to the magnitude of the stars in each constellation. During the day the sun shines

Nancy Holt's awesome *Sun Tunnels* (1973–76) consists of four large concrete tubes installed in the Great Basin desert in Utah. The size and configuration of the holes and the arrangement of the cylinders all correspond to different celestial phenomena. The view above shows the work marking the sun's position on the horizon.

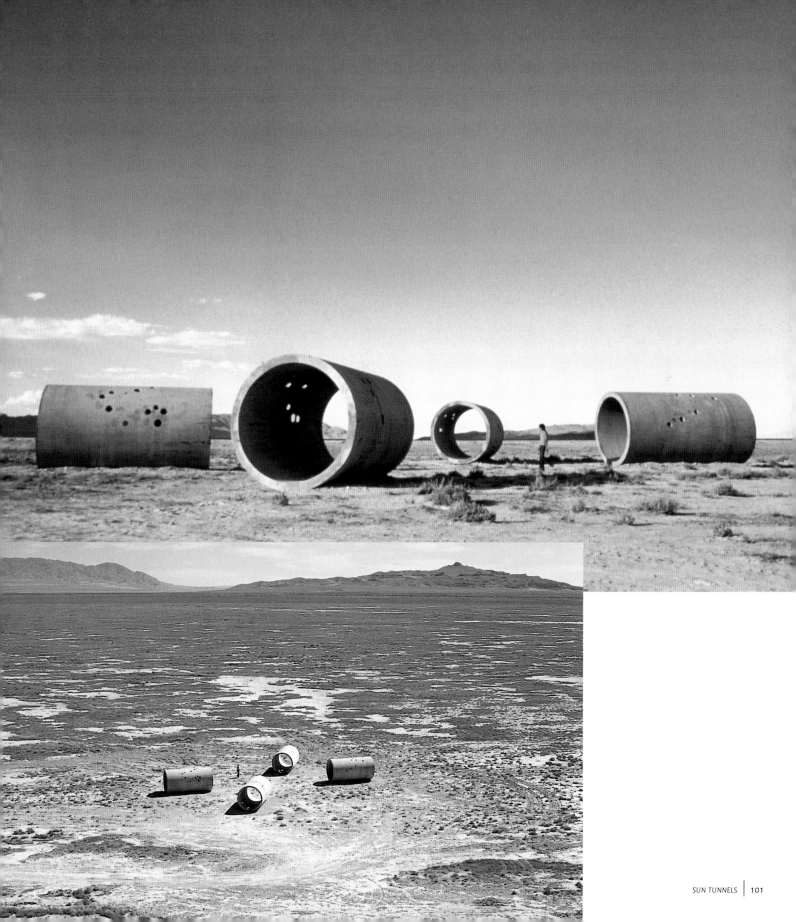

through the holes creating ever-changing patterns of cast light on the bottom halves of the tunnels. In the darkness of the interior they take on the personae of stars and their constellations. The tunnels also provide welcome relief from the desert heat, as they remain some fifteen to twenty degrees cooler than the outside temperature.

Sun Tunnels has drawn many visitors from the art world over the years. Its impact was also felt closer to home, as it captured the attention of locals, many of whom had never been out to the location before. Holt explains:

So by putting Sun Tunnels in the middle of the desert, I have not put it in the middle of their regular surroundings. The work paradoxically makes available, or focuses on, a part of the environment that many local people wouldn't normally have seen.

This serene, poetic, majestic piece of Land Art beautifully frames the sky and the vista and interacts with the sun by marking the solar year as well as hourly, daily and seasonal changes. It certainly gives cause to reflect on the passing of time as well as the timeless quality of its natural surroundings.

Sun Tunnels is located on land still owned by Holt. Visitors are welcome to visit and camp on her land with the request that they respect the work and the land and leave both as they found them. Smithson's *Spiral Jetty* (see p. 90) is a two to three hour drive away.

Nancy Holt's *Sun Tunnels* act as an instrument for reading the sky and for framing sections of the dramatic landscape in which it is set.

BATCOLUMN

CHICAGO, ILLINOIS, USA
Claes Oldenburg and Coosje van Bruggen
1977

I am for an art that is political-erotical-mystical, that does something other than sit on its ass in a museum. CLAES OLDENBURG

In 1975, the United States General Services Administration's Art-in-Architecture programme, one of the largest patrons of public art in the USA, commissioned *Batcolumn* from Swedish-born American Pop artist Claes Oldenburg (b. 1929). He and his wife, Dutch-born American Coosje van Bruggen (1942–2009), collaborated on the steel baseball bat rising almost one hundred feet into the air from the centre of downtown Chicago, which was installed in 1977. The work is sited in the plaza in front of the Harold Washington Social Security Administration Building in downtown Chicago and interacts with its location on a number of levels. The form of the monument evokes and echoes the heroic architecture of older buildings in the city – the soaring towers of Chicago's skyscrapers and the smokestacks of industry. Its diagonal open latticework steel construction makes for a striking visual contrast with the gridwork of the windows of the building behind it, as well as allowing it to survive the gales of the Windy City. The bat rests on its knob, with the barrel rising into the sky, creating a sense of a balancing act. Oldenburg explained that the position of the bat made it seem 'to connect Earth and sky the way a tornado does', a not uncommon sight in the Midwest. Oldenburg also noted that a building turned upside down would look like a 'bat balanced on its handle'. The positioning of the bat prevents it from getting lost in the industrial smokestacks surrounding it, and also inverts the forms of the chimneys of labour into a symbol of leisure and pleasure. Conceptually, *Batcolumn* not only references the city's devotion to the national pastime of baseball, but also makes a nod to its reputation for violence and corruption.

Oldenburg and van Bruggen enjoyed creating these large-scale public artworks for the opportunities they provided to reach a large audience. The sheer scale of many of the couple's sculptures, such as *Batcolumn*, provoke a childlike sense of wonder and amazement, leaving you feeling like you have stepped into a scene from *Alice in Wonderland* or have arrived after some giant has just left the space. Over forty of their large urban pieces bring smiles to people's faces in Asia, Europe and the United States. While in Chicago, visitors should also take the opportunity to see Millennium Park (see p. 210).

Although *Batcolumn*, with its everyday subject and simple appearance, seems at first to be part of Oldenburg's self-proclaimed celebration of 'the excruciatingly banal', it is complex in its references and sense of place. It both embraces American ideals and makes fun of them. Not only does it praise Chicago's love of baseball, it also resembles a policeman's truncheon. A few years earlier, the city had been the site of the 1968 Democratic Convention, which erupted into violence as police cracked down heavily on anti-Vietnam War demonstrations.

THE LIGHTNING FIELD

NEAR QUEMADO, NEW MEXICO, USA
Walter De Maria
1977

Isolation is the essence of Land Art. WALTER DE MARIA

The Lightning Field, by American artist Walter De Maria (b. 1935), is in a remote desert location in southwestern New Mexico. The work consists of 400 stainless-steel poles arranged in a rectangular grid that measures one mile by one kilometre and six metres. The poles are spaced 220 feet apart, with 25 marking out the mile-long sides and sixteen spanning the kilometre-long ones. The poles are two inches in diameter and measure from sixteen feet to twenty-seven feet high to compensate for the slight fluctuations of ground level at this almost entirely flat site and to ensure that their tips are all dead level. But these are just the facts, and, as De Maria's notes on site make clear: 'The sum of the facts does not constitute the work or determine its esthetics.'

The dramatic landscape – the scrubby terrain of treeless high desert (7,200 feet above sea level) – and the climatic conditions are key components of the work. It took five years for De Maria to find the right location with its 'desirable qualities of ... flatness, high lightning activity and isolation'. While the poles are needle-tipped to attract the summer storms that are common in the area, lightning is but one ingredient of the piece. As De Maria has commented, 'The light is as important as the lightning.' Rather than conducting lightning, the extraordinary installation directs your attention to the elemental forces of nature, with their gradual but spectacular performance – poles glinting and colouring in the rays of sunset and sunrise, shimmering in the haze of intense heat, glowing in the moonlight, and disappearing under bright sunlight. The setting heightens this theatrical effect, for the work is ringed in the distance by mountains, creating an arena or amphitheatre-like space. The elements of order, geometry, measure, mathematics and the interest in context and perceptual phenomenon present in The Lightning Field call to mind De Maria's more accessible but equally thought-provoking urban pieces, such as The New York Earth Room (1977) and The Broken Kilometer (1979) (see p. 122).

A visit to The Lightning Field requires preparation, time and commitment. The nearest town, Quemado, is some three hours' drive from Albuquerque and The Lightning Field is yet another hour away along rough dirt roads (vistors to the site are driven there from Quemado by Robert, the caretaker). The journey needed to get there and the time required to fully experience it while there were all concerns of De Maria's. In an interview in 1972 he explained:

How much time does a person spend with a piece of sculpture? An average of perhaps less than one minute, maximum of five or ten, tops. Nobody spends ten minutes looking at one piece of sculpture. So by starting to work with land sculpture in 1968 I was able to make things of scale completely unknown to this time, and able to occupy people with a single work for periods of up to an entire day. A period could even be longer but in this case if it takes you two hours to go out to the piece and if you take four hours to see the piece and it takes you two hours to go back, you have to spend eight hours with this piece, at least four hours with it immediately, although to some extent the entrance and the exit is part of the experience of the piece.

The Dia Art Foundation, which commissioned the work in 1977 and continues to maintain it, accommodates these concerns by taking groups of six or fewer from Quemado to stay overnight in a cabin near the site. As such, the relationships you have or develop with those in your group in this isolated location also become part of the experience.

With or without lightning, The Lightning Field highlights relationships between the Earth and the sky and man and nature, and celebrates the power and visual splendour of natural phenomena. It also gives cause to reflect on the possibilities of the interactions of art, nature, science and engineering – instead of seeing them as constantly opposed and in tension, here they have fused into something particularly magical and poetic. Or, in De Maria's words, 'The invisible is real.'

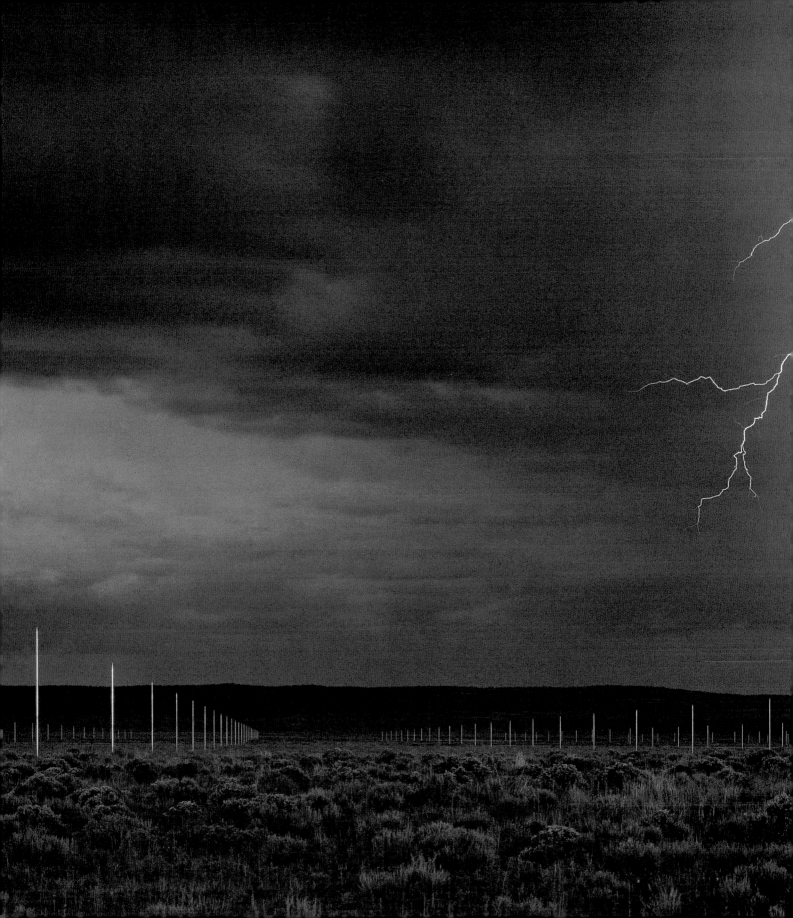

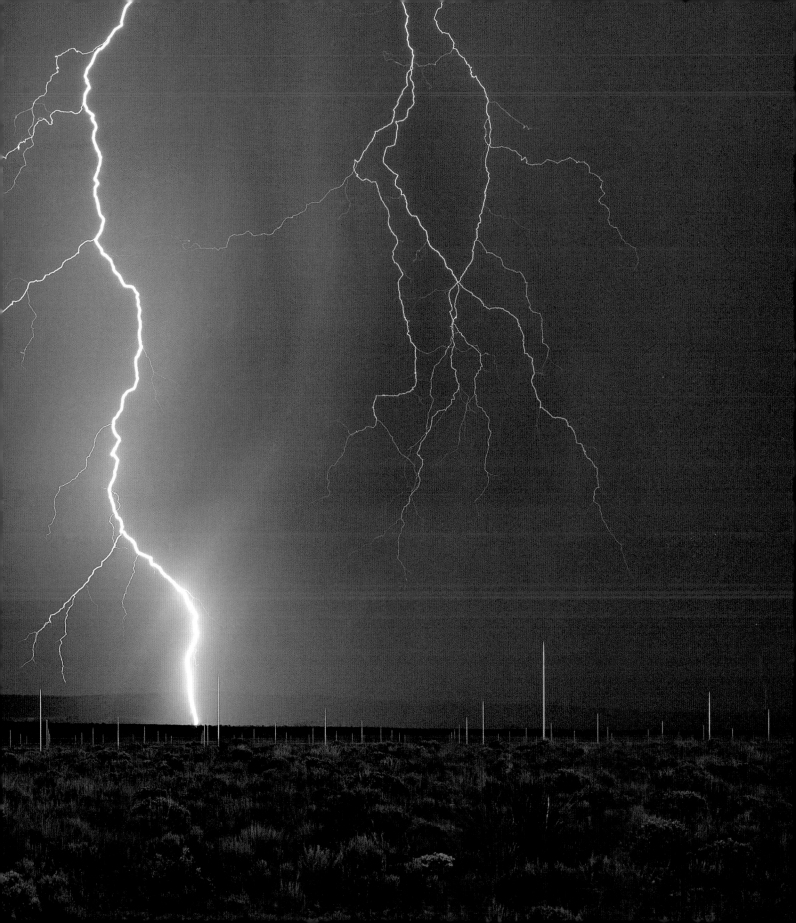

HENRY MOORE FOUNDATION

PERRY GREEN, MUCH HADHAM, ENGLAND

Henry Moore

From 1977

Painting and sculpture help other people to see what a wonderful world we live in. HENRY MOORE

If you like your modern art bucolic, it is hard to beat a visit to the Henry Moore Foundation in the hamlet of Perry Green, near the village of Much Hadham in Hertfordshire, England. There you will find the grounds and studios of British artist Henry Moore (1898–1986), one of the most celebrated artists of the twentieth century. Despite much of his work being sited in urban locations, Moore preferred nature as the setting for his large bronze sculptures.

Moore wanted his works to be experienced from all 360 degrees and sought open landscapes, preferably with large skyscapes or fields of wild grass, as backdrops for his sculptures. Such landscape was not always available, but he found it in the gentle agricultural countryside of Perry Green. Moore and his wife Irina moved there in 1940 after their home in London was damaged during the Blitz. Over the years they acquired more of the surrounding farmland and the estate now covers twenty-five hectares.

Irina designed the gardens and grounds which became home to an ever-changing array of Moore's sculptures. Formal manicured lawns and gardens, park areas with trees and ponds, orchards, meadows and pastures can all be found on the estate. These different environments provide a range of backgrounds for Moore's monumental sculptures. For instance, *Large Reclining Figure* (1984) sits atop a small hill overlooking the estate, creating a striking silhouette against the open sky. *The Arch* (1969) is on its own in a particularly dramatic setting, drawing you to it and through it down a long avenue of grass enclosed by trees. Elsewhere, *Large Figure in a Shelter* (1985–86), Moore's last monumental bronze, is itself in an enclave which adds to its impact.

Moving around *Double Oval* (1966) and exploring the changing views of it and those provided through its holes, you really appreciate how Moore's sculptures come to life with enough space to

Wander around this idyllic sculpture park in the heart of rural England and you will encounter amazing creations that sit comfortably in the garden of British sculptor Henry Moore.
Right Large Figure in a Shelter (1985–86)
Below The Arch (1969)

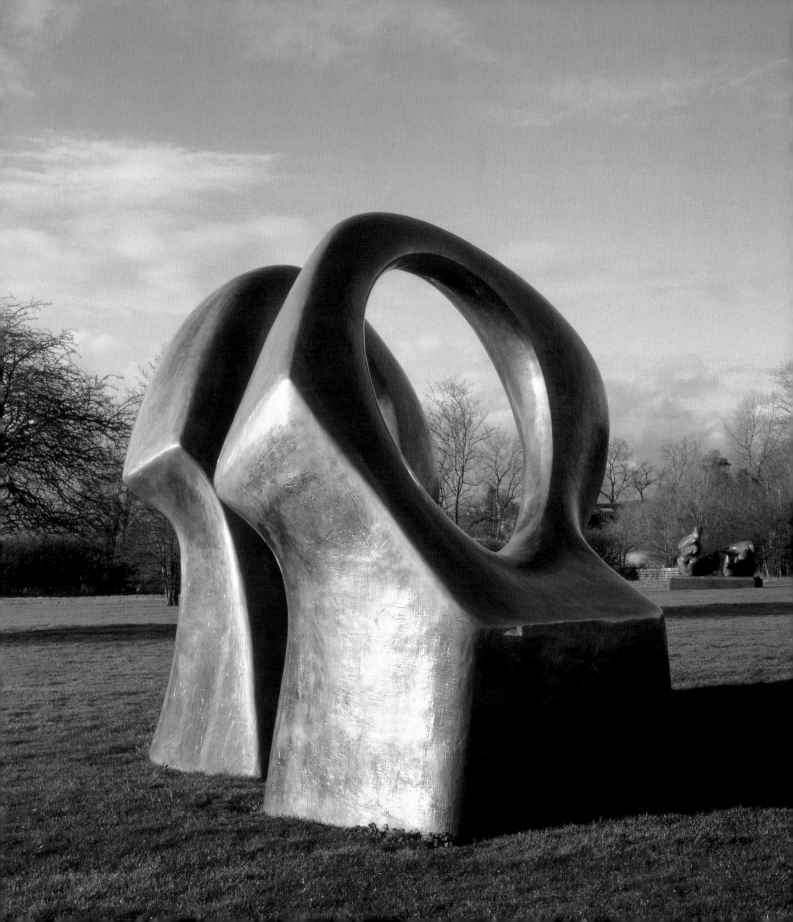

experience them. A personal favourite is *Sheep Piece* (1971–72), located in an actual sheep field, claimed by the sheep, who gather around and under it for shelter from the elements. The sheep have made it their own, and left their mark – a shiny band near the bottom of the sculpture where they have rubbed against it.

Moore was an international celebrity during his lifetime and his works are featured in indoor and outdoor collections all over the world. The 'Moore experience' in the genteel Perry Green does not, however, feel international, but quintessentially English, even if you have seen one of the same sculptures elsewhere. Experiencing his sculptures in the 'green and pleasant land' immortalized by William Blake (1757–1827) in the hymn *Jerusalem* feels like stepping into a landscape painting by those earlier great British artists John Constable (1776–1837) or J. M. W. Turner (1775–1851). This is Perry Green's charm, for seeing Moore's work in this lyrical, pastoral context was a completely new experience. Here you can fully appreciate how crucial a source of inspiration nature was for Moore and why it was the preferred setting for his outdoor sculptures.

The Henry Moore Foundation was established in 1977 by Moore to share his love of the fine arts, particularly sculpture, with the public. He gave the Perry Green estate to the Foundation at its inception and it is open to the public by appointment, from April to September. Some of the outdoor sculptures are on permanent display, while others change according to availability due to the works' exhibition schedule. There are also a number of studio buildings on the site, which house changing exhibitions of Moore's work, his maquettes and found objects (bones, stones and fossils), tapestries based on his drawings and an educational studio explaining his working practices.

At Perry Green, Henry Moore's sculptures are displayed in the setting he preferred for them – nature.
Left Double Oval (1966)
Below Sheep Piece (1971–72)

FLEVOLAND

FLEVOLAND, NETHERLANDS
Robert Morris, Piet Slegers, Richard Serra,
Marinus Boezem and Daniel Libeskind
1977–97

God created the world, and the Dutch created the Netherlands. DUTCH SAYING

Flevoland is a new province in the Netherlands, east of Amsterdam. Officially announced in 1986, 1419 square kilometres of land have been in the process of being reclaimed from the Zuider Zee, an inland sea, since 1932, primarily for farmland. The towns are recent additions, most little more than twenty-five years old. It is a place whose social history has not been contaminated by wars and power struggles, its land has not been scarred by conflicts and its visual landscape is not full of reminders of lost loved ones. This does not mean it is soulless however, for those involved in its planning and development have embraced the challenge of helping to create an identity for this new man-made environment. Art and high-quality new architecture have been incorporated from the start. It is an environment in which the boundaries between art, architecture, design, engineering, urban planning and the rural landscape have been blurred and fused into a new entity.

It is fascinating to be in a place where everything is so new, including the land and the landscape, and interesting to see it in the process of defining itself. Public art has played its part since the beginning, and in fact, many of the works of art have been in Flevoland longer than the towns and their inhabitants. For instance, the initiative to include art as an integral feature of Zeewolde, a village in South Flevoland, dates back to 1984, before the village was even built. The Kunstbaan Zeewolde (Art Route Zeewolde) was officially incorporated into the development plan for the municipality in 1989. It features art by an internationally renowned cast of artists, such as Richard Serra, Lothar Baumgarten, Anya Gallaccio, Carel Visser and Lawrence Weiner. The cultural aspirations of the polder (reclaimed land) pioneers were announced from the start, with the new territory staked out with 'bestemming kunst' (destination art).

Flevoland is particularly rich in outdoor sculptures, and while they may be monumental, they are not monuments or memorials. There are over 150 sculptures dotted around the province in a collection that is still growing. You come across them in towns, parks, lakes, fields and alongside the roads – lending a sense of the province as one large sculpture park. A very special aspect of this collection is its Land Art, which was an initiative of the IJsselmeer Polder Department (National Department of Public Works). There are five major Land Art pieces in Flevoland: *Observatorium* (Observatory) by Robert Morris, *Aardzee* (Earth Sea) by Piet Slegers, *Sea Level* by Richard Serra, *De Groene Kathedraal* (The Green Cathedral) by Marinus Boezem and *Polderland Garden of Love and Fire* by Daniel Libeskind.

Robert Morris, *Observatorium*
The first Land Art piece to be built was Robert Morris's (b. 1931) *Observatorium* in 1977. The American artist was one of the pioneers of the land art movement which emerged in the USA in the late 1960s. He was one of the participants in 'Sonsbeek '71', an exhibition which included works sited around the Netherlands in addition to its main exhibition site at Sonsbeek Park in Arnhem. Morris contributed a temporary *Observatorium* in the dunes near Velsen. Afterwards, the Sonsbeek Foundation found a permanent home for a larger version of it in East Flevoland. It was built in 1977 on a large grassy field outside Lelystad, the capital of the province, which welcomed its first new residents in 1967.

The work consists of two concentric earth rings with openings and three V-shaped markers. The outer ring comprises three mounds, aligned northeast, southeast and west. Two of the V-shaped markers, made of granite, are on top of the northeast and southeast mounds. Enter the complex through a triangle-shaped opening in the west

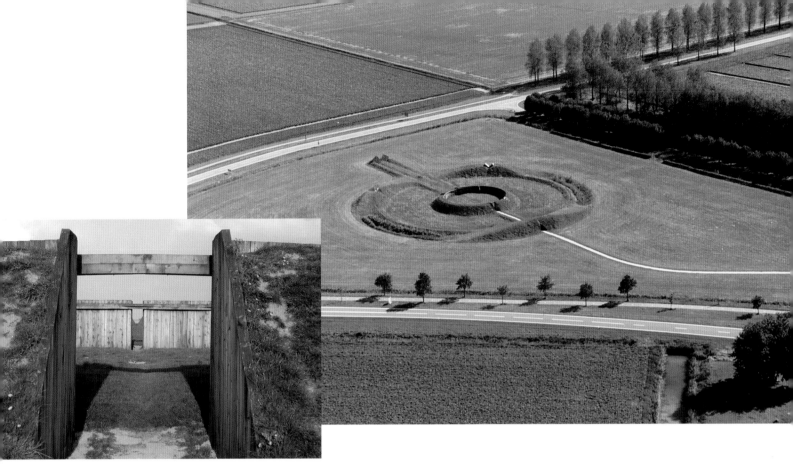

mound, from which you can see through two openings in the inner circle to the other V, made of large steel plates sited outside the outer ring to the east. The inner circle consists of a circular timber stockade holding up an exterior earth wall of forty-five degrees. It has openings facing east, west, northeast and southeast to connect with the Vs and the triangle opening. Once inside, the openings draw you to them and from them you see the Vs, which function as viewfinders to witness the arrival of the seasons and mark the solar year. The east-facing centre one with the steel viewfinder frames the sunrise on the spring equinox (around 21 March) and the autumn equinox (around 21 September), when day and night are of equal lengths. The two stone viewfinders announce the summer (21 June, the longest day of the year) (northeast) and winter (21 December, the shortest day of the year) (southeast) solstices. Even if visiting at other times, the work still gives cause to reflect on natural phenomena, with the viewfinders and geometric openings in the circles helping to isolate and frame segments of the vast space and sky. As the work relies on its setting so heavily it was placed in an isolated location

and Morris was guaranteed that no development would interfere with the sight lines for at least fifty years.

This apparently minimalist structure performs very complex operations in order for the viewer to reflect on and appreciate the wonders of the universe. The forms and function of *Observatorium* explicitly evoke such ancient monuments as Stonehenge, as well as the spirituality and mystery associated with them. In the centre of the work there is another unexpected dimension, for the inner circle acts as an echo chamber or a whispering gallery, adding to the piece's rather mystical presence.

Observatorium also draws on the cult of the sun and the pagan rituals involved, and the symbolism of a work which celebrates the dawn set in a new land was not lost on this viewer. Morris provided the young, developing community with a new ceremonial site with ancient and universal associations of hope and creation. It is often used for its intended purpose, with poets and musicians camping out for the summer solstice and as a setting for musical, dance and theatrical performances at other times in the year.

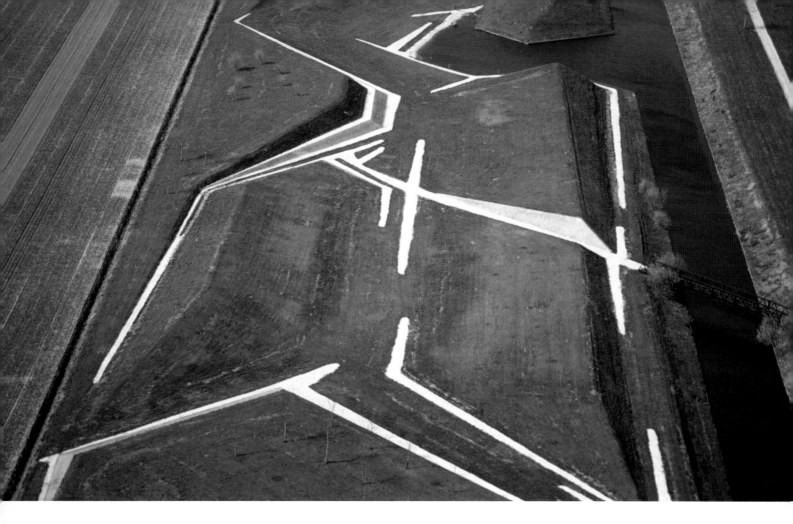

Piet Slegers, *Aardzee*

The second Land Art piece realized in Flevoland was *Aardzee* (Earth Sea) by Dutch artist Piet Slegers (b. 1923). It was conceived and designed in 1975 and constructed in 1982 in the agricultural centre of South Flevoland. As the title of the work suggests, Slegers was inspired by the process of land reclamation. He was captivated by the transformation of the wild sea into this new serene flat polder landscape and a dialogue between the elements of water and earth is at the core of the work. Measuring five hectares, the same size as the surrounding plots of farmland, it consists of bridges, shell paths which zigzag across and around the plot, earth walls, stone embankments, sloping grassy lawns and a lake. In distinct contrast to the flat farmland all around, the only horizontal surface in the work is that of the water, and the earthen components instead reference the dynamism of a sea, with undulating slopes that look like waves crashing. Slegers's attention to detail increases the impact, for the type of tree he chose, white poplars, has white-tinted leaves which flutter in the wind, looking and sounding like surf crashing. The paths start off and then end, encouraging you to go explore the different levels, or 'surf the waves'. These higher levels allow panoramic views over the surrounding landscape and the opportunity to appreciate its beauty and grandeur.

Slegers hoped that *Aardzee* would become a place of recreation and repose – a place where people from cities would come for a break from hectic urban living. While the neighbouring farmers were originally not happy that valuable land was given over to art, *Aardzee* has since been accepted and is used by the locals for social events, performances and picnics.

Richard Serra, *Sea Level*

Another work which addresses the land/water dichotomy and how it figures in the past and present of the region is *Sea Level* (1996) by American sculptor Richard Serra (b. 1939). It is located on the outskirts of the Netherlands's youngest village, Zeewolde, founded in 1984. *Sea Level* consists of two black pigmented concrete walls, each two hundred metres long and twenty-five centimetres thick. The walls are in line with each other, on opposite sides of a canal, separated by two hundred metres. This space in between stretching over the canal visually connects the two walls such that the three sections read as one whole piece. This line cuts diagonally through De Wetering Landscape Park, designed by Dutch artist Bas Maters (1949–2006) and landscape architect Pieter van der Molen (b. 1943), in 1986. The park is bounded by two slopes, each starting below sea level and rising to the height of the dikes which enclose the polder and allow the region to exist.

Serra's wall interacts with the park environment and references the area's past as a sea and its present as polder. The wall slices through the area enclosed by Maters's slopes and runs into them. The top edge of Serra's horizontal wall is at sea level and draws attention to the fact that Zeewolde is on what was the bottom of the Zuider Zee.

The interaction of Serra's wall with Maters's slopes helps describe physically and visually the definition of sea level and the genesis of Zeewolde. *Sea Level* animates the whole landscape and seems to pay tribute to the incredible engineering feat of land reclamation. As you walk along beside the wall there is this sensation where you aren't really sure if you are going lower or the wall is getting higher. The wall can have quite an ominous presence at its high ends and there is a sense of coming up for air after having been below water when you reach the low ends.

Sea Level is part of Art Route Zeewolde. The seven-kilometre route takes you through the village of Zeewolde, De Wetering Landscape Park, the woodland and across the Randmeren dike, and is a very pleasant way to discover the area and experience art in a variety of landscapes.

While taking very different forms, Piet Sleger's *Aardzee* (opposite) and Richard Serra's *Sea Level* (below) both reference Flevoland's past as a sea and its transformation into new, reclaimed land.

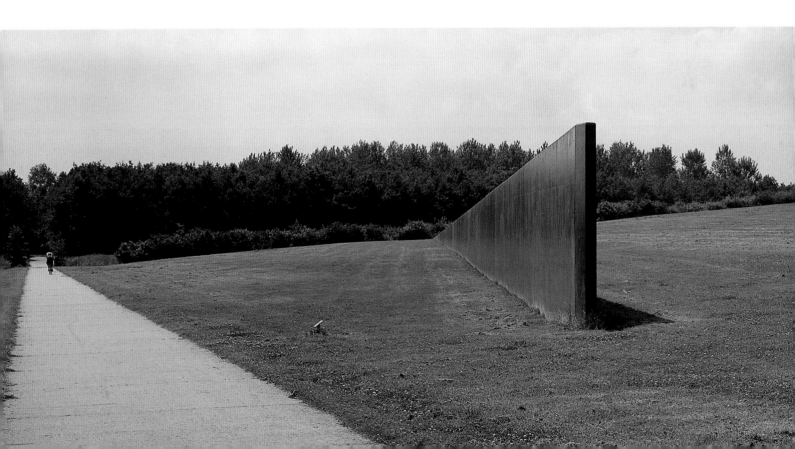

Marinus Boezem, *De Groene Kathedraal*

Almere (population 175,000) is the largest city in Flevoland. It is home to a rapidly growing population and two major Land Art pieces. One is *De Groene Kathedraal* (The Green Cathedral) (1987–96) by Dutch artist Marinus Boezem (b. 1934). This extraordinary, monumental, time-based living project made primarily of trees is located just on the outskirts of town. Boezem designed this 'growth project' – a slowly developing and then dying, nature-based project – specifically for an artificial polder landscape in 1978.

He began the work in April 1987 by planting 178 Lombardy poplars in the shape of the floor plan of the famous gothic Notre Dame Cathedral (1211–90) in Rheims, France. For Boezem this cultural landmark was the pinnacle of human endeavour and represented a harmonious fusion of spirituality, philosophy and art and of striving for excellence. All of these associations fed into Boezem's choice, resonate with its context and add to the impact and meaning of the work.

The trees function as the columns of the cathedral and concrete paths represent the ribs of the cathedral's vaulting. This particular type of tree (*Populus nigra Italica*) was chosen not only for its tall, slender, graceful silhouette but also for its short lifespan of around thirty years. Once the trees reach their full height of around thirty metres, approximately the height of the Rheims Cathedral, they will begin to slowly die, such that this part of *De Groene Kathedraal* will become one of the first 'ruins' on this young province.

There is, however, another part to *De Groene Kathedraal*, which will eventually take over from the first. On an adjacent site, Boezem has created another dimension to his time and space 'growing project'. It again takes the form and dimensions of Rheims Cathedral, but this time the external shape has been inscribed with sturdy, slow-growing, long-living shrubs and trees such as hornbeam, oak and birch. Over the next few decades, as the first cathedral decays, the second phase will come into its own as it matures into a grassy open space in the woods. *De Groene Kathedraal* will live on in this second incarnation both as a resurrection of the first and as a memorial to its passing.

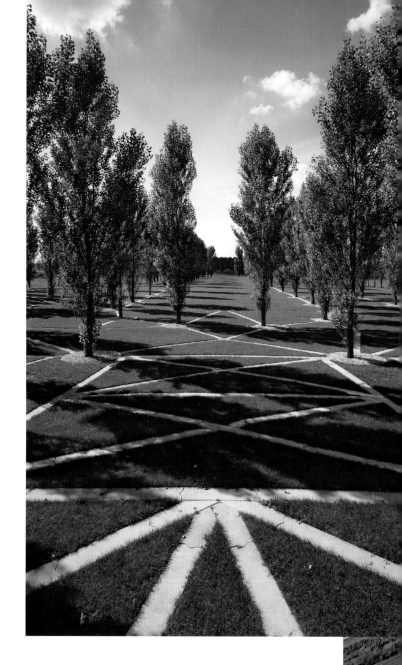

The aerial view (*below*) shows the two parts of Marinus Boezem's *De Groene Kathedraal* – the 'negative' cathedral that is defined by slow-growing, long-living trees and shrubs and the glorious 'positive' cathedral (*left*), which was created by planting 178 short-living Lombardy poplars in the shape of the floor plan of the gothic Notre Dame Cathedral in Rheims, France.

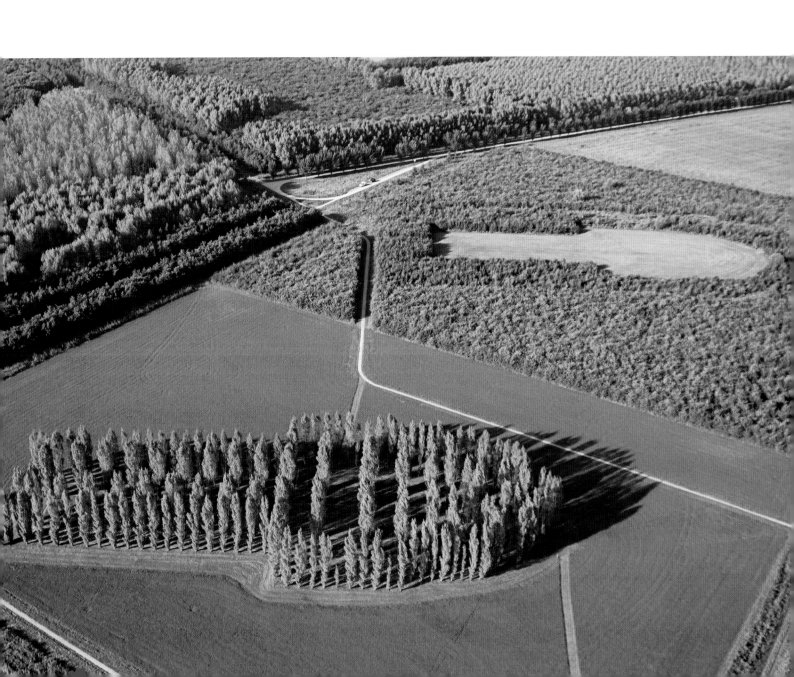

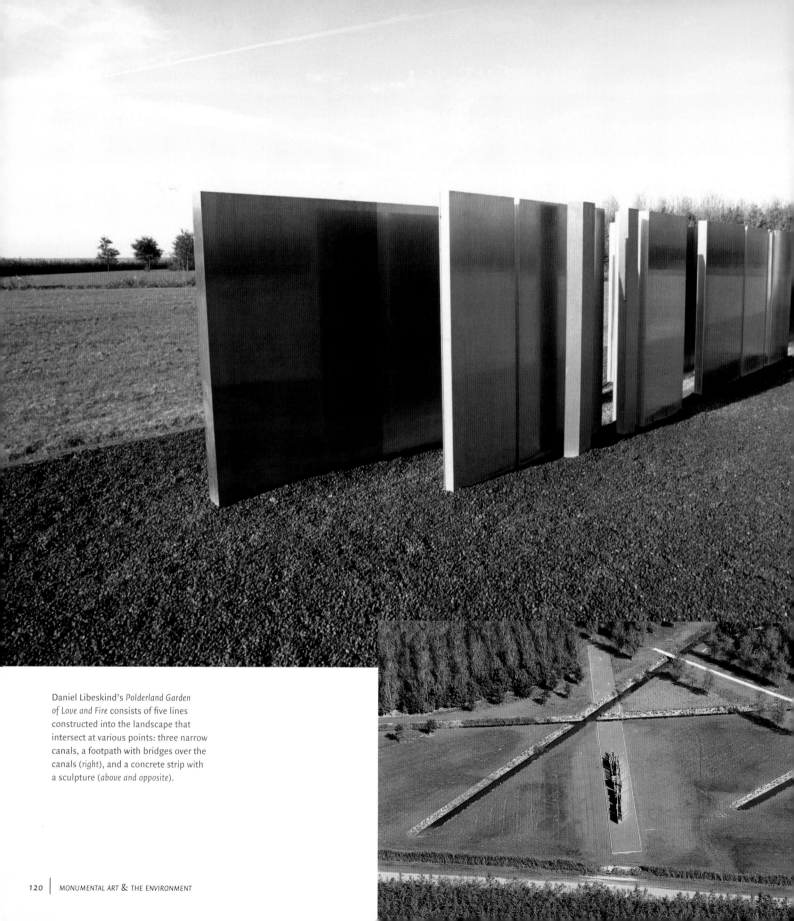

Daniel Libeskind's *Polderland Garden of Love and Fire* consists of five lines constructed into the landscape that intersect at various points: three narrow canals, a footpath with bridges over the canals (*right*), and a concrete strip with a sculpture (*above and opposite*).

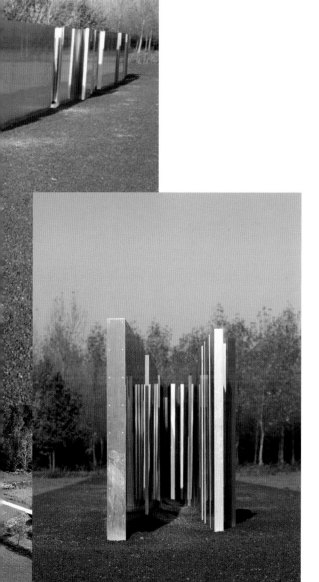

Daniel Libeskind, *Polderland Garden of Love and Fire*

The other work in Almere is *Polderland Garden of Love and Fire* (1992–97) by Polish-born American architect Daniel Libeskind (b. 1946), famed for designing the Jewish Museum in Berlin (1989–99) and the master plan for the World Trade Center site in New York City (2003). It consists of five lines constructed in the landscape which intersect at various points: three narrow canals, a concrete strip with a sculpture and a footpath with bridges over the canals. Libeskind developed the project for Almere after participating in a group exhibition in Amsterdam of art inspired by the ideas of the sixteenth-century Spanish mystic and poet, San Juan de la Cruz (St John of the Cross). His lyrical poems, such as *Dark Night of the Soul* and *Living Flame of Love*, which advocate a union with God through the mystical or contemplative life, are considered some of the masterpieces of the Spanish Renaissance.

Libeskind is interested in history, memory and rootlessness and calls for a greater awareness of these issues in many of his works. Lines play an important role in his work as a whole for the way they can be either connections or borders, the way they can either unite or divide. This work is no exception, with its lines interacting with the real polder landscape of Almere and linking the people of Almere with other times and places. The three canals represent imaginary links between three cities: the ancient Spanish university town of Salamanca, where De la Cruz studied; Berlin where Libeskind was living and working at the time; and Almere, the site of the project. The labyrinthine sculpture on another of the lines symbolizes life's starts, stops and wrong turns; the false starts and new beginnings on the road to figuring out the meaning of life.

Libeskind has referred to the work as a 'garden for meditation'; a place to reflect on the interplay between nature and the built environment, and a place to ponder the many different possible meanings and readings it affords. With its references to history, memory and the possibilities that the future holds, *Polderland Garden of Love and Fire* seems a poignant call to the people of Almere to remember the past while embarking on their new future in this brave new world.

THE NEW YORK EARTH ROOM AND THE BROKEN KILOMETER

NEW YORK, NEW YORK, USA

Walter De Maria

1977 and 1979

One man's dirt is another man's sculpture. RUSSELL BAKER

In New York City's bustling SoHo district there are two permanent installations by the Minimal, Conceptual and Land Artist Walter De Maria (b. 1935), *The New York Earth Room* and *The Broken Kilometer*. Although not in a remote location like the American artist's best-known work, *The Lightning Field* in New Mexico (see p. 106), here De Maria has created two retreats in which to have a (semi) private experience with a work of art that you wouldn't otherwise get in a museum crowded with art or people. De Maria has commented that he believes that a successful work of art should have many meanings and that the interpretations should include the personal and the social. The information provided on site about these two works is minimal and factual, allowing – or forcing – viewers to come up with their own meanings, ideas and connections. Here are a few of mine.

The New York Earth Room is a horizontal, flat interior earth sculpture of 280,000 pounds (127,300 kilos) of rich black-brown earth in a pristine white gallery space. It consists of 250 cubic yards (197 cubic metres) of earth, twenty-two inches (fifty-six centimetres) deep which fills the gallery space like a very plush carpet or a thick layer of snow. On view to the public since 1980, the work claims 3,600 square feet (335 square metres) of prime real estate in SoHo for Land Art in perpetuity.

You do not experience the work by walking through it, instead you stand staring at it like a painting, as there is a glass barrier that holds the earth in and keeps the viewer out. Despite this (or because of it?), the experience is a multi-sensory one. As you enter the building and climb the stairs you feel the humidity in the air caused by the daily watering and smell the pungent aroma of the earth. The textural and colour contrasts between the soil and the gallery walls also make the piece very visually striking and rather beautiful. It is also very soothing, and provoked in me an almost overwhelming desire to jump in it to see if it would feel like landing on a crash mat or jumping into a big pile of leaves.

A few minutes walk away on West Broadway, *The Broken Kilometer* has been claiming an even larger space since 1979. *The Broken Kilometer* is just that – five hundred gleaming solid round brass rods, each two metres long and two inches in diameter which, if laid end to end would measure one kilometre (3280 feet). It weighs eighteen and three-quarters tons. The rods are arranged in five neat parallel columns of one hundred rods each, covering an area forty-five feet wide by one hundred and twenty-five feet deep. The work is lit by Metal Halide stadium lights, which pick out different colours on the rods and add to the theatrical feel of the work. Entering from the chaos of the SoHo streets into the calm and orderly presence of the work is a serene, almost hypnotic experience.

Measure, order, geometry and mathematics are important elements in most of De Maria's sculptures, and this is no exception. Perceptual phenomenon also plays a part, for the apparent exacting regularity of the work is an illusion, with the space between the rods in each row increasing five millimetres as they go back and the rods rising minutely in elevation. This distorts the illusion of perspective and creates the appearance of regularity.

While each of these works stands on its own, both are also connected to other pieces by De Maria, making them works which occupy not only physical space but also the space of the imagination. For instance, De Maria's first *Earth Room* was executed in September 1968 in Munich, Germany. *50M3 (1,600 Cubic Feet) Level Dirt/The Land Show: Pure Dirt/Pure Earth/Pure Land* (also known as the *Munich Earth Room*) was exhibited at the Galerie Heiner Friedrich. This was followed in 1974 by the *Darmstadt Earth Room* at the Hessisches Landesmuseum in Darmstadt, Germany. Both were temporary installations.

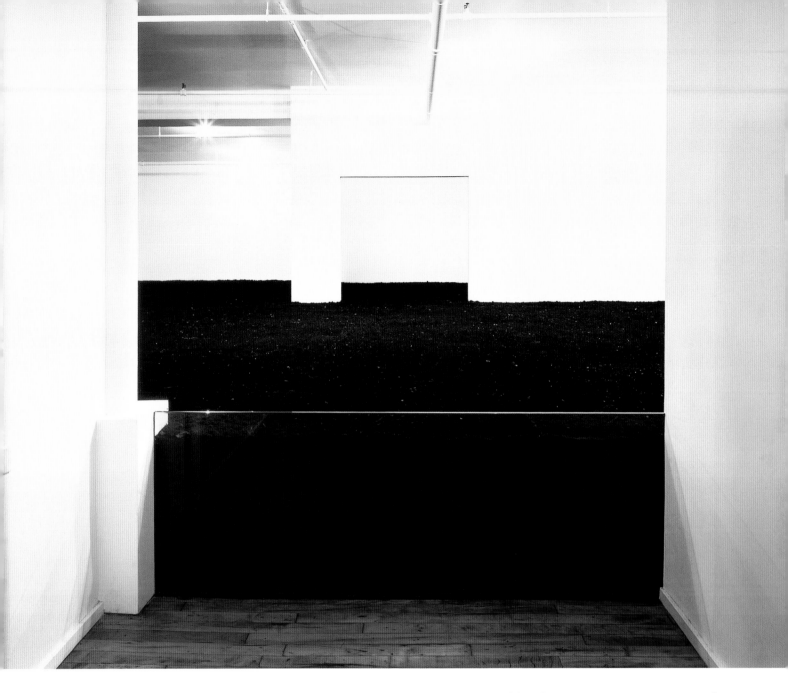

The *New York Earth Room* made its debut in 1977 in Heiner Friedrich's SoHo gallery on Wooster Street. The exhibition closed in 1978 and was reopened to the public in the same space in 1980 as a permanent installation supported by the Dia Art Foundation, founded in 1974 by Friedrich, heiress Philippa de Menil and art historian Helen Winkler. They established the foundation specifically to support this newly emerging type of work, often large-scale or site-specific, which did not fit easily into the existing gallery and museum system.

The Broken Kilometer debuted in 1979 in its space on West Broadway, in another of Friedrich's galleries. After the exhibition closed it was decided that the piece should remain in the space. It reopened later in the year as a permanent exhibition maintained by the Dia Art Foundation. Its companion in time and space is *The Vertical Earth Kilometer* in Kassel, Germany, a permanent Earth sculpture installed in 1977. In this work, also financed by the Dia Art Foundation, a kilometre-long brass rod of the same diameter, weight and length

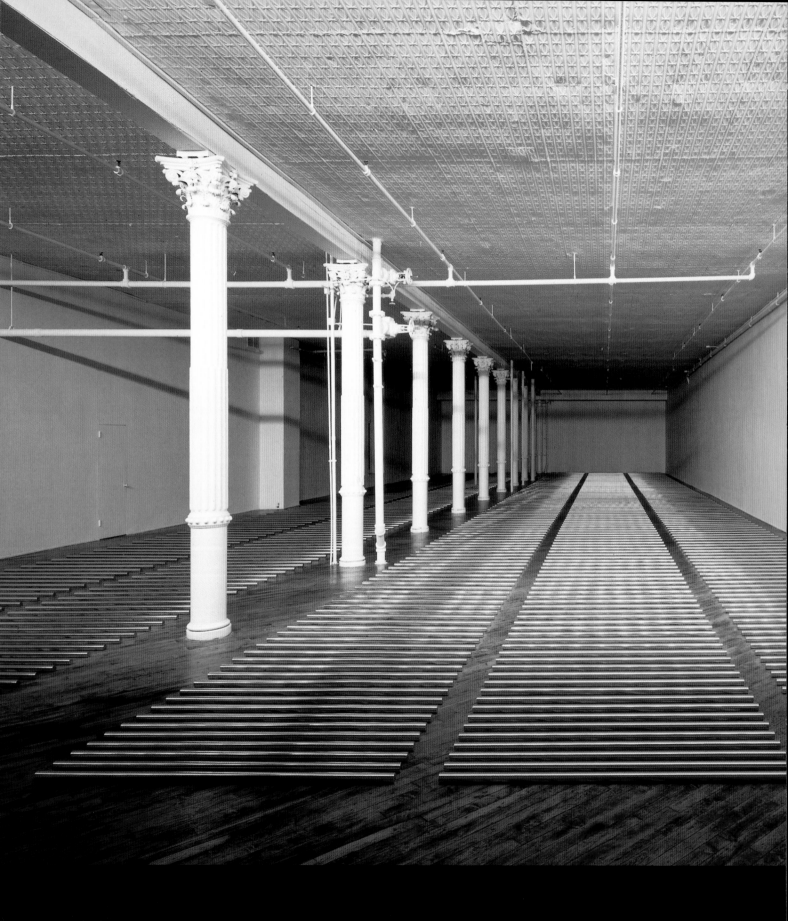

as *The Broken Kilometer* was buried vertically in the ground of one of the city's squares. Only the top cross-section, two inches in diameter, can be seen of the work, which brings to mind such contradictory thoughts as the vulnerability of the Earth and the damaged caused to it by drilling and mining as well as the many archaeological treasures it holds.

Some of the things that I find particularly interesting about these urban pieces are the connections they make between Europe and America, which brings to the fore the growing internationalism of the art world in the 1970s and the emphasis on context as an integral ingredient of the work – be it a city centre, gallery space or desert – in De Maria's work as a whole. *The New York Earth Room* and *The Broken Kilometer*, as long-term residents in a fast-changing neighbourhood, draw attention to the way the make-up of cities changes over time. The contemporary art world in New York has moved to Chelsea and SoHo has become a fashionable shopping and dining district. These two works stubbornly stand their ground and act as a reminder of SoHo's past as the hub of the contemporary art world.

De Maria's use of imperial and metric measurements sparks off other ideas and associations. Again there is the European–American axis and the timeliness of the appearance of these two pieces in New York, as there was a concerted effort to introduce and teach the metric system in the USA during the 1970s, with Congress's passing of the Metric Conversion Act of 1975. De Maria's work could be seen as trying to help us visualize and understand the two systems of measurements or perhaps commenting on man's resistance to change and the ongoing confusion caused by the use of both systems. Or are they just helping us to picture what 280,000 pounds of soil looks like, how long a kilometre is, or ponder how many geological layers through the Earth a vertical kilometre would pass?

A pile of dirt and a bunch of rods? Or complex artworks that are surprisingly beautiful, help to make abstract ideas concrete, and explore a variety of relationships, between art and its context to man and his? If you have the opportunity, spend some time with the works and decide for yourself.

GIARDINO DEI TAROCCHI

PESCIA FIORENTINA, ITALY
Niki de Saint Phalle
1978–98

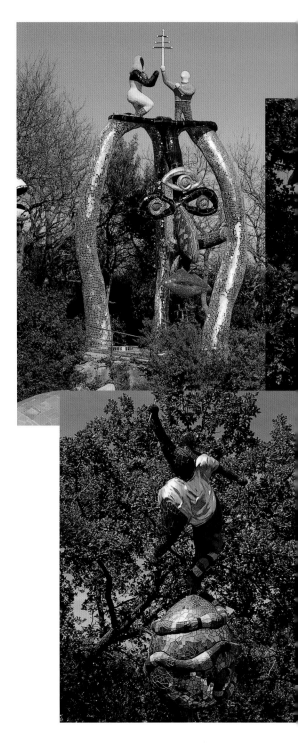

I knew that I was meant one day to build my own Garden of Joy.

NIKI DE SAINT PHALLE

In southern Tuscany, about seventy miles northwest of Rome, is a magical wonderland created by Franco–American artist Niki de Saint Phalle (1930–2002). The *Giardino dei Tarocchi* (Tarot Garden) is on top of an old stone quarry on a hill just outside of Capalbio, overlooking the picturesque coast. Saint Phalle was a great fan of the fantastic architecture of Antoni Gaudí (see *Park Güell*, p. 22), Le Facteur Cheval (see *Le Palais Idéal*, p. 14) and Simon Rodia (see *Watts Towers*, p. 26) and had dreamt of creating a sculpture garden of her own since first seeing Gaudí's *Park Güell* in 1955. In 1974, while recovering in Switzerland from a lung ailment caused by her work with resins, she confided to her friend Marella Agnelli her desire to build 'a garden that would be a dialogue between sculpture and nature'. Taken with the idea, Agnelli spoke to her brothers, Carlo and Nicola Caracciolo, who granted her the right to use a plot of their land in Italy. Saint Phalle was delighted, describing the area as 'a little corner of paradise and a junction where man and nature could meet'.

In 1978 Saint Phalle began realizing her vision of a sculptural environment based on the twenty-two symbols of the Major Arcana of the Tarot, concepts that had intrigued Saint Phalle throughout her life. These were the inspiration for the collection of monumental sculptures and architectural structures on site, such as *The Empress*, *The Magician*, *The High Priestess*, *The Tower*, *The Emperor* and *The Hanged Man*, many of which can be entered. The sculptures are made of iron frames covered with wire mesh and cement, and they are richly embellished with brightly coloured glass, glass and ceramic mosaics, mirrors and reliefs. The sculptures are entwined with the Mediterranean vegetation and rocky terrain which are reflected in their shiny surfaces. Rather like a small town, there is a courtyard, a roof terrace, a pool, fountains and a chapel with walkways and steps connecting them. The work is the result of a mixture of child-

Top The Hierophant and the Sun
Above The World
Above right The Devil
Opposite The Empress
Overleaf Overview of the garden

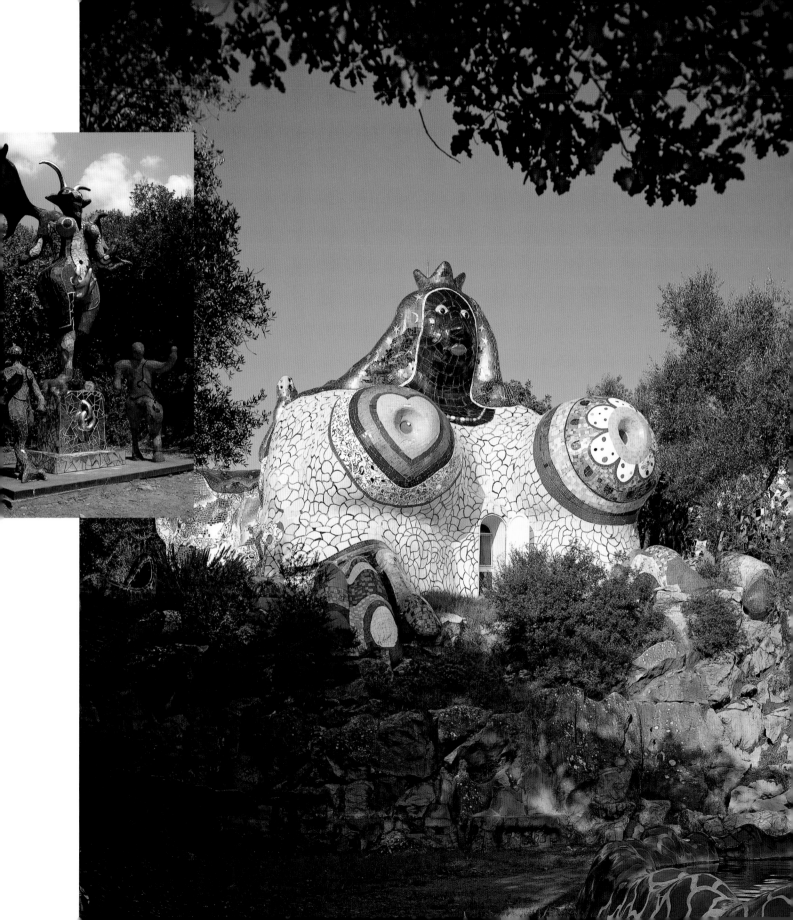

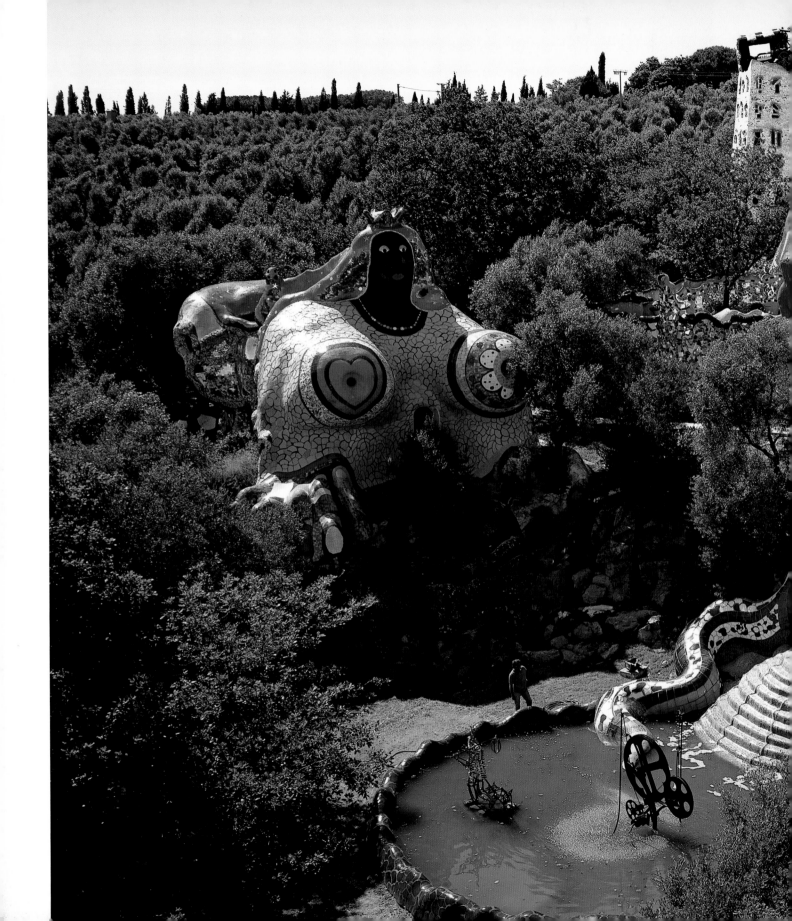

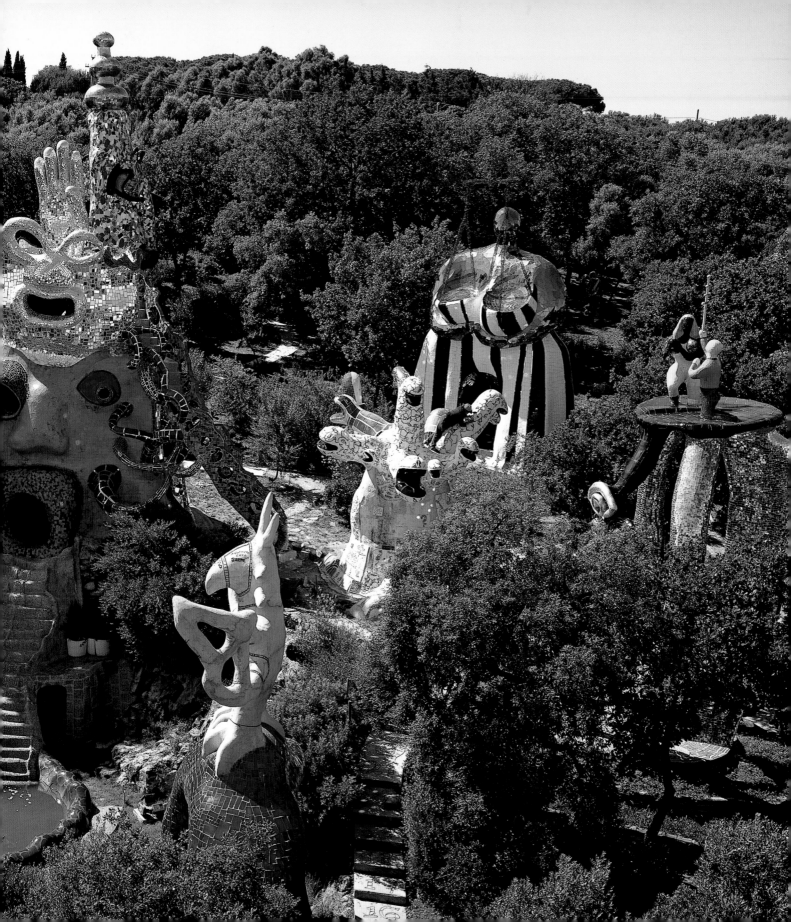

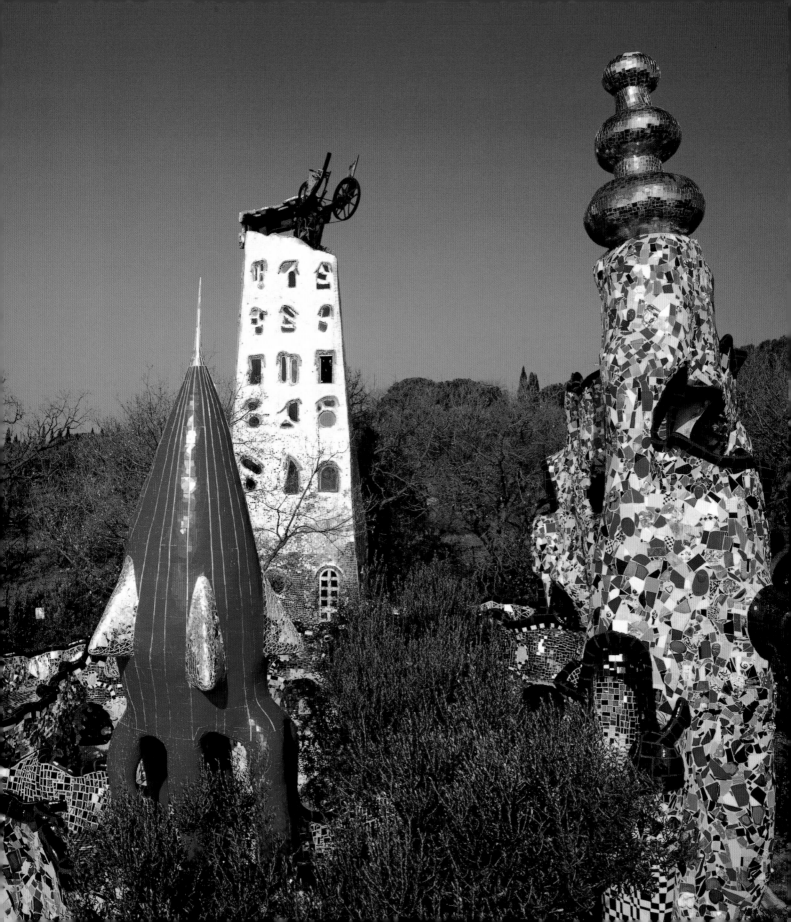

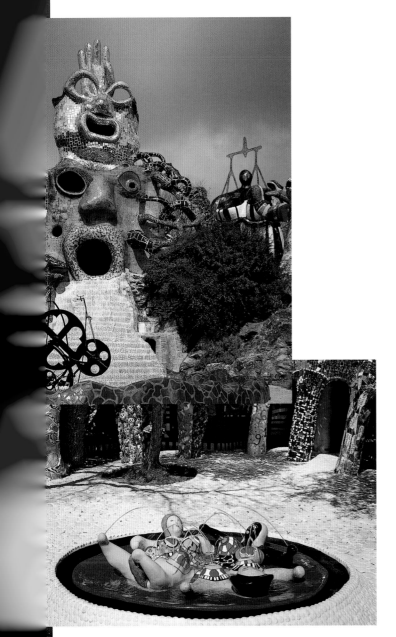

like awe and an exploration of such sophisticated intellectual dichotomies as good and evil, hope and despair, male and female.

Saint Phalle spent some twenty years bringing her dream to life, and for much of that time she lived and worked in the interior of the sphinx-like *Empress*, the central figure of the complex. Important collaborators on the project included her husband, Swiss artist Jean Tinguely (1925–91), Swiss artists Sepp Imhof, Rico Weber and Mario Botta, Argentinian Ricardo Menon, Dutch artist Doc Winsen and Italian ceramicist Venera Finocchiaro. Local artists and craftsmen also worked on the project, which was financed by Saint Phalle from the sale of her artwork and perfumes. It was opened to the public in 1998.

Saint Phalle's hard work paid off. By bringing together sculpture, architecture, nature, poetry, narrative, and yes, a little bit of magic, she created a garden that is more like another world than a sculpture garden. The whole is surrounded by a tall stone wall, which has a large circular opening for access, increasing the feeling of entering a secret garden or another world, one that is populated by mystical, magical creatures. Inside is a riot of colours, textures and gorgeous finishes and the overall impression is that of an exuberant celebration of the joys and challenges of life and of creativity.

Other sculpture parks and gardens in the region include *Il Giardino di Daniel Spoerri* (see p. 190), *Parco Sculture del Chianti* (see p. 266), *Fattoria di Celle: The Gori Collection of Site-Specific Art* (see p. 199) and Paul Wiedmer's *La Serpara* (see p. 208).

The *Giardino dei Tarocchi* provides a unique insight into the creative mind of Niki de Saint Phalle. Every feature is beautifully coloured, intricately sculpted and carefully placed in this magical garden.
Left The *Falling Tower* and The *Emperor's Castle*
Top The *Magician* and The *High Priestess*
Above Four *Nana Fountain* in the Emperor's courtyard

THE CHINATI FOUNDATION

MARFA, TEXAS, USA
Donald Judd and others
From 1979

*In looking you understand. You look and think, and look and think, until it
makes sense, becomes interesting.* DONALD JUDD

American Donald Judd (1928–94) became one of the foremost
figures of Minimalism in the USA in the early 1960s. In 1961 he
abandoned painting to make objects. For Judd, working in three
dimensions permitted him the freedom to explore new ways of
creating art. He used a variety of materials and colours, including
ones not usually used in art, such as plywood, aluminum, plexiglas,
iron and stainless steel. The apparently simple structures he created
in a body of work that includes floor and wall sculptures,
installations, architecture, furniture, and prints, provide a way to
consider the complex effects produced by different shapes, colours,
sizes and surfaces.

A constant theme in Judd's work is the interplay between negative
and positive spaces in actual objects, and the interaction of objects
with their immediate environment, such as the museum or gallery
space. In 1972, Judd took complete control of this issue by moving
to the remote cattle town of Marfa, in southwestern Texas, near the
Mexican border. There, on the high desert plains, some two hundred
miles southeast of El Paso, he found the place and the space to work
on a grand scale. In 1979 he purchased, with initial funding from
the Dia Art Foundation, three hundred and forty acres of a defunct

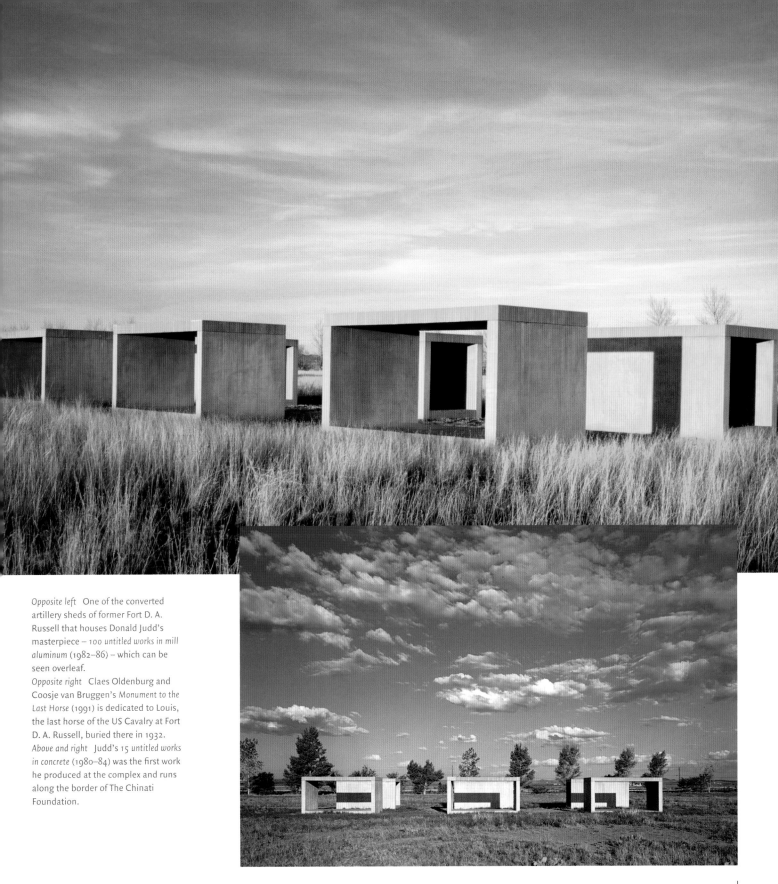

Opposite left One of the converted artillery sheds of former Fort D. A. Russell that houses Donald Judd's masterpiece – *100 untitled works in mill aluminum* (1982–86) – which can be seen overleaf.

Opposite right Claes Oldenburg and Coosje van Bruggen's *Monument to the Last Horse* (1991) is dedicated to Louis, the last horse of the US Cavalry at Fort D. A. Russell, buried there in 1932.

Above and right Judd's *15 untitled works in concrete* (1980–84) was the first work he produced at the complex and runs along the border of The Chinati Foundation.

military base, Fort D. A. Russell, located just outside of town. Judd began converting its buildings into homes for permanent installations of his work and that of his artist-friends, Americans John Chamberlain (b. 1927) and Dan Flavin (1933–96).

Judd also bought buildings in town, to use for storage, as studios and living space and to exhibit work – placing his project firmly in the heart of the bewildered community. One of these is the former wool and mohair warehouse in central Marfa, which he made into a permanent exhibition space for twenty-three of Chamberlain's painted and welded sculptures made from steel and crushed automobiles (1972–82). Explaining his mission, Judd wrote:

It takes a great deal of time and thought to install work carefully. This should not always be thrown away. Most art is fragile and some should be placed and never moved again. Somewhere a portion of contemporary art has to exist as an example of what the art and its context were meant to be. Somewhere, just as the platinum-iridium meter guarantees the tape measure, a strict measure must exist for the art of this time and place.

The first works made specifically for the new complex were Judd's fifteen untitled multi-part sculptures in concrete (1980–84) which were installed over a four year period outside in a straight north–south access line, one kilometre in length, running along the border of the property. This outdoor work is complemented by his sumptuous indoor masterpiece – *100 untitled works in mill aluminum* (1982–86) housed in two converted gunsheds. Each of the one hundred boxes in this extraordinary installation measures forty-one by fifty-one by seventy-two inches and has a unique interior. Large windows allow the daylight in, which creates an ever-changing show as the shimmering surfaces reflect the buildings, the other boxes, viewers and the dramatic, minimalist landscape of flat land and vast sky – drawing the outside in and uniting art, architecture and environment.

Plans for a major Flavin light work in the derelict army barracks began as early as 1979. Sadly, neither Judd nor Flavin lived to see it realized. Flavin completed his plans for the installation shortly before his death in 1996 and the work was installed posthumously and inaugurated in 2000. Flavin's sensual spectacle, *Untitled (Marfa project)* (1996), is played out in six identical U-shaped buildings in which two parallel tilted corridors have been constructed. Fluorescent tubes of pink, green, yellow and blue in various

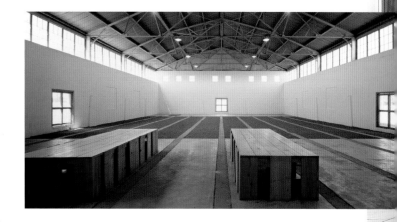

Above Judd created an installation in The Arena, the former fort's gymnasium, which he restored in the mid-1980s.
Opposite top Donald Judd, *100 untitled works in mill aluminum* (1982–86)
Opposite bottom The foundation also installs works in downtown Marfa. John Chamberlain's painted and chromium steel sculptures (1972–82) can be found in the former Marfa Wool and Mohair Building.

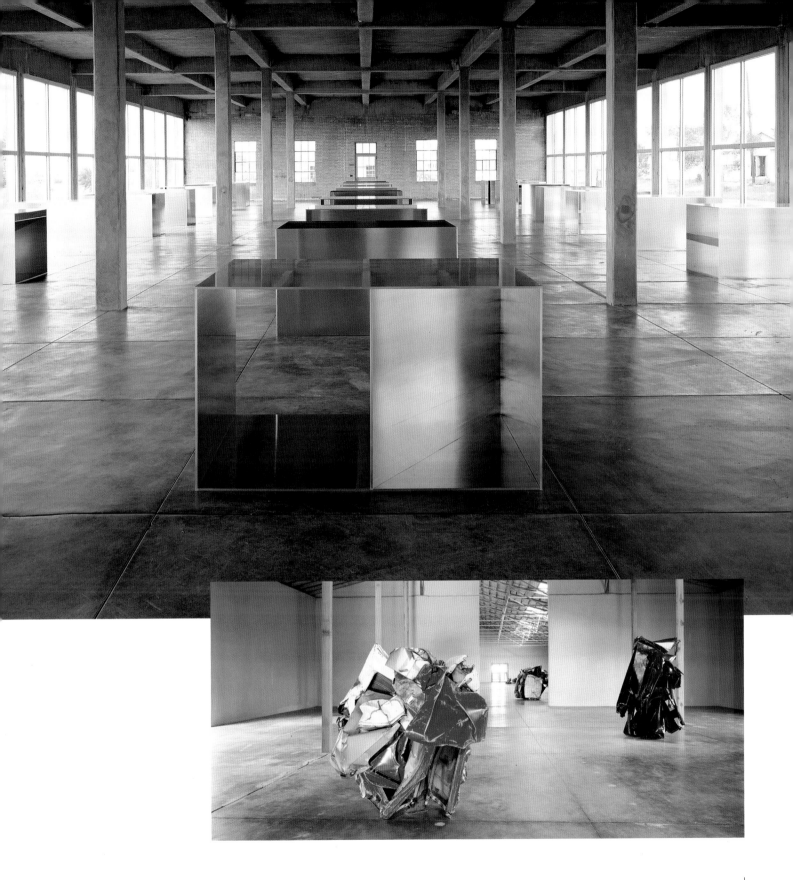

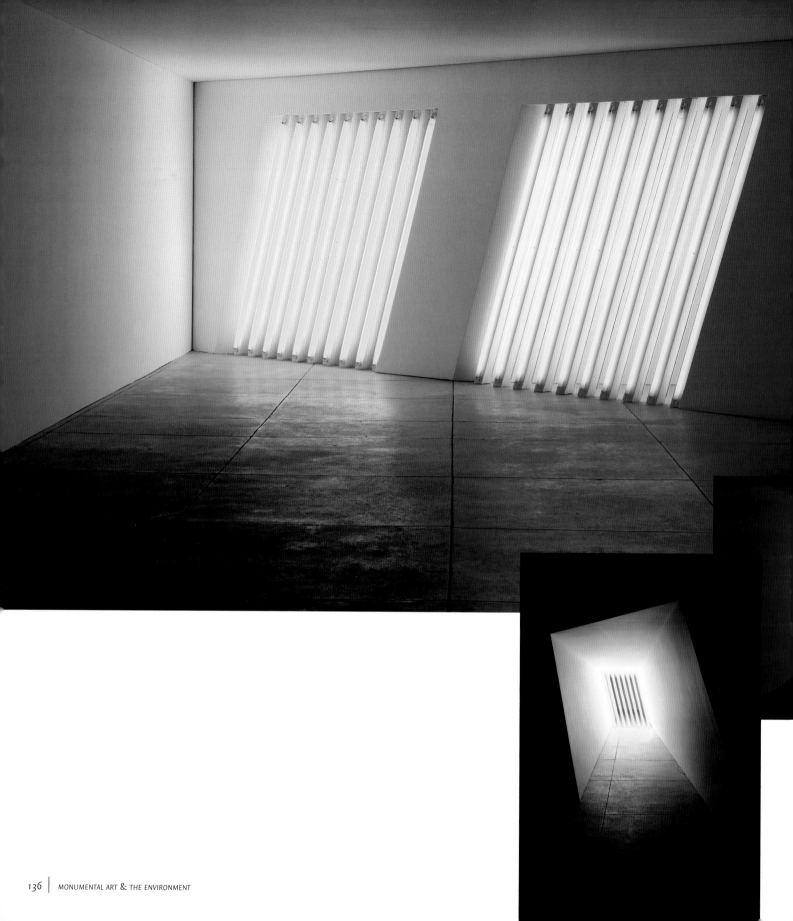

combinations create barriers of light and colour which fill the corridors and enchant spectators.

The permanent collection expanded during Judd's lifetime and after to include work by a limited number of other artists whose work he admired: Americans Carl Andre (b. 1935), Roni Horn (b. 1955), John Wesley (b. 1928), Claes Oldenburg (b. 1929) and Coosje van Bruggen (1942–2009), Briton Richard Long (b. 1945), Canadian David Rabinowitch (b. 1943), Icelander Ingólfur Arnarsson (b. 1956) and Russian Ilya Kabakov (b. 1933). He opened his art universe to the public in 1986 and named it The Chinati Foundation, after a mountain range nearby. In 1986 he inaugurated an annual Open House – a free weekend of art, music, meals and lectures for the local community and visitors to enjoy – a tradition which continues every October. The Foundation also hosts temporary exhibitions of contemporary art, symposia, an internship, and an artist-in-residence programme.

Judd successfully realized his bold vision and created a visual utopia, a 'strict measure' of 'what the art and its context were meant to be'. The result is truly magnificent, and is perhaps the only place where you will see work like this installed so sympathetically, with such grandeur and with such attention to detail. The art is exalted and the effect is exhilarating.

In Marfa you can also tour *La Mansana de Chinati*, the walled compound where Judd lived and worked, commonly known as 'the Block'. It features an impressive collection of his early work interspersed with objects of daily life. While not a part of Judd's mission, his presence and project had a profound impact on Marfa. He once commented that, 'In West Texas, there is a lot of land but nowhere to go.' His Chinati Foundation has changed this, making Marfa a definite 'destination', a fact not lost on its originally sceptical residents whose small town is now firmly on the art world map and thriving.

Dan Flavin's sensual multi-part spectacle *Untitled (Marfa project)* (1996) is housed in former army barracks.

1

2

3

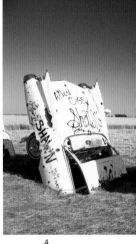

4

Closerie Falbala (1)

Périgny-sur-Yerres, France

Jean Dubuffet, 1971–76

French artist Jean Dubuffet (1901–85) built this fantastical black-and-white resin walled garden near his studio in Périgny-sur-Yerres, south of Paris. The environment spreads over 1610 square metres and rises to eight metres. The Fondation Dubuffet is next door, with over one thousand works.

Golem (2)

Jerusalem, Israel

Niki de Saint Phalle, 1971

Franco–American Niki de Saint Phalle's (1930–2002) sculptural funhouse, *Golem*, was commissioned by the Rabinovitch family in 1971. More than thirty-five years on, it continues to delight local children, who scramble in and over it and slide down its three luscious red tongues.

Amarillo Ramp (3)

Amarillo, Texas, USA

Robert Smithson, 1973

Sadly, American artist Robert Smithson (1938–73) died in a plane crash during an aerial inspection of the site during the construction of *Amarillo Ramp* in Texas. The Land Art piece was completed by his wife, Nancy Holt (b. 1938), and their friends, Richard Serra (b. 1939) and Tony Shafrazi. The work was originally partially surrounded by water, but the dam broke a few years ago and the ramp is now on dry land. Despite the different context, you still experience a soaring sensation when ascending the ramp.

Cadillac Ranch (4)

Amarillo, Texas, USA

Ant Farm, 1974

In 1974, renegade Californian creative collective, Ant Farm (Chip Lord (b. 1944), Hudson Marquez (b. 1947), Doug Michels (1943–2003)), created *Cadillac Ranch*, one of the best-known works of public art in the USA. They planted ten vintage Cadillacs nose-down in a row in the middle of a field along Route 66 (now Interstate 40), about eight miles west of Amarillo. The installation was moved another two miles west in 1997 in order to escape expanding Amarillo and to preserve its 'wide-open spaces' setting. Visitors are encouraged to take part by

leaving their mark on the ever-changing public sculpture (see above and p. 5).

Hirshhorn Museum and Sculpture Garden (5)

Washington, DC, USA

Various artists, from 1974

In the Sculpture Garden of the Smithsonian's Hirshhorn Museum and Sculpture Garden, Washington, DC's museum of modern and contemporary art, there are over sixty large-scale sculptures in a lovely tree-shaded sunken garden. The history of modern sculpture is beautifully presented in works from the 1880s to the 1960s, by leading figures such as French sculptor Auguste Rodin (1840–1917), Briton Henry Moore (1898–1986) and American Mark di Suvero (b. 1933) pictured above.

Sod Maze

Newport, Rhode Island, USA

Richard Fleischner, 1974

In the grounds of Newport's palatial Victorian Gothic mansion, Chateau-sur-Mer, is *Sod Maze*, a Land Art piece created by artist Richard Fleischner (b. 1944). The piece is made of sod and earth and consists

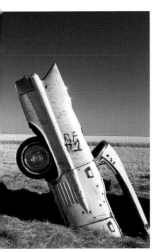

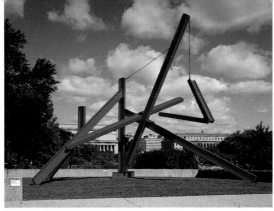

5

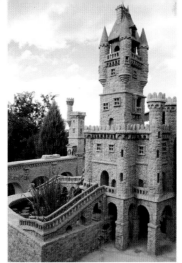

6

7

of four concentric circles with a path that leads to the centre. It measures 350 centimetres in diameter and its slopes are forty-six centimetres high. The work was created for 'Monumenta: A biennale exhibition of outdoor sculpture' in 1974, in which sculptures by an international cast of artists were sited throughout the town. The only remaining work from 'Monumenta', *Sod Maze* became the focus of attention in 2004 when its thirtieth anniversary was celebrated with a site-specific dance performance choreographed by Daniel McCusker.

Le Jardin de Nous Deux
(The Garden of the Two of Us) (6)
Civrieux d'Azergues, France
Charles Billy, 1975–91
Charles Billy (1909–91), a corset maker, spent his retirement creating this architectural fantasy located seventeen kilometres northwest of Lyon, for himself and his wife Pauline. The buildings, arches, vaults, turrets, pathways and terraces surrounding his home are built of local sandstone from derelict farmhouses.

His use of a mix of styles from different cultures and ages earned him the nickname 'the new Facteur Cheval'.

Taal Monument (Language Monument)
Paarl, South Africa
Jan van Wijk, 1975
The *Taal Monument* is a massive sculptural complex, complete with garden and amphitheatre. It was designed by architect Jan van Wijk and inaugurated in 1975. Its various elements represent the different influences that led to the creation of the Afrikaans language. Located on the slopes of Paarl Mountain, a visit leads to splendid views over the valley.

Adjacent, Against, Upon
Seattle, Washington, USA
Michael Heizer, 1976
In American Michael Heizer's (b. 1944) stunning *Adjacent, Against, Upon*, three fifty-ton boulders are partnered with three concrete geometric forms. It speaks of the relationships between natural and man-made objects and, as the title suggests, between fixed and movable ones.

The Seattle landmark is sited along one hundred and thirty feet of the shoreline of Elliott Bay, where it has a beautiful backdrop of sea and sky.

Haize-Orrazia (Peine del Viento, XV)
(Wind Comb) (7)
San Sebastián, Spain
Eduardo Chillida, 1976
San Sebastián is a coastal resort in the Basque Country of northern Spain. It is also the hometown of Eduardo Chillida (1924–2002), one of Spain's most important twentieth-century artists, and the site of one of his most impressive works, *Haize-Orrazia (Peine del Viento, XV)* or *Wind Comb*. The massive three-part claw-like steel sculpture is attached to the base of Mount Igueldo overlooking San Sebastián bay.

Yorkshire Sculpture Park (1)

Wakefield, Yorkshire, England

Various artists, from 1977

A sculpture park spread over 500 acres of eighteenth-century parkland which was formerly a country estate. It has eight differently landscaped areas in which modern sculptures are presented in changing exhibitions. At least forty works are on display at any time, by artists such as Henry Moore (1898–1986), Barbara Hepworth (1903–75) (see above), Jonathan Borofsky (b. 1942) and Mark di Suvero (b. 1933).

Skulptur Projekte

Münster, Germany

Various artists, from 1977

Once every ten years since 1977, the city of Münster in northwest Germany hosts a major international sculpture exhibition, in which artists are invited to make works that respond to the urban environment, in effect turning the whole city into a sculpture park. While most of the installations are temporary, a number of pieces remain, so that the city now has an impressive collection of public art by an international cast of artists, such as

Spaniard Eduardo Chillida (1924–2002), Dutch herman de vries (b. 1931), German Rebecca Horn (b. 1944), Americans Donald Judd (1928–94) and Richard Serra (b. 1939) and Cuban Jorge Pardo (b. 1963) (see p. 5).

Kikar Levana (White Square) (2)

Tel Aviv, Israel

Dani Karavan, 1977–88

Kikar Levana by Dani Karavan (b. 1930) is a white concrete architectural sculpture located in a park overlooking the city of Tel Aviv. This sundial complex covers an area of thirty by fifty metres, using elements of nature such as the wind, sun, water and an olive tree. The work marks the relationship between the town and the sea and pays homage to the International Style of architecture used by the pioneers of the White City of Tel Aviv.

Wat Sala Kaew Koo Buddha Park (3)

Nong Khai, Thailand

Luang Pu Bunleua Surirat, 1977–96

Visionary Luang Pu Bunleua Surirat (1932–96), leader of his own religious sect, moved to Thailand from Laos in 1975. He and

his followers bought sixteen acres of land to construct a sculpture park that would convey his religious beliefs. He was helped in the construction of the massive sculptures – some up to twenty-five metres high – by hundreds of devotees and volunteers who came to live and work on site. The whole features a mixture of the symbolism and imagery of various Eastern religions and scenes showing the evils of sins such as drinking and gambling. Surirat's mummified body is also on view.

Grizedale Sculpture Project (4)

Grizedale Forest Park, Ambleside, England

Various artists, from 1977

In Grizedale Forest in the Lake District, is an art-in-the-environment project established in 1977. Since that time, Grizedale Arts has been commissioning site-specific sculptures from artists who are invited to develop work relating to the lake and forest contexts of the area. There are around 90 sculptures throughout the 6000-acre site. There is an easy trail with child-friendly sculptures ideal for families. Other works, such as those by Keith Rand (b. 1956) and Alannah Robins (right), require more committed hiking or cycling to reach them.

4

Mill Creek Canyon Earthworks (5)
Kent, Washington, USA
Herbert Bayer, 1979–82
Austrian immigrant artist Herbert Bayer's
(1900–85) *Mill Creek Canyon Earthworks*
is one of the earliest examples of a
municipally-funded project employing
environmental art to rehabilitate a
landscape abused by mining. The park-like
environment is composed of geometric
earthworks that serve both as drainage
basins and seating for visitors.

5

FOUR:
DESTINATION ART
COMES OF AGE

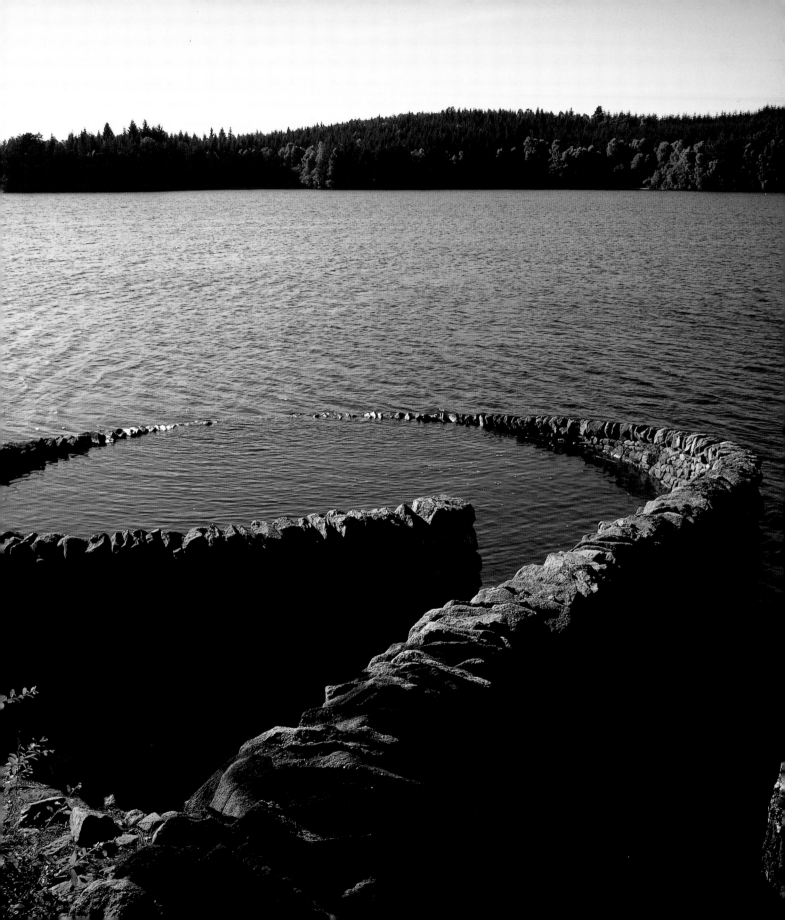

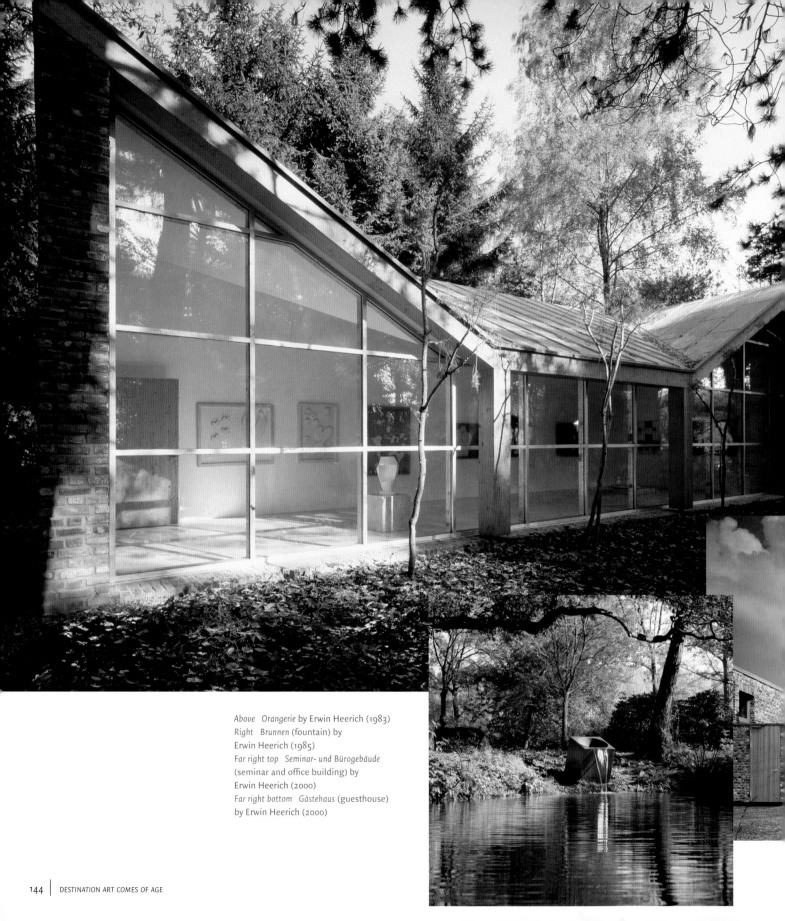

Above Orangerie by Erwin Heerich (1983)
Right Brunnen (fountain) by
Erwin Heerich (1985)
Far right top Seminar- und Bürogebäude
(seminar and office building) by
Erwin Heerich (2000)
Far right bottom Gästehaus (guesthouse)
by Erwin Heerich (2000)

STIFTUNG INSEL HOMBROICH: ART PARALLEL TO NATURE

NEUSS, GERMANY
Various artists
From 1982

The island is a small space on which people from all spheres of culture meet.
KARL-HEINRICH MÜLLER

Stiftung Insel Hombroich (Hombroich Island Foundation) is an innovative cultural complex on a sixty-acre island in a nature reserve in the river Erft, near Düsseldorf in northwest Germany. It came about as a result of property developer and collector Karl-Heinrich Müller's (1936–2007) desire to make his vast and varied collection, which stretches from archaeological artifacts to contemporary art, accessible to the public. The visionary collector wanted to create an environment that was a synthesis of art and nature, a new kind of cultural space in which art and artists could flourish and enrich the lives of those who came into contact with them.

After failing to find a suitable site in Düsseldorf, Müller came across Hombroich Island, an overgrown park near Neuss, in 1982. Müller bought the property and began turning his vision of an art oasis into a reality. The buildings on site were refurbished as exhibition spaces and as a residence for Müller and as studios for his German artist-friends Erwin Heerich (1922–2004), Anatol Herzfeld (b. 1931) and Gotthard Graubner (b. 1930). Landscape architect Bernhard Korte restored and restructured the terrain into three different landscapes – a water-meadow typical of Lower Rhine flood plains, a woodland and a terraced garden with meadows and orchards.

Planted in these lush landscapes are eleven pavilions by Heerich. His striking minimalist 'walk-in' red brick sculptures have white stucco interiors with openings in their roofs to provide natural light. They house Müller's very personal, eclectic collection, which includes Chinese figures dating back to the Han dynasty, pre-Columbian and Khmer sculptures as well as works by modernist artists such as Frenchmen Jean Arp (1887–1964), Francis Picabia (1879–1953), Jean Fautrier (1898–1964) and Yves Klein (1928–62),

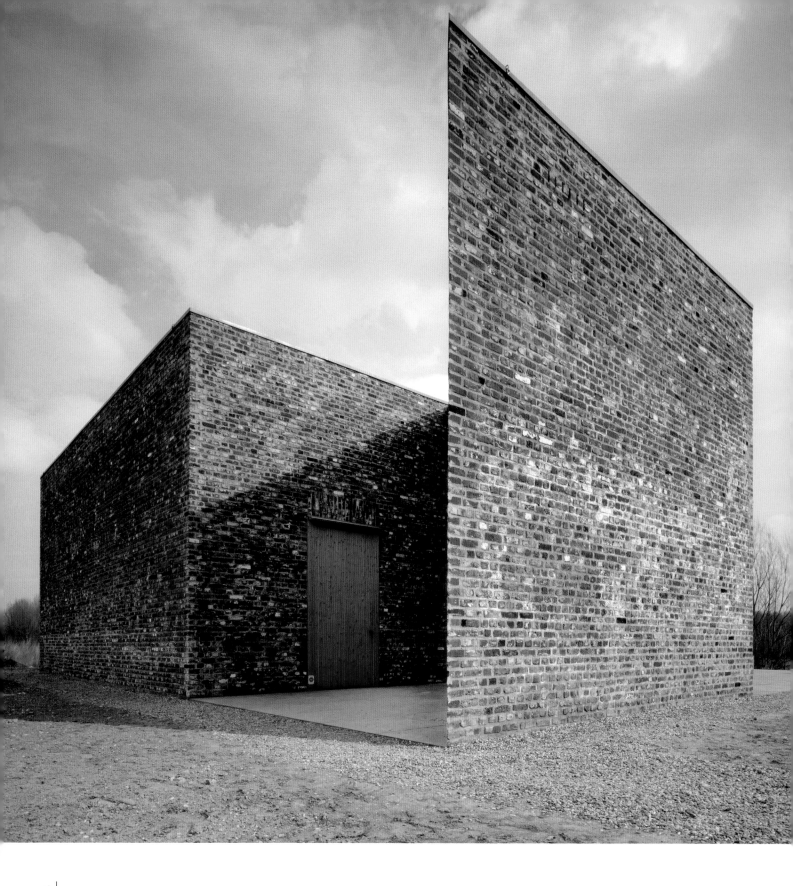

Opposite *Schnecke* (snail) by
Erwin Heerich (1993)
Below The interior of the *Zwölf-Räume-
Haus* (twelve-room house) by Erwin
Heerich (1993) has paintings by Dutch
painter Bart van der Leck (1876–1958)
Bottom The interior of *Fontana Pavilion*
also by Erwin Heerich (2000)

Germans Kurt Schwitters (1887–1948) and Norbert Tadeusz (b. 1940) and Americans Alexander Calder (1898–1976) and Ellsworth Kelly (b. 1923). A variety of work is displayed together, setting up dialogues between visual art of different times, traditions and cultures. Through the way that Heerich's sculptural buildings choreograph the visitor's movement and line of sight, a dialogue between art, architecture and landscape is also always to the fore.

In keeping with Müller's wish that his project should be a multidisciplinary one – that the island should be a stimulating place for the communion of various souls – concerts, poetry readings, workshops and seminars have all been important ingredients since its inception. Since 1987 the public has been invited as well.

In 1994 Müller purchased the adjacent abandoned Hombroich Missile Base. He and German artists Heerich and Oliver Kruse (b. 1965) and Japanese Katsuhito Nishikawa (b. 1949) renovated and redesigned the former NATO base's bunkers, observation tower and hangars, and added new buildings, primarily as accommodation and studios for artists, musicians, writers and scientists. Monumental sculptures by Nishikawa, Herzfeld, Heerich, Kruse, German sculptor Heinz Baumüller (b. 1950) and Spaniard Eduardo Chillida (1924–2002) also grace the area, adding to the rich tapestry of people, art, architecture, plantlife and wildlife on the island. Chillida's fourteen-metre-high concrete sculpture, *Begirari* (Look-Out) (2000), nicknamed 'Rosebud' by the local community, acts as a beacon for this part of the development. Other aspects of this continually evolving creative commune include a children's day-care centre, Kinder Insel (Children's Island) (1999), designed by Kruse, the International Institute of Biophysics (2000) in a building designed by Heerich, three Chapels designed by Dane Per Kirkeby (b. 1938) and the Langen Foundation (2004) of Japanese and Western art, housed in a beautiful new building by Japanese architect Tadao Ando (b. 1941).

This private initiative became a public institution in 1996 with a foundation established to secure its future. As much an experiment about how to live as how to display art, words like 'idyllic' and 'utopian' are often used to describe Müller's venture, and with good reason, for the care and attention he and his artist-friends lavished on the project transformed a neglected parkland and a former military base into a beautiful, sensuous place of refuge, encounter, discovery and conversation.

GOLDWELL OPEN AIR MUSEUM

NEAR THE GHOST TOWN OF RHYOLITE
NEVADA, USA
Albert Szukalski and others
From 1984

Art in a place where it seemingly shouldn't be. WILLIAM L. FOX

Rhyolite is in the Amargosa Valley in southern Nevada, near the
California border and the eastern entrance to Death Valley National
Park. It was founded in 1904 when prospectors found gold in
the hills nearby. In the gold rush that ensued Rhyolite boomed,
becoming the third largest city in Nevada, with a population of some
10,000 people by 1908. Its glory days were short-lived however, as
a financial panic followed and by 1915 the population had dwindled
to only fifteen. By mid-twentieth century, Rhyolite was a ghost town.

In 1984, thirteen new ghostly residents, in the form of a life-sized
sculpture based on Leonardo da Vinci's *Last Supper* (1498) joined
the ghosts of Rhyolite. The extraordinary sculpture is the work of
Belgian artist Charles Albert Szukalski (1945–2000), known as
Albert, who discovered Rhyolite while visiting a friend who lived
in the Amargosa Valley. He was fascinated by the area and wanted
to make an artwork in Death Valley. Once he found out that it would
not be permitted he turned his attention to Rhyolite. The dramatic
landscape of the Mojave Desert where Rhyolite is located captured
his imagination for its vastness, emptiness and peacefulness and its
resemblance to the Holy Land. He was also seduced by the mystery,
romance and magic of the town and by the American dream that had
led those early pioneers to settle this arid landscape.

Szukalski made *The Last Supper* in September 1984 with the help
of friends from the neighbouring town of Beatty, who allowed
themselves to be posed and covered in burlap soaked in water and
plaster, which was then reworked with more wet plaster after the
model had emerged from underneath the already-hardening piece.
The sculpture was installed just outside of town and inaugurated
in October 1984, and Szukalski was subsequently made an honorary
citizen of Rhyolite.

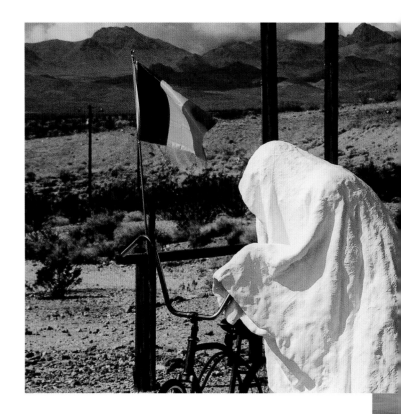

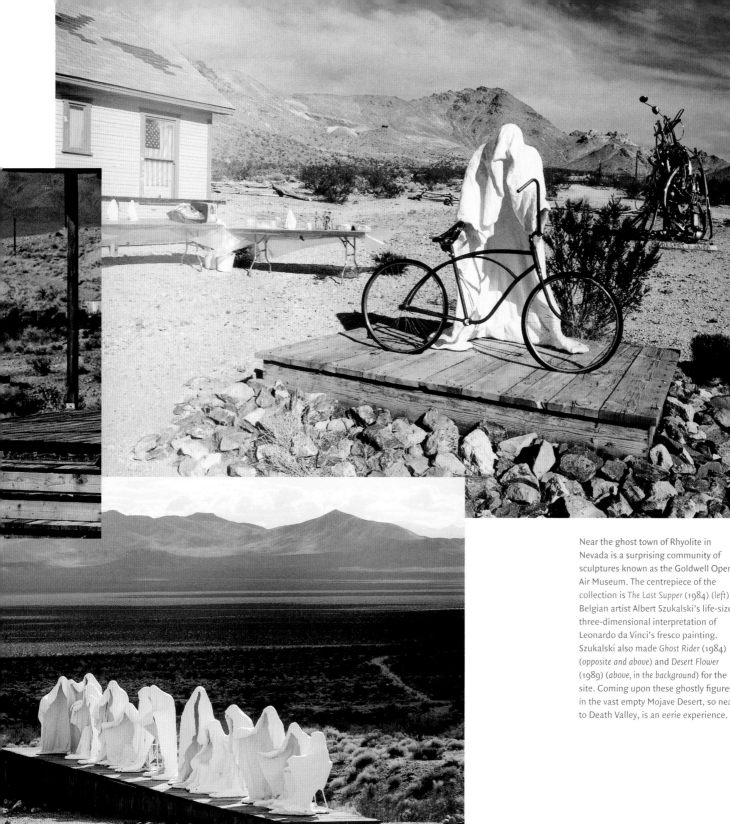

Near the ghost town of Rhyolite in Nevada is a surprising community of sculptures known as the Goldwell Open Air Museum. The centrepiece of the collection is *The Last Supper* (1984) (*left*), Belgian artist Albert Szukalski's life-sized three-dimensional interpretation of Leonardo da Vinci's fresco painting. Szukalski also made *Ghost Rider* (1984) (*opposite and above*) and *Desert Flower* (1989) (*above, in the background*) for the site. Coming upon these ghostly figures in the vast empty Mojave Desert, so near to Death Valley, is an eerie experience.

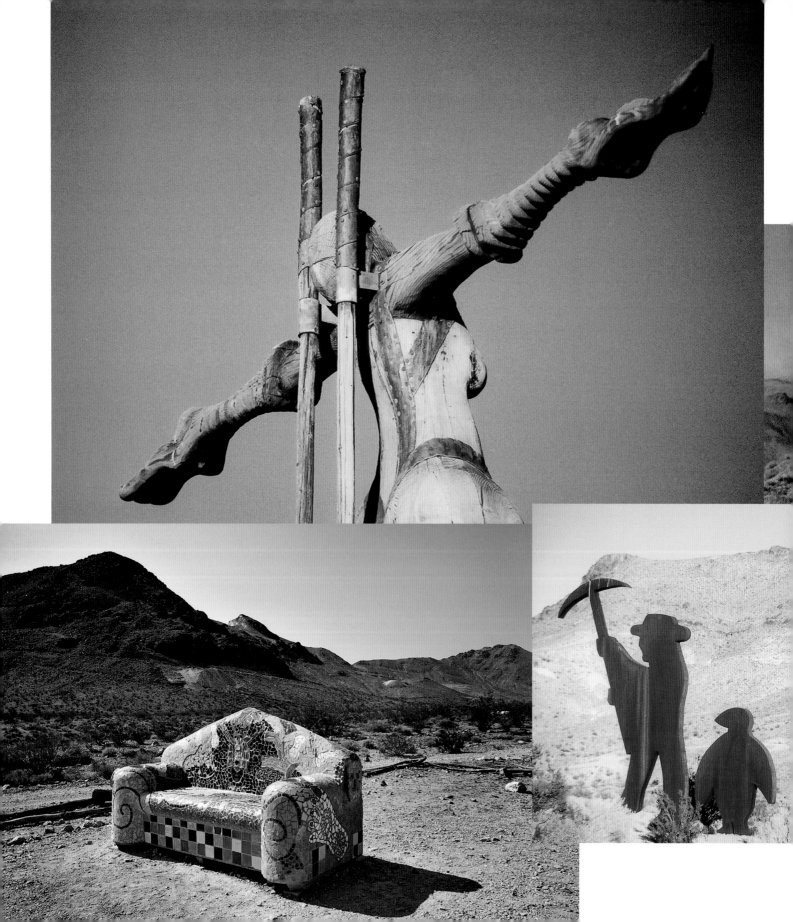

Other enigmatic sculptures in the desert:
Clockwise from far left Dre Peeters, *Icara* (1992), Dr Hugo Heyrman, *Lady Desert: The Venus of Nevada* (1992), Fred Bervoets, *Tribute to Shorty Harris* (1994) and Sofie Siegmann, *Sit Here!* (2000, installed and restored at Goldwell in 2007)

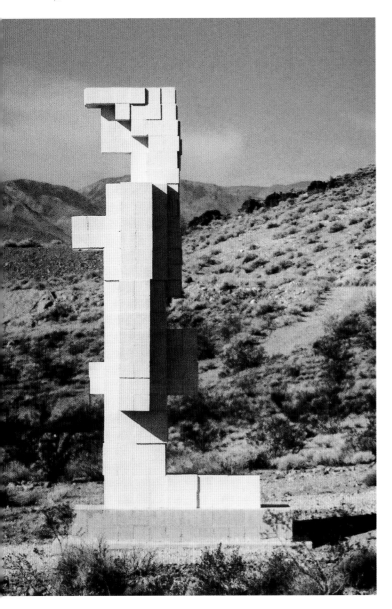

Although at first the haunting installation seems an incongruous sight, the surreal sculpture soon appears at home in its surroundings. The silhouettes of the drapery echo the shapes of the mountains in the distance and the way that Szukalski suggests the absent forms of Jesus and his disciplines by the plaster and fiberglass shrouds finds its correlative in the remaining shells of the ruined buildings in town. Intended both to watch over the dead in Death Valley and as a tribute to those who tried to make a new life in the West, the siting of the work near a defunct gold mine also gives cause to reflect on what man will sacrifice in pursuit of the precious metal, from Christ's time to the present.

Szukalski created two other pieces for the site, *Ghost Rider* (1984), a ghostly figure with a bicycle, and *Desert Flower* (1989). He also invited other artists to create works for this desert environment. Belgian Dr Hugo Heyrman (b. 1942) contributed *Lady Desert: The Venus of Nevada* (1992), a twenty-five-foot-high pink cinder-block woman, Belgian Dre Peeters (b. 1948), *Icara* (1992), a carved wooden female Icarus reaching for the sun, American David Spicer, a monumental stone sculpture, *Chained to the Earth* (1992) and Belgian Fred Bervoets (b. 1942), *Tribute to Shorty Harris* (1994), a twenty-four-foot-high steel sculpture in homage to one of the early prospectors in the area.

Szukalski died in 2000, and his business partner donated the sculptures to the non-profit organization that was formed to care for the works. Christened the Goldwell Open Air Museum, the museum now includes an exhibition and lecture space and an artist-in-residence programme.

Sadly, *Desert Flower* was knocked down in a windstorm in 2008 and *Chained to the Earth* was damaged beyond repair in 2009, also by the wind. Both sculptures have since been removed from the site. However, two new works have joined the collection, a plaque entitled *Rhyolite's District of Shadows* (2006) by American artist Eames Demetrios (b. 1962) and a colourful mosaic-covered concrete couch by German artist Sofie Siegmann (b. 1964) entitled *Sit Here!* (2000, installed and restored at Goldwell in 2007).

Rhyolite is also home to the *Bottle House* built by miner Tom Kelly (1832–1928) in 1906 out of thousands of beer and medicine bottles and adobe. It is about an hour's drive to Marta Becket's Amargosa Opera House in Death Valley Junction, California (see p. 87) and a two to three hour drive to Michael Heizer's *Double Negative* near Overton, Nevada (see p. 80).

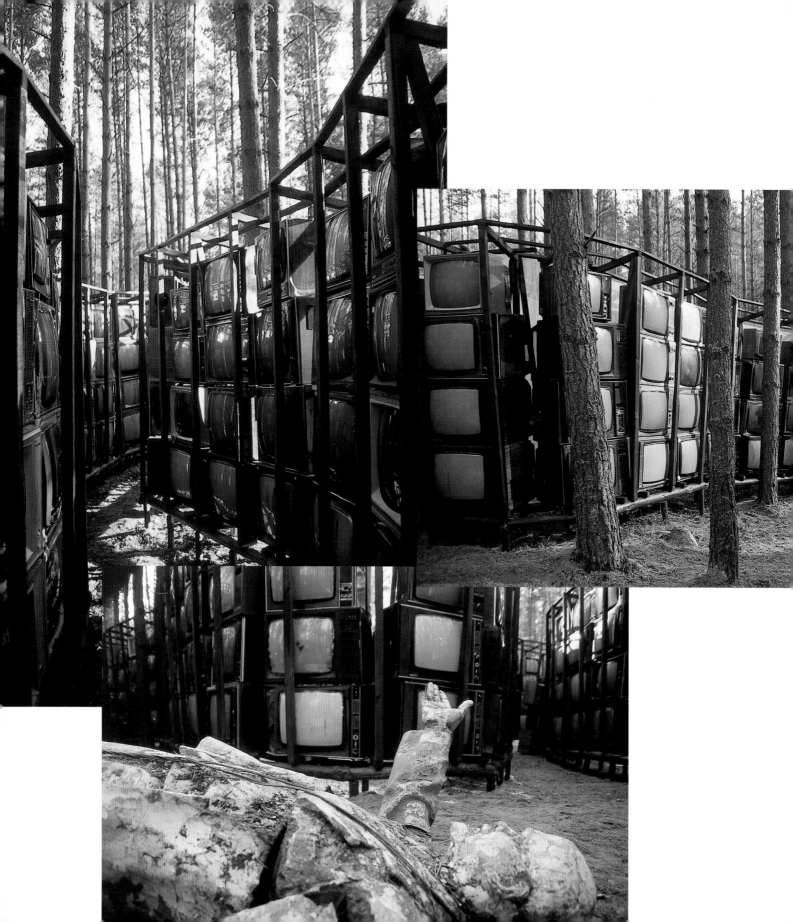

EUROPOS PARKAS

VILNIUS, LITHUANIA
Gintaras Karosas and others
From 1991

Above and opposite Take a walk along the tree-lined paths of Europos Parkas, winding in and out of the many and varied works, and you will be instantly impressed by the scale and imagination of each sculpture, such as Gintaras Karosas's *LNK Infotree* (2000).

A park in which sculpture from all over the world meets public from all over the world. MAGDALENA ABAKANOWICZ

Europos Parkas, an open-air museum of contemporary art on the outskirts of Vilnius, Lithuania, was the brainchild of Lithuanian art student Gintaras Karosas (b. 1968). Inspired by the declaration of the French National Geographical Institute in 1989 that named Vilnius the geographical centre of Europe, the young student decided to mark this unique condition with an international sculpture centre.

After spending a few years landscaping a neglected swampy forest in the countryside north of Vilnius – clearing it of heaps of fallen trees and fashioning ponds and pathways – Karosas christened his new venture with a sculpture, *Symbol of Europos Parkas*, in 1991. This was also the year that Lithuania reestablished its independence, providing greater opportunities to include foreign artists in his project.

The following year, the ambitious student proposed hosting an International Sculpture Symposium in his new park, and approached the Vilnius Art Academy (where he was a student) for support. He was expelled for his efforts. Undaunted, the dogged Karosas persevered, found the necessary support elsewhere and organized the first symposium in 1993. Fourteen sculptors from Armenia, Finland, Greece, Hungary, Lithuania and the USA created work on site out of the native boulders and oak. The symposium, which was the first of its kind in Lithuania, was a grand success and generated international interest in Europos Parkas.

The collection of sculptures generated by emerging artists at the yearly symposia was soon joined by large-scale works by more famous names. In 1996, renowned American artist Dennis Oppenheim's (b. 1938) *Chair/Pool*, a giant metal chair with a two ton pool of water in its seat, was built, followed two years later by *Drinking Structure with Exposed Kidney Pool*, a house seemingly about to rock forward and take a drink from a pond with its huge tongue. Oppenheim's tacit endorsement of Europos Parkas led to the

participation of other art world luminaries, such as Polish sculptor Magdalena Abakanowicz (b. 1930), Americans Sol LeWitt (1928–2007) and Beverly Pepper (b. 1922) and Czech Aleš Veselý (b. 1935).

Abakanowicz's *Space of Unknown Growth* (1998) is a site-specific work consisting of twenty-two egg-like concrete boulders of varying sizes inserted into the natural landscape over an area of 2,012 square metres. LeWitt's contribution is the monumental geometric *Double Negative Pyramid* (1999), beautifully reflected in the pond nearby, Pepper's, the striking earthwork *Theatre* (2001), and Veselý's, *Chamber of Light* (1998–2000), a massive swinging steel and stainless steel structure that surprises and delights visitors who enter it.

Other highlights of the collection include the gigantic metal patchwork *Lying Head* (2001), by Lithuanian Adomas Jacovskis (b. 1948), and sculptures by Karosas. His *Monument of the Centre of Europe* (1993–96) comprises a granite pyramid, grass and granite markers identifying the direction and distance to the other European capitals. *LNK Infotree* (2000) is a sculpture-maze of claustrophobic pathways made from 2903 old television sets (donated by Lithuanian citizens) with a toppled sculpture of Lenin in the centre. *The Place* (2001–03) is another site-specific landscape sculpture by Karosas, made of boulders, a pond and rust-covered steel poles. Karosas's greatest artwork, however, is the park as a whole, its conception, evolution and the ongoing choreography of its various elements. His vision was to create a place …

… where everything exists in unity as a whole entity, where some places are empty and some places are full, where the placement of sculpture is sometimes unexpected, where some things are hidden, where there are often surprises, and where the happiness of discovery is paramount.

Karosas succeeded admirably, despite the odds. The impressive collection now includes over one hundred artworks by artists from thirty-one countries, which are in dialogue with the space, the other artworks and the viewer, displayed in a fifty-five-hectare beautifully landscaped park in the centre of Europe.

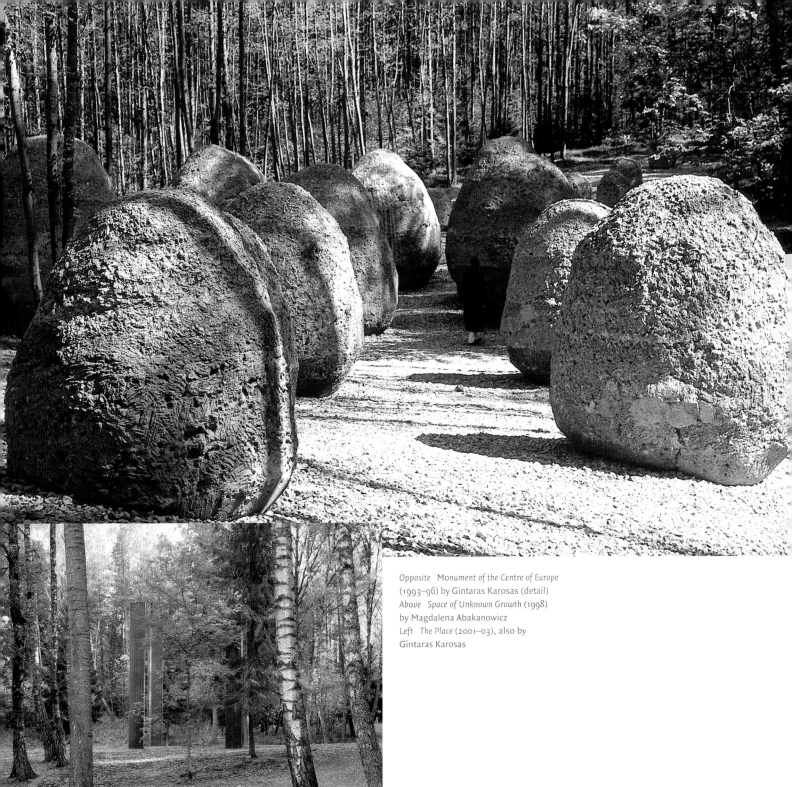

Opposite Monument of the Centre of Europe
(1993–96) by Gintaras Karosas (detail)
Above Space of Unknown Growth (1998)
by Magdalena Abakanowicz
Left The Place (2001–03), also by
Gintaras Karosas

THE STRATA PROJECT
PINSIÖ, FINLAND
Agnes Denes and Nancy Holt
1992–96 and 1998

In a time when meaningful global communication and intelligent restructuring of our environment is imperative, art can assume an important role.
AGNES DENES

Finnish artist Osmo Rauhala (b. 1957) initiated The Strata Project in 1987 to prompt debate about finding creative solutions to revitalizing the damaged landscape of the large Pinsiönkangas ridge near Pinsiö in the Western Lakeland region of Finland. Under the auspices of the project, the possibilities of using public and environmental art to address man's relationship with nature have been explored in temporary exhibitions and through large-scale permanent artworks in the abandoned quarries around the village. This was particularly innovative, as environmental art was previously unknown in Finland, and the project has received the support of the Ministry of the Environment, the United Nations Environmental programme and private sponsors.

Agnes Denes, *Tree Mountain – A Living Time Capsule – 11,000 Trees, 11,000 People, 400 Years*
The first major environmental project realized in Finland was *Tree Mountain – A Living Time Capsule – 11,000 Trees, 11,000 People, 400 Years* (1992–96) by American Agnes Denes (b. 1938), which reclaimed the Pinsiö gravel pits near Ylöjärvi. The Finnish government announced the project to the world at the Earth Summit held in Rio de Janeiro in June 1992 and it was formally dedicated by the President of Finland in June 1996. Aira Kalela of the Ministry of the Environment, one of those responsible for bringing the project to fruition, described *Tree Mountain* as 'the largest monument on earth that is international in scope, unparalleled in duration, and not dedicated to the human ego, but to benefit future generations with a meaningful legacy'.

 Tree Mountain (*Puuvuori*) is a massive earthwork in which 11,000 people from all over the world planted 11,000 Finnish pine trees in an intricate mathematical pattern on a man-made mountain. Those

who participated received certificates naming them and their heirs for twenty-six generations as custodians of the trees they planted, a powerful way to help create continuing ownership in the artwork. This collaborative project is on protected land that is to be maintained for four centuries and will, over time, lead to a new spiral pine forest, providing a home for wildlife and preventing land erosion.

Nancy Holt, *Up and Under*
Tree Mountain was the first project of its kind in Finland, and its success led to others, including another environmental artwork nearby, *Up and Under* (*Yltä ja alta, maataideteos*) (1998) by American Nancy Holt (b. 1938). On the outskirts of the industrial town of Nokia, Holt has reclaimed an abandoned sand quarry as art with her landscape sculpture made of sand, concrete, topsoil, grass and

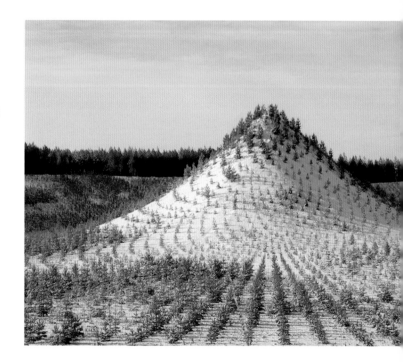

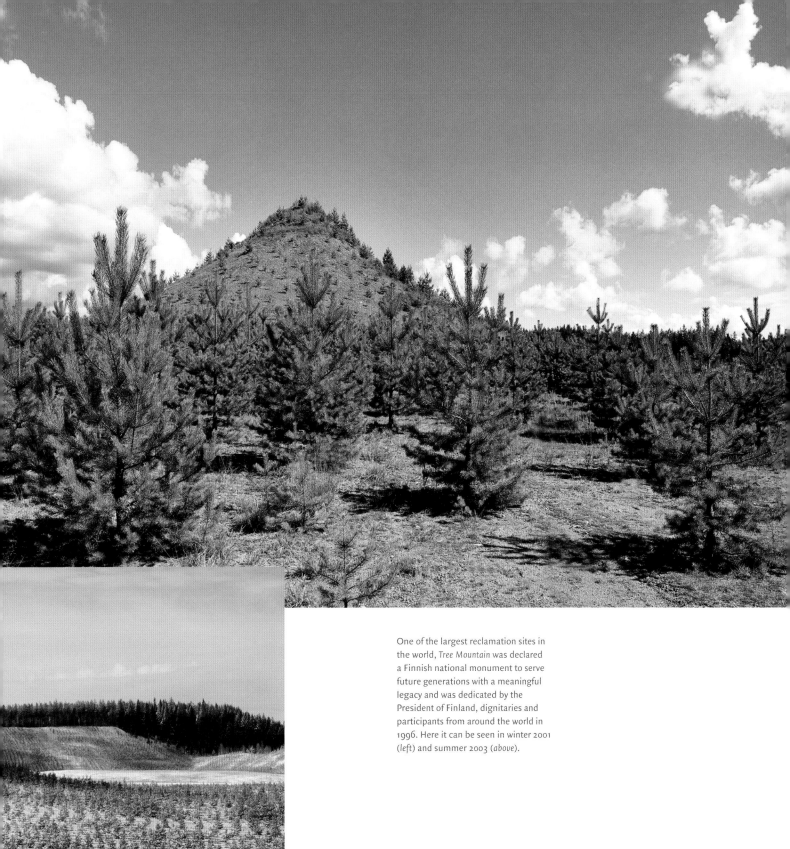

One of the largest reclamation sites in the world, *Tree Mountain* was declared a Finnish national monument to serve future generations with a meaningful legacy and was dedicated by the President of Finland, dignitaries and participants from around the world in 1996. Here it can be seen in winter 2001 (*left*) and summer 2003 (*above*).

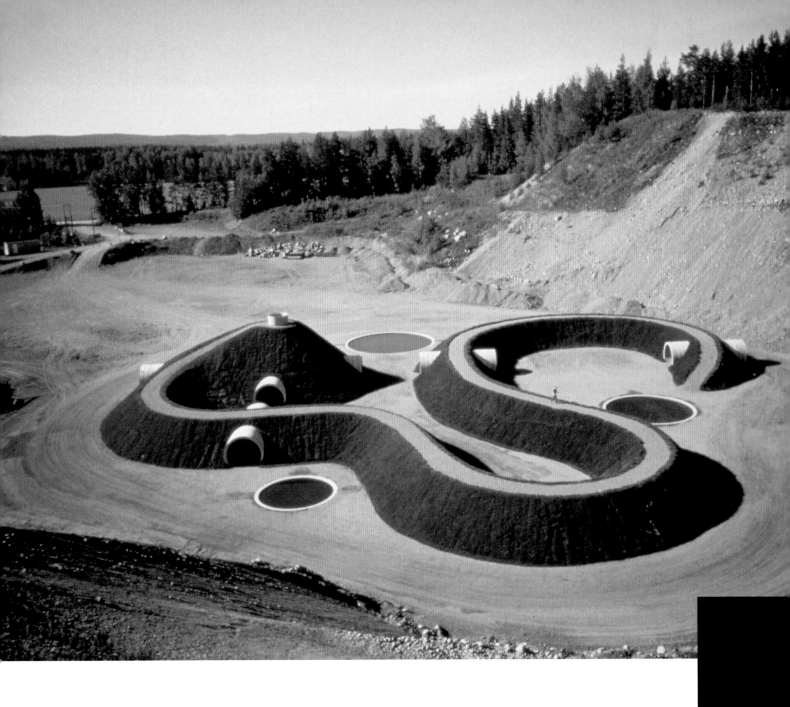

Above and right The interior of *Up and Under* contains samples of earth from all over Finland. Nancy Holt describes her idea: 'What was important was that the earth in the center of *Up and Under* be from all over Finland, so in my mind not only was the center of the work a center of the universe based on the North Star, it became both physically and conceptually the center of the Finnish land, the earth from many regions mixed together and placed in the sixth dimension, the vertical earth dimension.'

water. The work consists of tunnels, pools of water, a curving earth mound and a path along the cliffs that encircle the fourteen-acre site. The earth mound measures 630 feet long, 26 feet high, and 225 feet wide and has a walking path on top. It winds around three pools and is intersected by five concrete horizontal tunnels, each 8.5 feet high and 10 feet wide with a total length of 241 feet. Two are aligned north–south and three are aligned east–west and with each other. The snaking mound ends with a conical hillock in which two of the horizontal tunnels cross over and are connected to the sky by a soaring vertical tunnel. Samples of earth from towns all over Finland are buried under the vertical tunnel.

Like Holt's early work in Utah, *Sun Tunnels* (see p. 100), *Up and Under* explores perceptual relationships and the interrelationship of Earth and sky. As the title of the work makes clear, *Up and Under* is meant to be entered into, walked upon and experienced from a variety of elevations. You can walk along the earth mound and look down the vertical tunnel. You can also walk through the tunnels and see the sky brought down to earth in its reflection in the pools of water at your feet and by looking up into the sky through the vertical tunnel from below the earth. From the path on the ninety-foot high cliffs that curve around the perimeter of the site the prehistoric-like structure can be seen in its entirety.

Although Denes's and Holt's works take very different forms, the two sculptors' ambitions are similar, as is clear when reading what they have to say about their individual works:

It is benign problem solving and shaping, structuring the future: an egoless art form that calls attention to social concerns and involves people from all walks of life. It builds pride and self esteem in people and benefits future generations with a meaningful legacy. (Denes)

I hope this project will stimulate consideration of other unique ways to develop the numerous sand quarries and other industrially devastated areas of Finland and elsewhere, restoring them for public use, while making them once again part of the ecosystem. (Holt)

A trip to Pinsiö provides a rare opportunity to see major pieces in close proximity by two pioneering environmental artists. More outdoor sculpture can be seen in the Pirkkala Sculpture Park in Pirkkala, about a thirty-minute drive away (see p. 266).

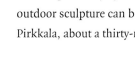

PARK IN THE WATER

THE HAGUE, NETHERLANDS
Acconci Studio
1993–97

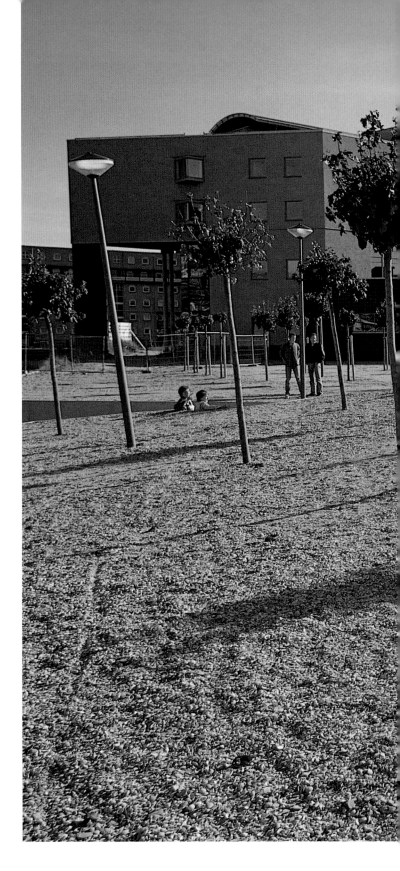

Public art exists to thicken the plot. VITO ACCONCI

Since the 1960s, American artist Vito Acconci (b. 1940) has been exploring issues of private and public space and the effects they have on behaviour. His body of work encompasses poetry, prose, performance, video, film, sculpture, installations, furniture, public art and public spaces. As he turned his attention to the challenges of configuring public spaces he began to collaborate with architects, artists and engineers, founding Acconci Studio in 1988. The group is known for creating projects that reinterpret the everyday function of a site, often turning it on its head.

Stroom (The Hague Centre for Visual Arts) is a Dutch foundation that specializes in art in public spaces, especially those in cities. In 1993 they invited Acconci to exhibit his proposals for interventions in public spaces and to design one for a site in The Hague. He was drawn to the Laakhaven/Hollands Spoor area, an old industrial port. It was in the process of being redeveloped by the city and having its function transformed from that of an industrial zone into a mixed-use site, with a new college of further education (Haagse Hogeschool), new housing and business and shopping facilities. Acconci's fantastic design 'exploded' the area – turning water into land and land into water.

While the plan was deemed unrealistic and unworkable, it was inspirational. The exhibition helped communicate Acconci's belief that public spaces should not be 'fillers' between buildings, but active, useable components of a cityscape. Dutch architect Hans van Beek of Atelier PRO, who was designing the Haagse Hogeschool and its surrounding area, was one of those taken by his ideas. He was so impressed that he asked Acconci to reduce the project in scale so that it stood a chance of being realized.

Acconci won the municipal and college officials over, and four years later *Park in the Water* was opened to the public. Acconci and his team (Luis Vera, Jenny Schrider and Charles Doherty), in conjunction

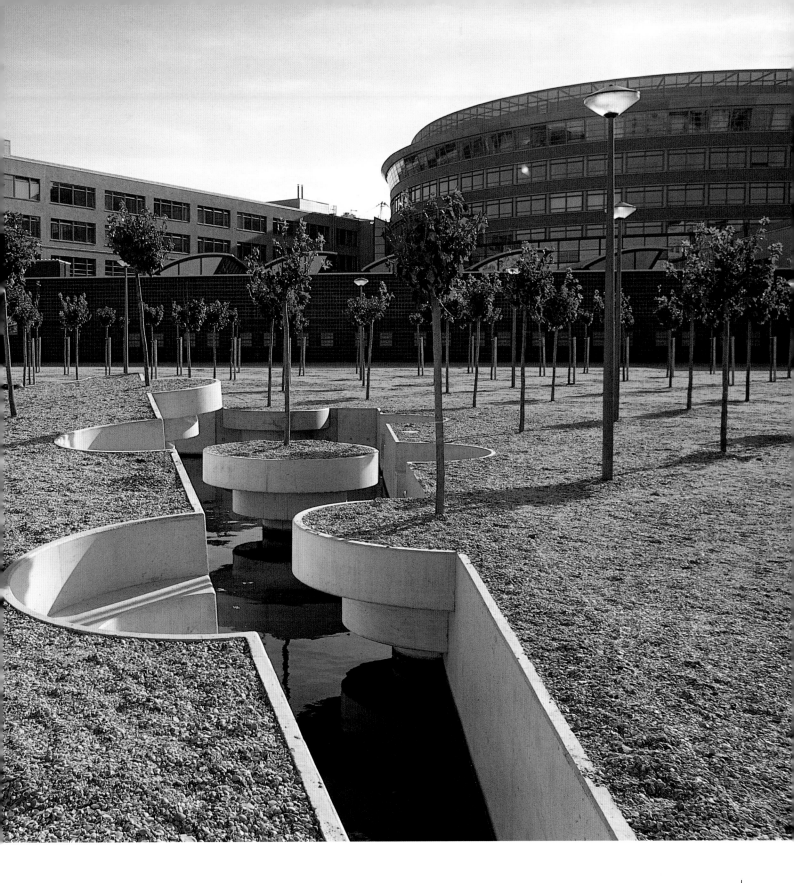

with PRO, have created an extraordinary park that looks like a glacier sliding into the sea or as if you have just arrived in the aftermath of an earthquake. A triangular piece of land planted with a triangle of regularly spaced and sized trees juts out into a U-shaped channel of water. A wedge-shaped piece of that land has been cut out, pivoted and tilted into the water, taking the trees, street lamps and the ground cover with it. Trees and street lamps in large pots have landed in the water as the earth has seemingly been pulled apart; their remaining negative forms on each side have created seating and stepping stones to the various sections. Acconci's ongoing interest in private and public spaces, and indeed, in private spaces within public ones can be detected in the seating and nooks and crannies of the jigsaw puzzle-like park.

If the intentions of the team were to create an activated space that interacts with its site and the user, it certainly has been achieved by this work that is at once sculpture, architecture and performance. The site draws you to it and through it to hop from section to section to explore it. It both plays on the rigid geometry of the formal planting in the area (common in the Netherlands as a whole) and disrupts it. The ground cover of seashells, the mix of land and water, the unnatural architectural shape of the land and the notions of displacement and subsidence that it brought to mind all called forth for me the constant battle between man and nature. It also gave me cause to reflect upon the incredible architectural engineering feat that is the Netherlands, a country largely man-made from land reclaimed from the sea.

While at *Park in the Water*, have a look around the handsome Haagse Hogeschool complex by Atelier PRO (completed in 2003). The central hall is particularly striking with its soaring statue atop a tree trunk by German sculptor Stephan Balkenhol (b. 1957).

While in The Hague, don't miss James Turrell's *Celestial Vault/Panorama in the Dunes* (see p. 184). It's also well worth seeing what's on at Stroom. It hosts temporary exhibitions of artists whose work explores the role or possibilities of art in public spaces.

Park in the Water is a visually and physically engaging public art space that interacts with its site and the visitor alike.

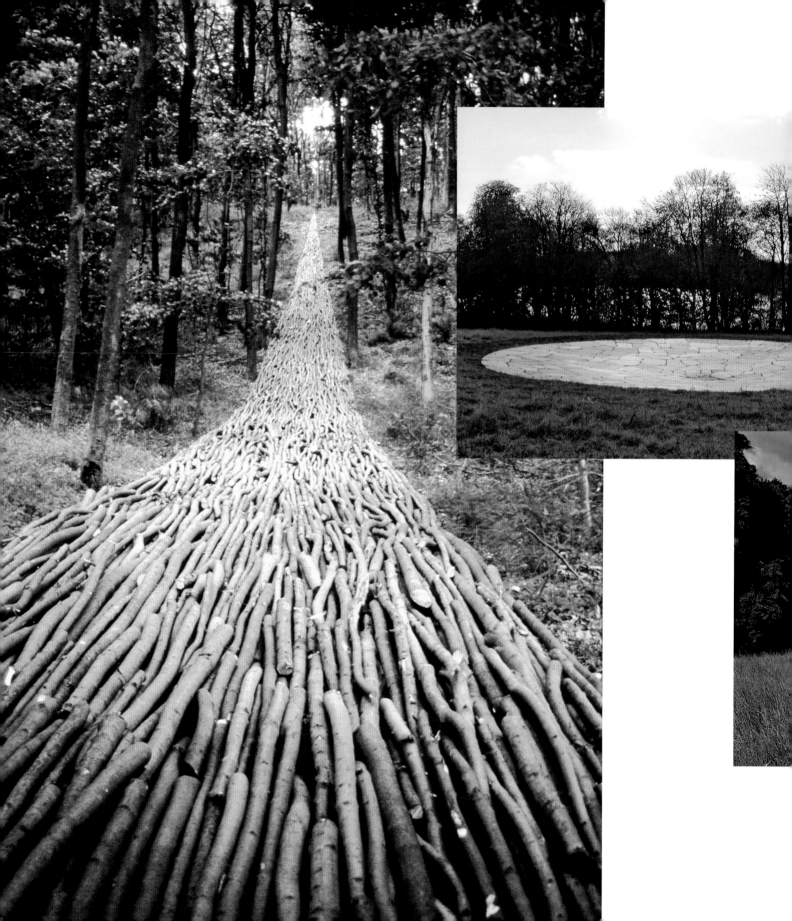

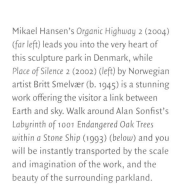

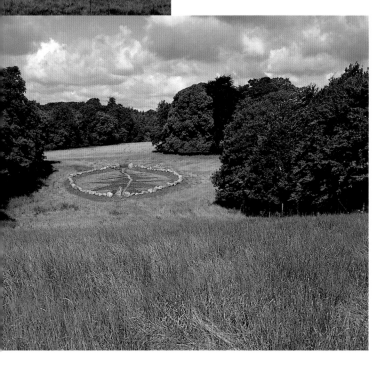

Mikael Hansen's *Organic Highway 2 (2004)* (*far left*) leads you into the very heart of this sculpture park in Denmark, while *Place of Silence 2 (2002)* (*left*) by Norwegian artist Britt Smelvær (b. 1945) is a stunning work offering the visitor a link between Earth and sky. Walk around Alan Sonfist's *Labyrinth of 1001 Endangered Oak Trees within a Stone Ship (1993)* (*below*) and you will be instantly transported by the scale and imagination of the work, and the beauty of the surrounding parkland.

TRANEKÆR INTERNATIONAL CENTRE FOR ART AND NATURE (TICKON)

LANGELAND, DENMARK
Alfio Bonanno and others
From 1993

TICKON is not a sculpture park but a living organism.

GERTRUD KØBKE SUTTON

Langeland (long island) is a slender island in southern Denmark, located between the larger islands of Funen and Lolland. Tranekær, a small well-preserved village, is the focal point of the island and home to Tranekær Castle, an almost impossibly beautiful red building that looks like it belongs in a Hans Christian Andersen story. The castle is surrounded by a nineteenth-century English-style landscaped park, complete with lake and exotic trees. Parts of the structure date back to AD 1200 and it is Denmark's oldest still occupied castle. The current resident is Count Preben Ahlefeldt-Laurvig, whose family has lived there since 1659.

During the late 1980s, Langeland languished due to social and economic problems caused by centralization. In 1990, in an effort to inject some new life and enthusiasm into the community, Tranekær County Council approached local resident and pioneering environmental artist, Italian-born Dane Alfio Bonanno (b. 1947), about his long-running campaign to create an international centre for art in nature in Langeland. Count Ahlefeldt-Laurvig agreed to provide sixty acres of his castle grounds for the initiative and for the next three years Bonanno worked with a committee that included art historian Gertrud Købke Sutton, poet Vagn Lundbye, the director of the Kunthalle Brandts in Odense, the Count, the community, and county and city councils to realize the Tranekær International Centre for Art and Nature (TICKON).

Sutton explained the aims of the non-profit foundation:

We hope to encourage sculptors, composers or poets to create the unexpected and to turn ecological issues into aesthetic ones. And by creating encounters and collaboration between artists and specialists in all fields, from farmers and

artisans to biologists, zoologists, botanists, etc, it is hoped to foster creativity and a more enhanced understanding of the mechanisms of a specific locality and of the frailty and resilience of its nature.

TICKON opened to the public in 1993 with a conference and sixteen artworks by a veritable 'who's who' of environmental art, including Britons Andy Goldsworthy (b. 1956), Chris Drury (b. 1948) and David Nash (b. 1945), Swede Lars Vilks (b. 1946), German Nils-Udo (b. 1937) and American Alan Sonfist (b. 1946). Sonfist contributed *Labyrinth of 1001 Endangered Oak Trees within a Stone Ship* (1993) to the new venture – 1001 young oak trees planted in the shape of an oak leaf mapped out and encircled by stones. Speaking about his work in general, Sonfist explains that 'The idea of digging up the past to bring it into the present is exactly what my art is about. I see myself as a visual archaeologist.' This can be seen at play in his piece in Denmark, a work that also projects into the future, as he explained, writing that stone ships ...

... were created during the Viking period to protect the dead. Oak trees were used historically to make the Viking ships. The historical Oak forests are gone. I have taken the symbology of the stones and used them to protect the life of the future Oak forest in Denmark.

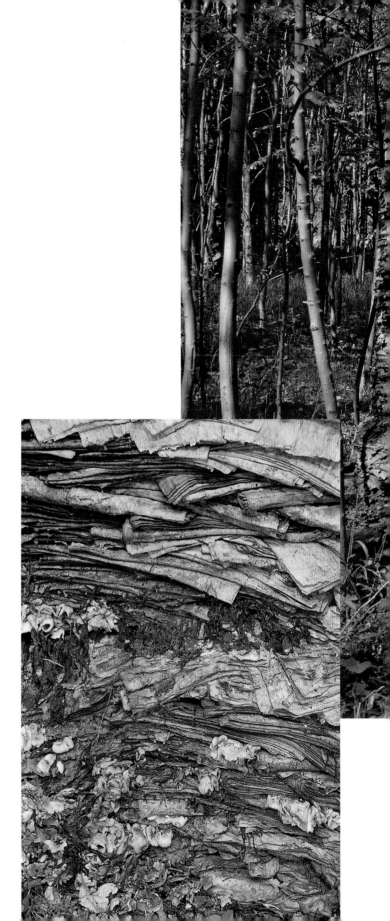

Since its opening over thirty artists have been invited to work on and with the site. What sets TICKON apart from other sculpture parks with site-specific work is that it has very specifically been an 'art and nature' project since its inception. In 'art and nature' projects artists collaborate with nature, working with its materials and within natural environments. This focus continues at TICKON, and although the work produced is wide-ranging, the artists who participate share a profound respect for nature as well as art-making practices in which nature is a core source of inspiration. Some works are ephemeral and only exist as photographs, others are temporary and performative, such as the magical light installation by German Rainer Gottemeier (b. 1949), *Campus Stellae* (summer 2005), while others are more durable and permanent. At TICKON the visitor experiences the fruits of these types of collaborations in the fascinating, multi-layered, thought-provoking artworks at home in their exquisite setting.

There are around twenty site-specific works, most made from natural local materials, interacting with the manicured, almost

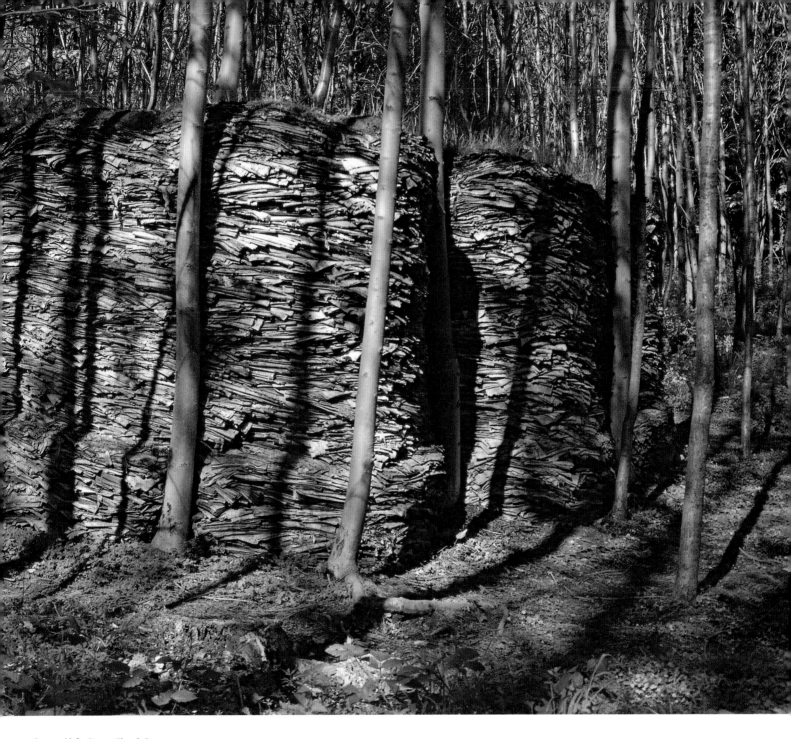

Above and left Steven Siegel, *Squeeze* (1997) is a curiously beautiful and engaging grass-topped sculpture of old newspapers slowly returning to their original state as organic matter.

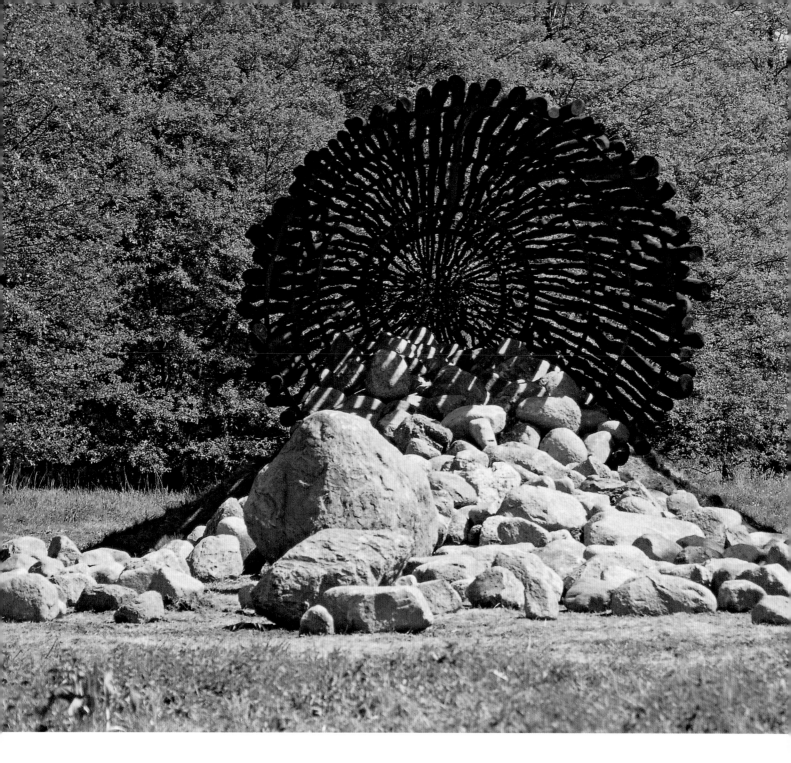

Above and right Alfio Bonanno's monumental *Between copper beech and oak* (2001), dramatically pouring forth boulders, draws you to it to investigate further and to explore the area in which it is sited.

sculptural qualities of the landscaped park. A number of paths through the grounds take visitors on a journey to and through the artworks and exotic trees. In such an unreal, fairytale-like setting, works such as *Unicorn* (1993), a long spiral carved out of a live oak tree by Danish artist Jørn Rønnau (b. 1944), sits easily, as do the other large, rather surreal works you encounter along the way. Some of these are American Steven Siegel's (b. 1953) *Squeeze* (1997), a grass-topped sculpture of old newspapers slowly returning to their original state as organic matter, Dane Mikael Hansen's (b. 1943) sixty-metre long *Organic Highway 2* (2004) made of some 1200 tree trunk sections, and Bonanno's gigantic wood and steel cornucopia spilling forth boulders, *Between copper beech and oak* (2001). When asked about the work Bonanno explains:

In 2001 when I created Between copper beech and oak *more than ten years had passed since I started to explore and introduce the Park to artists invited by TICKON. I had seen and walked every corner of the Castle park so many times but there was always something new, different to observe ... discover.*

Bonanno's piece helps share this sense of new discovery – it draws you to the area and sends you off to explore it and see it more intently, perhaps in search of the copper beech and the oak trees nearby, and to reflect on the richness of the environment. It also stands as a fitting symbol for the continuing fertility of the whole 'art and nature' project that Bonanno initiated.

While in southern Denmark, don't miss the opportunity to visit another of Bonanno's installations, *Himmelhøj* (see p. 236), on the outskirts of Copenhagen and the Louisiana Museum Sculpture Park (see p. 85), Humlebæk, both a two to three hour drive from TICKON.

SZOBORPARK

BUDAPEST, HUNGARY
Various artists
1993

A memento of an unfortunate era. ÁKOS RÉTHLY

With the collapse of Communism in Hungary in 1989, the issue of what to do with all the politically charged public monuments raised its head. While some wanted them destroyed, an article by literary historian László Szörényi in the periodical *Hitel* (5 July 1989), suggested the creation of a national 'Lenin garden' to house all the Lenin statues from Hungary as a resource for scholars of the history of Communism. While his proposal was not realized, it was the seed that led to Szoborpark (Statue Park), an outdoor museum of Communist statues and memorials on the outskirts of Budapest.

In 1991, the newly elected Budapest Assembly decided that each district would decide whether to remove or keep each of its individual public statues from the previous political regime. The Assembly also decreed that a statue park would be established for the dismantled monuments on the Tétényi plateau, donated by Budapest's District XXII. Architects were invited to submit tenders for the future Statue Park. The winning design was by Ákos Eleod of Studio Vadász and Co. Eleod was well aware of the delicate nature of the challenge he was undertaking and of the need to create a space that could display and document without heroizing or moralizing. He explained:

This park is about dictatorship and the moment this can be spoken aloud, written down and expressed in architecture, the park will really be about democracy! Only democracy can give us a chance to think freely about dictatorship – or about democracy or anything else for that matter.... Inevitably, the American tourist who has only read about 'dictatorship' will respond very differently from the one who was bound to this region by tragic fate and who brings to the park the drama of a whole life wrecked in the name of whatever these statues stood for. Silence is what can be shared.

A sensitive, thoughtful design was also essential to prevent the project from becoming a kitsch Communist theme park. In his

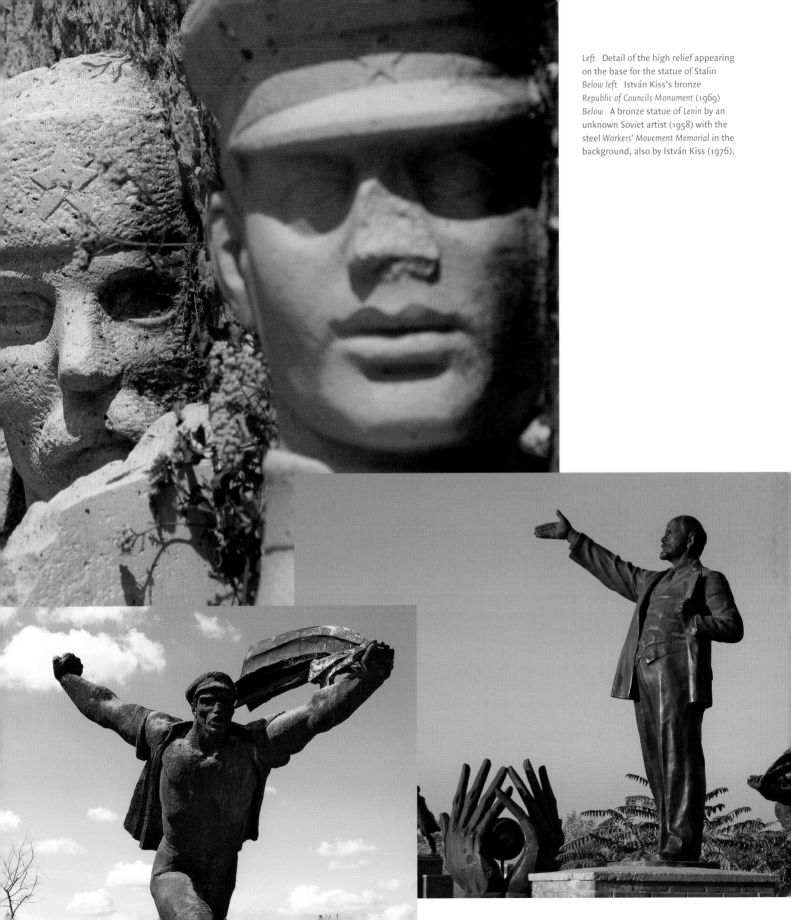

Left Detail of the high relief appearing on the base for the statue of Stalin
Below left István Kiss's bronze *Republic of Councils Monument* (1969)
Below A bronze statue of *Lenin* by an unknown Soviet artist (1958) with the steel *Workers' Movement Memorial* in the background, also by István Kiss (1976).

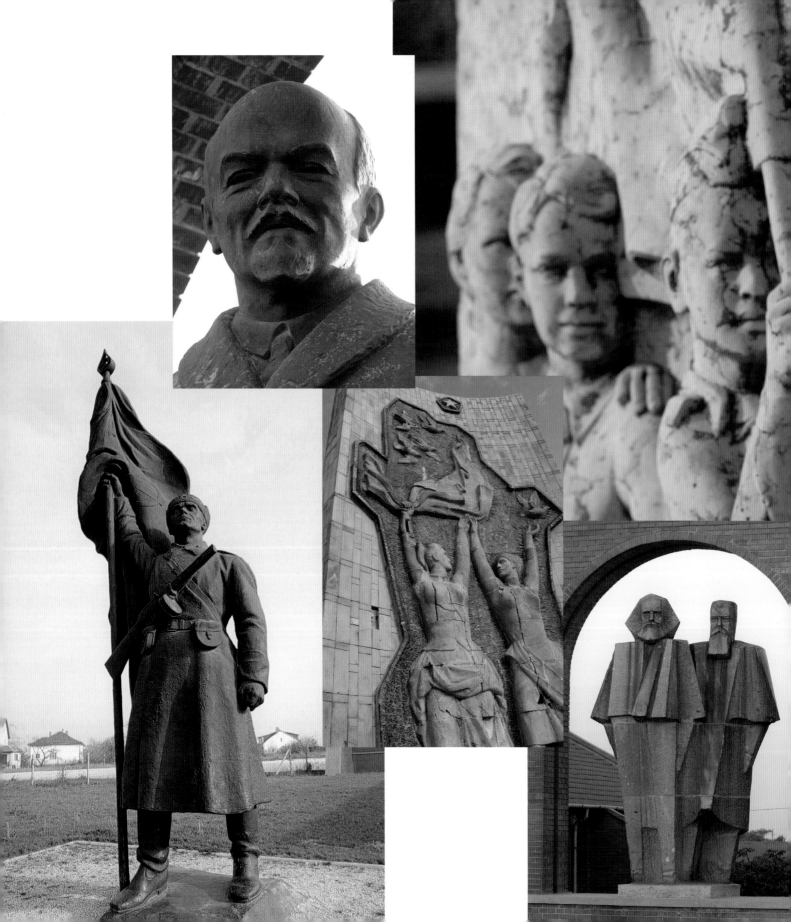

design Eleod treats the statues as works of art and as relics of the recent past. They are presented in a solemn environment that recalls their original placements and functions in public places. The Park was built in 1992–93 and opened to the public in 1993, two years after Soviet troops withdrew from Hungary.

The entrance to the park is a monumental portal using the vocabulary of Socialist Realist architecture. However the grandiose 'façade of Communism' has no building behind it, just emptiness. *Statues of Lenin* (Pál Pátzay, 1965) and *Marx and Engels* (György Segesdi, 1971) in the side arches greet the visitor and guard the main gate, which remains resolutely locked. Entrance is by way of two small side gates.

Inside, there are forty-two sculptures displayed in three thematic sections – 'The endless promenade of the liberation monuments', 'The endless promenade dedicated to persons in the labour movement' and 'The endless promenade dedicated to the ideas and events of the labour movement'. In the centre of the park is a red star-shaped flowerbed, its delicate, temporal nature in distinct contrast to the power and permanence of the statues around it. After circling through Hungary's history and returning to the straight path you are led straight into a brick wall. It is a dead end. You must turn around and reconsider what you have seen on your way out.

Far left bottom Liberation Monument
(1947, 1958) by Zsigmond Kisfaludy
Stróbl (1884–1975) in bronze
Far left top Pál Pátzay's (1896–1979)
bronze sculpture of *Lenin* (1965)
Left centre Soviet–Hungarian Friendship
(1975) by Barna Buza in pyrogranite
Above The Republic of Councils' Pioneers
Memorial Plaque (1965)
Left Marx and Engels (1971) by György
Segesdi in granite

CASS SCULPTURE FOUNDATION

GOODWOOD, ENGLAND
Various artists
From 1994

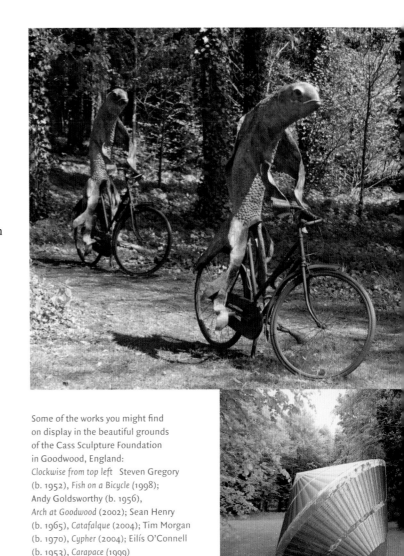

It's a living museum for British sculpture. WILFRED CASS

The Cass Sculpture Foundation was founded by retired businessman Wilfred Cass and his wife Jeannette in 1994. The goal of the charitable organization is to promote twenty-first-century British sculpture, to increase the public's enjoyment and appreciation of contemporary sculpture and to support new and developing artists. Exhibitions are held in the spectacular grounds of the Foundation's estate at Goodwood in the Sussex Downs near Chichester in southern England.

At Goodwood, the nation's finest collection of large-scale outdoor British sculpture is displayed in a romantic woodland in the English countryside. Most of the works exhibited are for sale and the display changes regularly – with some works moving on and new commissions added. Profits from sales are put back into the Foundation to support further commissions. Around ten to fifteen new works are commissioned each year. Works supported encompass a variety of styles – figurative, abstract, kinetic, assemblage, conceptual, interactive – are made from a wide range of materials – bronze, glass, steel, stone, fiberglass, rubber – and are by a number of generations of British artists.

In its first ten years, the Foundation enabled the fabrication of over one hundred and sixty large-scale works by artists such as Zadok Ben-David (b. 1949), Peter Burke (b. 1944), Anthony Caro (b. 1924), Lynn Chadwick (1914–2003), Stephen Cox (b. 1946), Tony Cragg (b. 1949), George Cutts (b. 1938), Antony Gormley (b. 1950), Thomas Heatherwick (b. 1970), Jon Isherwood (b. 1960), Eduardo Paolozzi (1924–2005), William Tucker (b. 1935), Gavin Turk (b. 1967) and Bill Woodrow (b. 1948).

A new four-acre extension to the estate opened in 2005 to celebrate the tenth anniversary of the Foundation. A beautifully landscaped amphitheatre was created in a chalk bowl and it is used

Some of the works you might find on display in the beautiful grounds of the Cass Sculpture Foundation in Goodwood, England:
Clockwise from top left Steven Gregory (b. 1952), *Fish on a Bicycle* (1998); Andy Goldsworthy (b. 1956), *Arch at Goodwood* (2002); Sean Henry (b. 1965), *Catafalque* (2004); Tim Morgan (b. 1970), *Cypher* (2004); Eilís O'Connell (b. 1953), *Carapace* (1999)
Overleaf Stephen Cox, *Granite Catamarans on a Granite Wave* (1994)

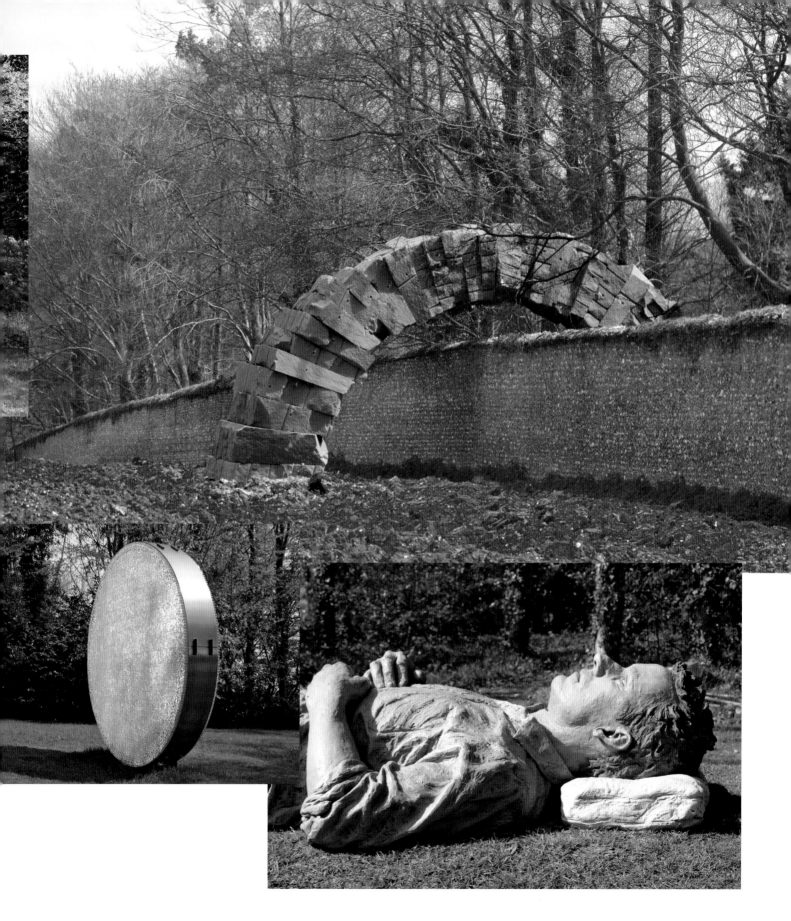

to present in-depth exhibitions of an individual artist's work. Its bright white embankments and manicured green grass makes for a striking setting. The inaugural exhibition was of monumental sculptures by Tony Cragg.

When I visited there were over seventy works on display in the natural surroundings. Follow the path that winds around the twenty-six acres to see works in woods, open fields, along an old flint wall, in trees and in the chalk pit. Each work has enough room to breathe and to interact with its setting. Other works can be glimpsed in the distance, but you are never quite certain when you will happen upon them, which heightens the joy of discovery. There is also an Education Centre on site with a gallery, archive and library.

A preview of what is in store at Goodwood, as well as further information about the Foundation and the artists exhibited, can be obtained at the Cass Sculpture Foundation's Visitor Gallery.

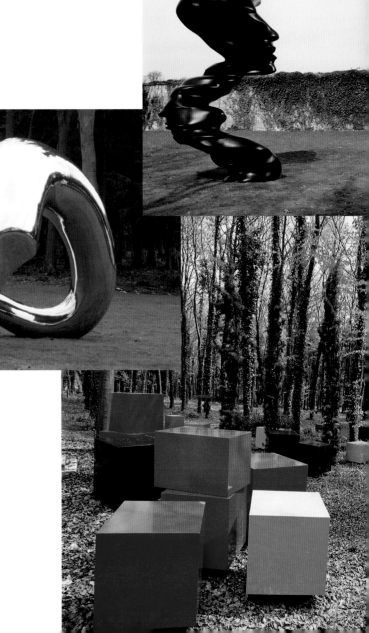

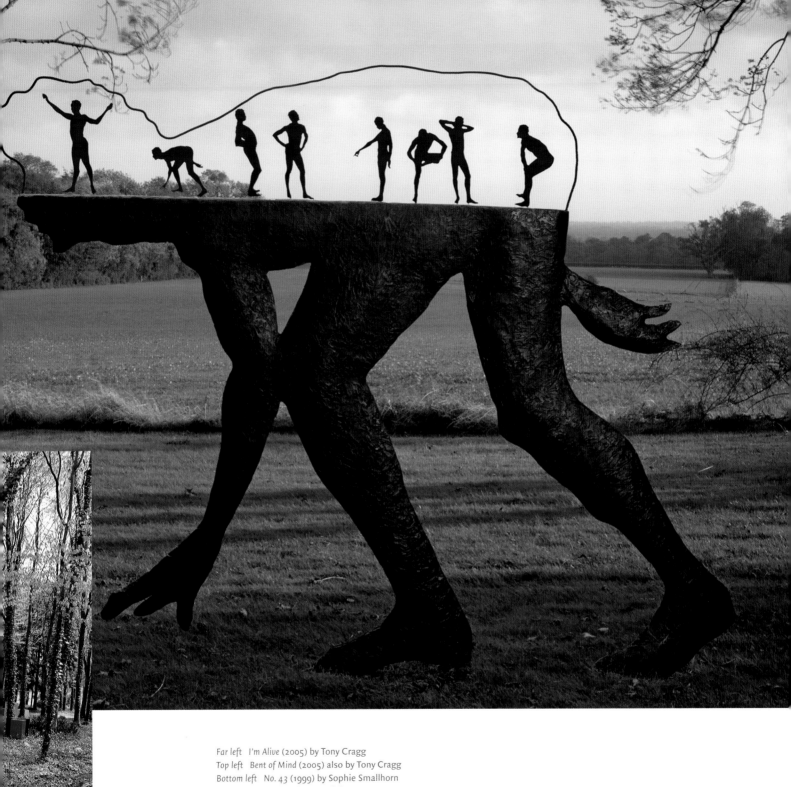

Far left I'm Alive (2005) by Tony Cragg
Top left Bent of Mind (2005) also by Tony Cragg
Bottom left No. 43 (1999) by Sophie Smallhorn
Above Conversation Piece (1996) by
Zadok Ben-David

ART AND ARCHITECTURE AT KIELDER

KIELDER WATER AND FOREST PARK
KIELDER, ENGLAND
Various artists
From 1995

The site-specific artworks at Kielder, such as the award winning shelter *Kielder Belvedere* (1999) by Softroom, respond to the natural beauty surrounding them and encourage you to explore and appreciate the local scenery.

Viewpoints are heroic, strategic or quiet. They are destinations.

TANIA KOVATS

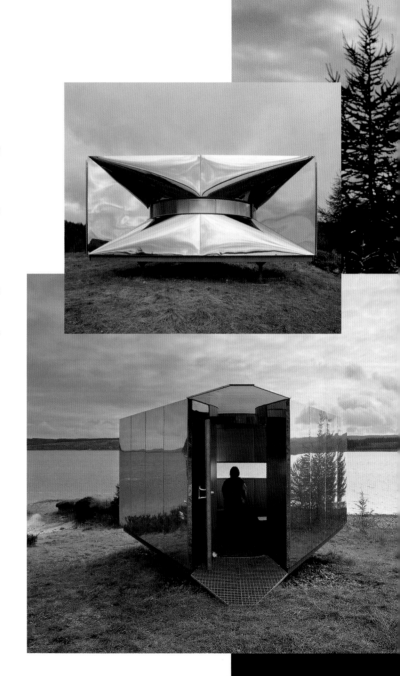

Kielder Water and Forest Park is located in northeast England, in Northumberland near the Scottish border and Hadrian's Wall. At 62,000 hectares, Kielder Forest is the largest forest in England, Kielder Water the most extensive man-made lake in Europe, and together they comprise one of Britain's largest nature reserves. Since 1995 contemporary artists and architects have been invited to create works that respond to its varied landscape of forests, hills, lake and moors.

Over twenty works are sited in the forest and around the lake. They are subtle interventions, many are made of natural materials and they sit easily in their surroundings. The sensitive, considered placements mean that the artworks do not detract from the natural beauty, but add to it, and are a delight to discover on a visit. In such a vast setting, the artworks provide a way to orient yourself and the journeys to find them create a way into exploring the sensational scenery.

A good place to start is at the Kielder Castle Forest Park Visitor Centre overlooking Kielder village. It is the park's main visitor centre and has *Art and Architecture at Kielder* pamphlets, which have a map and directions to all the artworks. While there, get lost in the *Minotaur* (2003), an intriguing contemporary maze of rock glass and basalt stone by London-based architect Nick Coombe and Scottish artist Shona Kitchen (b. 1968).

Then you can set off on a number of walks to visit other artworks. Some are just a few minutes walk from the parking areas. These include *Kielder Column* (1999), a spiralling sandstone column by British sculptor John Maine (b. 1942) at Bakethin Weir, *Viewpoints* (1998) by Briton Tania Kovats (b. 1966), a two-part sculpture sited on opposite shores of the lake, and *Whirling Beans* (1995) by Briton Colin Rose (b. 1950), who sites his works in trees. At Kielder his

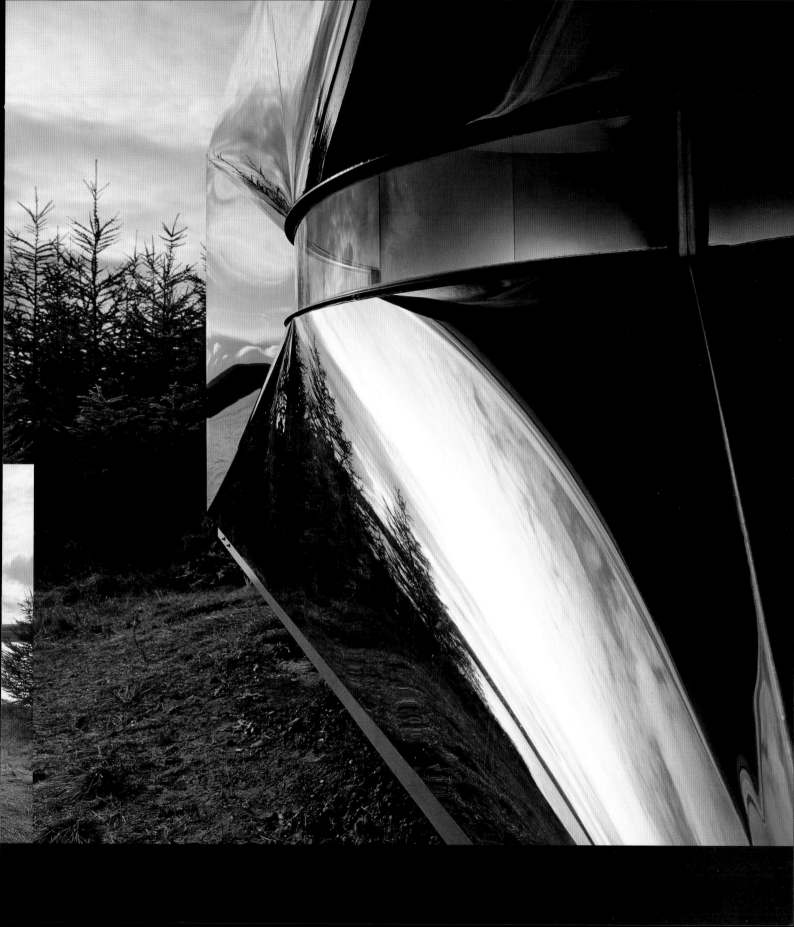

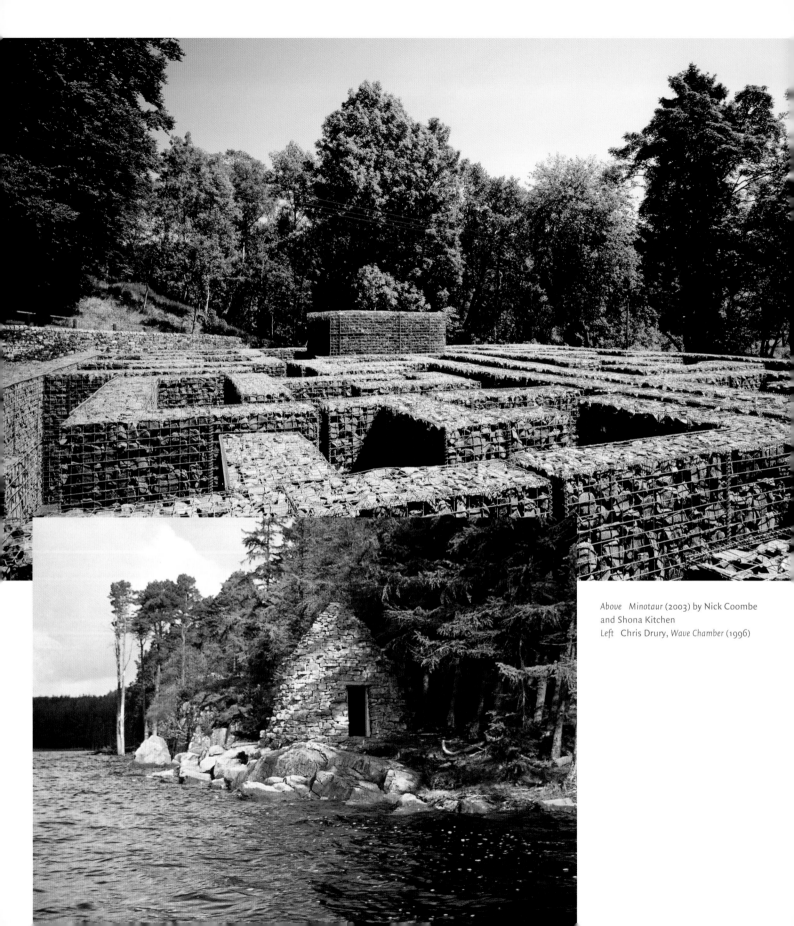

Above *Minotaur* (2003) by Nick Coombe
and Shona Kitchen
Left Chris Drury, *Wave Chamber* (1996)

beans made of rope can be found in the knarled, moss-covered beech trees that were planted in the eighteenth century along what is now known as *Beeches Walk*.

Other installations require a greater commitment to reach them. Some of the most impressive are American James Turrell's (b. 1943) *Cat Cairn Skyspace* (2000), British artist Chris Drury's (b. 1948) *Wave Chamber* (1996) and *Kielder Belvedere* (1999) by London-based architecture and design studio Softroom. Turrell's *Cat Cairn Skyspace* is a cylindrical chamber with a circular opening in its roof which focuses your attention on the sky and its almost tangible presence. Right before dawn and just after sunset, ambient lights within the chamber are activated which interact with the natural spectacle outside of changing light and colour. It is located on a rocky outcrop and access to it is via walks of thirty to fifty minutes through old and newly planted forest.

Drury's *Wave Chamber* is on a sandstone cliff on the rocky shoreline of Kielder Water next to dense forest on the beautiful Belling Peninsula, about a thirty to forty minute walk from the Hawkhope car park. It is a four-metre-high dry-stone beehive hut. From within this isolated shelter in the wild landscape you can hear the sound of the waves lapping against the shore. A lens and mirror are built into the top of the structure so that it functions as a camera obscura, projecting an image of the waves dancing on the stone floor, seeming to dematerialize it, giving cause to think about the power of water to erode and overpower. Continue on along the same path for another two hours to reach *Kielder Belvedere* on the north shore of Kielder Water (it can also be reached by ferry during the summer). It is a triangular shelter clad in stainless steel with a curved golden inner chamber that is bathed in daylight streaming through a yellow skylight. This striking structure mirrors and reflects the surrounding panoramas and is a welcoming refuge for walkers and those waiting for the ferry in this remote location.

These are but a few of the treasures in store for you at the Kielder Water and Forest Park, a unique rural environment in which to experience award-winning contemporary art and architecture.

CELESTIAL VAULT/ PANORAMA IN THE DUNES

THE HAGUE, NETHERLANDS

James Turrell

1996

I am concerned with issues of how we perceive. JAMES TURRELL

American artist James Turrell (b. 1943) attempts to share his joy of seeing and love of light with the viewer. Through a whole array of different installations, indoor and out, temporary and permanent, he explores various aspects of light, such as its colours and textures and the way they can shape space and our perceptions. One such permanent outdoor installation is *Celestial Vault/Panorama in the Dunes* in the Netherlands. It was completed in 1996 in the poetically and appropriately named Kijkduin (*Kijk*=look; *duin*=dune), on the outskirts of The Hague.

Physically, the work consists of an artificial crater with a bench in it and another bench up behind it on a higher dune. Although these are quite interesting and attractive in themselves, they are but the tools Turrell is using to activate the experience and sensations that he wants to share with the spectator. These include the physical sensation of seeing, the joy of seeing and an awareness of the way our observations construct our world, giving cause to reflect on the wonders of nature and of the human brain. In 'Mapping Spaces' (1987) Turrell explained:

My desire is to set up a situation to which I take you and let you see. It becomes your experience.... It's not taking from nature as much as placing you in contact with it.

To reach the elliptical crater, which is about five metres deep, thirty metres wide and forty long, you climb up the dune on wooden stairs and enter through a concrete tunnel. The earthen wall of the crater creates a bowl-shaped space which obstructs the view of the surroundings and encourages the viewer to look upwards. The bench in the centre of the crater invites the viewer to lie down on it and gaze into the sky. When doing this there is the sensation that the sky is a tangible material shaped like a dome resting on the edge of the earthen wall. When you stand up, the sky seems to take a different, flatter shape. Heading to the bench on the higher dune a bit further up, you are presented with an unobstructed view of your surroundings – of the dunes, sea, beach, flat landscape and sky. Lying down on the bench and observing the dome-shaped sky again in a different situation, I was struck by how quickly the mind accepted the world turned upside down, or rather righted it.

Ultimately, light, space and the viewer's observations are the constituent materials in Turrell's work, whether it be *Celestial Vault/Panorama in the Dunes*, *Cat Cairn Skyspace* in northern England (see p. 180) or *Roden Crater*, his work-in-progress in the Arizona desert. Turrell sets up situations that make visible the invisible and allow us to notice the unnoticed or overlooked. He creates places that enable us to concentrate on the act of seeing and to stop and take time out to appreciate the experience. Turrell explains:

You create the world around you, but you are not aware that you are doing so. You generally do not see light filling space, we are not aware of the material nature of light. In my work, you become aware that the act of observing can create color and space. But it is never 'just' an impression that you get, your eyes actually experience light as physically present, and present it is.

By the time *Celestial Vault/Panorama in the Dunes* opened to the public in 1996 it was no longer as remote, as the town had developed to meet it. This has provided easier access and greater usage, which has in turn brought problems. Maintenance is an issue for all art in public spaces and a particular challenge for Land Art pieces. This work is used by many and vandalized by some, from dogs and rabbits to teenagers. The challenge facing its keepers is how to reconcile the

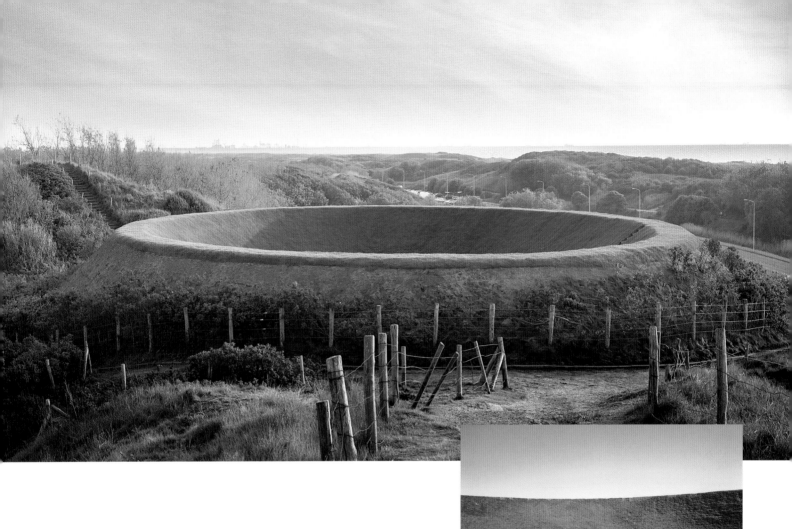

success of the piece and access to it with issues of preservation, especially as the more formal aspects of the piece (such as the crisp rim of the crater bowl) are those which heighten its effect. The work was renovated in 2008.

While in The Hague, have a look at Acconci Studio's *Park in the Water* (p. 160). Another experience not to be missed – and one which makes a nice complement to a visit to Turrell's *Celestial Vault/ Panorama in the Dunes* – is a visit to the *Panorama Mesdag*. The 360 degree painting, created by Dutch artist Hendrik Willem Mesdag (1831–1915) in 1881, measures more than fourteen-metres-high and 120 in circumference. It is the oldest nineteenth-century panorama that can still be seen in its original cylindrical viewing room. The composition is painted from the position of the top of a dune and encompasses the surrounding seascape, cityscape and skyscape. Turrell visited and liked the work a lot, for like his own piece from the top of a dune, it also explores Dutch light and the phenomena of perception and changing perspective.

Top This photograph of James Turrell's *Celestial Vault/Panorama in the Dunes* was taken after it was renovated in 2008. *Above* A view of the bench in the crater – lie down with your feet elevated and your head at the outer edge for a unique experience.

MUSEO GUGGENHEIM BILBAO

BILBAO, SPAIN
Frank O. Gehry
1997

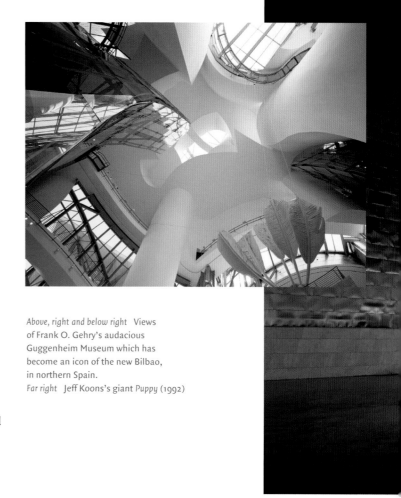

But unless the work is inventive formally, it cannot change anything. It has to be inventive formally to change one's perception, emotions, and experience.
RICHARD SERRA

Since 1997, tourists and art lovers have been flocking to Bilbao in northern Spain. The draw to the industrial port city has been the new Museo Guggenheim Bilbao designed by Canadian-American architect Frank O. Gehry (b. 1929). Gehry's spectacular building was immediately hailed as his masterpiece, as one of the most important buildings of the twentieth century and was credited with 'putting Bilbao on the map'.

Bilbao was Spain's steel-producing powerhouse during the Industrial Revolution but had been in decline since the 1960s. The Guggenheim was a key element in the city's urban renewal plans and was the result of an enlightened partnership between the Solomon R. Guggenheim Foundation, the city of Bilbao and the regional Basque Government. Located on the river Nervión, it became the focal point for the recuperation of the city's river and port zones, which had been neglected since the decline of the steel industry.

Gehry's building is an awesome sight – its undulating forms sheathed in 'fish-scale' titanium interconnect with limestone cubic shapes and glass-curtain walls. Its shimmering, billowing curves make it look like a ship from some angles, neatly referencing the city's past as an important industrial port and its engineering achievements, past and present. The inspired design plays with and works with its hillside site on the edge of the river with entrances that invite visitors to different levels and introduce them to new perspectives of the building and the city. It reunites the city centre with its riverfront.

Gehry's Guggenheim Museum is at once a building, a sculpture, a monument and an icon, as much a symbol of Bilbao as Antoni Gaudí's buildings (1852–1926) are of Barcelona (see *Park Güell*,

Above, right and below right Views of Frank O. Gehry's audacious Guggenheim Museum which has become an icon of the new Bilbao, in northern Spain.
Far right Jeff Koons's giant *Puppy* (1992)

p. 22). Gehry's exuberant building is an amazingly successful piece of public art which has become a powerfully positive symbol of the new Bilbao, one which incorporates the city's proud past as well as embodying its current confidence.

While the building has received almost unanimous approval as a piece of architecture and a tool for urban regeneration, its appropriateness as a contemporary art space was called into question. Critics pointed to the difficulty of displaying artworks

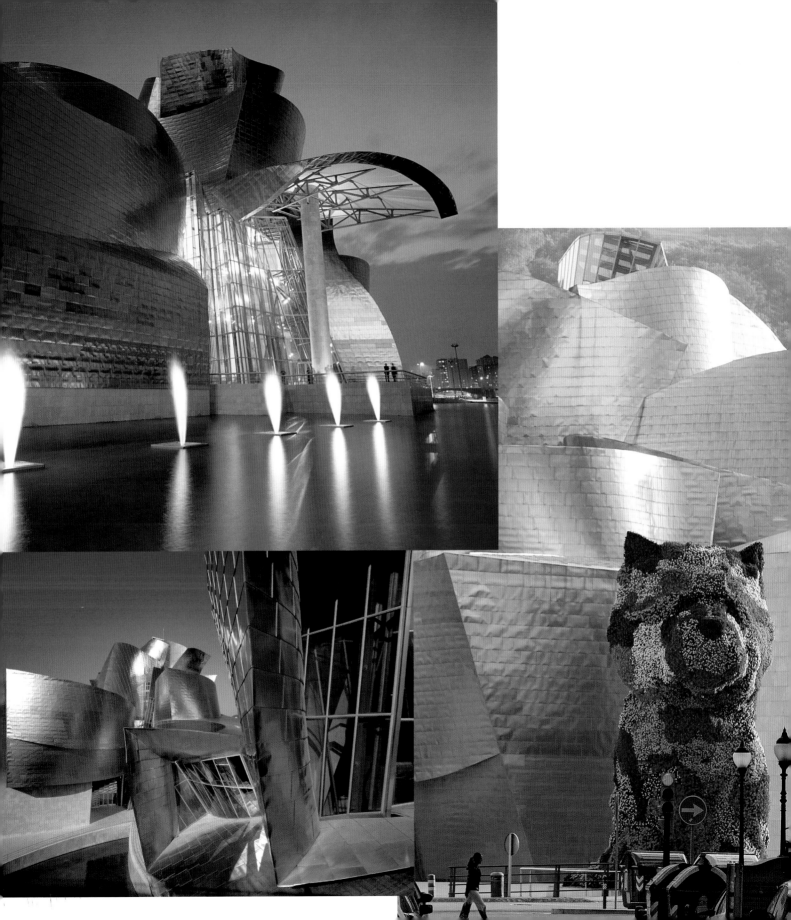

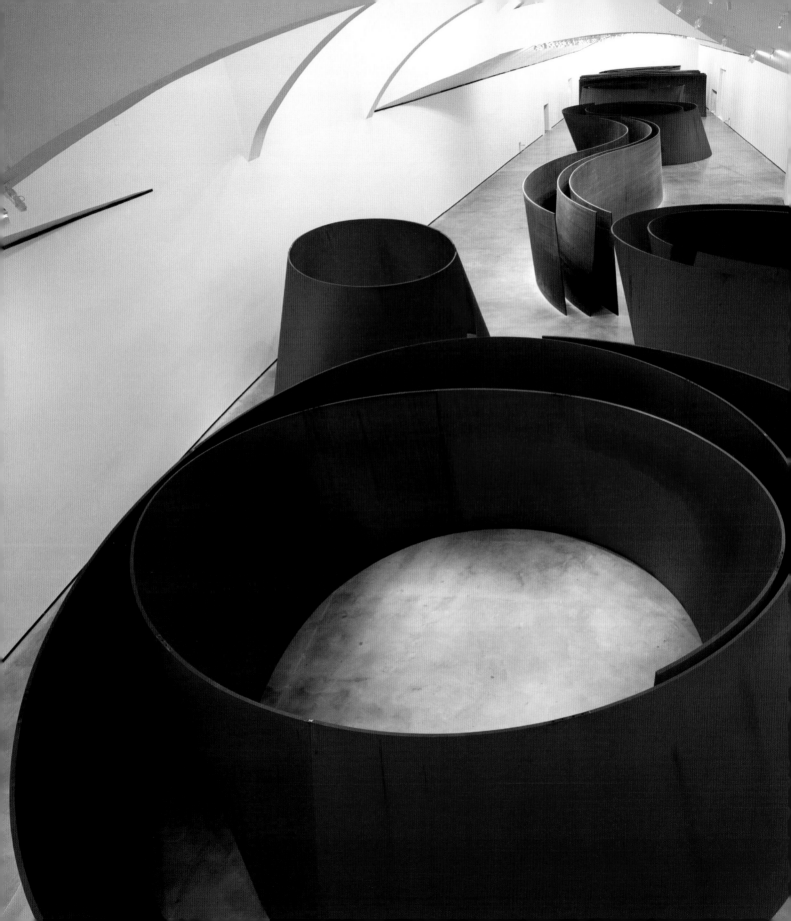

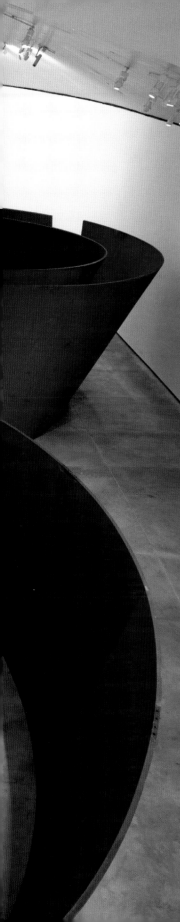

The Matter of Time (2005)
by Richard Serra

in its idiosyncratic rooms and to the problem of the architecture overwhelming the art. These voices were silenced, however, with the permanent installation in 2005 of the extraordinary work *The Matter of Time*, by American sculptor Richard Serra (b. 1939) in the vast 'Fish' gallery – a thirty-metre-wide, 130-metre-long space which dwarfed most former installations. Serra's most ambitious project to date, the monumental eight-part curved and twisted steel installation is comprised of three-dimensional abstract sculptures that have passageways through them, such that the physical sensations of the journey and the act of discovery are an integral part of experiencing the works. The spaces within and between the sculptures play off each other and with the cavernous space of the gallery. As Gehry's building revitalized Bilbao, Serra's installation gives new life to the museum. The architecture has found its complement – a dramatic, eloquent artwork that holds its own in its challenging surroundings.

To those who have discovered Bilbao as a result of the draw of Gehry's masterpiece have been added those making a pilgrimage to see Serra's. Both of these extraordinary creative and engineering feats are watched over by American Jeff Koons's (b. 1955) giant (twelve-metre-high) *Puppy* (1992) carpeted in colourful bedding plants. Rather ridiculous and certainly kitsch, it could be read as a playful take on the grand formal gardens or lawns that often greet visitors to cultural spaces. Perhaps then it is not so ridiculous after all, but right at home with Gehry's audacious reconfiguration of the art museum, Serra's regeneration of the tradition of abstract sculpture, or indeed Bilbao's reinvention of itself as a cultural destination.

Through temporary exhibitions and its permanent collection, the museum has brought world-class modern and contemporary art to Bilbao. There is a particularly strong emphasis on European and American art since the mid-twentieth century, with works by American artists Robert Rauschenberg (1925–2008) and Roy Lichtenstein (1923–97), Briton Richard Long (b. 1945) and Italian Mario Merz (1925–2003) often on view. Elsewhere in the city there are also fine examples of contemporary architecture by Briton Norman Foster (b. 1935) and Spanish architect Santiago Calatrava (b. 1951). The phenomenal success of Bilbao's civic revival has spurred others around the world to follow suit with programmes using art and architecture to drive development, a trend often referred to as 'the Bilbao effect'.

IL GIARDINO DI DANIEL SPOERRI

SEGGIANO, ITALY
Daniel Spoerri and friends
From 1997

I suspect all men fear nature and do their best to tame, prune and uproot it.
DANIEL SPOERRI

In a varied career which has encompassed dance, poetry, performance and assemblage, Romanian-born, Swiss-bred artist Daniel Spoerri (b. 1930) has often explored the social aspects of art and its performative and ephemeral qualities. His current project, *Il Giardino di Daniel Spoerri*, choreographing a large sculpture park in southern Tuscany, incorporates these elements as well as engaging with the topography and ecology of the site and creating a dialogue between man and nature, nature and culture.

After having lived all over the world, Spoerri decided to settle down in Tuscany, near the small town of Seggiano, about eighty kilometres south of Siena. In 1989 he and his wife, artist Katharina Duwen (b. 1962), purchased a sixteen-hectare estate at the foot of Monte Amiata, the tallest mountain in Tuscany. After turning the dilapidated farm buildings into a home and studio, Spoerri began placing some of his sculptures around the property. Soon, artist-friends were also contributing work to the project, which eventually became a foundation and opened its doors to the public in 1997. There are now over eighty sculptures and installations by some forty artists. The international cast of artists includes Eva Aeppli (b. 1925), Arman (1928–2005), Olivier Estoppey (b. 1951), Karl Gerstner (b. 1930), Dani Karavan (b. 1930), Bernhard Luginbühl (b. 1929), Nam June Paik (1932–2005), Dieter Roth (1930–98), Jesús-Rafael Soto (1923–2005), Jean Tinguely (1925–91) and Paul Wiedmer (b. 1947), amongst others.

The works are scattered along a botanical trail designed by landscape architect Irma Beniamino, providing an excursion that includes contemporary art and a tour of the native flora. The path leads across fields and hills, through vegetable gardens, orchards and olive groves. For Spoerri, this is an integral feature of the

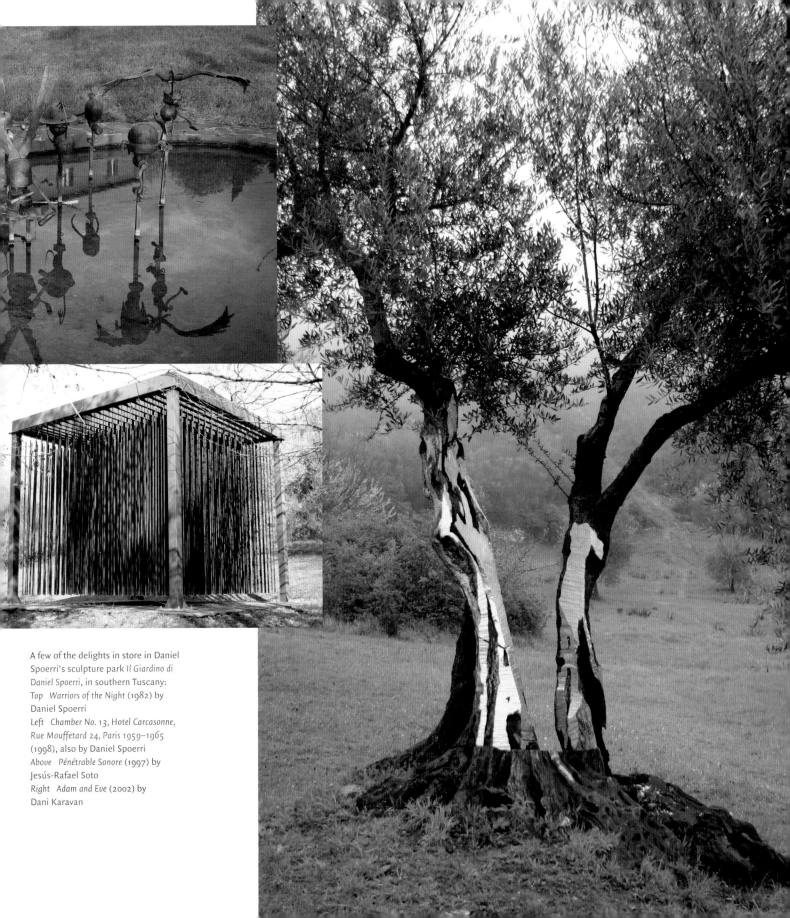

A few of the delights in store in Daniel
Spoerri's sculpture park *Il Giardino di
Daniel Spoerri*, in southern Tuscany:
Top Warriors of the Night (1982) by
Daniel Spoerri
*Left Chamber No. 13, Hotel Carcasonne,
Rue Mouffetard 24, Paris 1959–1965*
(1998), also by Daniel Spoerri
Above Pénétrable Sonore (1997) by
Jesús-Rafael Soto
Right Adam and Eve (2002) by
Dani Karavan

*Opposite Courtship Display (1992)
by Daniel Spoerri
Left Olivier Estoppey, Dies Irae
(Judgment Day) (2001)
Below Daniel Spoerri,
Labyrinthic mural path (1996–98)*

ponds. With work that ranges from humorous to macabre, quirky to intense, a dialogue takes place between the artworks and their environment and an important aspect of the project is the tension or harmony between art and nature that results from these interactions. For instance, there are a number of spooky heads by Aeppli through out the park – alone or in groups, often staring down at you from pedestals or from within a tree itself, such as *The other side* (1974–80). Another work in an unexpected place is Karavan's *Adam and Eve* (2002), which consists of gold leaf applied to the split in an olive tree rent in two by lightning. On a bright sunny day it is almost impossible to look at – perhaps blinded by the intersection of art and nature?

Some of the works are interactive, such as Soto's *Pénétrable Sonore* (1997), in which you walk through its four hundred aluminium tubes creating a soundscape to go with the artwork and the landscape. Others draw you to a particular viewpoint or place, such that the artworks – and the hunt for them – serve as tools to explore the area and its particular characteristics. When Spoerri's *Circle of Unicorns* (1991) beckons, answer its call and you will be rewarded with an amazing view over Seggiano. The unicorns sit atop a hill and seem to be paying homage to and protecting the tiny village.

It takes about three hours for a leisurely visit. Other sculptures that I am particularly fond of are Wiedmer's fire-breathing *Ivy Dragon* (1998) and Spoerri's *Grass sofas* (1985–93) and *Labyrinthic mural path* (1996–98). The design of the path is based on pre-Columbian pictographs representing the union of Father Sun and Mother Nature. Unlike traditional mazes, in which you walk along paths created by walls, here you walk along the walls, and trace the path from above, following its curves, starts, stops and intersections. If you join Esther Seidel's (b. 1964) *Visitor* (1998–2000) on its viewing platform, you get a good aerial view of the *Labyrinthic mural path* as well as Arman's *Monument for Settlers* (1999–2000), an eight-metre-high accumulation of ploughs and other agricultural instruments in a pond.

As an artist-led initiative, this extraordinary park has a very personal feel to it that sets it apart from more institutional sculpture parks and gives it its unique flavour. Other sculpture parks and gardens in the area not to miss are Niki de Saint Phalle's *Giardino dei Tarocchi* (see p. 126), *Fattoria di Celle: The Gori Collection of Site-Specific Art* (see p. 199), Paul Wiedmer's *La Serpara* (see p. 208) and *Parco Sculture del Chianti* (see p. 266).

project: 'The pathway is important, and it's important to measure one's steps, take in its fragrances, sense the sounds around you, the water, the gradient of the land, the fields, the woods and the brushwood.' Searching for and exploring the sculptures along the route encourages this attention to the countryside and its various sensory features.

Spoerri explained that 'the idea was to carefully select where to place the works of art within nature so that they would not overshadow the setting in an egocentric way.' Here, nature is not tamed, and the artworks engage with and enhance, rather than dominate it. Sculptures appear in trees, shrubs, grassy fields and

UNTITLED

MILAN, ITALY
Dan Flavin
1997

Give me a place to light and I will invent an installation that will bring it out.
DAN FLAVIN

Santa Maria Annunciata in Chiesa Rossa, usually shortened to
Chiesa Rossa (Red Church), in the southern outskirts of Milan,
was built in 1932 by Giovanni Muzio (1893–1982). Muzio was a
prominent member of the Milanese Novecento group of architects
who sought to reinterpret Italian classical forms in a modern idiom.
Sixty-five years later the interior of the church was transformed into
a magical environment by American light artist Dan Flavin
(1933–96), who bathed different parts of the building in sensuous
colours – green, blue, pink, yellow and ultraviolet. His light
installation created a dialogue with the architecture and
transformed the whole into an ethereal environment.

This innovative initiative came about through the efforts of the
parish priest, Father Giulio Greco, and one of his parishioners, art
historian Laura Mattioli Rossi. Father Greco was distressed by the
sombre interior, especially the heaviness of the red brick vault, and
Rossi, who was familiar with Flavin's work, put forth the idea that
a work by him could completely renovate the church interior and lift
the atmosphere dramatically. She suggested that Father Greco visit
the Villa Panza in Varese, where Flavin's work is particularly
sensitively displayed in eleven rooms dedicated to him. Father Greco
went and was particularly impressed with Flavin's piece in memory
of his twin brother who died in Vietnam – *Monument for Those Who
Have Been Killed in Ambush (To P.K. who reminded me about death)* (1966)
and became convinced that the emotive power of Flavin's work could
'illuminate our church, surrounded by so much sorrow and solitude'.

On a trip to New York in 1995 Rossi mentioned the idea to Michael
Govan, director of the Dia Art Foundation, who volunteered to
approach Flavin about the possibility. At the time Flavin was
seriously ill and unable to go to Milan to see the church in person,

Dan Flavin's minimalist light
installation transforms the sombre
interior of Santa Maria Annunciata
in Chiesa Rossa (by Giovanni Muzio)
into an ethereal environment.

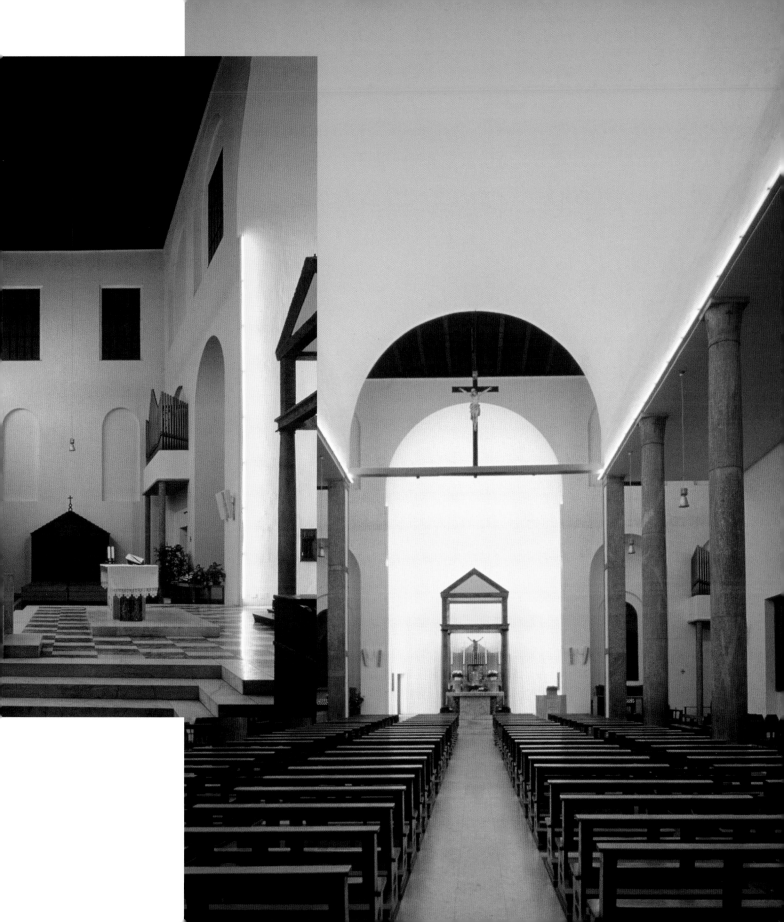

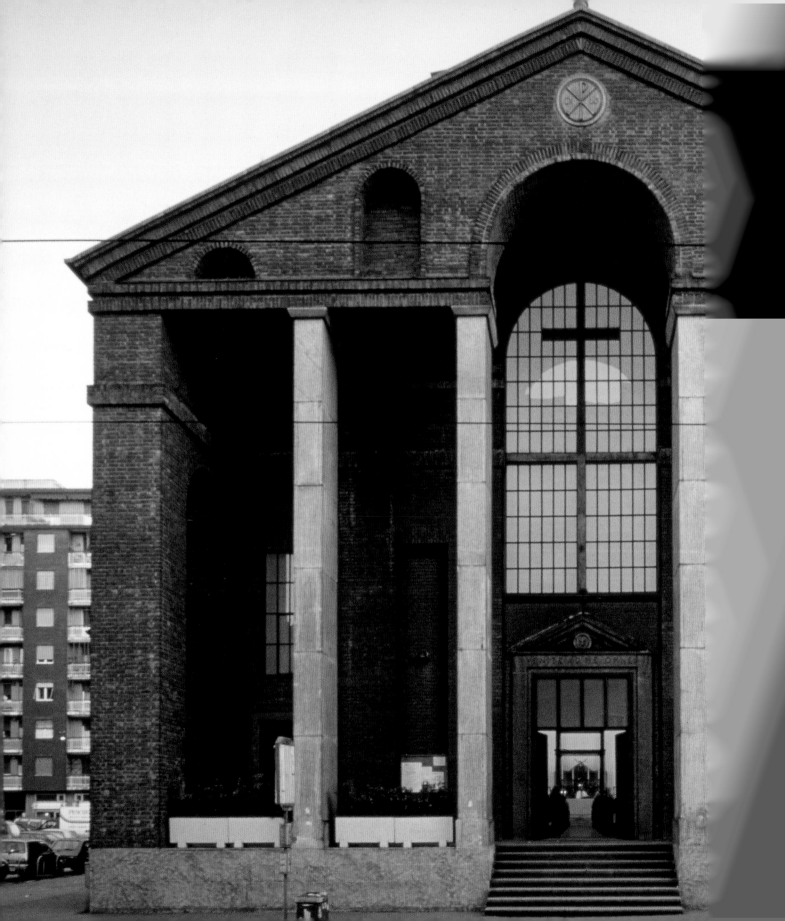

so Govan went on his behalf and filmed the church and the interested parties. Although intrigued by Muzio's building, Flavin initially refused the commission, due to his hostility towards the Catholic Church as a result of unhappy times at Catholic school.

In May 1996 Father Greco decided to write to Flavin directly about his desire for the church to be a place to provide hope and comfort for those suffering in his troubled district of Milan, which was rife with organized crime and socio-economic problems. Father Greco expressed his hope that Flavin would help them make the space come alive and enable them to take the first step on the road to rehabilitating the area. Impressed by Father Greco's passion, Flavin relented and accepted the commission.

Flavin finished his designs for Chiesa Rossa on 27 November 1996 and passed them on to Govan saying, 'Now I can finally die in peace'. Two days later he did. *Untitled* was realized posthumously with the support of the Fondazione Prada. The installation was inaugurated on 29 November 1997, the first anniversary of Flavin's death, in conjunction with an exhibition of his work at the Fondazione Prada.

The vault and the walls of Chiesa Rossa were painted white and fluorescent tubes of different colours and lengths were installed in the nave and transepts. The interior is entirely illuminated by Flavin's light system and the once heavy barrel vault has been transformed into a weightless blue sky and the golden apse beckons. Warm pinks and cool greens in other areas of the church envelope the visitor in an environment that is at once soothing and uplifting. From the outside the beautiful colours stream out of the windows, lighting up the church like a beacon, and inside the whole interior is imbued with an effect like that of light shining through a stained glass window.

The Fondazione Prada hosts exhibitions by internationally acclaimed contemporary artists at their space in central Milan, and is certainly worth a visit, as is Parco Portello (p. 269). The beautiful Villa Panza in Varese is about an hour north of Milan.

The light from Flavin's installation inside Chiesa Rossa can even be seen from the street.

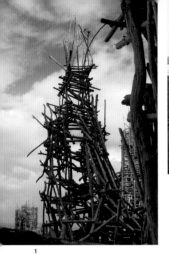

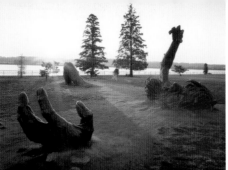

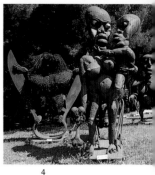

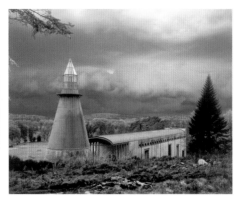

Nimis and Arx (1)
Kullaberg, Skåne, Sweden
Lars Vilks, from 1980
Swedish artist and art historian Lars Vilks (b. 1946) began work on his massive driftwood construction on the sea *Nimis* (Latin for too much), in 1980. He chose as his site an isolated spot in the Kullaberg nature reserve in northwest Skåne in southern Sweden. The remoteness of the location meant that the work was not discovered until 1982, when legal battles began with the county council regarding its removal. Much of the sculpture was destroyed in a fire set by vandals in 1985. Undeterred, Vilks rebuilt the work, which now measures over 150 metres. Also subject to court proceedings is another work which Vilks began building nearby in 1991, *Arx* (Latin for fortress), a monumental concrete and stone construction. The court battles concerning both continue to this day.

The Awakening (2)
National Harbor, Maryland, USA
J. Seward Johnson, Jr, 1980
The Awakening (1980), by American sculptor J. Seward Johnson, Jr (b. 1930), is a five-piece cast aluminum sculpture measuring some seventy feet. Located on the banks of the Potomac River, Johnson's super-real head, knee, foot, hand and arm depict a giant trying to rise up from the ground.

Axe Majeur (Main Axis)
Cergy Pontoise, France
Dani Karavan, from 1980
Israeli artist Dani Karavan's (b. 1930) *Axe Majeur* is a powerful fusion of sculpture, architecture, urban planning and landscape design. Created for the new town of Cergy Pontoise in the Ile de France to the north-west of Paris, the work starts with a thirty-six-metre-high panoramic tower and ends some three kilometres later at a road intersection. It runs along an esplanade and via twelve stations (including a piazza, an orchard, twelve columns, a garden, an amphitheatre, a bridge, a pyramid on the water and an astronomical island) drawing attention to the relationships between Cergy Pontoise and Paris and between the new development and its surrounding landscape. The whole artscape is connected by a laser beam at night.

Centre International d'Art et du Paysage de Vassivière (3)
Ile de Vassivière, France
Various artists, from 1982
An art centre and sculpture garden on a beautiful wooded island in the Lac de Vassivière, about thirty-seven miles east of Limoges. There are site-specific works by international artists such as Britons Andy Goldsworthy (b. 1956) (see p. 143) and David Nash (b. 1945), France's Alain Kirili (b. 1946) and Bernard Pagès (b. 1940) and Kimio Tsuchiya (b. 1955) from Japan.

Musée Moralès (4)
Port-de-Bouc, France
Raymond Moralès, from 1982
Former blacksmith Raymond Moralès (b. 1926) has created a 5000 square metre sculpture park in Port-de-Bouc on the Mediterranean coast, about forty-five kilometres west of Marseille. The walled compound is filled with over seven hundred of his menacing monumental welded metallic sculptures.

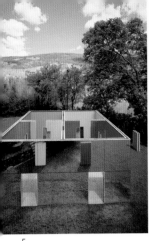

6

7

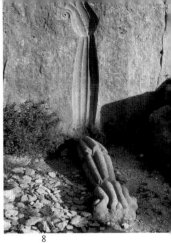

8

5

Fattoria di Celle: The Gori Collection of Site-Specific Art (5)

Santomato di Pistoia, Italy
Various artists, from 1982
The Gori Collection is a world-class collection of site-specific art just outside of Pistoia in Tuscany. Collector Guiliano Gori and his family began inviting artists to create works for the park, farmland, olive groves, farm buildings and the seventeenth-century villa on their property in 1982. Since then some seventy installations have been created on the farm by such internationally renowned artists as Americans Robert Morris (b. 1931), Beverly Pepper (b. 1922) and Alan Sonfist (b. 1946), Pole Magdalena Abakanowicz (b. 1930), Daniel Buren from France (b. 1938) (see above) and Spaniard Jaume Plensa (b. 1955).

Hundertwasser House (6)

Vienna, Austria
Fritz Hundertwasser, 1983–86
Austrian painter Fritz Hundertwasser (1928–2000) believed fervently that for man to live well he should live in harmony with nature, and that this required an architecture that respected both man and nature. When the Viennese city council hired him to design a public housing project he was able to put his theories into practice. The resulting 'house of dreams' is home to around two hundred tenants in fifty apartments and some two hundred and fifty trees and plants, which grow from the rooftop and peer out of its windows. The playful design features a brightly coloured, curvaceous façade, nineteen roof terraces and golden onion towers.

The Dan Flavin Art Institute (7)

Bridgehampton, New York, USA
Dan Flavin, 1983
American Dan Flavin (1933–96) is known for his fluorescent light sculptures and installations which transform a gallery or museum space into an ethereal environment for the spectator. In 1983, a former firehouse and church in Bridgehampton became a permanent home for nine of his works, tracing twenty years of his career.

Tout Quarry Sculpture Project (8)

Isle of Portland, England
Various artists, from 1983
This quarry sculpture park was founded in 1983 as part of a larger initiative to regenerate a number of disused quarries on the Isle of Portland, a rocky outcrop off the coast of Dorset. Forty artists created work in the first year, often working with the local Portland stonemasons to carve pieces into the rockface or make works from the local materials. More than ninety artists, such as Stephen Marsden (see above), have made more than 120 temporary and permanent works addressing the environment since. There are more than fifty permanent works on site.

The Land of Evermor

Prairie du Sac, Wisconsin, USA
Tom O. Every, from 1983
In 1983 salvage and demolition worker Tom O. Every (b. 1939), decided it was time for a change. Tired of destroying industrial objects, he decided that he would give them new life and respect by recycling them into art objects. He turned over the family

1

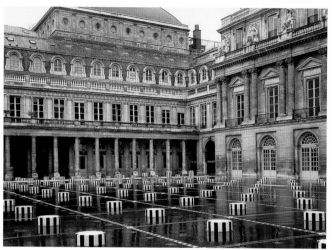

2

3

business to his son, created the alter ego of Victorian inventor Dr Evermor, and set to work on the *Forevertron* – a gigantic space travel machine made from scrap metal which by 2000 weighed over 400 tons. The *Forevertron* is surrounded by hundreds of satellite sculptures, many of them kinetic, together forming a moving monument to the machine age (see p. 6).

The Open Museum
Tefen, Israel
Various artists, from 1985
The Open Museum was the brainchild of industrialist Stef Wertheimer, who in his quest to foster creativity wanted to create an environment that brought art and industry together. The Open Museum, which is part of the Tefen Industrial Park in the hills of Western Galilee, was the result. The inner courtyard is home to a sculpture garden covering twenty-nine acres. There are around one hundred works by Israeli artists such as Yehiel Shemi (1922–2003), Michael Gross (1920–2004), Menashe Kadishman (b. 1932) and Yaacov Dorchin (b. 1946).

Campo del Sole (Field of the Sun)
Lido di Tuoro, Italy
Pietro Cascella and others, 1985–89
Near the Punta Navaccia on Lake Trasimeno there are twenty-seven stone column-sculptures forming a forty-four-metre spiral that leads to a central solar symbol by Italian sculptor Pietro Cascella (1921–2008), who initiated the project. A number of Italian and foreign artists contributed to the *Campo del Sole*.

Benson Sculpture Garden (1)
Loveland, Colorado, USA
Various artists, from 1985
Loveland, about fifty miles north of Denver, is home to the seven-acre Benson Sculpture Garden, initiated by a group of local sculptors and residents. The collection comprises around one hundred predominantly, but not exclusively, representational sculptures in a variety of media. The sculptures are sited around a lagoon with the majestic Rocky Mountains as a backdrop. The sculpture above is by George Walybe.

Les Deux Plateaux (Two Levels) (2)
Palais Royal, Paris, France
Daniel Buren, 1985–86
Les Deux Plateaux by French artist Daniel Buren (b. 1938) is situated in the courtyard of the Palais Royal in Paris. When the revolutionary Conceptualist transferred the trademark stripes from his familiar temporary installations to a grand permanent site, it provoked as much outrage from progressives accusing him of selling out, as from reactionaries objecting to the defacement of a much-loved monument. With time, however, Buren's work has since come to be appreciated as an intelligent transformation of an ugly car park into a magical public space. The truncated striped columns, situated over an underground canal, lead viewers to the columns of the museum itself, and, at night, red and green lights on the upper level create a runway effect, while blue fluorescent lights ethereally colour the steam escaping from underground.

4

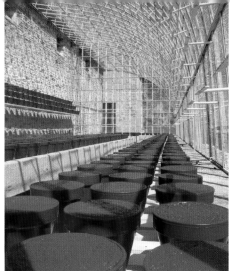

5

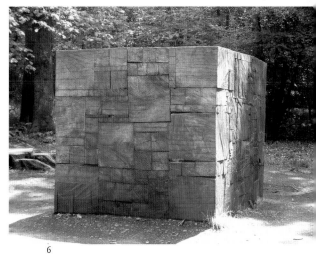

6

Vollis Simpson's Whirligig Park (3)

Lucama, North Carolina, USA

Vollis Simpson, from 1985

Amongst the pine trees in a farmyard at a country crossroads outside of the small town of Lucama, North Carolina, about fifty miles east of Raleigh, you will spy Vollis Simpson's (b. 1919) wonderful Whirligig Park. The park features around thirty giant wind-powered kinetic metal sculptures. Many of the brightly painted whimsical sculptures feature reflectors so that when seen at night in car headlights it looks like a magical fairground. The sculptures are the work of retired mechanic Simpson, who adapted the heavy machinery he had designed for use in moving houses and farm buildings to harness the wind in order to power his new creations.

Socrates Sculpture Park (4)

Long Island City, New York, USA

Various artists, from 1986

The Socrates Sculpture Park is a 4.5 acre neighbourhood park located on the East River in an industrial neighbourhood in Long Island City, Queens, New York.

The waterfront site, with its stunning views of the Manhattan skyline, was an illegal dumping ground until American sculptor Mark di Suvero (b. 1933) galvanized a group of artists and residents to clean it up and turn it into a vital public space. The site and its activities combine sculpture and community in a way which underscores the importance of each, as well as the way that they can interact with and enhance the experience of each other. Work by American Leo Villareal (b. 1967) above.

Museo Mural Diego Rivera

Mexico City, Mexico

Diego Rivera, 1986

This one-mural museum was built in 1986 specifically to house one of Mexican Diego Rivera's (1886–1957) most famous murals, *Sueño de una Tarde Dominical en la Alameda* (Dream of a Sunday Afternoon in the Alameda) (1947–48), after its former home was damaged in an earthquake in 1985. The mural is fifteen metres long and four metres high. The museum is right across the street from the park where the painting is set.

Domaine de Kerguehénnec, Centre d'Art Contemporain (5)

Bignan, France

Various artists, from 1986

The sculpture park at the 430-acre Kerguéhennec estate is a major draw in Brittany. The estate features an eighteenth-century castle, twenty-seven-acre lake, model farm, library, artists' studios and a park landscaped by Denis Bühler in 1872. Sculptures that can be found in the extensive park are by artists such as Marta Pan (1923–2008), François Morellet (b. 1926) and Jean-Pierre Raynaud (b. 1939) (see above) from France, Britons Ian Hamilton Finlay (1925–2006) and Richard Long (b. 1945), Italians Mario Merz (1925–2003) and Giuseppe Penone (b. 1947) and Americans Richard Artschwager (b. 1923) and Dan Graham (b. 1942), amongst others.

Forest of Dean Sculpture Trail (6)

Coleford, Gloucestershire, England

Various artists, from 1986

The ancient Royal Forest of Dean is on the border of England and south Wales. Since

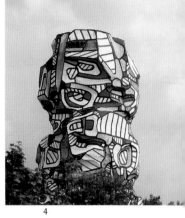

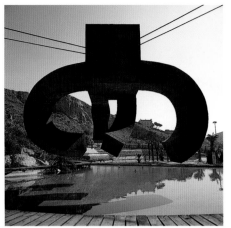

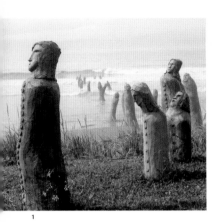

1986 artists have been invited to create temporary and permanent sculptures which respond to the beauty and history of the forest. There are seventeen permanent sculptures by artists such as Magdalena Jetelová (b. 1946) from the Czech Republic, Britons Carole Drake (b. 1963), Keir Smith (1950–2007) and Ian Hamilton Finlay (1925–2006) and South African-born Neville Gabie (b. 1959) on p. 201.

Le Grand Rassemblement (The Great Gathering) (1)

Sainte-Flavie, Quebec, Canada
Marcel Gagnon, 1986–96
Sainte-Flavie is a tiny coastal town at the mouth of the Gaspé Peninsula. There you will find Marcel Gagnon's *Le Grand Rassemblement*, an installation of over one hundred life-size concrete figures and seven manned rafts, which starts on shore and stretches into the St Lawrence River. At low tide you can walk out to join most of the figures while at high tide many are up to their necks in water and the rafts look like they are floating.

Wanås Foundation (2)

Knislinge, Sweden
Various artists, from 1987
The Wanås Foundation is located in the countryside on an organic farm in Knislinge, in southern Sweden. International artists are invited to visit and make site-specific installations, often in collaboration with local craftsmen. Americans Dan Graham (b. 1942), Maya Lin (b. 1959) (see above), Roxy Paine (b. 1966) and Jenny Holzer (b. 1950) are some of the big names in the forty strong permanent outdoor collection.

Parc la Creuta del Coll (3)

Barcelona, Spain
Ellsworth Kelly and Eduardo Chillida, 1987
In northern Barcelona, not far from *Park Güell*, is the Parc la Creuta del Coll, on the site of a former quarry. It features two monumental sculptures: *Totem* (1987) by American Ellsworth Kelly (b. 1923), which is a steel monolith over thirty feet high and *Elogi de l'aigua* (Eulogy to Water) (1987) by Spaniard Eduardo Chillida (1924–2002), a massive eighty-ton claw-like reinforced concrete sculpture hanging over the lake!

Tour aux figures (4)

Issy-les-Moulineaux, France
Jean Dubuffet, 1988
French artist Jean Dubuffet (1901–85) approved the site, a park on the island of Saint-Germain on the outskirts of Paris, for *Tour aux figures* (1988) just before his death. The interior of his jolly monumental (twenty-four metres high) red, white and blue resin sculpture-tower can be viewed by appointment.

Joshua Tree Environment

Joshua Tree, California, USA
Noah Purifoy, 1989–2004
In 1989, after a lifetime spent as a pioneering community activist and educator in Los Angeles promoting the use of art as a force for social change, American Noah Purifoy (1917–2004) relocated to the rural desert community of Joshua Tree to resume his own art-making. The 2.5 acre site is filled with over one hundred of his large-scale outdoor assemblage sculptures, earthworks and installations, most made from found objects and materials.

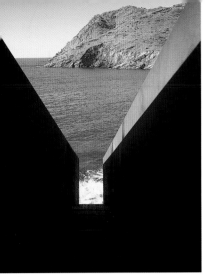

5

6

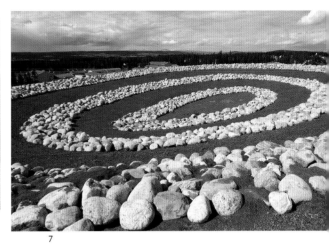

7

Passages – Homage to Walter Benjamin (5)
Portbou, Spain
Dani Karavan, 1990–94

Israeli artist Dani Karavan's (b. 1930) sculpture is a memorial to Walter Benjamin (1892–1940), the Jewish–German philosopher who committed suicide in 1940 in this small port town on the Franco–Spanish border when he was refused passage to Spain while fleeing Nazi-occupied France. The poetic piece creates a passage from the town cemetery to the sea's whirlpools via a cor-ten steel tunnel. The work continues on with a rough pathway leading to an olive tree and a steel cube on a steel platform overlooking the Mediterranean through the cemetery fence.

East Side Gallery (6)
Berlin Wall, Berlin, Germany
Various artists, 1990

The East Side Gallery is a 1.3 kilometre section of the Berlin Wall. In January 1990, a few months after the fall of the wall, Scottish artist Christine MacLean began to paint on the east side of the Wall near the Spree River. She was soon joined by artists from around the world capturing this profound historical moment in paint. 118 from twenty-one countries created an open-air gallery of over 100 paintings. Unfortunately, pollution, graffiti, rust and souvenir hunters have taken their toll and many of the paintings are in a bad state of repair. Around a third of the paintings were restored in 2000, but have already begun to deteriorate again. Despite the efforts of the *Künstlerinitiative* (Artists Initiative) to secure funding to restore and preserve the monument, the future of the East Side Gallery is still uncertain.

Afangar (Milestones)
Videy, Iceland
Richard Serra, 1991

This topological sculpture by American sculptor Richard Serra (b. 1939) is located on the harbour island of Videy, just a five-minute ferry ride from Reykjavik. It is comprised of nine pairs of beautiful basalt standing stones, placed to frame the view and to guide the viewer on a voyage of discovery around the lovely, uninhabited island.

Goldener Vogel (Golden Bird)
Cologne, Germany
H. A. Schult, 1991

German artist H. A. Schult's (b. 1939) *Goldener Vogel* – a golden winged Ford Fiesta – has been nesting in the Museum of the City of Cologne's sixteenth-century tower since 1991. Originally controversial, it has since become a much-loved landmark.

Sky Park (7)
Östersund, Sweden
Gunilla Bandolin, 1991

Swedish artist Gunilla Bandolin (b. 1954) made a permanent earthwork of stone, earth and grass out of an excavated hill that resulted from building a new housing area in Östersund in northwest Sweden. It has become a social space for the community.

Urban Configurations
La Barceloneta, Barcelona, Spain
Various artists, 1992

The neglected industrial neighbourhood of La Barceloneta was regenerated when Barcelona hosted the Olympic Games in 1992. As part of the redevelopment, eight

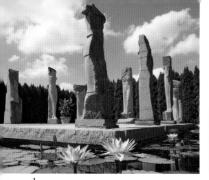

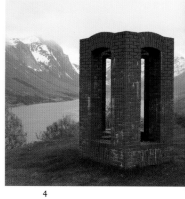

1

2

3

4

international artists were invited to create permanent outdoor sculptures for the public spaces in the area. Monumental works by German sculptors Lothar Baumgarten (b. 1944), Rebecca Horn (b. 1944) (see p. 6) and Ulrich Rückriem (b. 1938), Italian Mario Merz (1925–2003), Greek artist Jannis Kounellis (b. 1936) and Spanish sculptor Juan Muñoz (1953–2001) can be found by walking through the neighbourhood and along the waterfront.

Grounds for Sculpture (1)
Hamilton, New Jersey, USA
Various artists, from 1992
Grounds For Sculpture, a thirty-five-acre sculpture park and museum in New Jersey, was founded by American sculptor J. Seward Johnson, Jr (b. 1930) in 1992 with the goal of making contemporary sculpture more accessible to the public. There are over 200 works installed in the beautiful grounds by artists such as Magdalena Abakanowicz (b. 1930), Benbow Bullock (1929–2010), Anthony Caro (b. 1924), Carlos Dorrien (b. 1948) (see above), Marisol (b. 1930), Beverly Pepper (b. 1922) and George Segal (1926–2000).

Landmark (2)
Cardiff, Wales
Pierre Vivant, 1992
French artist Pierre Vivant's (b. 1952) installation is on a roundabout at the junction of East Tyndall Street and Ocean Way at the entrance to a large residential area and an industrial site. Known locally – and fondly – as 'the magic roundabout', it consists of six large, colourful geometric structures constructed from traffic signs spiralling out from the centre of the roundabout. The structures are surrounded by topiary fashioned into the same shapes.

Open-Air Art Museum at Pedvale (3)
Pedvale, Latvia
Ojars Feldbergs and others, from 1992
Near the small town of Sabile in western Latvia, is the 100-hectare Open-Air Art Museum founded by Latvian sculptor Ojars Feldbergs (b. 1947) in 1992. On an abandoned country estate, Feldbergs exhibits his work and that of others, such as Villu Jaanisoo (b. 1963) (see above), uniting virgin land with agricultural landscape and contemporary art. There are over 150 pieces in the permanent collection.

Artscape Nordland (4)
Nordland, Norway
Various artists, 1992–98
Thirty-three international artists, representing a range of sculptural tendencies created thirty-three site-specific artworks for the local municipalities of the northern Norwegian county of Nordland. Britons Tony Cragg (b. 1949) and Anish Kapoor (b. 1954), Irish sculptor Dorothy Cross (b. 1956), Icelander Sigurdur Gudmundsson (b. 1942) and Dane Per Kirkeby (b. 1938) (see above) are amongst those who participated in Artscape Nordland (Skulpturlandskap Nordland), an initiative to bring contemporary art to a rural area.

The Sculpture Park in Thassos (5)
Kallirahi, Thassos, Greece
Various artists, from 1992
Marble sculptures in an olive grove in the village of Kallirahi, on Greece's northernmost island of Thassos. International symposiums are organized by Artlogos, a non-profit organization which invites artists such as Hektor Papadakis (b. 1960) (see above), to Thassos to work with its pure white marble.

5

6

7

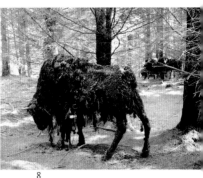

8

Tír Sáile – The North Mayo Sculpture Trail
Mayo, Ireland
Various artists, 1993

Fourteen site-specific sculptures are dotted along the rugged north Mayo coastline in the west of Ireland. The works were created on site during the summer of 1993 as part of a celebration of 5000 years of the region's history. Following the trail from Ballina to Blacksod takes you along miles of stunning, remote coastal landscape.

M8 Art Project (6)
Between Edinburgh and Glasgow, Scotland
Various artists, 1993–99

The M8 is Scotland's busiest motorway, connecting its two major cities, Edinburgh and Glasgow. It was historically known for being a particularly monotonous journey. The M8 Art Project's mission was to change this by siting monumental public artworks along the motorway. Artists have created site-specific works that break up the journey and function as landmarks. If driving from Edinburgh to Glasgow, the first major piece you encounter on the right is *Sawtooth Ramps* (1993) by Patricia Leighton (b. 1950). The striking earthwork of seven thirty-six-foot-high ramps measures 1000 feet long and has become known locally as *The Pyramids*. Next up is *The Horn* (1997) by Matthew Dalziel (b. 1956) and Louise Scullion (b. 1966). The massive (eighty feet high) wacky stainless steel horn heralds the halfway point of the journey and acts as a beacon for the Polkemmet Country Park. When you reach Mossend in Lanarkshire, you are greeted by David Mach's (b. 1956) *Big Heids* (1999) (see above). The three giant portraits (thirty feet high) are based loosely on people the artist met in Motherwell. The heads are made of thousands of pieces of steel and use upended containers as plinths. The work pays homage to the strength and resolve of local people, references the area's history as a site of the steel industry, and announces the location of Eurocentral, a new railfreight terminal.

Field of Corn
(with Osage Orange Trees) (7)
Dublin, Ohio, USA
Malcolm Cochran, 1994

American artist Malcolm Cochran (b. 1948) 'planted' 109 human-sized ears of concrete corn in rows in front of a row of real Osage orange trees on a large traffic island in Dublin, Ohio. Researching the site, Cochran discovered that it was formerly owned by Sam Frantz, a leading corn hybridizer of the 1940s and 1950s. While a celebration of the region's agrarian past, the installation's funereal presence also seems to be a eulogy for the rapidly disappearing rural landscape.

Tyrebagger Sculpture Project (8)
Near Aberdeen, Scotland
Various artists, from 1994

Twenty contemporary sculptures by artists such as Briton Sally Matthews (b. 1964) (see above), in Tyrebagger Wood in Kirkhill Forest and in the adjoining heathland of the Elrick Hill, near Aberdeen in northeast Scotland.

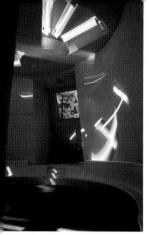

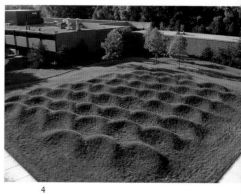

Dwan Light Sanctuary (1)

Montezuma, New Mexico, USA

Virginia Dwan, Charles Ross and
Laban Wingert, 1994–96

Art patron Virginia Dwan wanted to build
a space for quiet meditation for people of
all faiths. With the aid of American artist
Charles Ross (b. 1937) and architect Laban
Wingert, the nondenominational Dwan Light
Sanctuary was realized at the United World
College in Montezuma, New Mexico.
Twenty-four of Ross's long glass prisms
bathe the conical chamber with the changing
solar spectrum.

The People's Gallery

Derry, Northern Ireland

The Bogside Artists, 1994–2008

The Bogside Artists (Tom Kelly, Kevin
Hasson and William Kelly) worked
collaboratively on twelve large-scale murals
on buildings along Rossville Street in the
area of Derry known as 'Free Derry Corner'.
The majority tell the Bogsiders' story of thirty
years of civil conflict during 'The Troubles'.
These are primarily monochromatic and
photorealist. The final one as you leave the
area is a brightly coloured mural dedicated to
peace and the hope for a better future, while
the 2008 mural features portraits of John
Hume, Martin Luther King, Jr, Nelson
Mandela and Mother Teresa, all recipients of
the Nobel Peace Prize. The artists' goal is to
use their art as a tool in the ongoing struggle
for peace and reconciliation by documenting,
commemorating, educating and uplifting.

Zoom in/Turn Around (2)

The Hague, Netherlands

Marin Kasimir, 1995

In the parking garage of the gorgeous all-
white City Hall and Central Library (Stadhuis
en Bibliotheek) by American architect
Richard Meier (b. 1934) on the Spui is an
artwork in an unexpected public space.
Along the back wall hangs *Zoom in/Turn
Around*, an extraordinary 820 degree
panoramic photograph by German artist
Marin Kasimir (b. 1957), measuring seventy-
five metres long by two metres high, that
draws you into life on the Spui. There are
also eighty-two close ups of sections of the
panorama hanging throughout the City Hall
and Library.

Mennesket ved havet (Man meets the Sea) (3)

Esbjerg, Denmark

Svend Wiig Hansen, 1995

Visitors to the port city of Esbjerg, Denmark
on the North Sea are confronted by Danish
artist Svend Wiig Hansen's (1922–97) colossal
sculpture *Man meets the Sea*. The nine-metre-
high sculpture sits on the shore and depicts
four seated figures gazing out at the sea.

The Wave Field (4)

Ann Arbor, Michigan, USA

Maya Lin, 1995

The Wave Field is an earthwork by American
artist Maya Lin (b. 1959), famed for the
Vietnam War Memorial in Washington, DC.
Located in the courtyard of the FXB
Aerospace Engineering Building of the
University of Michigan, it consists of grass
waves in eight rows which rise to five or six
feet high, engulfing or sheltering the viewer.

Refuges d'art

Digne-les-Bains, France

Andy Goldsworthy, from 1995

British artist Andy Goldsworthy (b. 1956)
is creating thirteen *Refuges d'art* in the

5

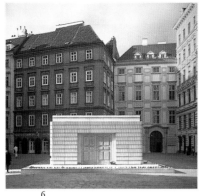

6

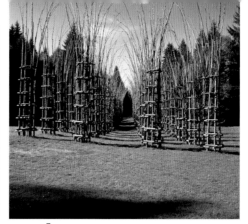

7

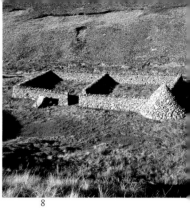

8

countryside of Alpes-de-Haute-Provence. He has built cairns (stone cone-shaped monuments) in each of the area's three valleys and rebuilt other old buildings as shelters. A walk of about ten days is necessary to link all the works, which are spread over more than one hundred miles.

Sculpture in Woodlands (5)
Devil's Glen Wood, Ashford, Ireland
Various artists, from 1995
About four kilometres from the village of Ashford in County Wicklow, south of Dublin, is the Devil's Glen Wood. Owned by Coillte, a state-owned forestry company, 600 acres of the woodland is used as an open-air sculpture gallery. There are sixteen monumental site-specific sculptures by artists such as Janet Mullarney (see above) located in the magnificent woodland.

Holocaust Memorial (6)
Vienna, Austria
Rachel Whiteread, 1996–2000
Austria's first memorial to the 65,000 Austrian Jews who lost their lives in the Holocaust was unveiled in 2000. The austere cast concrete monument by British sculptor Rachel Whiteread (b. 1963) is 12 feet high, 24 feet wide and 33 feet long. The stark white sculpture is of a room full of books, but one with doors that can't be opened and of books without titles or authors. Much of Whiteread's work is involved with memory, absence and loss, like this 'nameless library', which gives cause to reflect on lives lost and stories untold.

ARTENATURA (Art in Nature) (7)
Arte Sella, Borgo Valsugana, Italy
Various artists, from 1996
Arte Sella, a summer biennial exhibition of contemporary art and nature projects, began in 1986 in the woods of the Val di Sella in Trento, Italy. Since 1996 many of the works created for the exhibitions have been placed along a path on the slope of the Armentera mountain. The ARTENATURA route runs about three kilometres through lovely woods and fields, climaxing with Italian artist Giuliano Mauri's (b. 1938) monumental growing *Tree Cathedral* (2001), which is the same size as a Gothic cathedral (see above).

Sheepfolds (8)
Cumbria, England
Andy Goldsworthy, 1996–2003
Andy Goldsworthy (b. 1956) used existing derelict sheepfolds (dry stone constructions built to pen sheep) to root his massive countywide environmental sculpture in Cumbria, in northwest England. Forty-six of these agricultural structures were rebuilt or repaired and transformed into artworks. Many feature sculptures inside of them, and all interact with their location, drawing attention to the history and geography of the region and its strong farming tradition. The sculptures are sited in barren, isolated spots, in town centres and along a motorway, highlighting the changing use of the land. Searching out these hidden sculptures makes you more acutely aware of your surroundings and soon all the stone constructions, whether artist-made, man-made or nature-made, begin to seem like extraordinary artworks.

Domagojeva ladja (Domagoj's boat) (1)
Vid, Croatia
Stjepan Skoko, 1997

Vid is on the site of the ancient city of Narona in the Neretva Delta in Dalmatia. The tiny village is home to many newly discovered archaeological treasures and an impressive new sculpture by Stjepan Skoko (b. 1959) from Bosnia and Herzegovina. The bronze sculpture represents Croatian Prince Domagoj (864–76) and members of his navy who successfully defended the coast by defeating the Venetians at sea. It certainly calls to mind the continual struggle for control of the seas and for national independence. Located atop a little hill, the 4.2 by 5 by 7.7 metre sculpture acts as a beacon for Vid – drawing you to it to explore further, and to the splendid views over the wetland valley.

Herring Island Environmental Sculpture Park (2)
Melbourne, Australia
Various artists, from 1997

Herring Island is in the Yarra River near Melbourne. A former basalt quarry, it is now a conservation and recreation area. In the late 1990s a number of environmental artists were invited to create site-specific works out of natural materials that would complement the bush setting. Work by Briton Andy Goldsworthy (see above) and Australians John Davis, Jill Peck, Julie Collins, John Gollings with Samantha Slicer, Robert James, Robert Jacks, Ellen Jose and Robert Bridgewater can be seen around the island.

Train (3)
Darlington, England
David Mach, 1997

In Morton Park on the A66 on the edge of Darlington in northeast England, is Scottish artist David Mach's (b. 1956) *Train*. The gigantic brick sculpture of a train emerging from a tunnel of smoke pays tribute to the area's railway heritage and the engineering feats of those involved. Mach's *Train* is life size, measuring some fifty metres long by six metres high and took over 185,000 bricks to make. It is sited on land that used to be part of the original Stockton to Darlington Railway, which launched the world's first steam-hauled passenger train in 1825.

La Serpara (4)
Civitella d'Agliano, Italy
Paul Wiedmer and others, from 1997

La Serpara is a sculpture park in the grounds of the home of Swiss artist Paul Wiedmer (b. 1947) in central Italy. The collection includes his own work – mostly iron sculptures, usually with an element of fire – and that of some of his artist-friends, such as Italian Bruno Ceccobelli (b. 1952), Slovakian Pavel Schmidt (b. 1956), Swiss artist Ursula Stalder (b. 1953) (see above) and Romanian Daniel Spoerri (b. 1930).

Both Nam Faileas: Hut of the Shadow (5)
Lochmaddy, North Uist, Scotland
Chris Drury, 1997

A grass-roofed, granite structure by British artist Chris Drury (b. 1948). It has three mirrors and a lens built into one of its walls, which projects the dramatic landscape of the Western Isles onto the opposite wall. The experience is rather like watching an old movie of the elements while simultaneously being sheltered from them.

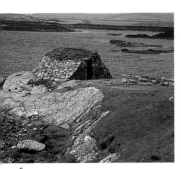

5

6

7

8

A13 Artscape (6)
London, England
Various artists, 1997–2004
The A13 Artscape is an ambitious public art project transforming six kilometres of the A13 motorway through the harsh urban landscapes of the industrial boroughs of Barking and Dagenham in east London. Lead creative on the project, Irish architect Tom de Paor (b. 1967), envisioned a linear park along, through and around the motorway which would 'fire your curiosity and make a whole new road experience'. de Paor has collaborated with a number of artists on the project in his quest to choreograph this new environment for pedestrians, cyclists and drivers, both during the day and at night. The composition includes earthworks, lighting, installations, sculptures and growing landscape elements, which link the areas as well as punctuate the journey. Particularly striking elements include *Pump House* by de Paor and Clare Brew at Movers Lane (see p. 6), Anu Patel's subway approach (see above) and the *Twin Roundabouts* at the interchange of the old A13, now the A1306,

by Thomas Heatherwick (b. 1970). Heatherwick's whimsical structures on the roundabouts look like the road's tarmac has been pulled up into the sky.

Bramme (für das Ruhrgebiet) (Slab (for the Ruhr district))
Essen, Germany
Richard Serra, 1998
American sculptor Richard Serra's (b. 1939) *Bramme* is a gigantic slab of solid steel that measures 14.5 metres high by 4.2 metres wide and weighs 70 tons. It sits atop the fifty-metre-high Schurenbachhalde, which is a landscaped mound created in 1995 on the site of a former waste dump for the neighbouring coal mines. Both the sculpture and the mound pay tribute to the steel and coal industries of the area and draw the viewer to them and to a magnificent view of the Ruhr district.

The Fields Sculpture Park (7)
Omi, New York, USA
Various artists, from 1998
The Fields Sculpture Park is part of the Art Omi International Arts Center, a multi-disciplinary arts retreat in Omi, New York, a small hamlet in the Hudson River Valley, about a two-hour drive north of Manhattan. There are 400 acres of rolling farmland with different terrains in which to site sculptures by internationally known artists such as Americans Carl Andre (b. 1935), Donald Lipski (b. 1947) (see above), Dennis Oppenheim (b. 1938) and Beverly Pepper (b. 1922), Dane Olafur Eliasson (b. 1967) and Frenchman Bernar Venet (b. 1941) (see p. 6). There are over 80 contemporary sculptures in the growing collection.

Art House Project (8)
Honmura, Naoshima, Japan
Various artists, 1998–2006
In Honmura village on the island of Naoshima, seven derelict traditional buildings were transformed into permanent artworks by artists and architects. Japanese artists Tatsuo Miyajima (b. 1957), Rei Naito (b. 1961) and Hiroshi Sugimoto (b. 1948) (see above) created works, and American James Turrell (b. 1943), collaborated with architect Tadao Ando (b. 1941) on an installation in a Buddhist temple on an ancient site.

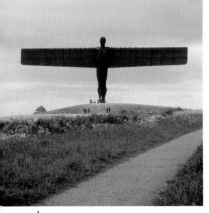

1

2

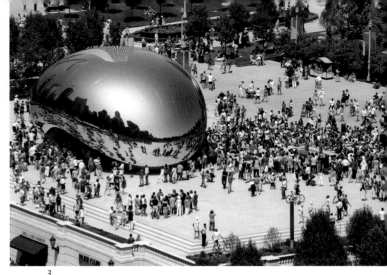

3

The Angel of the North (1)

Gateshead, England

Antony Gormley, 1998

This majestic public artwork by Briton Antony Gormley (b. 1950) is sited on a hill above a former colliery pit head bath in Gateshead, in northeast England. Built from 208 tonnes of steel it towers at twenty-eight metres in height, with a wingspan of fifty-four metres. Both the physical site of the sculpture – the mine and the hill, which reminded Gormley of a 'megalithic mound' – and the spirit of the place – a 'celebration of this industry'– are vital to the success of the piece, which has been embraced by the public as a place to visit and as a testimony to the history of the area and its people.

Isla de Esculturas (Island of Sculptures)

Xunqueira Island, Pontevedra, Spain

Various artists, 1999

This tiny island inside the city of Pontevedra on Spain's Atlantic coast is home to twelve impressive installations by world-class international artists, such Italian Giovanni Anselmo (b. 1934), Americans Robert Morris (b. 1931), Dan Graham (b. 1942) and Jenny Holzer (b. 1950), German Ulrich Rückriem (b. 1938) and British artists Richard Long (b. 1945) and Ian Hamilton Finlay (1925–2006). The commission had two criteria – that the works must be made out of granite and that they must engage with their natural surroundings. The resulting thoughtful works sit beautifully in their raw natural setting.

Slice of Reality (2)

Greenwich, London, England

Richard Wilson, 1999

British sculptor Richard Wilson's (b. 1953) *Slice of Reality* is an astounding site-specific sculptural/architectural construction permanently installed on the Thames riverbed. It is a twenty-metre-high sliced vertical section of a 600-ton sea-going sand dredger.

Millennium Park (3)

Chicago, Illinois, USA

Frank Gehry, Anish Kapoor and Jaume Plensa, 1999–2004

Chicago's outstanding collection of architecture and public art was further enhanced with the creation of Millennium Park. The centrepiece of the park is the stunning Jay Prizker Pavilion, designed by famed Canadian-American architect Frank Gehry (b. 1929). Gehry also contributed the twisting pedestrian footbridge providing new views of the city. Other highlights include Indian-born British sculptor Anish Kapoor's (b. 1954) 110-ton stainless steel sculpture, *Cloud Gate*, and *The Crown Fountain* by Spanish sculptor Jaume Plensa (b. 1955).

Skulpturenpark Drau-Rosental (4)

Drau River, Rosental, Austria

Various artists, from 1999

In the Rosental region of southern Austria, near the border with Slovenia, there is a two mile-long sculpture park along the banks of the Drau River. It features monumental environmental sculptures by Austrian and international artists including Americans Patrick Dougherty (b. 1945) and Tim Curtis (see right), Nigerian-born German Mo Edoga and Austrian Johann Feilacher (b. 1954).

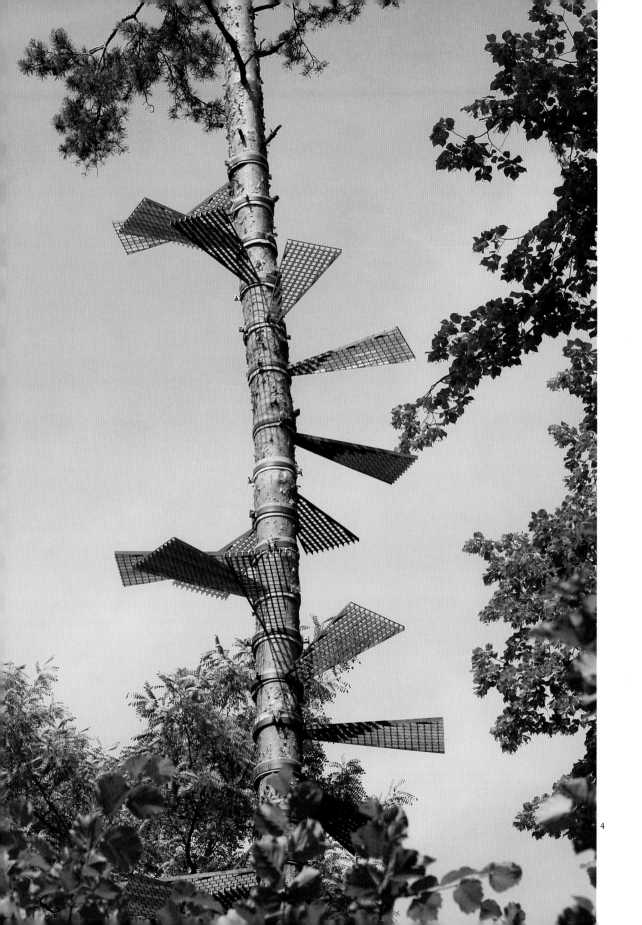

4

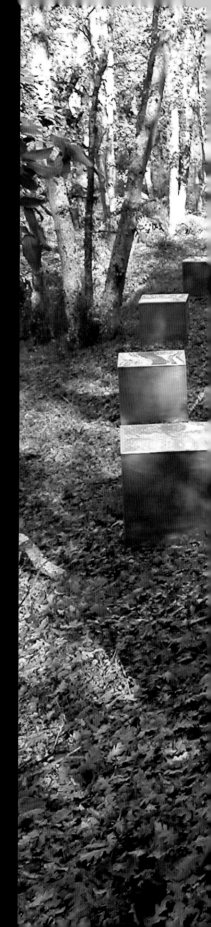

FIVE:
INTO THE FUTURE

LAROUCHE

LAROUCHE, QUEBEC, CANADA
Claude Simard
From 2000

Everything is possible. You can do something great even in the smallest of contexts. CLAUDE SIMARD

An extraordinary and fascinating, not to mention ambitious, artwork is taking shape in rural Quebec under the watchful eye of Canadian artist Claude Simard (b. 1956). The site, and to a certain extent, the subject, of the installation is Larouche, a village of around one thousand inhabitants. It is Simard's hometown, and although he left in 1976, his ties to the village where his family still lives remain strong. His bold vision for Larouche is nothing short of turning the village into a living, breathing work of art. This involves reshaping the visual landscape through the insertion of built elements integrated into the existing environment. The project is conceived as a single, evolving work, in which the new elements are not randomly imposed, but carefully situated to guide the viewer on a voyage of discovery throughout the village. This journey facilitates contact between a variety of cultures, exposure to different art tendencies and forms of expression, and highlights the surrounding natural beauty of the area.

The project was conceived in 2000. As of 2010 this work-in-progress has involved the purchase of eighteen buildings and their transportation to Larouche. The majority of these are from Quebec and include the village's first outpost (1890 – Larouche was founded in 1895), a Quebec house and two presbyteries (priests' houses) – one from 1895 and the other from the 1920s, an old cabinet-making warehouse and a number of houses from the 1930s and 1940s. Many of these have been saved from destruction and moved to the centre of Larouche, creating a walk through the traditional architecture of the region. A stroll down main street immediately makes clear the all-pervasive influence of the Catholic Church in the formation of the identity of the region.

The most astonishing elements in the transformation of Larouche are the buildings transplanted from southern India, which Simard

Top The Canadian village of Larouche lies nestled in the hills of rural Quebec. *Above* Several Quebec buildings have been transported to Larouche. The right-hand building will be an exhibition space for video art, while the building on the left will house a permanent exhibition of work by Canadian artist Arthur Villeneuve (1910–90).

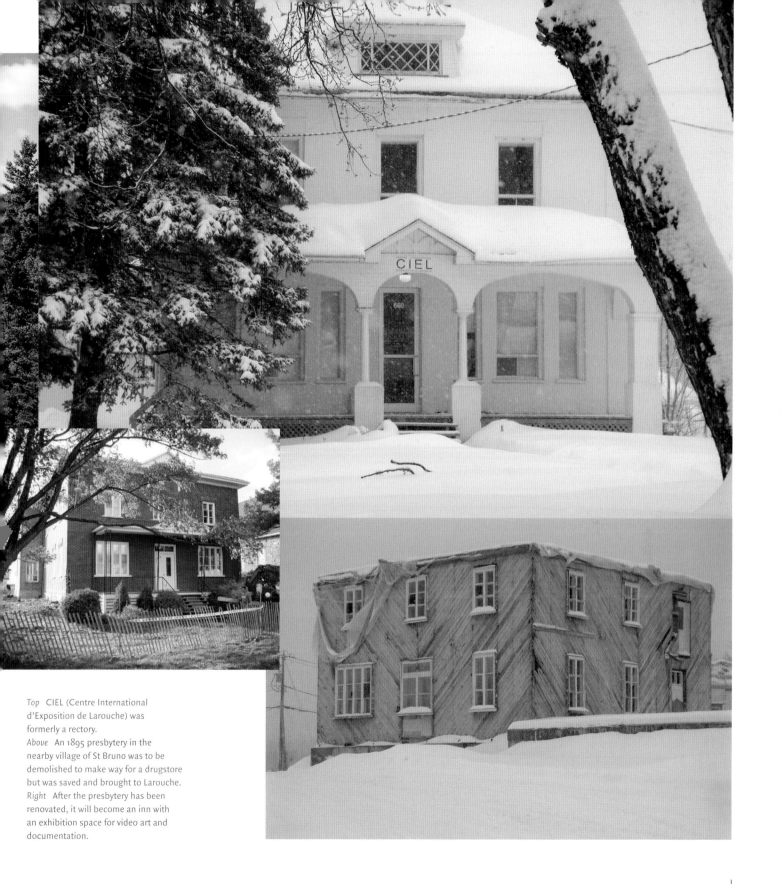

Top CIEL (Centre International d'Exposition de Larouche) was formerly a rectory.

Above An 1895 presbytery in the nearby village of St Bruno was to be demolished to make way for a drugstore but was saved and brought to Larouche.

Right After the presbytery has been renovated, it will become an inn with an exhibition space for video art and documentation.

came across during his travels. In order to save them from imminent destruction, he bought a sixteenth-century mosque and two eighteenth-century Indo-Portuguese churches and had them dismantled and shipped to Larouche where they are being painstakingly reconstructed piece by piece. One of these Indian buildings, the façade of Manassery Church, will occupy the privileged position formally claimed by the bell-tower of the parish church, that of the village focal point. The other Indian church façade, that of Pariyaram St George's, is located behind the village school at the threshold of the park, acting as a beacon, providing a welcoming entrance to the network of pedestrian trails through the natural environment. The Muslim Mosque and Pavilion of Thirunelveli (originally a Hindu temple) is being installed on a small mountain in the village, giving a sense of promenade to the whole installation and leading to a path that provides access to a panoramic view of the village. Plans are also underway to transport and install a seventeenth-century Brahmin's (Hindu priest) dwelling, a typical Hindu house and another church of Indo–Portuguese origin that includes an abbey and a refectory.

Simard plans to exhibit Indian art and artifacts in these buildings alongside international visual and applied art, and in the Quebec buildings, Canadian with international art. In this gathering of places of worship, homes of spiritual leaders and ordinary citizens of different religions and nationalities one cannot help but reflect on how strong religious heritage informs culture and helps shape its identity.

In addition to the religious buildings, the multi-faceted project so far also includes a gas station, inn and restaurant opened by Simard. The restaurant, Chez Margot, which opened in 2003, serves regional food with a French twist to truck drivers and the glitterati alike. It has changing exhibitions of art – from modern masters to contemporary newcomers – which the staff are trained to be able to explain. It has initiated his projects of integrating art into daily life and providing employment opportunities. These elements of the project are part of the 'long vision', demonstrating Simard's awareness that if Larouche is to become a 'destination', supporting facilities are necessary to make the journey attractive and practical. The whole scheme is ultimately devised to provide a rich and varied experience for the viewer, whether resident or visitor.

In an international context, Simard's project seems to hark back to, and continue, the utopian vision of those of the past who believed

Opposite A nineteenth-century Keralan courtyard fence to be installed in a street in Larouche.
Far right One of the eighteenth-century Indo-Portuguese churches in India where it was due to be demolished to make way for a car park. After two years of negotiations, Simard managed to buy it and transport it to Larouche where it will be rebuilt (right).

fervently that art and architecture could enrich, educate and inspire. Briton William Morris (1834–96) of the Arts and Crafts movement at the end of the nineteenth century comes to mind, as do the pioneering German and Dutch modernist architects of the 1920s, and those of the 1960s and 1970s, such as Constant, Archigram and Archizoom. Closer to home, in a Canadian, and particularly, Quebecois context, Simard's project can be seen as extending the project of modernizing Quebec society and dragging it into the international arena begun by predecessors such as Paul-Émile Borduas (1905–60) and Jean-Paul Riopelle (1923–2002). In 1948 Borduas and his followers published *Refus Global* (Total Refusal), which took the conservative political regime to task and laid much of the blame for the provincial, repressed nature of Quebec society on the Catholic Church. As much a political manifesto as an artistic one, the document and the attitudes it expressed has since led the artists involved to be credited with helping to propel Quebec into the modern age. Simard seems to be extending the programme to this forgotten corner of the province.

In an age of archness and defeatism, when irony and cynicism are fashionable (or easier?), what a joy to encounter an artist who genuinely and passionately believes in the possibility and power of art to effect change. Importantly, this conviction is backed up by the drive and commitment to put it into practice. Instead of bemoaning the state of the world, or the arts, Simard has knuckled down and taken on the challenge of proving to himself and others that art can be redemptive, and a force for good. To do this, he has had to learn and take on the roles of a museum, or indeed, those of an urban planner – fundraising, planning permission, consultation and convincing those affected of the positive outcomes of his plan.

While some were originally suspicious of Simard's motives, his enthusiasm for the project and the commitment he has demonstrated so far have been infectious. The Centre International d'Exposition de Larouche (CIEL, International Centre for the Exhibition of Larouche) has been formed to purchase and exhibit works and local government is firmly on board, hiring a full-time employee to catalogue all the works. What began as the vision of one man has evolved into the shared aspirations of a large part of the community. While Simard squirms when confronted with the altruistic nature of his project, insisting that it is as much to do with his artistic vision as his social commitment, I for one, am confident that the transformation of Larouche will enhance and enrich the lives of its residents and visitors alike.

MONTENMEDIO ARTE CONTEMPORANEO

VEJER DE LA FRONTERA, SPAIN
Various artists
From 2001

Exploring the site-specific sculptures
in this nature reserve can be a dazzling
experience. Olafur Eliasson's
Quasi Brick Wall (2003) is made from
mirrored crystalline bricks and enacts
a constantly changing dialogue with
the natural environment and the viewer.

It is a place abstracted now, almost, to art. RICHARD NONAS

Montenmedio is a vast five hundred-hectare estate in southern Spain near Cádiz overlooking Cape Trafalgar, where the Atlantic Ocean meets the Straits of Gibraltar. Three hundred hectares of the estate are a nature reserve. Since 2001, thirty hectares of the reserve have been given over to site-specific art. This new centre for contemporary art, Montenmedio Arte Contemporaneo (NMAC Foundation), is in the process of creating a permanent outdoor collection of art which engages with its surroundings, be it the landscape or the socio-political or historical character of the region. It also hosts temporary exhibitions and events.

NMAC Foundation aims to become a focal point for contemporary art in this rural region; one that can converse with the international scene and serve as a catalyst for the regeneration of the area. Each year, an international cast of artists is invited to create works on site. The site-specific nature of the artworks reinforces these objectives by focusing attention on the locale and lends a very distinctive flavour to the whole project. An itinerary is provided which guides you to the sculptures and also takes you on a tour of the varied landscape and its flora and fauna, which includes numerous types of migratory birds, wild animals, pine, wild olive and cork trees, a lake and a quarry. The outdoor sculptures are interspersed throughout, like another species to be protected and preserved for the future.

Serbian Marina Abramovic (b. 1946), Italian Maurizio Cattelan (b. 1960), Dane Olafur Eliasson (b. 1967), Scot Anya Gallaccio (b. 1963), Americans Sol LeWitt (1928–2007) and Richard Nonas (b. 1936), Spaniard Susana Solano (b. 1946), Chinese artists Huang Yong Ping (b. 1954) and Shen Yuan (b. 1959) and Polish-born Aleksandra Mir (b. 1967) are amongst those who have created pieces for the outdoor collection so far. The reactions of the artists to the social and historical dimensions of the region as well as its

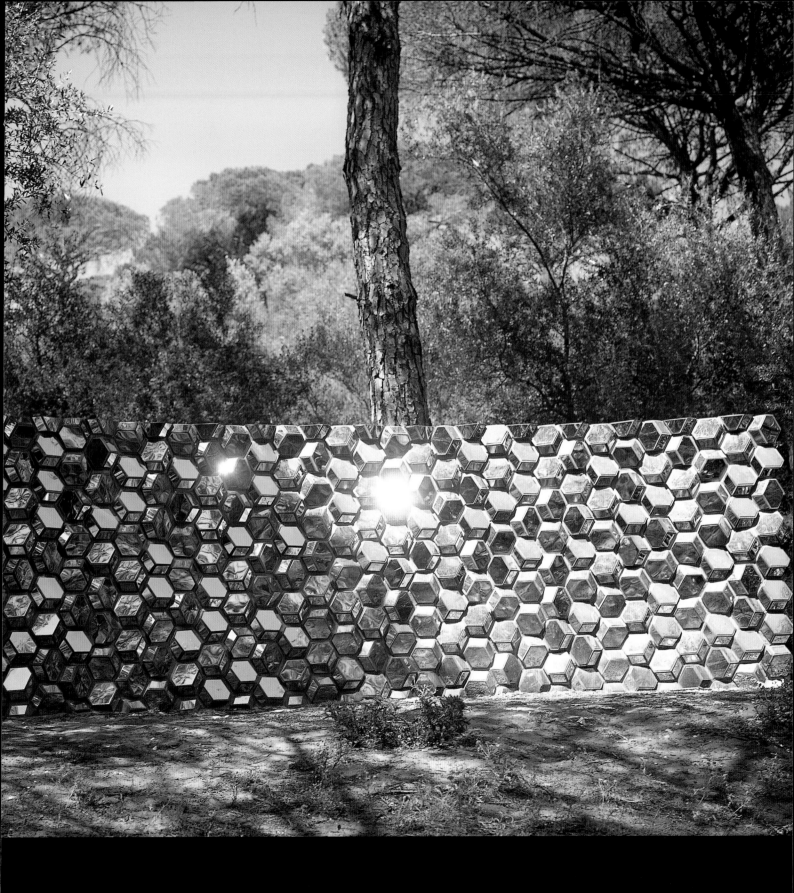

landscape provide the viewer with interesting ways to discover and think about his or her surroundings. For instance, the province of Cádiz is a crossroads between Europe and Africa, on the path of migrating birds and human beings, a fact captured beautifully by Abramovic's *Human Nests* (2001), seven small cave-like 'nests' dug into the quarry.

With *Transplant* (2001), a fourteen-metre high stainless steel tree, American Roxy Paine (b. 1966) has introduced a new species into a nature reserve that is preserving the old. Standing tall on a hill above the surrounding trees on land that was once farmland, is it people's fears about genetically-modified organisms made manifest? Or is it a poignant reference to immigration and the alienness that one feels when 'transplanted' to a new culture? It need not be all doom and gloom though, for this new shimmering tree serves as a proud beacon for this locus of a conversation between nature and culture and has been adopted by the birds as a resting place.

Eliasson's *Quasi Brick Wall* (2003), with its mirrored crystalline bricks, enacts a constantly changing dialogue with its natural environment, especially the light, and the visitor. While the viewer becomes a part of the spectacle in Eliasson's work, in Mir's *Love Stories* (2005), the public is both the subject of the work and was an integral factor in its creation. One thousand love stories were collected from the public and the initials of the protagonists were carved in hearts into pine trees in the forest. This created a sense of ownership in the project and a guidebook produced with the stories in them points out 'their' tree to those who participated. The work raises interesting issues about private and public acts, for here what is usually a private act has been turned into a public display and the stories behind the initials are freely available to read. Is it a comment on contemporary society's seemingly endless fascination with peering into the private lives of others as well as on its desire to bare all in a public forum? For the time being, the work is adding an art dimension to the wooded area, but it will eventually be reclaimed by nature when the bark grows over the carvings.

While still early days, the NMAC Foundation is well on its way to achieving its aims of providing contemporary art in a rural region and making that location a destination for fans of art and nature projects by building an impressive collection of relevant, thought-provoking artworks.

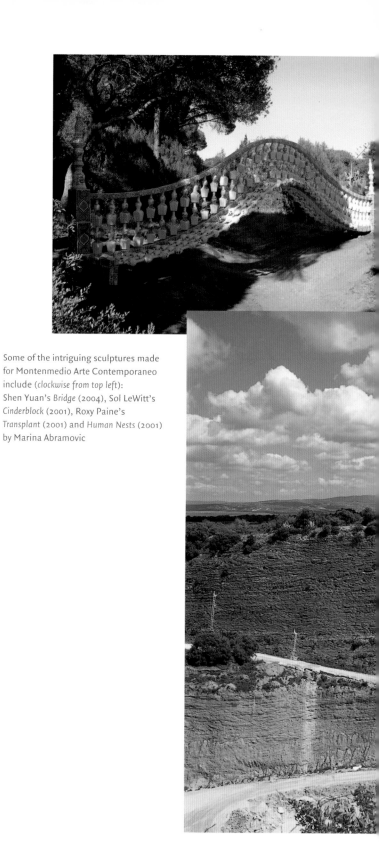

Some of the intriguing sculptures made for Montenmedio Arte Contemporaneo include (*clockwise from top left*): Shen Yuan's *Bridge* (2004), Sol LeWitt's *Cinderblock* (2001), Roxy Paine's *Transplant* (2001) and *Human Nests* (2001) by Marina Abramovic

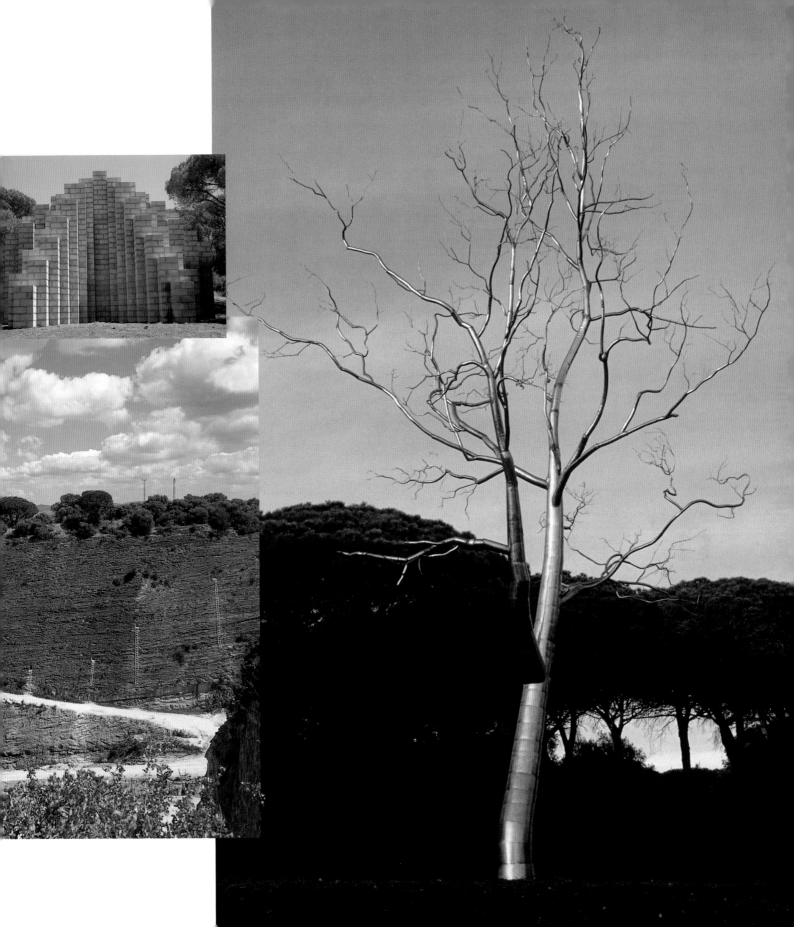

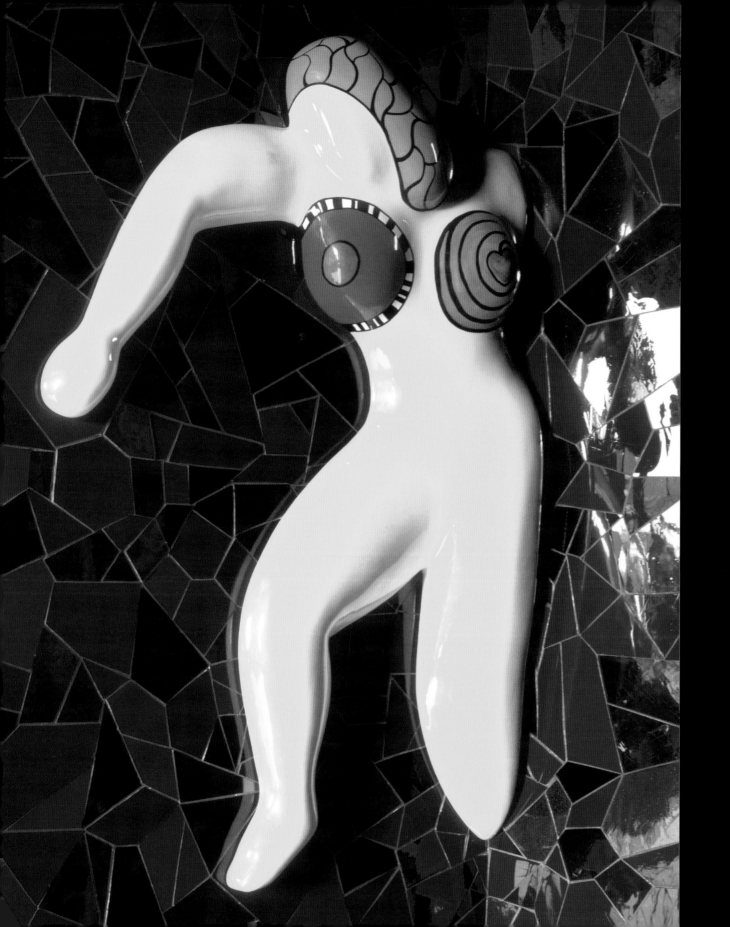

THE GROTTO

HANNOVER, GERMANY
Niki de Saint Phalle
2001–03

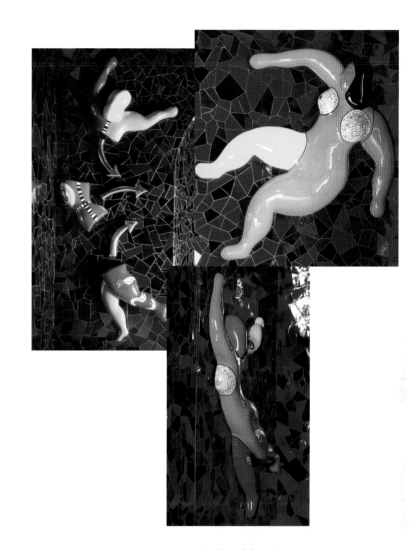

I work in the darkness of a secret tunnel, always searching for the Sun, hiding from the Moon, and paying homage to the stars. NIKI DE SAINT PHALLE

The baroque Grosser Gärten (Great Garden), of the Herrenhäuser Gärten in Hannover in northern Germany, was begun in 1666 and expanded between 1674–78 and 1696–1714. Grottoes, artificial enchanted caves to delight and retreat to on a hot day, were important features of baroque gardens. The three-room grotto in the Great Garden was built in 1676–80 and its interior was decorated with shells, crystals, minerals and had a pebble mosaic floor and a number of fountains. It quickly fell into disrepair and the interior decorations were lost during emergency repair work during the second half of the eighteenth century. In 1966 the exterior was restored for the three hundredth anniversary of the gardens, but the building remained closed to the public and served as a rather grand garden shed. It was not until Hannover's hosting of the Expo 2000 World's Fair prompted further restoration that the grotto was reopened to visitors.

The bare interior of the empty grotto was less than enchanting. As there wasn't enough documentary evidence to facilitate a faithful reconstruction of the original interiors, Franco–American artist Niki de Saint Phalle (1930–2002) was commissioned to bring the rooms back to life. Saint Phalle's relationship with the city stretched back to 1974, when she was given her first major commission. Three giant *Nanas* (brightly-coloured, jubilant, voluptuous female figures) were installed on the bank of the river Leine near the town hall. Originally a source of controversy, the sculptures quickly became much-loved landmarks. They were named Caroline, Charlotte and Sophie after important Hannoverian women by the city and are part of what is now known as the 'Mile of Sculpture' along Brühlstrasse and Leibnizufer.

Saint Phalle's elaborately ornamented grotto is a joy to experience. The first hint that you are about to enter something rather special is

Opposite and above Every aspect of Niki de Saint Phalle's *Grotto* in Germany is a whirlwind of colour, texture, movement and emotion, including these relief sculptures of dancing women in the magical *Blue Room*, with its theme of 'Night and the Cosmos'.

the ornamented stainless steel *Entrance Hall Grate* and the window grates on the Neoclassical façade. Inside, the three rooms have vaulted ceilings and are covered with mosaics of coloured glass, mirrors, pebbles and painted figures.

The Entrance Hall, or 'Room of Spirituality', has a pillar in the centre with gorgeous yellow, gold and red glass and pebble mosaics, which spiral around it, spread out over its ceiling and walls and lead to the other two rooms. To the left is the shimmering, sparkling *Silver Room*, on the theme of 'Day and Life', which contains over forty relief sculptures of animals, flowers and figures. To the right is the *Blue Room*, whose theme is 'Night and the Cosmos' and features brightly-coloured dancing female figures reaching for the stars in a rich ultramarine world. *The Grotto* is lit by natural light coming through the windows. The ever-changing light dances over and reflects off the mosaics such that the structural elements of the building seem to dematerialize as the visitor enters the dazzling mirrored rooms. The effect seems like being inside a giant kaleidoscope or precious jewel. During the summer months *The Grotto* is illuminated a few evenings a week and the effect is even more spectacular.

Sadly, Saint Phalle did not live to see the finished work. *The Grotto* was completed according to her instructions after her death in 2002 and opened to the public in 2003. Saint Phalle transformed the empty historical grotto into a magical one for the twenty-first century. It fulfills its purpose of enchanting and delighting and holds its own admirably in the setting of the grand formal Great Garden.

For admirers of Niki de Saint Phalle's work, Hannover is a treasure trove. In addition to *The Grotto* and the *Nanas* in the 'Mile of Sculpture', the Sprengel Museum of Modern Art has almost four hundred works which Saint Phalle donated in 2000.

Below and opposite below These relief sculptures – of a snake, dolphin, spider and flower – can be found in the shimmering *Silver Room*, with its theme of 'Day and Life'.

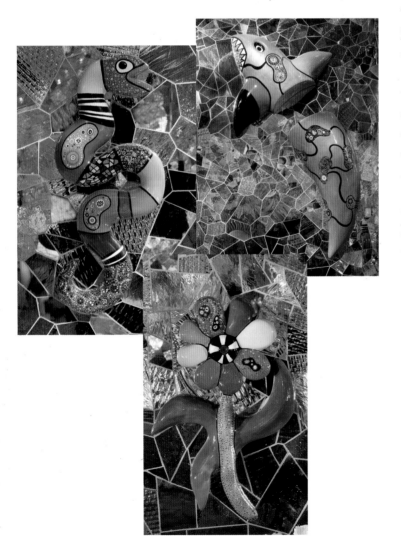

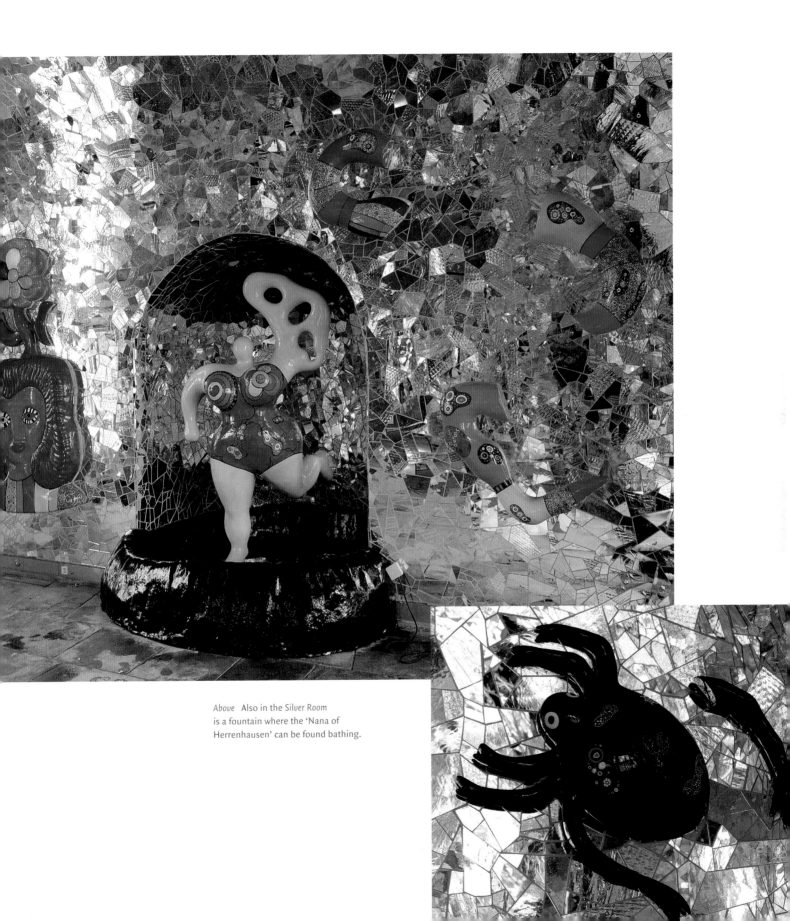

Above Also in the *Silver Room* is a fountain where the 'Nana of Herrenhausen' can be found bathing.

STEPINAC AND NYERERE

DAKAWA, TANZANIA
Ivan Klapez
2002–09

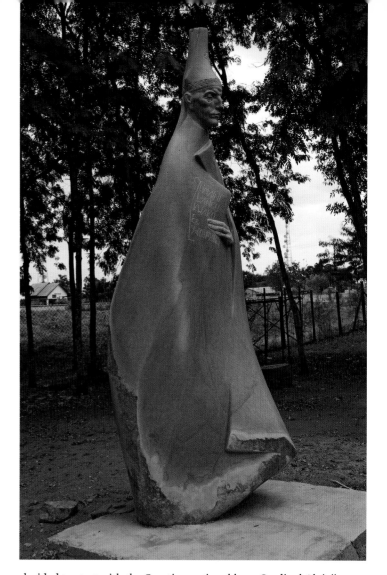

The world may destroy all material goods but cannot belittle the dignity of the human person. ALOJZIJE STEPINAC

Ivan Klapez (b. 1961) is a Croatian sculptor living and working in London. He exploits the expressive quality of materials and the architecture of forms to convey abstract qualities through sculptural composition. Whether through figures of the destitute and lonely, musicians and writers or the soaring forms of skyscrapers, Klapez seems to be addressing the human will to be and to create, in works which express the difficulties of those struggles as well as the ultimate dignity of those who try.

Klapez's brother, Father Drazan Klapez, is a Catholic missionary who has been working in Tanzania since 1982. Until April 2003 he was based in Ujewa, where he helped build a residential school for orphaned girls, a hospital and a church. Ivan offered to create a sculpture for the complex, as a way to contribute to the project and to mark the twenty years his brother and his colleagues had spent in the community. In 2002 Ivan spent a few months in Ujewa formulating ideas and searching for appropriate pieces of granite. While he had worked out a few possible ideas in terracotta maquettes which he fired in the earth, he knew that the materials he found would play a much larger role than usual in the creative process, becoming in a sense, a collaborator in it.

Ivan explains. Usually he works on a piece up to a plaster model and then goes to a quarry and there chooses from a selection of square cut blocks the one which suits his preconceived composition. Here, however, there are no machine-cut square blocks, but irregular-shaped ones discovered buried in the earth. This reverses the process, such that once a piece of granite is found, its shape suggests the object hidden within and Ivan becomes, in a sense, the liberator of the figure, working with a plaster model in response to the granite itself.

For instance, in the somewhat triangular shape of the first healthy piece of granite he found near Ujewa, Ivan saw bishop's robes, so decided to start with the Croatian national hero Cardinal Alojzije Stepinac (1898–1960). Stepinac's support of the persecuted during the Second World War, his unrelenting stance against the religious repression of the Communist regime and refusal to recant, transformed him from merely a religious hero into a national symbol of resistance and independence.

The next granite Ivan was able to free from the earth was earmarked to become the Tanzanian national hero Julius Nyerere (1922–99). Nyerere was the first president of Tanganyika (later the United Republic of Tanzania after it merged with Zanzibar in 1964), which became independent in 1961. A champion of education and lifelong learning, Nyerere dedicated his life to the development of the new nation. By the time of his resignation in 1985, he was one of the most respected and influential leaders in Africa. Despite the failure

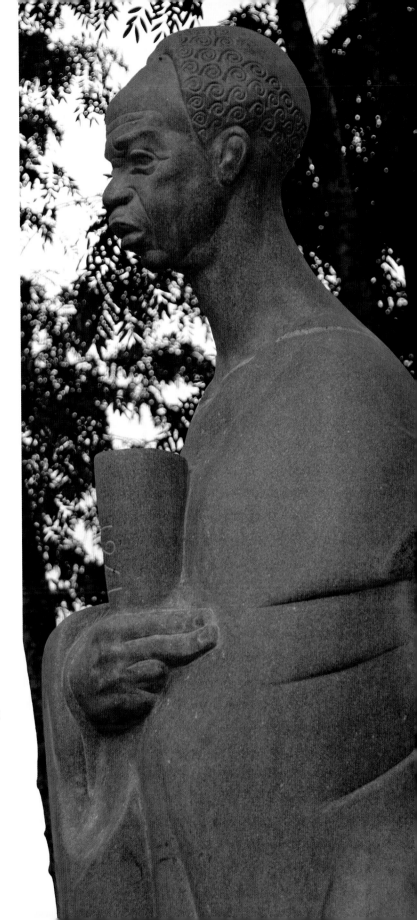

of his economic reforms, his legacy to Tanzania included increased literacy, a sense of national identity and unity, peace and stability.

Before Ivan could finish the sculptures, Father Klapez and his colleague, Father Nikola Saric, were transferred to Dakawa Parish in Mvomero district in the Morogoro Region. Dakawa Village is on the main road leading from Dar es Salaam, the commercial capital of the country, to Dodoma, the political capital of the country. It was decided that the two works-in-progress would accompany them on their new venture, whereby instead of commemorating past work they would signal and mark the beginning of the new.

It had to be quite a sight as the two new priests rolled up with their massive sculptures in tow. The priests received a warm welcome from the mixed community, which is made up of many different tribes and faiths, including followers of Islam, Christianity and African religions. The sculptures have also been embraced by the community and now serve as a meeting place and the focal point of the developing village. The locals were fascinated by the use of plaster and granite, as the vernacular tradition is carving in wood. The sheer scale of the figures, which measure around four metres high and weigh between ten and twenty tons, also astounds.

Both the village and the sculptures developed together. Ivan finished the sculptures in 2009, at which point an irrigation system, kindergarten and church (also designed by Ivan) had been completed in Dakawa. Future plans include a health centre and more schools. These awe-inspiring sculptures add a special extra element to the area and certainly a new dimension to its identity. They have caught the eye of the art world and government officials, which in turn has brought the needs of the developing community to a wider audience.

INSIDE AUSTRALIA

LAKE BALLARD, AUSTRALIA
Antony Gormley
2002–03

I would like this to be, just in a modest way, another place that people go to look at and wonder. ANTONY GORMLEY

In December 2002, British sculptor Antony Gormley (b. 1950) installed fifty-one black stainless steel figures on the dry salt bed of Lake Ballard, near the tiny outback town of Menzies, some eight hundred kilometres northeast of Perth in a remote part of Western Australia. The work was commissioned by the Perth International Arts Festival to celebrate its fiftieth anniversary in 2003.

Gormley was originally drawn to the project by the ancient geology of the region, but once on site became equally fascinated by the residents of Menzies. Menzies is an old mining town which in its heyday around 1900 had a population of around 10,000, but now has a population of around one hundred and thirty. He digitally scanned the bodies of most of the 'Menzies Mob', abstracted them and cast them in alloys made from the mineral rich landscape. The stick-insect-like figures populate a seven square kilometre area of Lake Ballard to create a 'field of antennae reflexive rather than representational, allowing what is already there to be perceived and felt, in an acutely heightened way'.

Gormley sees *Inside Australia* as 'an excuse for coming here and thinking about this place and the people who dwell in it'. This work in Australia's interior is not only 'inside Australia', but is also trying to get to the heart of its people by addressing issues of identity and the relationships between an individual and the community. The work is made up of the sculptures and the landscape and indeed, the sculptures are made from and arise out of the landscape. This, combined with the figures being based on local residents, brings to mind issues such as how an individual's identity is informed by a place. While certainly relevant for this largely indigenous community, this forceful installation raises the issue from the specific to the universal.

Inside Australia is another example of extending contemporary art to the remote regions of a nation, rather than it being solely the preserve of those who live in major urban centres. This is one of many issues which Gormley is addressing in the work, as he explained:

It's an experiment about who can make art, how it can be made, who can be represented by it and where it can be seen. And maybe as an extension of that, how it can be experienced, because in many ways, the art here is not the subject. The subject is the place and the viewer's own experience of this place, through the agency of the work.

Experiencing the haunting figures coming in and out of focus in the searing desert heat certainly highlights the mysterious qualities of this stark landscape. Using local figures as source material involves them in the project and certainly unites them with the difficult landscape in which they live, work and play. This surreal work is particularly amazing at sunrise and sunset, when it is imbued with an almost spiritual quality. For Gormley the project was 'the most difficult, long-distance, intense, exhilarating, fatiguing endeavour of my life – and the most rewarding'.

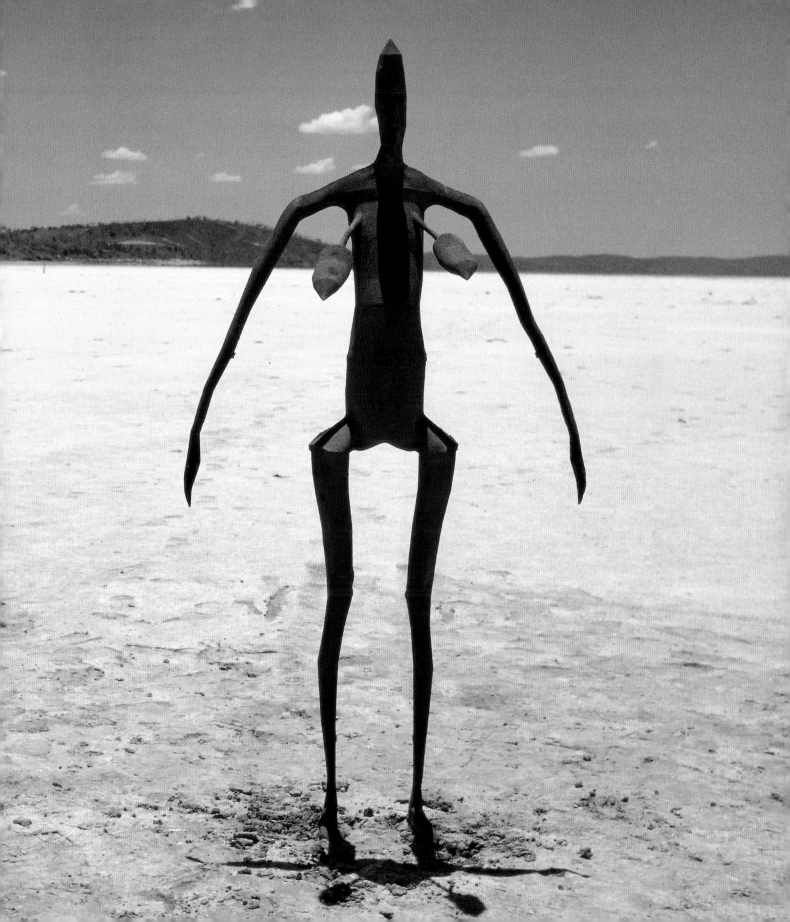

DIA:BEACON

BEACON, NEW YORK, USA
Various artists
From 2003

Beacon along the Hudson – beautiful like a Japanese haiku. SIMON GROOM

The Dia Art Foundation was founded in 1974 by German art dealer Heiner Friedrich, heiress Philippa de Menil and art historian Helen Winkler to support art by some of the most prominent artists of the 1960s and 1970s, which was often large-scale or site-specific and did not fit easily into the existing gallery and museum system. Since its inception, the foundation has enabled ambitious installations such as *The Lightning Field* by Walter De Maria in New Mexico (see p. 106) and amassed an impressive collection of work by artists such as Joseph Beuys (1921–86), John Chamberlain (b. 1927), De Maria (b. 1935), Dan Flavin (1933–96), Michael Heizer (b. 1944), Robert Irwin (b. 1928), Donald Judd (1928–94), Agnes Martin (1912–2004), Gerhard Richter (b. 1932), Fred Sandback (1943–2003), Robert Smithson (1938–73), Cy Twombly (b. 1928), Andy Warhol (1928–87), Robert Whitman (b. 1935) and La Monte Young (b. 1935).

In 2003, Dia:Beacon was opened to house the Foundation's permanent collection of art from the 1960s to the present. The museum is located in Beacon, New York on the banks of the Hudson River, about an hour north of New York City, in a former box-printing plant built by Nabisco in 1929. The converted industrial building provides 240,000 square feet of exhibition space beautifully lit by natural light from some 25,000 square feet of north-facing skylights.

It is a joy to see so many large works in a home which allows them the space to breathe and has the space for them to be permanently installed, as very few museums or galleries have the footprint to permanently dedicate to works of such size, or even large enough spaces to exhibit such works at all. Here they are out in all their glory in rooms especially designed for them. The three massive stunning steel sculptures in the former factory's train depot by Richard Serra (b. 1939) – *Torqued Ellipse II* (1996), *Double Torqued Ellipse* (1997) and *2000* (2000) – are a case in point, as is De Maria's striking multi-part stainless steel sculpture *The Equal Area Series* (1976–90) in the central galleries. Likewise, Sandback's exquisite works of acrylic yarn stretched across a space could only succeed somewhere with enough room – otherwise the amazing perceptual illusions of looking like solid glass panels from one angle and then seeming to disappear from another, would be destroyed.

Heizer's *North, East, South, West* (1967/2003) comprises four monumental geometric forms sunk twenty feet into the concrete floor of the gallery. It is enclosed by a low glass partition. Appointments can be made to view the work inside the enclosure before the gallery opens. I would highly recommend making the effort to see this awe-inspiring work at close quarters. When was the last time you experienced vertigo while standing firmly on the ground? Looking down into the voids, over the abysses is exhilarating – and unnerving. It provokes a slightly uneasy feeling, as if being on a tall structure, or looking down the side of a mountain or canyon. Shortly after he made this work, Heizer went on to create the work for which he is best known, *Double Negative*, another, even more monumental 'negative sculpture' located in the Nevada desert (see p. 80). *North, East, South, West* is an extremely powerful and intriguing piece of art which resonates long after you have left its side.

The whole collection is exemplary and a visit makes for a magical day out from Manhattan via a scenic train ride up the Hudson River departing from Grand Central Station. If you have a car, it is about a fifteen-minute drive from Dia:Beacon to the equally beautiful Storm King Art Center on the other side of the river (see p. 60).

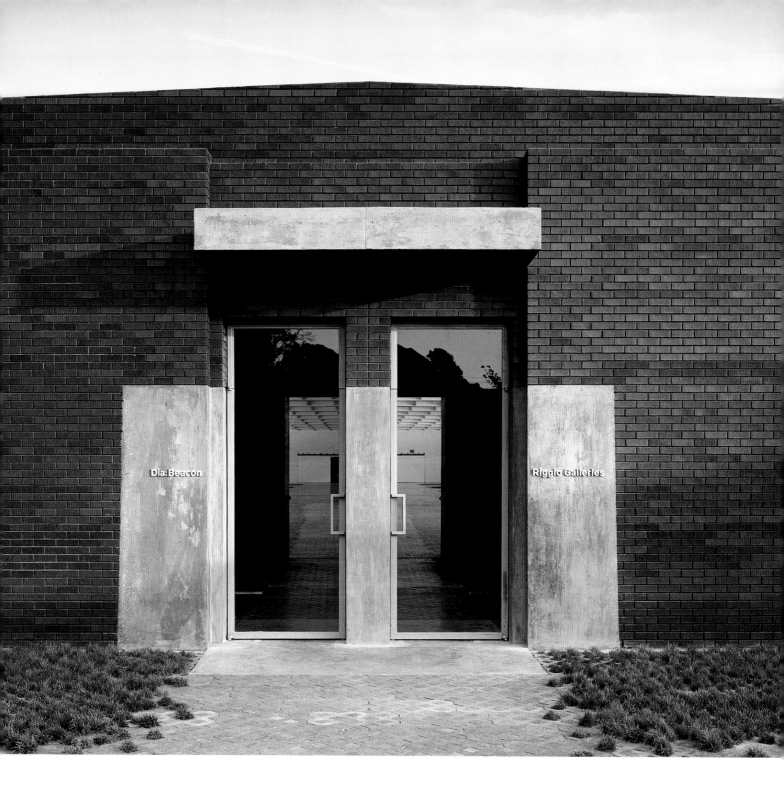

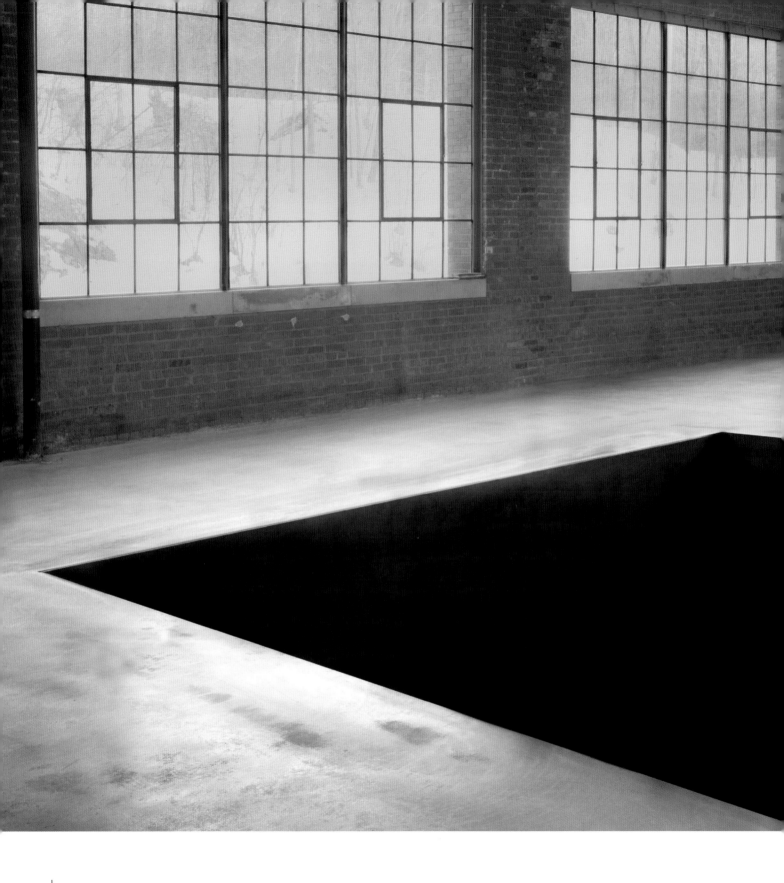

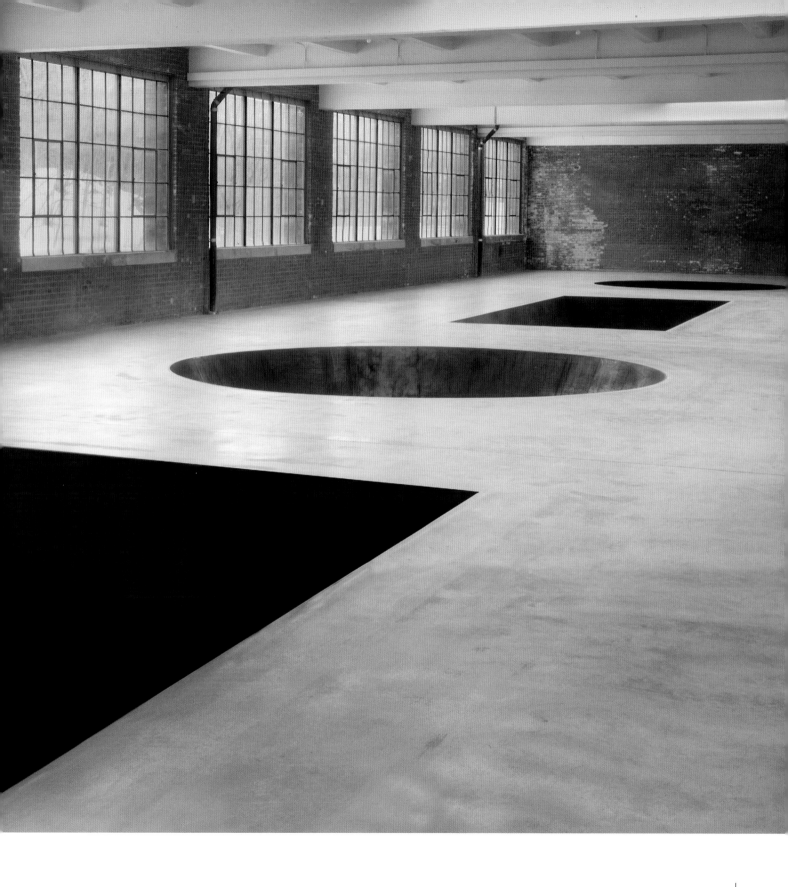

HIMMELHØJ

FÆLLEDEN, COPENHAGEN
DENMARK
Alfio Bonanno
2004

When I am successful I accentuate the feeling of a place. The work needs the site to breathe and function. ALFIO BONANNO

Italian-born Dane Alfio Bonanno (b. 1947) is a pioneering environmental artist who has been making site-specific installations, temporary and permanent, since the 1970s. While his work exhibits a profound interest in and respect for nature and often uses natural materials, he is determined not to become a 'nature Fascist' and is interested in working with and in different types of landscapes – be they natural, man-made or a hybrid. His rich works create dialogues between the city environment and the natural landscape, man and nature, nature and culture, and the sites of industry and those of leisure – through interventions that construe more than simple juxtapositions.

Many of Bonanno's artworks are also functional, like *Himmelhøj* (Sky-High), an art installation-cum-nature playground, commissioned by the Danish Ministry of the Environment. The work consists of four independent installations located on a flat, marshy area on the island of Amager, just south of the centre of Copenhagen in the Ørested region. This new area of Copenhagen that is in the process of being developed is a distinctly modern one to contrast with the old city centre. It is located between the existing city and the nature reserves on the coast and is connected by a new Metro system. For *Himmelhøj*, Bonanno was presented with what was, perhaps, his ideal scenario, for the site is a man-made 'natural' site (land reclaimed from the sea) on the grounds of the Vest Amager Nature Centre. It is surrounded by the smokestacks of industry (the Avenedø Coal energy plant), a forest, Scandinavia's largest shopping centre, the new elevated Metro and the skyline of Copenhagen's old city. From this threshold, this space 'in-between', you can see many facets of modern life and contemplate the problems that may arise when they come into conflict.

The best way to reach *Himmelhøj* is by the new Metro. Arriving from the city so quickly by the elevated sleek modern transportation

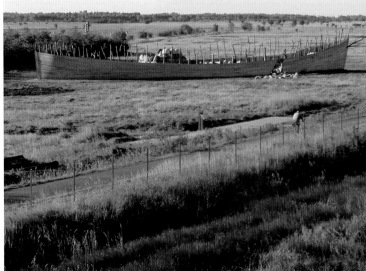

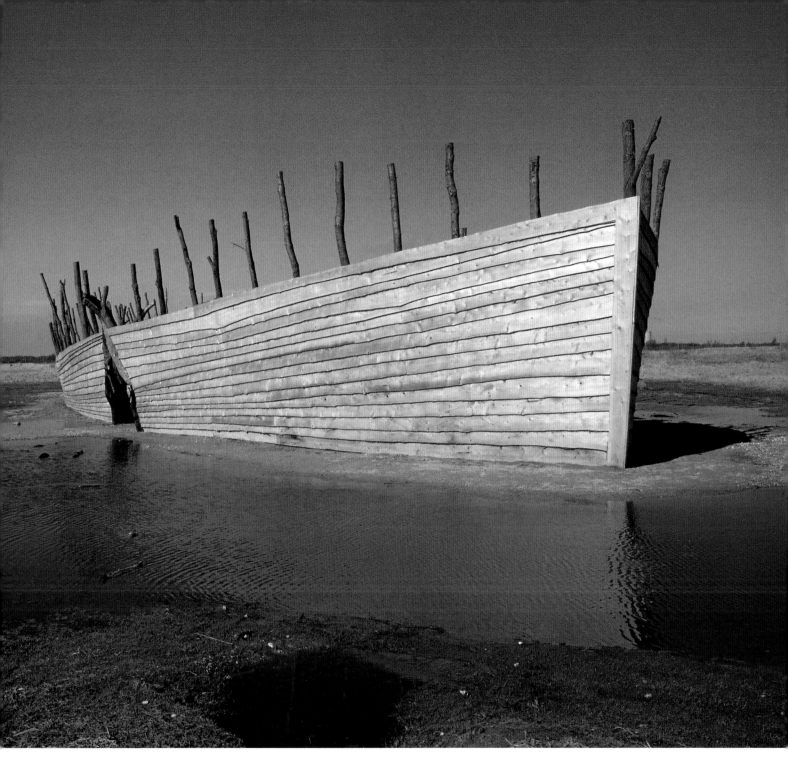

Above and left Amager Ark (2004) by
Alfio Bonanno, a fifty-five-metre-long
wooden boat run aground on the marshy
island of Amager in Denmark, is both
a surreal sight and one that seems oddly
at home in its surroundings.

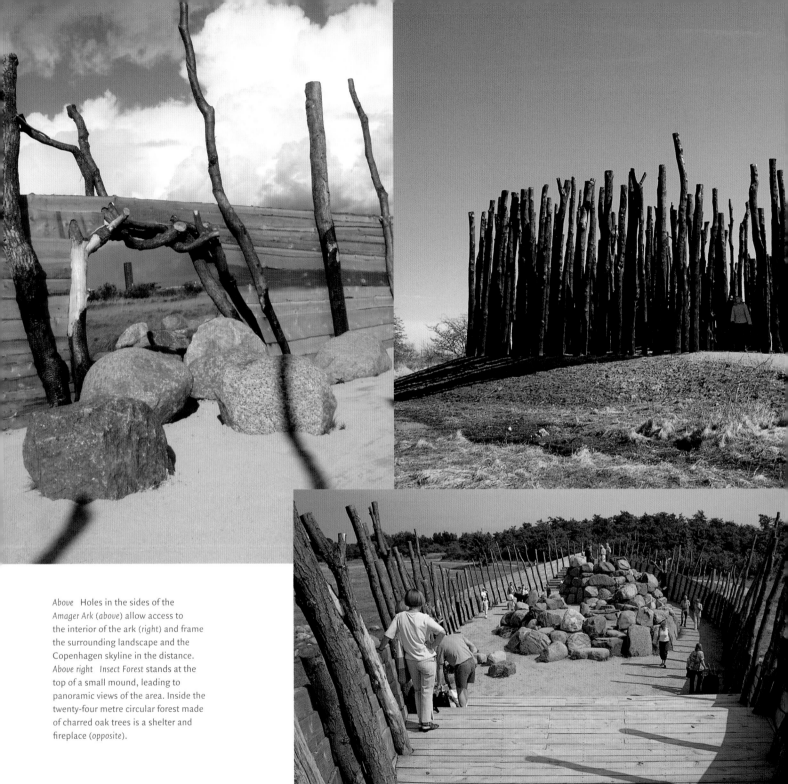

Above Holes in the sides of the
Amager Ark (above) allow access to
the interior of the ark (right) and frame
the surrounding landscape and the
Copenhagen skyline in the distance.
Above right Insect Forest stands at the
top of a small mound, leading to
panoramic views of the area. Inside the
twenty-four metre circular forest made
of charred oak trees is a shelter and
fireplace (opposite).

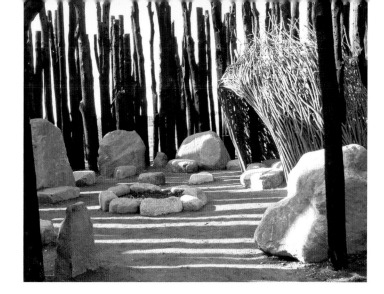

adds to the surrealness of the experience and heightens the other-worldliness of the place created by the artwork. So close to the hustle and bustle, and yet so far away, it is as if the artworks have carved out a neutral territory in which to explore, appreciate and enjoy the intertwining relationships between city and country, man and nature, art and nature. The first work you encounter is its 'flagship', *Amager Ark*, a fifty-five-metre-long wooden boat run aground. In addition to making a stark visual contrast with the hi-tech transportation nearby, it also neatly references the origins of the area as a former sea and the role of both modes of transport in populating new lands. Inside the *Ark* there are lookout platforms at the stern and the bow and a five-metre-high spiral tower in the centre made of granite boulders. These provide views of the complex skyline and animate and activate the space, inciting the imagination and encouraging play.

Paths lead to other works and an exploration of the site. *Fox Den Shelter and Nest* are installed in a little forest – the willow shelter has boulders for seats inside and the huge woven nest appears above, suspended in a tree. The *Fire Place* is also extraordinary. Measuring fifteen metres in diameter, the campsite-like social space is defined by thirty uprooted, fully grown pine trees. The *Insect Forest*, a circular labyrinthine forest made of three hundred and fifty charred oak trees, is equally dramatic. The trees were burnt to protect them from rotting; a method formerly used by local farmers for their fences. While this certainly connects the work to the history of the area, the way in which the giant trees reach skyward, echoing the smokestacks of the energy plant in the background, powerfully connects it to its present. The holes in the trees lead to the creation of weird sounds and lights and a spooky atmosphere, which to me also called forth the fragility of nature and the horrible aftermath of forest fires.

Bonanno's fanciful installations specifically reference and respond to their sites and local issues as well as raising more universal ones – urban–rural, work–leisure, nature–culture, man–animal, etc. The engaging sculptures have made the area come alive and they have served as catalysts for discovery and discussion. *Himmelhøj* has been adopted by the local wildlife and vegetation and has proved popular with the local community and visitors, providing a place where they can all interact and coexist.

More outdoor sculpture can be seen at the Louisiana Museum Sculpture Park (see p. 85) which is about thirty-five kilometres north of Copenhagen in Humlebæk and at TICKON (see p. 164) in Langeland, which is a two-to-three-hour drive from Copenhagen.

CHICHU ART MUSEUM

NAOSHIMA, JAPAN
Tadao Ando, Claude Monet, Walter De Maria
and James Turrell
2004

*I am deeply imbued with, and influenced by, the feeling of space embracing
life, a feeling you might get looking up at the sky from the depths of the earth.*
TADAO ANDO

In July 2004 the Chichu Art Museum opened on the small, remote
island of Naoshima in the Inland Sea off the coast of western Japan.
The museum is managed by the Naoshima Fukutake Art Museum
Foundation and was established as a place to encourage thought
about man's relationship with his environment. The collection
consists of five of French painter Claude Monet's (1840–1926)
famous water lily paintings, painted between 1914–26, American
Walter De Maria's (b. 1935) installation, *Time/Timeless/No Time* (2004),
and three works by American James Turrell (b. 1943), *Afrum, Pale Blue*
(1968), *Open Field* (2000) and *Open Sky* (2004), permanently installed
in Japanese architect Tadao Ando's (b. 1941) bespoke building.

The south side of the island where the museum is located is part
of the Seto Inland Sea National Park, a nature reserve. The museum
is on the cliffs that overlook the straits of the Seto Inland Sea. More
accurately, the museum is in the cliff, for Ando's extraordinary

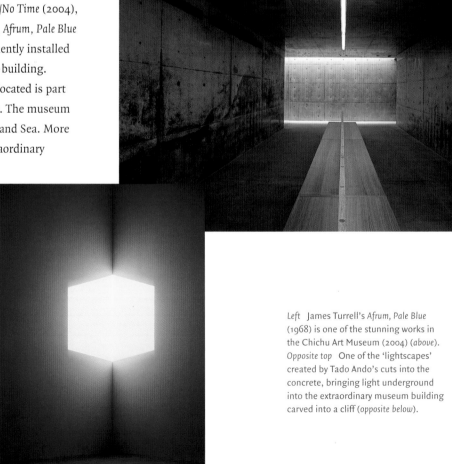

Left James Turrell's *Afrum, Pale Blue*
(1968) is one of the stunning works in
the Chichu Art Museum (2004) (*above*).
Opposite top One of the 'lightscapes'
created by Tado Ando's cuts into the
concrete, bringing light underground
into the extraordinary museum building
carved into a cliff (*opposite below*).

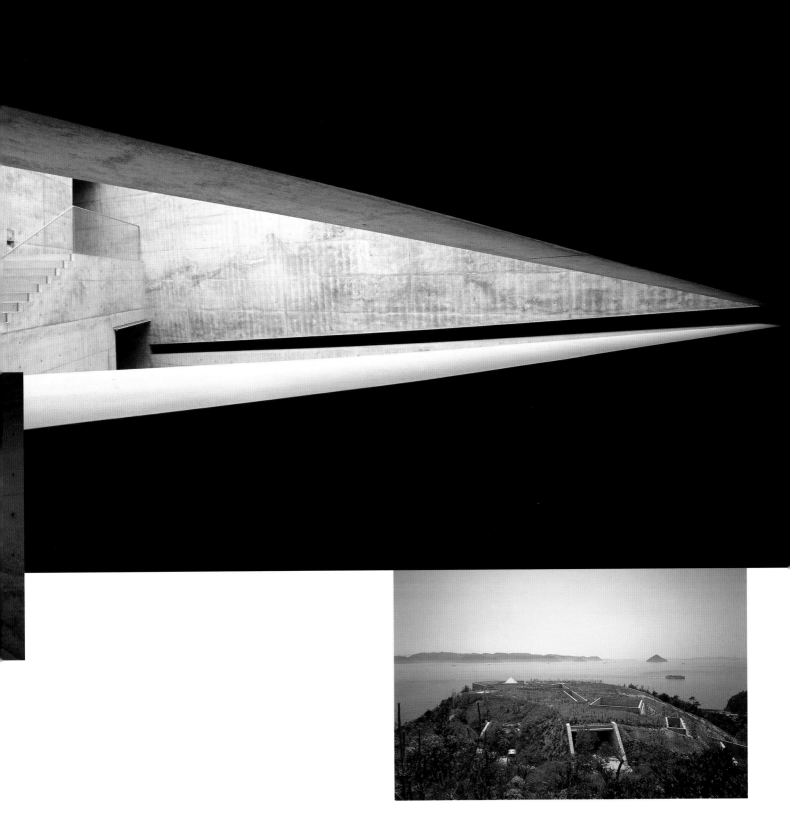

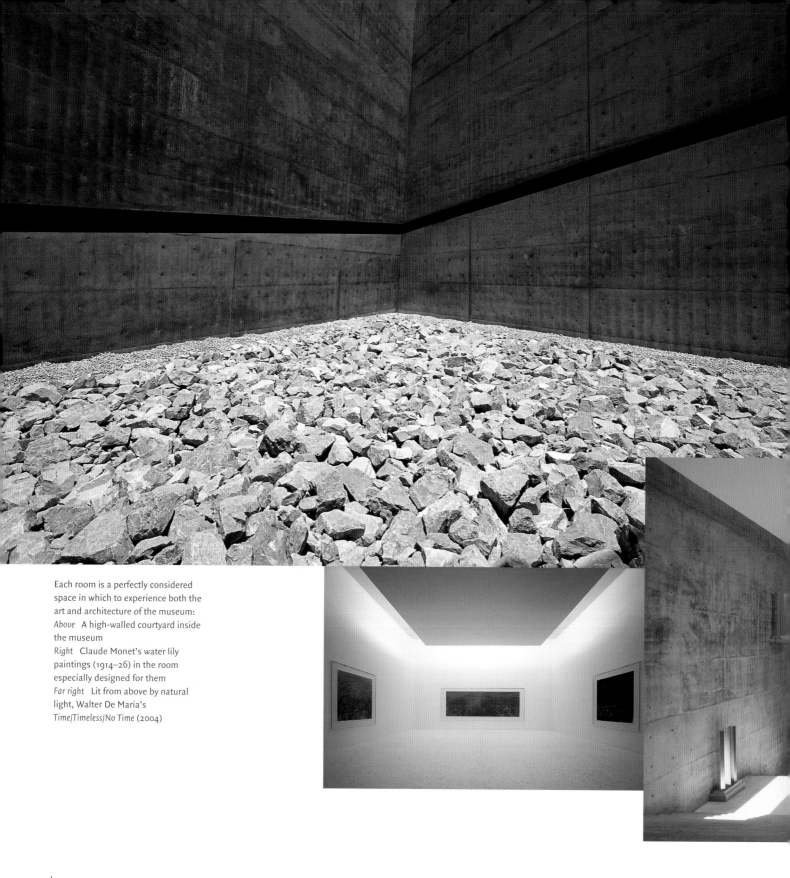

Each room is a perfectly considered space in which to experience both the art and architecture of the museum:
Above A high-walled courtyard inside the museum
Right Claude Monet's water lily paintings (1914–26) in the room especially designed for them
Far right Lit from above by natural light, Walter De Maria's *Time/Timeless/No Time* (2004)

building is almost completely underground. His three-level structure is comprised of geometric volumes carved into the earth. As Ando explained: 'My challenge was to achieve a highly complex and varied sequence of "lightscapes" within a configuration of simple, geometrical forms.... The museum was intended, holistically, to be visited with light as a guide.'

Ando met his challenge admirably – the gallery spaces are lit by abundant natural light and are connected by concrete corridors, some of which are open to the elements. The journey through the museum incorporates the sky, light and weather as integral features, such that the building as well as the artworks encourage reflection on man's relationship with nature. Ando's building also lent the museum its name, for 'chichu' means 'underground' in Japanese.

Impressionist artist Monet spent his later years painting huge water lily canvases which created an environment surrounding the viewer. Monet sought to convey the 'instability of the universe transforming itself under our eyes'. The ones presented here in their special room, lit by ever-changing natural light cannot help but grant Monet's wishes. In his paintings, the brushstrokes must

be connected in order to 'read' the works, inducing the viewer to participate in creating meaning, a concept crucial to later artists, including De Maria and Turrell.

De Maria's *Time/Timeless/No Time* (2004) consists of a highly polished black granite sphere measuring just over two metres in diameter surrounded by twenty-seven wooden sculptures with gold leaf which define the space. De Maria's interest in context and perceptual phenomenon is apparent here, as the space is aligned east to west so that the changing light, from sunrise to sunset, is an important ingredient in the serene work.

The three works in the collection by Turrell trace the artist's obsession with light and his passion for sharing it and its transforming qualities with the viewer. *Open Sky* (2004), which was made specifically for the museum, consists of a rectangular skylight in a room with hidden LEDs which change the colour of the room dramatically. The stunning work is even more spectacular at sunset. On Fridays and Saturdays the work can be viewed at sunset by appointment only.

This small but powerful collection is dazzling and although difficult to get to, it is well worth the effort. There is also an adjoining garden, Chichu Garden, containing the plants, flowers and trees Monet used in his garden in Giverny, France. Benesse House, a contemporary art museum and hotel complex, also designed by Tadao Ando is 1500 metres east of Chichu Art Museum. The Art House Project (see p. 209) is in Honmura, as is the Honmura Lounge & Archive which contains information about all the art projects on the island.

MÅLSELV VARDE

OLSBORG, TROMS, NORWAY
Alfio Bonanno
2005

Dreams and ambitions can become a reality. ALFIO BONANNO

Målselv Varde (Målselv Cairn) (2005) by Italian-born Danish artist Alfio Bonanno (b. 1947) is an ambitious project undertaken by and for a small rural community in Olsborg in the Målselv region of Arctic Norway. Bonanno was introduced to the region in 2000 and was struck by the beauty of its ...

... endless mountain ranges, waterfalls, forests of birch, fir and aspen; the Målselv River winding like a serpent through the fertile valley; the incredible light, everchanging as the magnificent cloud formations passed through, and at night, the Northern Lights projecting across the cold skies.

An environmental artist who is interested in working with different types of landscapes, Bonanno was delighted when Hans Olav Løvhaug, head of the Culture Department of the Målselv Kommune, invited him to create an installation to celebrate the Millennium. Years of consultation, research and planning followed, which allowed for input from all sectors of the community. The site agreed on for the project was a rest stop near Olsborg. It is between two bridges on the banks of the Målselv River, near the intersection of National Road 854 and Highway E6, the main road through the country that connects northern Europe and southern Norway with northern Norway and the Russian border. A recent addition to the site was a flood stone that marks high flood levels. The whole area is ringed by mountains.

The challenge for Bonanno was to create a site-specific installation that would respond to and engage with the man-made and natural elements of the site and become a focal point for the community. He responded with a landscaped environment that is dominated by a 6.5-metre-high circular stone cairn (a pile of stones formed to mark a spot) that is 4.5 metres in diameter and is enclosed by twelve sixteen-metre-tall charred fir trees. With the help of a local man who

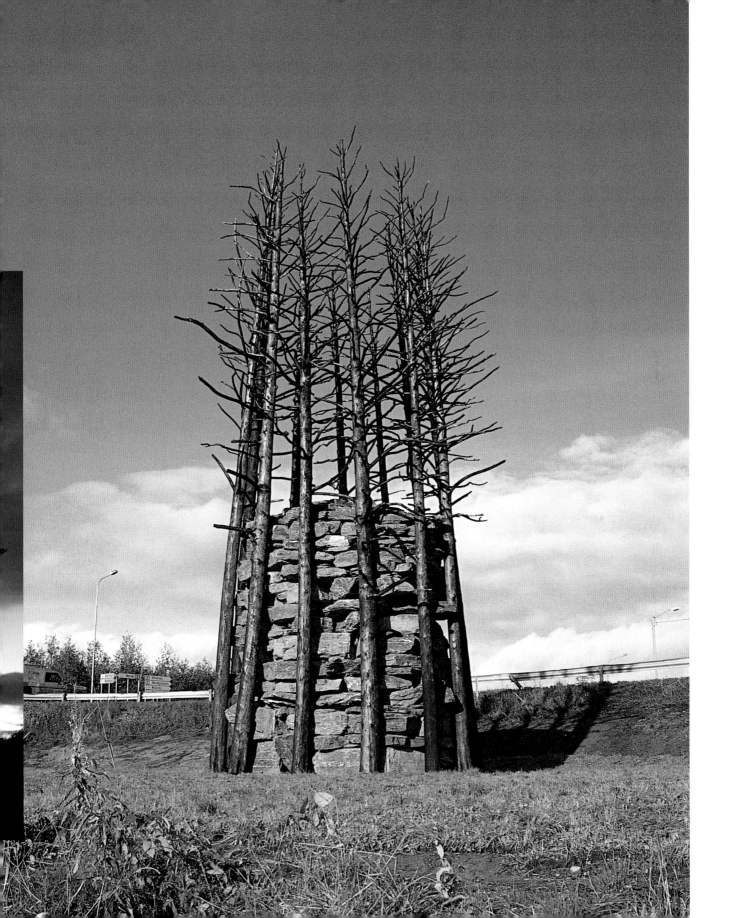

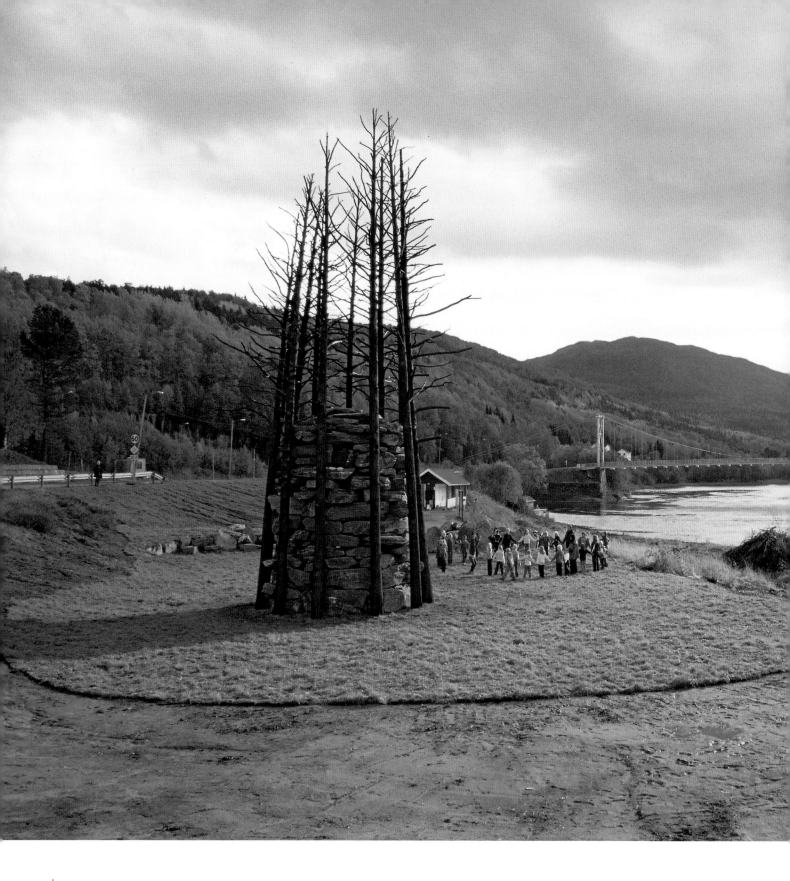

A real community project, the local Army Engineer Battalion helped with the construction of *Målselv Varde* and local farmers and high school students helped with the landscaping around the cairn.

builds ancient musical instruments, Bonanno carved 'whistles' into some of the top branches of the trees, so that the work sings in the wind. Other elements of the environment include an earth and stone embankment and an elevated stone gathering area with a fireplace and sitting stones.

Bonanno works with materials that are native to an area, and often references their vernacular use. This project is no exception. Fir trees are abundant in the area and are used for building shelters. They are also burned to create tar. Bonanno charred the fir trees used in his installation – this gives them a striking graphic presence against the sky and will prolong their durability. This characteristic and their encircling of the stones also nods at the traditional protective uses of trees and tar. The stone used in the installation is gabbro stone, quarried from the mountains nearby. Cairns are a common sight in Norway, particularly along mountain paths, where they are built by hikers to mark trails. Formerly, both stone and wooden cairns were used to communicate – they were placed at strategic points and then lit. At night and during the sunless winters, Bonanno's cairn is illuminated like a beacon.

Bonanno's installation has a commanding presence. The main sculpture echoes and inverts the shape and construction of the traditional campfire nearby, both reaching to the sky, but here the charred trees are surrounding and protecting the stones instead of the stones encircling and containing burning wood. The work is certainly visually successful, and it is hoped that it will also be socially successful too. The Army Engineer Battalion, local farmers and high school students all took part in the construction of the installation, and the sense of ownership engendered by participation in the project should help. A sense of ownership by the community is a crucial factor in determining the success or failure of public artworks – it is often the key reason a piece is ignored and/or vandalized or cherished and protected.

Both beacons and cairns had an important social function – as communication or commemoration. Many of Bonanno's artworks are functional, such as *Himmelhøj* in Denmark (see p. 236), and it is hoped that this contemporary cairn will also have a functional aspect – that it will enliven the area and become a focal point for the region, a meeting place, a place for leisure and pleasure, recreation and contemplation.

STAR CHAMBER

VANDERBILT DYER OBSERVATORY, BRENTWOOD, TENNESSEE, USA
Chris Drury
2006

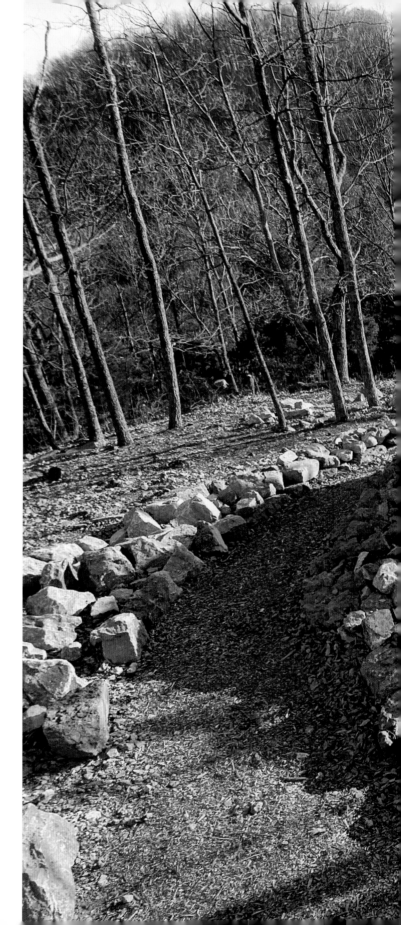

Star Chamber is a place where heaven, earth and the spirit of man meet.
ROCKY ALVEY

Star Chamber (2006), a stone and log sculpture by British artist Chris Drury (b. 1948), was created in collaboration with the Vanderbilt Dyer Observatory and the Vanderbilt University Fine Arts Gallery, under the guidance of gallery director Joseph Mella. The sculpture is situated 200 metres from the observatory, which was built in 1953 on a hilltop in central Tennessee, five miles from Nashville city centre and six miles south of Vanderbilt University campus. The observatory was originally intended for faculty and students of Vanderbilt but it is now a community resource, used for research, education programmes and events. It was added to the National Register of Historic Places in 2009.

Star Chamber was made to complement the observatory's goal of sharing the wonder of astronomy. Drury, Dyer staff and volunteers built it in twenty-nine days, using 200 tons of limestone rock donated from a construction project at the university. The installation demonstrates in a physical way the earth's elliptical orbit around the sun, the solar year and the arrangement of the stars. It is sited on the crest of a ridge that is believed to have been a Native American lookout point and is reached by a path that starts behind the observatory residence. As you approach the sculpture nestled in the woods, you are greeted by a spiral rock formation that draws you into the work and directs you to the chamber's door. In close proximity to this galaxy-like arrangement are seven standing stones that mark points on the horizon where the sun rises and sets on the equinoxes and solstices. The chamber itself is a low circular room with an octagonal domed roof made of notched oak logs taken from the site. It is designed to function as a camera obscura: a small hole in the ceiling lets in natural light, and once your eyes have adjusted to the dark an inverted scene of the trees and skyline outside can be seen projected onto the white dish-shaped interior.

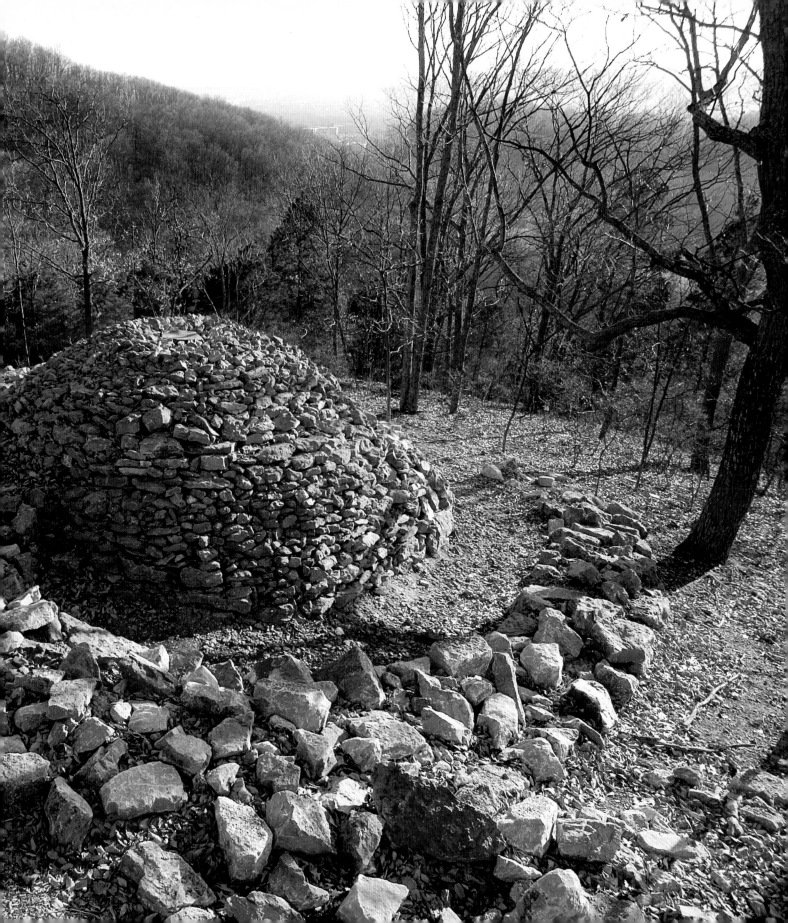

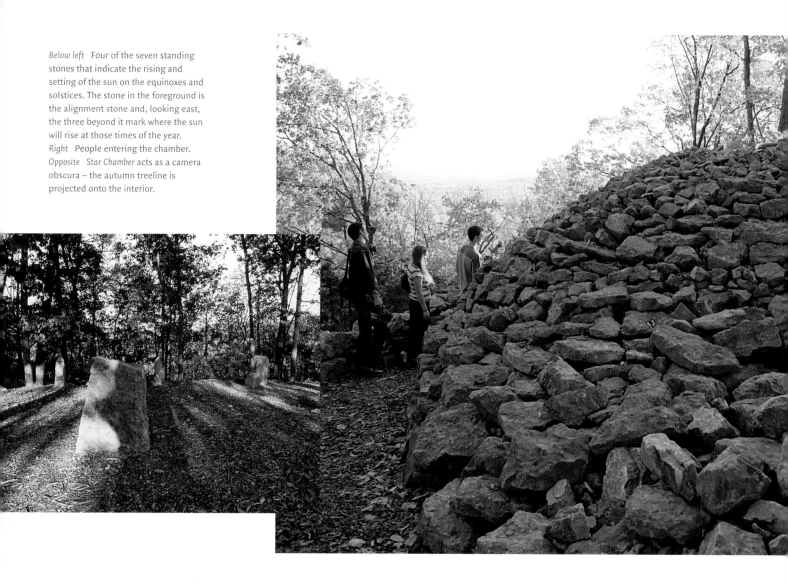

By means of another carefully calibrated aperture, the chamber marks the solar year and shows how the earth moves around the sun. For thirty minutes around noon each day, the sun and a slice of sky project through this hole in the top plate onto the wall and floor. Drury explains how over twelve months the sun traces an analemma, a figure 8, which is marked out in brass pins sunk into the plaster interior:

The sun traces this pattern because the Earth's orbit is elliptical rather than circular, and when combined with the tilt of the Earth's rotation axis and changing speed it draws a figure 8 over the course of a year. Just above where the figure 8 crosses are the equinoxes, while top and bottom mark the summer and winter solstices. On any given day you can calculate the time of the year; the interior therefore acts like a sundial and calendar.

At night, the circular lid can be opened to reveal the seasonal position of the stars. Whether experienced during the day or at night, the viewer is rooted to the earth, directed to the sky, and made powerfully aware of his or her connection to nature and the universe. For those who find astronomical concepts too abstract, or think that science is not for them, Drury's *Star Chamber* provides another way into the subject, one in which scientific phenomena are experienced in a way that is at once tangible and magical.

PULSE SCULPTURE PROJECT

BERGEN, NORWAY
Finn Eirik Modahl
2007

I want contemporary art to create a dynamic, giving the people living around the sculpture a chance to take part in it. FINN EIRIK MODAHL

Pulse Sculpture Project is a site-specific public art installation by Norwegian artist Finn Eirik Modahl (b. 1967). It is located in Råstølen, a new residential area fourteen kilometres south of Bergen city centre, which includes 500 new houses and apartment buildings, housing for senior citizens and disabled people, two nurseries and a site for a school. Art was a vital part of the project from the beginning, as Arne Liljedahl Lynngård, Marketing Director of Bergen tomteselskap AS, the land development company (owned by the City of Bergen) that initiated the project, recalls:

We wanted to create an atmosphere of wellbeing, safety and belonging for the new residents. Five hundred families or 1200 individuals were to move into their new homes. To create identity among the dwellers it was important to heighten the aesthetic qualities in the public spaces. Thus it was decided that contemporary art should be part of the visual shaping of the new residential area.

Curator and public art consultant Malin Barth guided the company away from the idea of a single sculpture at the entrance to the area towards commissioning a work that would be an integral, interactive part of the new community. The innovative, environmentally appropriate architecture of the development called for an equally dynamic artwork to reflect and complement its focus on issues such as sustainability and efficiency, and to cement its image as both contemporary and futuristic.

Modahl's *Pulse Sculpture Project* meets these criteria admirably. The installation engages with its social, built and natural environments in

Children playing on the steel and glass sun structure of *SOL*,
the heart of Finn Eirik Modahl's *Pulse Sculpture Project*.

Opposite and left Front and side views of SOL, with the globe on its bed of moulded concrete. It is brightly lit when energy consumption in the area is high. *Below left* LIV with its rowan tree at the top.

a thoughtful and emotional fashion. The core of the complex is SOL (Sun), a large (2.5 metres in diameter) steel and glass globe reminiscent of the geodesic domes created by the American inventor-designer R. Buckminster Fuller (1895–1983). The sculpture makes visual the energy consumption of the inhabitants, as Barth explains:

The globe, resting in an organically shaped canal of plastic concrete, pulsates slowly in tune with the collective use of energy among residents and indicates how many residents are 'at home' at any given point in time. The concrete is heated by the same waterborne heating system the houses are connected to. This makes it inviting to meet at, sit on and play with. The key work SOL is situated in the alley leading up to the residential area and has in record time become the focal point and brand logo of the area, which was also its goal.

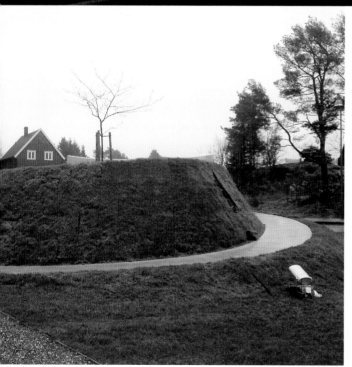

Further up the road is the next part of the constellation, LIV (Life), an artificial earth mound with a spiral pathway leading to a rowan tree at the top. The tree was taken from the protected area around Siljustøl, home of the composer Harald Sæverud (1897–1992). This connects the new community with its famous neighbour and their shared natural surroundings, which were an important source of inspiration for Sæverud. The third part of the artwork is still in the planning stages, and if built would connect Råstølen with the wider world through five 'beams', or planet-like sculptures, radiating out from the central sculpture, SOL, and sited across the globe.

Modahl wanted to appeal to the hearts and minds of the inhabitants and in this he has succeeded. The residents of Råstølen have embraced the *Pulse Sculpture Project* and claimed it as their own as a place to meet and play. This pioneering scheme has also received national attention and helped to forge the identity of the new area.

100 OLYMPIC SCULPTURES

BEIJING, PEOPLE'S REPUBLIC OF CHINA
Various artists
2008

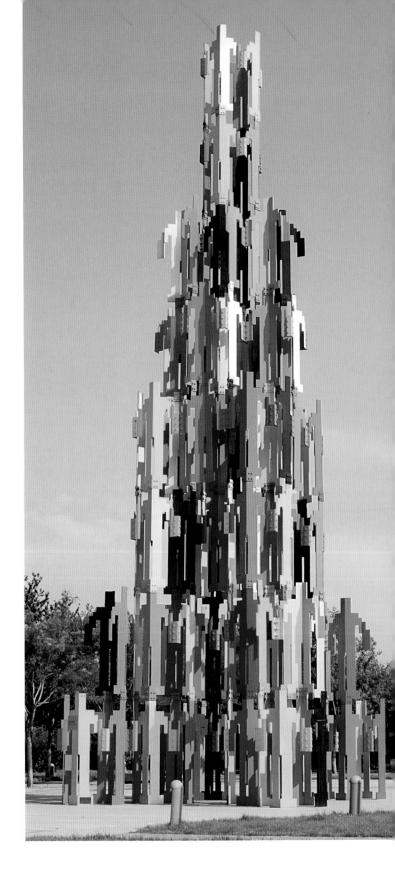

One World, One Dream. SLOGAN, BEIJING 2008 OLYMPIC GAMES

In 2008 one hundred outdoor sculptures were installed in Beijing
in order to enhance the visual and cultural image of the city for
the Olympic Games. The Beijing municipal government led the
various organizations involved in the project, beginning the
search for world-class sculptures in August 2005. The overarching
subject selected was 'Humanistic Olympics', with a 'Peace of
Mankind' theme.

The China Sculpture Institute invited distinguished international
artists to participate and their art committee chose nineteen works
to be part of *100 Olympic Sculptures*. These included projects by
Americans Charles Jencks (b. 1939) and Jonathan Borofsky (b. 1942),
the Frenchman Nicolas Bertoux (b. 1952), the German artist
Johannes Pfeiffer (b. 1954) and Ralfonso (Ralf Gschwend, b. 1959)
from Switzerland. Beijing City Sculpture Construct & Supervise
Office undertook the selection of the remaining 81 sculptures
from a worldwide open call to artists, which garnered over 2800
entries from 82 countries. The final *100 Olympic Sculptures* consists
of works by 45 foreign artists (from 23 countries) and 55 Chinese
ones, in keeping with the intention of having a balance between
indigenous sculptors and those from abroad.

All one hundred works were made in China, which provided an
opportunity for an exchange of information and traditions between
the foreign artists and the domestic technicians. The works were
fabricated and installed in one year, a particularly ambitious
undertaking given that this was the first international sculpture
event of this scale held in China and that the country's engagement
with public art really only dates from the early 1990s. It is an
emerging field, and there are plans to implement 'percentage for
art' stipulations (which allocate a certain amount of funds from the
budgets of new developments to art) like those common in the West,
as well as moves towards including public art in the planning stages

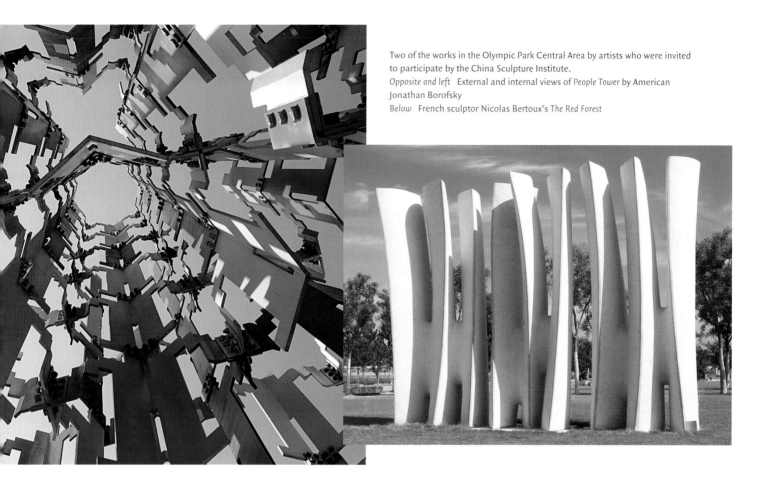

Two of the works in the Olympic Park Central Area by artists who were invited to participate by the China Sculpture Institute.
Opposite and left External and internal views of *People Tower* by American Jonathan Borofsky
Below French sculptor Nicolas Bertoux's *The Red Forest*

of urban development instead of installing sculptures as an afterthought.

A committee chose the locations for the sculptures after the works were made so the art is more event- than site-specific. The sculptures are sited around the city in the Olympic Park Central Area (65 sculptures), the Olympic Forest Park (14), Chao Yang Park (13), the National Centre for the Performing Arts (4), the Beijing Shooting Hall (2), the Laoshan Cycling Stadium (1) and the Mei Lanfang Theatre (1). The style ranges from fairly traditional representations of sporting events, such as *Shooting* by Chen Xiaoyang (b. 1973) and Xiao Jin (b. 1972) from China, which can be found at the Shooting Hall, to those with a distinct Chinese feel to them, such as *Joy of Sport* by China's Zhang Wenxia (b. 1962) in the Olympic Park Central Area. Others works are more abstract and conceptual, including American Mary Miss's (b. 1944) steel mesh *Wall of Water* in a lake in the Olympic Park Central Area and China's Huo Boyang's (b. 1956) steel *Memory of Water* in the

Olympic Forest Park. Also in the Olympic Forest Park is Jencks's extraordinary cosmological landscape sculpture, *Wu Chi*, located on the edge of a lake. It consists of a chessboard of aluminium plate and artificial grass, which appears to spin out from a central rotating turnstile.

Among the works that you will encounter in the Olympic Park Central Area are Ralfonso's *Dance with the Wind*, a wind-driven stainless-steel kinetic sculpture, Chinese Wang Shengli's (b. 1971) comical sculpture of a gigantic hand reaching out of the ground for a juicy green apple, *The Eden*, and Borofsky's colourful steel *People Tower*. Borofsky's sculpture consists of 136 figures interconnecting to create a 20-metre-tall structure that the viewer can walk into and through and become a crucial part of the foundation of this tower of humanity. *100 Olympic Sculptures* provided a platform for those who love sculpture to mix and share ideas about art and culture, and added a dynamic element to the Olympic legacy, one that enhances the visual landscape of Beijing.

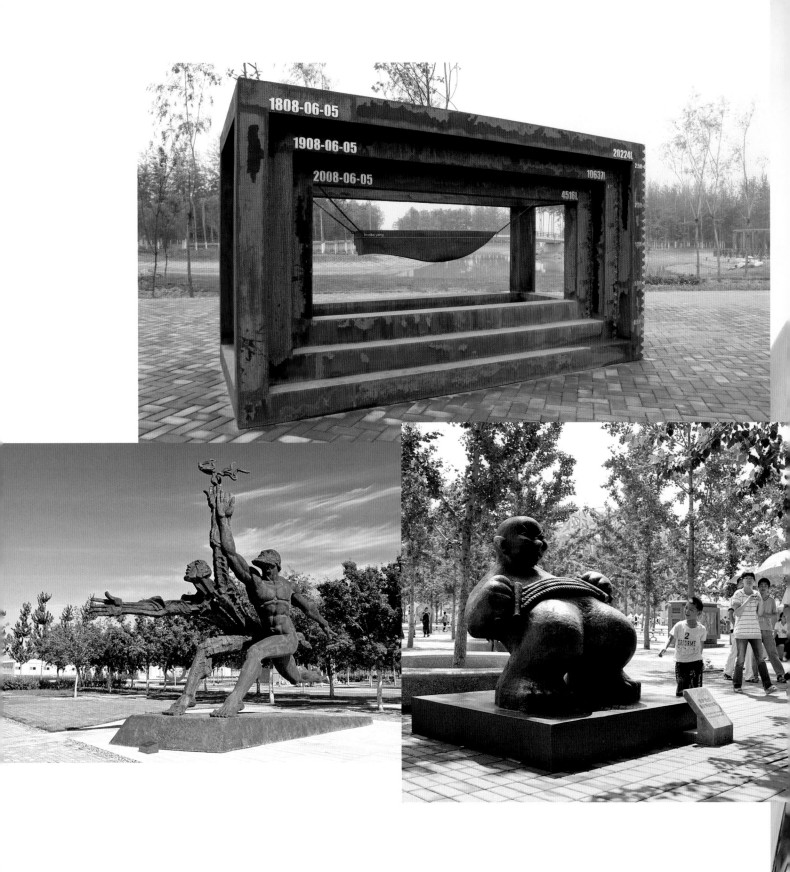

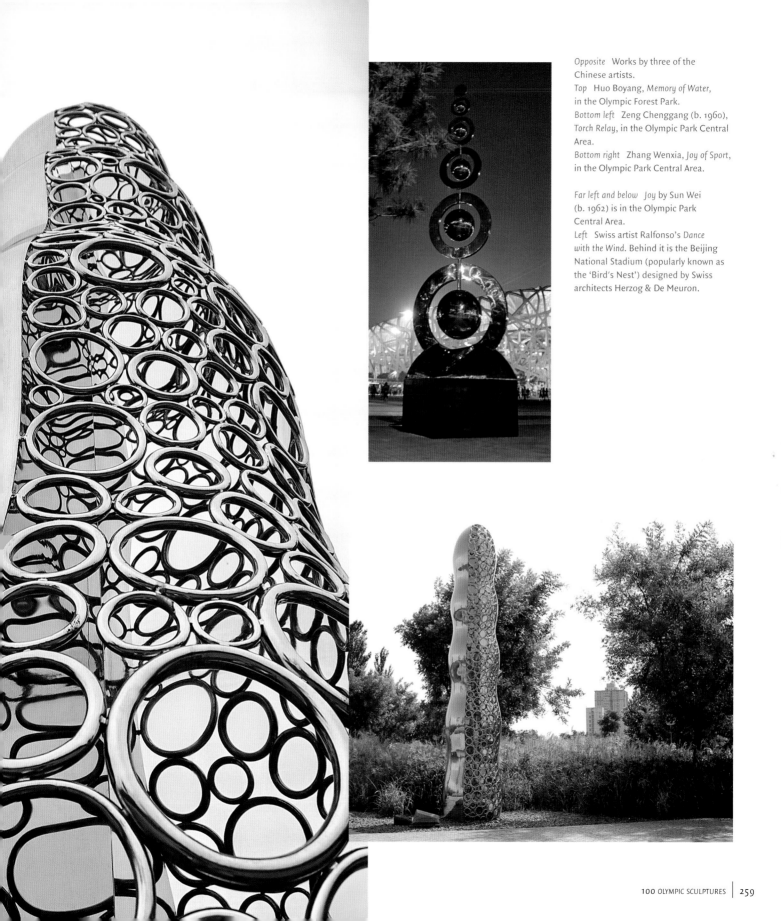

Opposite Works by three of the Chinese artists.
Top Huo Boyang, *Memory of Water*, in the Olympic Forest Park.
Bottom left Zeng Chenggang (b. 1960), *Torch Relay*, in the Olympic Park Central Area.
Bottom right Zhang Wenxia, *Joy of Sport*, in the Olympic Park Central Area.

Far left and below *Joy* by Sun Wei (b. 1962) is in the Olympic Park Central Area.
Left Swiss artist Ralfonso's *Dance with the Wind*. Behind it is the Beijing National Stadium (popularly known as the 'Bird's Nest') designed by Swiss architects Herzog & De Meuron.

JUPITER ARTLAND

EDINBURGH, SCOTLAND
Various artists
From 2009

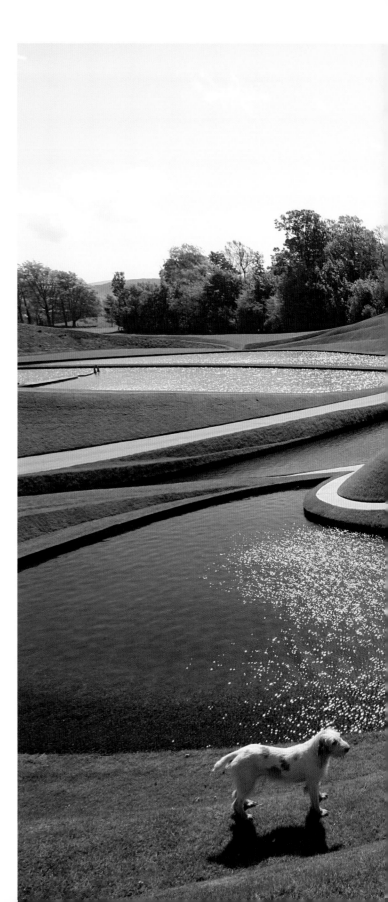

*It's in response to the house, and my love of art and my husband's love of art …
It's our dream.* NICKY WILSON

Jupiter Artland, a collection of contemporary outdoor artwork,
opened in the grounds of Bonnington House on the western
outskirts of Edinburgh in 2009. Nicky and Robert Wilson bought
the Jacobean manor house and eighty-acre estate, framed by the
Pentland Hills, in 1999. While working on the restoration of the
house and formal gardens, Nicky began to dream of a place where
all the important aspects of her life – family, home, art, nature and
livestock – could not only co-exist but thrive. Nicky was a sculptor
before bringing up the couple's four children, and both she and her
husband are committed art collectors.

In 2005 the Wilsons began building their collection of outdoor
artworks. The first artist they worked with was American Charles
Jencks (b. 1939), who encouraged their ambition and nurtured
their vision. The concept of an 'artland' – in which the art and the
land have a symbiotic relationship, working together to become
something that is greater than the sum of its constituent parts –
played an important role in their thinking, as did the example of
Jencks's own *Garden of Cosmic Speculation* (1989–2007) in the grounds
of Portrack House, near Dumfries, Scotland. Jencks's physical
contribution to Jupiter Artland is the magnificent *Life Mounds*
(2005–09), which greets you as you enter the estate. The work,
which Jencks intended should celebrate 'the cell as the basis of
life', covers nearly four acres and includes eight terraced, turf-clad
mounds with paths embedded in them which surround four lakes,
sculptures and seating.

Another major source of inspiration for the Wilsons was *Little
Sparta* (1966–2006), Briton Ian Hamilton Finlay's (1925–2006) art
garden, also outside Edinburgh. Finlay himself visited Jupiter Artland
shortly before his death and chose the sites for his four artworks
there. Like *Little Sparta*, Jupiter Artland is a garden of discovery, and

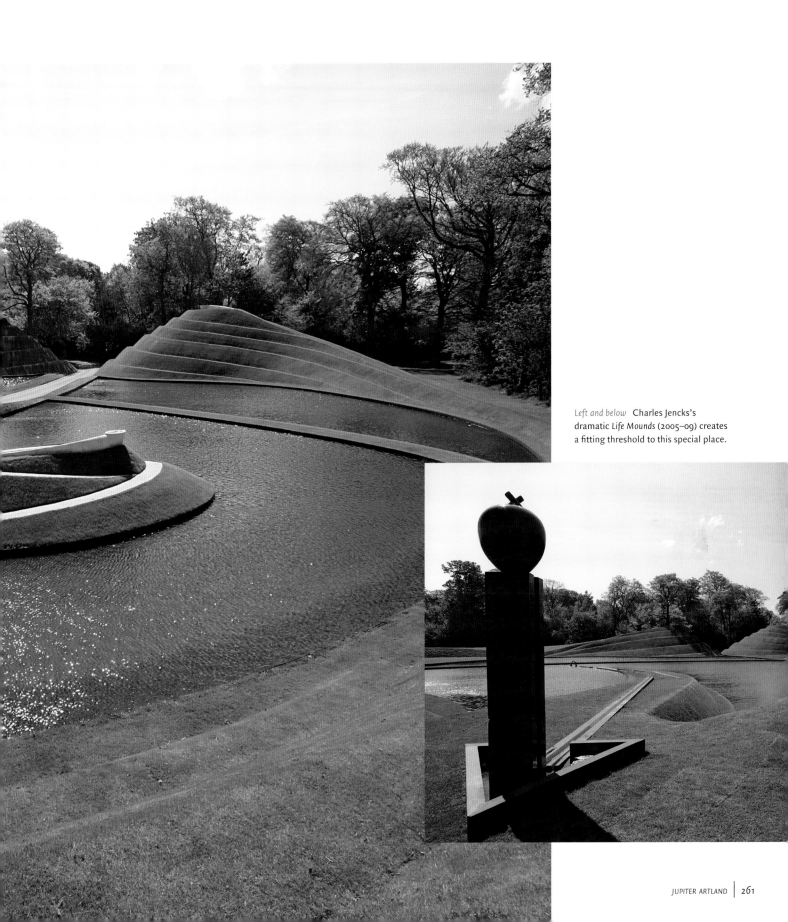

Left and below Charles Jencks's dramatic *Life Mounds* (2005–09) creates a fitting threshold to this special place.

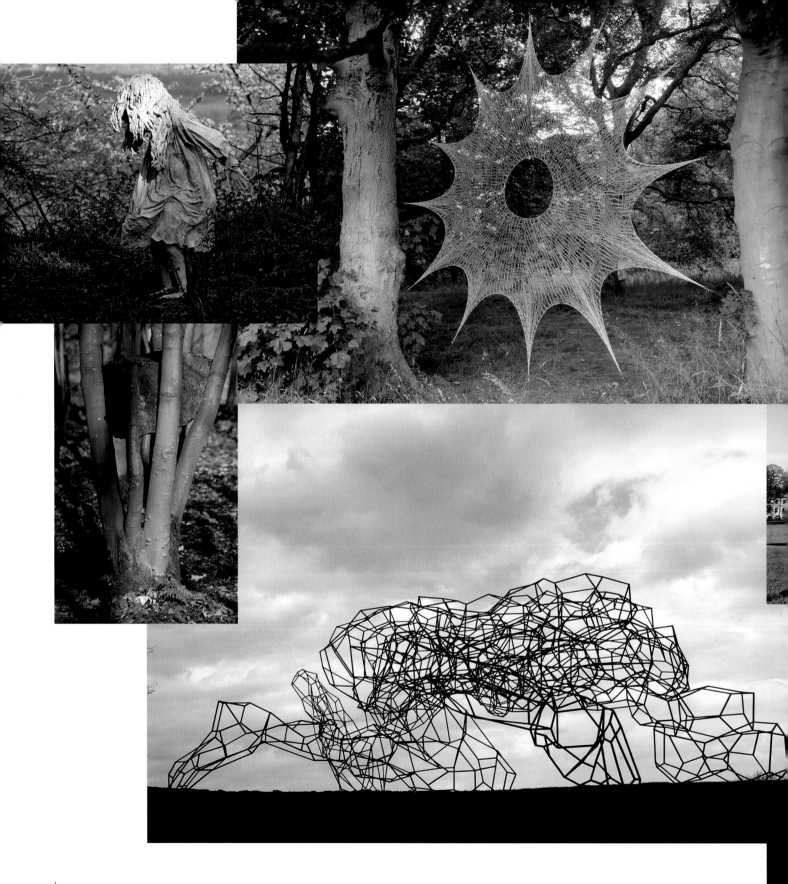

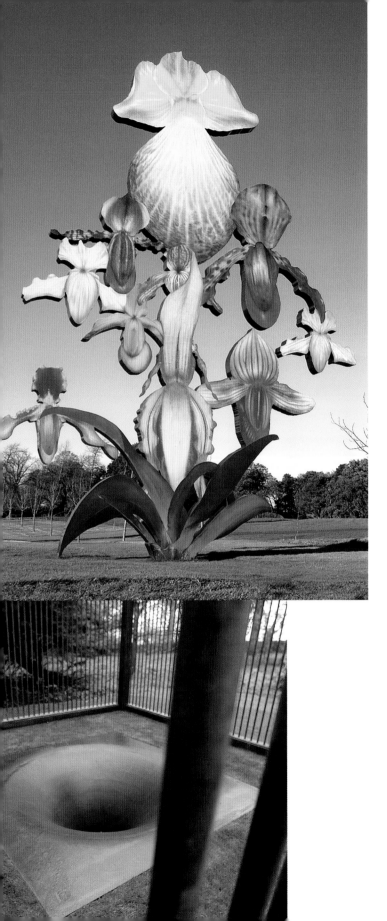

although there is a map, there is no set route. Changing terrains, unexpected vistas, livestock and thought-provoking artworks are all part of the experience.

As the artland has developed, it has become a place where the relationship between the artworks and the landscape with which they engage is crucial, not incidental. A number of the works were commissioned specifically for Jupiter Artland and are site-specific. Other works became site-specific, as the artists chose the locations and, in a number of cases, had the landscape reshaped to accommodate the artwork. British sculptor Antony Gormley's (b. 1950) piece, *Firmament* (2008), is a case in point. The 'drawing in space' of a giant man, kneeling with his face on the ground, required 100,000 tonnes of topsoil to create the horizon he wanted for the piece.

Works by other leading contemporary artists include the British sculptor Marc Quinn's (b. 1964) twelve-metre-high stainless-steel orchid, *Love Bomb* (2006); Indian-born Anish Kapoor's (b. 1954) *Suck* (2008), a swirling hole sinking into the ground surrounded by a cast-iron cage; Belgian Shane Waltener's knitted web framing the landscape, *Over Here* (2007); Briton Laura Ford's (b. 1961) eerie *Weeping Girls* (2009), five sculptures of faceless girls in the throes of a temper tantrum, sited in a quiet wood; and British artist Andy Goldsworthy's (b. 1956) extraordinary *Stone Coppice* (2009), which consists of fifty-four giant rocks suspended in trees, looking as if they had fallen from the air. Goldsworthy's piece inspires reflection on the strength and malleability of trees and wood. His work above ground calls to mind the sheer determination and strength of roots at work underground.

New works are continually being added to this magical destination so that repeat visits reveal fresh surprises. Other sites not to miss nearby include Jencks's *Landform Ueda* (see p. 266) in Edinburgh and Finlay's *Little Sparta* (see p. 70), which is about a 45-minute drive away at Dunsyre.

1

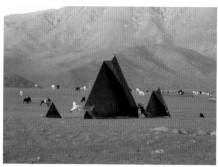

2

3

4

Babies (1)

Prague TV tower, Prague, Czech Republic
David Černý, 2000

The controversial TV tower in the Zizkov quarter of Prague is the city's tallest building at 216 metres high. The building was softened by the addition of Czech artist David Černý's (b. 1967) huge black babies climbing up it in 2000 when Prague was a city of culture. The installation has proved so popular that it is due to remain for the next ten to twenty years.

Bird of Peace

Medellín, Colombia
Fernando Botero, 2000

Fernando Botero (b. 1932), Colombia's best-known artist, donated a major bronze sculpture, *Bird*, to his birthplace of Medellín in the mid-1990s. The rotund dove was his gift to the city riddled by drug-related violence as a symbol of hope for a more positive future. In June 1995, a bomb was detonated inside the sculpture during an outdoor festival. Twenty-seven people were killed and hundreds were injured. No one was apprehended and the aim of the attack is still unknown. Instead of restoring or replacing the mangled sculpture, Botero insisted that it be left as is and donated the *Bird of Peace* to accompany it. Together the two sculptures form a stark reminder of the choice between violence and peace and stand as a poignant memorial to those killed by the act of senseless violence.

Parque Escultórico Cementerio de Carretas (Cart Cemetery Sculpture Park) (2)

Putaendo, Chile
Various artists, from 2000

Putaendo plain sits 650 feet above Putaendo village. It overlooks the rural farming community, is home to herds of goats and, since 2000, to a growing collection of site-specific sculptures based loosely on the theme of the old farm carts used in the region. The project was the brainchild of Chilean sculptor Ricardo Vivar (b. 1948). South American and international artists are invited to symposiums where they create works on site for the two hundred-acre park. The work above is by Nelson Miranda.

WaldSkulpturenWeg (3) (Woodland Sculpture Trail)

Rothaar Mountains, Germany
Various artists, from 2000

WaldSkulpturenWeg is a 23-kilometre route between the towns of Bad Berleburg in Wittgenstein and Schmallenberg in Sauerland. Eleven nature-based sculptures by artists such as American Alan Sonfist (b. 1946) and Germans Nils-Udo (b. 1937), Lili Fischer (b. 1947) (see above) and Gloria Friedmann (b. 1950) can be found along the trail.

At the Edge of the World (4)

Axel Vervoordt Kanaal, Wijnegem, Belgium
Anish Kapoor, 2000

Indian-born British artist Anish Kapoor's (b. 1954) extraordinary domed sculpture, *At the Edge of the World* (1998), found an ideal permanent home in 2000 in Axel Vervoordt's Kanaal, a restored ex-industrial building in the outskirts of Antwerp. The deep red dome, which measures eight metres in diameter and five metres in height and envelopes the viewer, has been dramatically installed in the old circular brew house.

5

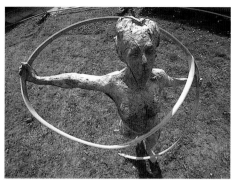

6

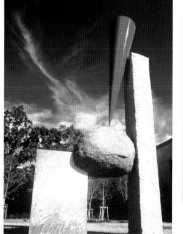

7

8

Set North for Japan (74° 33′ 2″) (5)

Echigo Tsumari Project, Niigata Prefecture, Japan

Richard Wilson, 2000

Briton Richard Wilson's (b. 1953) contribution to the Echigo Tsumari Project (an arts regeneration programme) in Japan is an extraordinary architectural intervention – a full-scale steel replica of the frame of his house in London transplanted to a field in front of the Nakasato Junior High School. It was installed at the same angle with the Earth – a rotation that sees it land almost upside down, emphasizing the distance between the two locations.

Louth Art Trail (6)

Louth, England

Various artists, 2000–02

Louth is an historic market town in Lincolnshire, England. The Louth Art Trail was developed in response to a town councillor's concern that Louth was completely devoid of public art. The trail that resulted introduces contemporary art in a number of sites around town. British sculptors Les Bicknell and Laurence

Edwards (see above), Simon Percival and Howard Bowcott created site-specific works that create a dialogue with the history and landmarks of the area.

Tirana

Tirana, Albania

Mayor Edi Rama and others, from 2000

Artist and activist Edi Rama (b. 1964) was elected mayor of Tirana, the capital of Albania, in October 2000. He instigated an ambitious and imaginative regeneration programme for the city with the goal of instilling pride and hope in its residents, attracting foreign investment and changing the nation's international reputation as a 'land of prostitutes and illegal immigrants'. Dilapidated buildings were torn down and replaced with green open spaces while the façades of others were given much-needed facelifts by a team of international artists. Dane Olafur Eliasson (b. 1967), Belgian Carsten Höller (b. 1961), Algerian Philippe Parreno (b. 1964), Mexican Pedro Reyes (b. 1972), Argentinian-born Rirkrit Tiravanija (b. 1961), French artist Dominique Gonzalez-Foerster (b. 1965)

and Briton Liam Gillick (b. 1964) are among those who have helped transform the city into a brightly coloured geometric collage.

Kirishima Open-Air Museum (7)

Yusui-cho, Kagoshima Prefecture, Japan

Various artists, from 2000

The Kirishima Open-Air Museum opened in the foothills of the Kirishima Mountain Range in southern Japan in 2000. It has an impressive collection of site-specific sculptures by such world-class national and international artists as American Dan Graham (b. 1942), Briton Phillip King (b. 1934), Israeli Dani Karavan (b. 1930), Italian Luciano Fabro (1936–2007) and Japanese Keiji Uematsu (b. 1947) (see above).

Fiets & Stal (Bicycle Stable) (8)

The Hague, Netherlands

Various artists, 2000–08

One of the many projects Stroom (The Hague Center for Visual Arts) has been involved with is *Fiets & Stal*, in which an international group of artists, designers and architects, such as Jan Snoeck (b. 1927) (see above), were invited to create

1

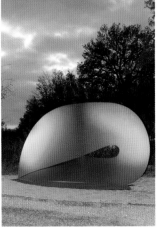

3

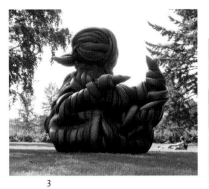

2

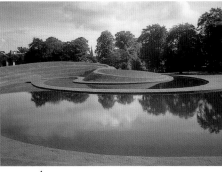

4

individual guard houses for bicycle shelters. Keep your eyes open for these often witty, functional artworks dotted around the city.

Noah's Ark Sculpture Park (1)

Tisch Family Zoological Garden, Jerusalem, Israel
Niki de Saint Phalle and Mario Botta, 2001
Franco–American artist Niki de Saint Phalle (1930–2002) made twenty-two brightly coloured, whimsically decorated animals for this zoo in Jerusalem. Swiss architect Mario Botta (b. 1943) built an amazing underground stone ark from which the animals seem to be disembarking, complete with a cascading waterfall to represent the flood.

Secret Garden

Walker Botanical Garden, St Catherines, Ontario, Canada
Alan Sonfist, 2001
Alan Sonfist (b. 1946) is an American environmental artist. *Secret Garden* in the Walker Botanical Garden in Ontario is comprised of monumental rocks and boulders creating a protective circular tower of stone around newly planted cedars. There

are openings in the stone wall that allow views of the trees' progress and light it during the summer and winter solstices.

Parco Sculture del Chianti (2) (Chianti Sculpture Park)

Pievasciata, Italy
Various artists, from 2001
The Chianti Sculpture Park is in a beautiful Tuscan wood, about ten kilometres north of Siena. Twenty-six internationally renowned artists, such as Italians Adriano Visintin (b. 1955) (see above) and Federica Marangoni (b. 1940) (see p. 7) and Briton William Furlong (b. 1944) (see pp. 212–13), have created works that integrate art and nature. American Benbow Bullock's (1929–2010) elegant steel *Homage to Brancusi* (2001), sited on a small hill among cypress trees, is another work that you will encounter on the one-kilometre walking trail.

Pirkkala Sculpture Park (3)

Pirkkala, Finland
Various artists, from 2001
The city park of the small town of Pirkkala, ten kilometres southwest of Tampere in

western Finland, has been transformed by the addition of a number of monumental site-specific sculptures by an international cast of artists. They are the results of International Cast Iron Symposiums organized by Estonian artist Villu Jaanisoo (b. 1963) (see above).

Landform Ueda (4)

Edinburgh, Scotland
Charles Jencks, 2002
American architect and architectural historian Charles Jencks (b. 1939) transformed the front lawn of the Scottish National Gallery of Modern Art in Edinburgh from a dull municipal space into an enormously popular, vibrant urban space with *Landform Ueda*, his magical serpentine earthwork. The landscape sculpture covers an area of more than 3000 square metres, rises to a height of seven metres and incorporates three pools.

Bus Home (5)

Ventura, California, USA
Dennis Oppenheim, 2002
The bus transfer station at the Pacific View

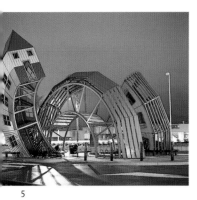

5

6

7

8

Mall in Ventura, California is the site of American Dennis Oppenheim's (b. 1938) fantastic functional sculpture *Bus Home*. The thirty-six-foot-high shelter enters the ground as a bus, exits the earth, loops around and down into the ground again, finally emerging as a house, anticipating the waiting traveller's journey home.

Reed Chamber (6)
The Wildfowl & Wetlands Trust, Arundel, West Sussex, England
Chris Drury, 2002
British environmental artist Chris Drury (b. 1948) created this chamber of willow battens and chestnut poles. It is thatched with reeds and sited on a floating boardwalk in a reed bed. The mirror and lens in the roof bring an image of the waving reeds inside.

L'Athanor-Musée Etienne-Martin (7)
Noyal-sur-Vilaine, France
Etienne-Martin, 2002
L'Athanor-Musée Etienne-Martin is a museum and sculpture park dedicated to the work of French sculptor Etienne-Martin

(1913–95). His monumental sculptures can be found in the three hectares of beautiful grounds of the privately owned, recently restored, fifteenth-century Château du Bois Orcan, just outside of Rennes in Brittany.

Sculpture in the Parklands (8)
Lough Boora Parklands, Tullamore, Ireland
Various artists, from 2002
Lough Boora Parklands is Ireland's national centre of cutaway boglands rehabilitation. The 2000-hectare site now features pastures, forests, wetlands, lakes and walkways. As part of the reinterpretation of the site, teams of Irish and international artists are invited to live and work in the community creating monumental land and environmental sculptures for the landscape. Danes Jørn Rønnau (b. 1944) and Marianne Jørgensen (b. 1959), Irish sculptors Eileen MacDonagh (see above) and Micheal Bulfin (b. 1939), Naomi Seki from Japan and Dutchman Johan Sietzema (b. 1953) are amongst those who have participated (see p. 7).

Laberinto Homenaje a Borges (Labyrinth in Honour of Borges)
San Rafael, Argentina
Randoll Coate, 2003
Five kilometres outside of San Rafael, in the Mendoza province in Argentina is an elaborate maze in homage to Jorge Luis Borges (1899–1986), the famous Symbolist writer. The work takes the shape of a book in which 'Borges' is spelled out and faced with its reflection on the pages. The maze was the brainchild of British diplomat turned garden maze designer, Randoll Coate (1909–2005). It is constructed out of 12,000 box hedges and covers two hectares of land on Finca Los Alamos, a country estate owned by the descendants of writer Susan Bombal, who introduced the two men in the 1950s. Coate drew inspiration from Borges's short story, *The Garden of the Forking Paths*, in which 'the book and the labyrinth were one and the same'. Conceived in 1979 the maze was finally planted in 2003.

1

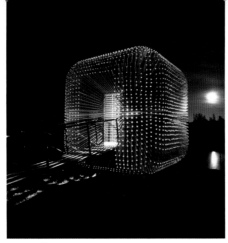

2

3

4

Broken Column (1)

Stavanger, Norway

Antony Gormley, 2003

Broken Column, by British sculptor Antony Gormley (b. 1950), is an installation of twenty-three cast iron sculptures placed throughout the Norwegian town of Stavanger. Each sculpture is 1.95 metres high and each successive sculpture is placed 1.95 metres lower than the previous one, such that if they were brought together they would form a column. They all face the same direction – towards the sea. The first sculpture is at the Rogaland Art Museum (where you can get a map of the installation), 41.41 metres above sea level, and 1.23 metres of the last one is installed in the sea. Some of the places they can be found include the local swimming pool, school, a football pitch, in a parking garage, a gas station and in a shop.

Sitooterie (2)

Barnards Farm, West Horndon, England

Thomas Heatherwick, 2003

Ingenious English designer Thomas Heatherwick (b. 1970) has created a peculiar yet rather wonderful garden shed for Barnards Farm, owned by Bernard and Sylvia Holmes. Heatherwick derived the name of his creation, *Sitooterie*, from a Scottish term for a small summer house (a place in which to 'sit oot'). The 2.4 cubic metre aluminium cube is perforated by nearly 5000 acrylic-tipped aluminium 'hairs' that glow orange during the day. At night the whole lights up like a giant hedgehog. Heatherwick's eccentric sculpture-shed seems right at home at Barnards Farm, with its mazes, copses designed from the air, kinetic and static sculptures, bog gardens, air strip and the National Malus (crabapple) Collection.

Changchun World Sculpture Park (3)

Changchun, China

Various artists, 2003

Changchun, in the Jilin Province in northeast China, hosted five international sculpture symposiums between 1997 and 2001. This vast modern urban sculpture park, at the south end of Renmin Street on the edge of the city, opened to the public in 2003 to exhibit the works made by the visiting artists during the conferences. The sculpture above is by Li Yinim.

Queen Califia's Magical Circle (4)

Escondido, California, USA

Niki de Saint Phalle, 2003

Franco–American artist Niki de Saint Phalle's (1930–2002) only large-scale environment in America is *Queen Califia's Magical Circle*. The enchanting sculpture garden is located in a twelve-acre natural habitat and is dedicated to the state's namesake, Queen Califia, the legendary black Amazon queen. It is comprised of large totem-pole-like sculptures surrounding that of Califia encircled by a serpentine wall.

Bleigiessen (5)

London, England

Thomas Heatherwick, 2004

English designer Thomas Heatherwick (b. 1970) and his studio have created a spectacular new sculpture for a seven-storey high space in the Wellcome Trust's new international headquarters. The curvaceous, twinkling sculpture is made from 150,000 glass spheres, weighs fourteen tonnes and is thirty metres high.

6

5

7

Heart of Reeds (6)

Lewes, East Sussex, England

Chris Drury, 2004–05

Heart of Reeds is a 1.6 hectare reed bed on the Lewes Railway Land Nature Reserve created by British artist Chris Drury (b. 1948) to increase the biodiversity of the site. The idea for this art and environment project came out of Drury's research into the relationship between science, nature and art and its shape was inspired by the pattern of a cross-section of the heart. There is a viewing mound and a hill nearby where you can see the overall design.

Memorial to the Murdered Jews of Europe (7)

Berlin, Germany

Peter Eisenman, 2005

American architect Peter Eisenman (b. 1932) designed the stark abstract memorial that covers five and a half acres in the centre of Berlin, near the Brandenburg Gate. It is comprised of 2,711 concrete pillars of varying heights. Walking through the corridors in the forest of pillars is an unsettling and rather frightening experience, as your vision is blocked and you can't see who is ahead or behind you.

Parco Portello (8)

Milan, Italy

Charles Jencks and LAND srl, 2011

American Charles Jencks (b. 1939) and Italian landscape architecture firm LAND (founded in 1990) joined forces to transform the polluted old Alfa Romeo site in northwest Milan into a new urban park. The former industrial site is now a major green space that serves as a welcoming gateway to the city as well as an important resource for the local community. Three large landforms, ponds, gardens, paving, planting and sculptures together tell the prehistory, history and present of Milan, as well as activate the space and provide intimate gardens, children's play areas and sites for recreation and repose.

8

PRACTICAL INFORMATION

IOO OLYMPIC SCULPTURES p. 256
The sculptures are located in the Olympic Park Central Area, the Olympic Forest Park, Chao Yang Park, the National Centre for the Performing Arts, the Beijing Shooting Hall, the Laoshan Cycling Stadium and the Mei Lanfang Theatre, Beijing, People's Republic of China
Further reading *Gathering Dreams: 100 Olympic Sculptures* (Culture and Art Publishing House, 2009), two-part book documenting the project, in Chinese and English

A13 ARTSCAPE p. 209
A13, London, England
www.barking-dagenham.gov.uk

ADJACENT, AGAINST, UPON p. 139
Myrtle Edwards Park (north of Pier 70),
3130 Alaskan Way W, Seattle, WA, USA

AFANGAR (MILESTONES) p. 203
Videy Island, Reykjavik Harbour, Iceland
Getting there Ferries daily from Reykjavik city centre, mid-May–Sept

AMARGOSA OPERA HOUSE AND HOTEL p. 87
Death Valley Junction, CA 92328, USA
Tel: + 1 760 852 4441 Fax: + 1 760 852 4138
www.amargosaoperahouse.com

AMARILLO RAMP p. 138
Amarillo, TX 70101, USA
www.robertsmithson.com
Admission By appointment only. Contact Melba Knowles, c/o Marsh Enterprises, 600 South Tyler, Box 12077, Amarillo, TX 70101, USA
Tel: + 1 806 372 5555 or email melba@marshent.com

THE ANGEL OF THE NORTH p. 210
Along the A167 nr the intersection with the A1, 3 miles south of Gateshead, England
www.antonygormley.com; www.gateshead.gov.uk

ART AND ARCHITECTURE AT KIELDER p. 180
Kielder Castle, Leaplish or Rower Knowe visitor centres, Kielder Water, Northumberland, England
Tel: + 44 (0)1434 220616
www.visitkielder.com
Getting there See the website for detailed instructions.
Further reading *Art and Architecture at Kielder 2004–2006*, pamphlet (Kielder Partnership, 2004)
C. Drury, *Chris Drury: Silent Spaces* (Thames & Hudson, 2004)

ART HOUSE PROJECT p. 209
Benesse Art Site Naoshima, 850–2 Naoshima-cho, Kagawa-gun, Kagawa 761–3110, Japan
Tel: + 81 87 892 2887
www.naoshima-is.co.jp

ARTENATURA (ART IN NATURE) p. 207
Arte Sella, Corso Ausugum 55–57,
38051 Borgo Valsugana, TN, Italy
Tel: + 39 0461 751 251 Fax: + 39 0461 756 391
www.artesella.it

ARTSCAPE NORDLAND p. 204
Nordland County, Norway
Tel: + 47 75 65 05 70
www.skulpturlandskap.no

AT THE EDGE OF THE WORLD p. 264
Axel Vervoordt Kanaal, Stokerijstraat 15–19,
2110 Wijnegem, Belgium
Tel: + 32 (0)3 355 33 00 Fax: + 32 (0)3 355 33 01
www.axel-vervoordt.com

ATELIER BRANCUSI p. 84
Place Georges Pompidou, 75004 Paris, France
Tel: + 33 (0)1 44 78 12 33
www.cnac-gp.fr

L'ATHANOR-MUSÉE ETIENNE-MARTIN p. 267
Château du Bois Orcan, 35530 Noyal-sur-Vilaine, France
Tel: + 33 (0)2 99 37 74 74
www.bois-orcan.com

L'AUBETTE p. 48
Place Kléber, 67000 Strasbourg, France
www.laubette.com

THE AWAKENING p. 198
National Harbor, MD 20745, USA
www.nationalharbor.com

AXE MAJEUR (MAIN AXIS) p. 198
Cergy Pontoise, France
www.axe-majeur.net

BABIES p. 264
Tower Praha, a.s., Mahlerovy sady 1,
Prague 3, Czech Republic
Tel: + 420 242 418 778 Fax: + 420 222 724 014
www.tower.cz

BATCOLUMN p. 104
600 West Madison Street, Chicago, IL 60661, USA
Tel: + 1 312 744 7487
www.oldenburgvanbruggen.com
Getting there By train Blue Line, Clinton stop
Further reading G. Celant, C. Oldenburg &
C. van Bruggen, *Claes Oldenburg, Coosje van Bruggen* (Skira, 1999)

BENSON SCULPTURE GARDEN p. 200
2908 Aspen Drive, Loveland, CO 80538, USA
www.sculptureinthepark.org

BERNHARD LUGINBÜHL STIFTUNG p. 87
3324 Mötschwil, Switzerland
Tel: + 41 (0)79 487 06 15
www.luginbuehlstiftung.ch

BIENNALE OF SPATIAL FORMS p. 66
Centrum Sztuki Galeria EL, ul. Kusnierska 6,
82–300 Elblag, Poland
Tel: + 48 55 232 53 86 Fax: + 48 55 236 16 33
www.galeria-el.pl (There is an extensive guide online at www.galeria-el.pl/przewodnik/index.html)
Opening hours Spring and summer, Mon–Sat, 10am–6pm; Sun, 10am– 5pm; Autumn and winter, Mon–Sat, 10am–5pm; Sun, 10am–4pm
Getting there Elblag is 60 km from Gdansk and easily accessible by train or bus.
Further reading J. Denisiuk & Z. Opalewski (eds), *Od Laboratorium Sztuki, Do Centrum Sztuki, Galeria El w Latach 1961–2002*, in Polish and English (Centrum Sztuki Galeria EL, 2001)
Open Gallery: Spatial Forms in Elblag Guidebook, in Polish, English and German (Centrum Sztuki Galeria EL, 2006)

BIRD OF PEACE p. 264
Parque San Antonio, Medellín, Colombia

BISHOP CASTLE p. 87
12705 Highway 165, Rye, CO 81069, USA
Tel: + 1 719 485 3040

BLEIGIESSEN p. 268
The Wellcome Trust, Gibbs Building, 215 Euston Road, London NW1 2BE, England
www.wellcome.ac.uk
Admission The sculpture can be seen from outside the building on Gower Street. Public tours are by appointment only: email Elayne Hodgson e.hodgson@wellcome.ac.uk

BOTH NAM FAILEAS: HUT OF THE SHADOW p. 208
Sponish, Lochmaddy, North Uist, Scotland
Tel: + 44 (0)1876 500293
www.chrisdrury.co.uk

BRAMME (FÜR DAS RUHRGEBIET) (SLAB (FOR THE RUHR DISTRICT)) p. 209
Halde Schurenbach, Nordsternstraße,
45329 Essen-Altenessen, Germany

BRANCUSI ENSEMBLE p. 36
Târgu-Jiu, Romania
www.targujiu.ro
Getting there Trains from Bucharest take 4½ hours. For timetables, see www.cfr.ro
Further reading *Constantin Brancusi: The Essence of Things* (Tate, 2004)
R. Varia, *Brancusi* (Rizzoli, 2003)

BRASILIA p. 84
Brasilia, Brazil

BROKEN CIRCLE/SPIRAL HILL p. 96
c/o Gerard and Eric de Boer, Emmerhoutstraat 150,
7814 XX Emmen, Netherlands
Tel: + 31 (0)59 1623037
www.robertsmithson.com
Admission By appointment only
Getting there *By train* See www.ns.nl. *Broken Circle/Spiral
Hill* is about 2–3 km from the station. Hire bicycles at the
station or walk to the site on Roswinkelerweg. *By car* The
entrance is on Emmerhoutstraat. Pamphlets and maps
available at the tourist office (5-min walk from the station).
Further reading S. Boettger, *Earthworks: Art and the
Landscape of the Sixties* (University of California Press, 2002)
G. Shapiro, *Earthwards: Robert Smithson and Art After Babel*
(University of California Press, 1995)

BROKEN COLUMN p. 268
Stavanger, Norway
www.rkm.no

BRUNO WEBER SKULPTURENPARK p. 87
Spreitenbach, 8953 Dietikon, Switzerland
Tel: + 41 (0)44 740 02 71 Fax: + 41 (0)44 740 02 13
www.bruno-weber.com

BUS HOME p. 266
North end of Pacific View Mall, Mills and
Telegraph Roads, Ventura, CA, USA
www.cityofventura.net

CADILLAC RANCH p. 138
Interstate 40, between exits 60 and 62, Amarillo, TX, USA
www.libertysoftware.be/cml/cadillacranch/ranch/crabtr.htm

CAMPO DEL SOLE (FIELD OF THE SUN) p. 200
Punta Navaccia, Lake Trasimeno, Lido di Tuoro,
Umbria, Italy
www.trasinet.com
Admission Free, open daily

CASINO KNOKKE p. 84
Zeedijk-Albertstrand 509, 8300 Knokke-Heist, Belgium
Tel: + 32 (0)5 063 05 00 Fax: + 32 (0)5 061 20 49
www.casinoknokke.be

CASS SCULPTURE FOUNDATION p. 174
Goodwood, West Sussex PO18 0QP, England
Tel: + 44 (0)1243 538449 Fax: + 44 (0)1243 531853
www.sculpture.org.uk
Getting there See the website for detailed instructions.
Further reading *Sculpture at Goodwood: A Vision for Twenty-
first Century British Sculpture* (Sculpture at Goodwood, 2002)
Tony Cragg at Goodwood (Sculpture at Goodwood, 2005)

**IL CASTELLO INCANTATO
(THE ENCHANTED CASTLE) p. 47**
Via F. Bentivegna, 92019 Sciacca (Agrigento), Italy
Tel: + 39 0925 993 044
www.castelloincantato.net
Opening hours Tues–Sun, 9am–1pm and 3–5pm
(winter), 4–8pm (summer)

CELESTIAL VAULT/PANORAMA IN THE DUNES p. 184
Opposite the Restaurant De Haagsche Beek, Machiel
Vrijenhoeklaan 175, Kijkduin, The Hague, Netherlands
Getting there *By train* Take a direct train from
Amsterdam Centraal to Den Haag Centraal Station
(50 mins). From there take a Line 24 bus to Kijkduinse
straat/Machiel Vrijenhoeklaan. Walk 500 metres to the
site. Guides are often present at the site at weekends
during the summer. Alternatively, go to *Stroom Den Haag*
first for a pamphlet, map and directions.
Further reading *James Turrell – Kijkduin*, in Dutch
and English (Stroom Den Haag, 1996)
P. Noever (ed.), *James Turrell: The Other Horizon*
(Hatje Cantz, 2001)
See also Stroom Den Haag, Hogewal 1–9, 2514 HA
The Hague, Netherlands, Tel: + 31 (0)70 3658985
Fax: + 31 (0)70 3617962
www.stroom.nl
Opening hours Wed–Sun, 12–5pm
See also *Panorama Mesdag*, Zeestraat 65, 2518 AA
The Hague, Netherlands, Tel: + 31 (0)70 3644544
www.panorama-mesdag.nl
Opening hours Mon–Sat, 10am–5pm; Sun and
bank holidays, 12–5pm

**CENTRE INTERNATIONAL D'ART ET DU PAYSAGE
DE VASSIVIÈRE p. 198**
Ile de Vassivière, 87120 France
Tel: + 33 (0)5 55 69 27 27 Fax: + 33 (0)5 55 69 29 31
www.ciapiledevassiviere.com
Opening hours Daily
Admission Sculpture park free

CHANGCHUN WORLD SCULPTURE PARK p. 268
Southern end of Renmin St, 130056 Changchun,
Jilin Province, People's Republic of China
http://en.changchun.gov.cn
Admission Entrance fee

CHAPELLE DU ROSAIRE p. 52
468 Avenue Henri Matisse, 06140 Vence, France
Tel: + 33 (0)4 93 58 03 26 Fax: + 33 (0)4 93 58 21 10
http://pagesperso-orange.fr/maison.lacordaire/
Opening hours Mon, 2–5.30pm; Tues, 10–11.30am and
2–5.30pm; Wed, 2–5.30pm; Thurs, 10–11.30am and
2–5.30pm; Fri, 2–5.30 during holidays; Sat, 2–5.30;
Sun, Mass at 10am. The Chapelle du Rosaire is closed
for all French holidays and from mid-Nov to mid-Dec
Admission Entrance fee
Getting there Vence is 21 km west of Nice (50 mins by
bus). The Chapelle du Rosaire is about half a mile north
of the centre of town.
Further reading M.-A Couturier & L.-B. Rayssiguier,
Henri Matisse: The Vence Chapel: The Archive of a Creation
(Skira, 1999)
R. Percheron & C. Brouder, *Matisse: From Color
to Architecture* (Harry N. Abrams, 2004)

CHAPELLE NÔTRE-DAME-DU-HAUT p. 83
70250 Ronchamp, France
Tel: + 33 (0)3 84 20 65 13 Fax: + 33 (0)3 84 20 67 51
Opening hours Daily

CHICHU ART MUSEUM p. 240
Naoshima Fukutake Art Museum Foundation,
3449–1 Naoshima, Kagawa 761–3110, Japan
Tel: + 81 (0)87 892 3755 Fax: + 81 (0)87 840 8285
www.chichu.jp
Opening hours Mar–Sept, 10am–6pm (last entry 5pm);
Oct–Feb, 10am–5pm (last entry 4pm); closed every Mon
and 30 Dec–2 Jan. During national holidays, open on
Mon but closed the following Tues
Getting there See the website for detailed instructions.
Further reading *Chichu Art Museum: Tadao Ando Builds for
Walter De Maria, James Turrell and Claude Monet*, in English
(Chichu Art Museum & Hatje Cantz, 2005)

THE CHINATI FOUNDATION p. 132
1 Cavalry Row, Marfa, TX 79843, USA
Tel: + 1 432 729 4362 Fax: + 1 432 729 4597
www.chinati.org
Admission Adults $10, students and seniors $5.
Accessible by guided tour only, Wed–Sun at 10am.
Reservations are recommended 3 days in advance.
For large groups (7+ people), contact the museum
at least 2 weeks in advance (Tel: + 1 432 729 4362 or
email ttanabe@chinati.org). Note that visitors should
wear footwear that is comfortable and protective.
Open-toed shoes are not recommended. People
who have difficulty walking or need assistance may
contact the museum in advance to make special
arrangements. May–Sept temperatures can reach
38°C (100°F). Oct–Apr temperatures fluctuate between
1° and 24°C (30° and 75°F). Hats, sunglasses and sun
block are always recommended.
Getting there See the website for detailed instructions.
Further reading *Donald Judd* (Tate, 2004)
Light in Architecture and Art: The Work of Dan Flavin
(Chinati Foundation, 2002)
See also Judd Foundation, 104 South Highland Ave,
Marfa, TX 79843, USA, www.juddfoundation.org
Reservations for tours (Wed–Sun at 4.40pm, $20) of
La Mansana de Chinati should be made at least 5 days
in advance through the Judd Foundation (Tel: + 1 432
729 4406 or email marfatours@juddfoundation.org)

CHRIST THE REDEEMER OF THE OPEN ARMS p. 47
Corcovado Mountain, Rio de Janeiro, Brazil
www.corcovado.com.br
Opening hours Daily, 8.30am–6.30pm

CLOSERIE FALBALA AND FONDATION DUBUFFET p. 138
Périgny-sur-Yerres, Val-de-Marne, France
Admission By appointment only
Tel: + 33 (0)1 47 34 12 63
www.dubuffetfondation.com

CONFEDERATE MEMORIAL CARVING p. 47
Stone Mountain Park, Memorial Lawn,
Stone Mountain, GA 30086, USA
Tel: + 1 770 498 5690 or + 1 800 401 2407
www.stonemountainpark.com

CORAL CASTLE p. 47
28655 South Dixie Highway,
Homestead, FL 33033, USA
Tel: + 1 305 248 6345
www.coralcastle.com

CRAZY HORSE MEMORIAL p. 83
12151 Avenue of the Chiefs,
Crazy Horse, SD 57730, USA
Tel: + 1 605 673 4681 Fax: + 1 605 673 2185
www.crazyhorsememorial.org

CUBIST LAMP POST p. 47
Jungmannovo námestí, Prague, Czech Republic

LE CYCLOP p. 76
91490 Milly-la-Forêt, France
Tel: + 33 (0)1 64 98 83 17
www.lecyclop.com
Admission Guided tours in French of the interior only
(45 mins). No children under 10 allowed inside the
sculpture. Tickets available from the old red firetruck.
Opening hours Sat, 2pm, 2.45pm, 3.30pm, 4.15pm, 5pm
(in Oct last visit 4.15pm); Sun, 11am, 11.45am, 12.30pm,
2pm, 2.45pm, 3.30pm, 4.15pm, 5pm, 5.45pm (in Oct last
visit 5pm). Further information and group reservations:
Tel: + 33 (0)1 64 98 95 18, Fax: + 33 (0)1 64 98 95 72 or
email associationlecyclop@wanadoo.fr
Getting there By car From Paris take the A6 south to
exit 13 for Milly-la-Forêt. Take Route D372 to the D837
towards Etampes. Follow signs to Le Cyclop, which is off
the D837. By train From Gare du Nord or Gare de Lyon
take the RER D4 train line towards Malesherbes to
Maisse. Once at Maisse, it is an 1½-hour walk along the
D837 towards Milly-la-Forêt (Route de Milly). After 7 km,
you reach a roundabout, just before Milly-la-Forêt.
Turn left onto the D837 towards Etampes. Follow signs
to Le Cyclop, which is off the D837. By taxi Private taxis
in Milly-la-Forêt can take you to Le Cyclop and deliver you
back to the train station in Maisse. Call the tourist office
(+ 33 (0)1 64 98 83 17) for names and numbers.
Further reading I. Siben, Niki de Saint Phalle & Jean
Tinguely (Prestel, 2005)
H. Violand-Hobi, Jean Tinguely: Life and Work
(Prestel, 1995)

THE DAN FLAVIN ART INSTITUTE p. 199
Corwith Avenue, Bridgehampton, NY, USA
Tel: + 1 212 989 5566, extension 518
www.diaart.org

LES DEUX PLATEAUX (TWO LEVELS) p. 200
Palais Royal, Paris, France

DIA:BEACON p. 232
Riggio Galleries, 3 Beekman Street,
Beacon, NY 12508, USA
Tel: + 1 845 440 0100 Fax: + 1 845 440 0092
www.diaart.org
Opening hours See website
Admission Adults $10, students and seniors (65+) $7,
free for children under 12. Adult-only tours of North,
East, South, West are at 10.30am. To reserve call + 1 845
440 0100 x42 or email heizer@diabeacon.org with your
surname, the number of people in your group (10 guests
maximum) and the day of your visit.
Getting there See the website for detailed instructions.
Further reading L. Cooke & M. Govan, Dia:Beacon
(Dia Art Foundation, 2003)
M. Taylor, L. Cooke & M. Govan, Richard Serra: Torqued
Ellipses (Dia Art Foundation, 1997)

DOMAGOJEVA LADJA (DOMAGOJ'S BOAT) p. 208
Vid, Dalmatia, Croatia

**DOMAINE DE KERGUÉHENNEC, CENTRE D'ART
CONTEMPORAIN** p. 201
56500 Bignan (Locminé), France
Tel: + 33 (0)2 97 60 44 44 Fax: + 33 (0) 2 97 60 44 00
www.art-kerguehennec.com

DOUBLE NEGATIVE p. 80
Mormon Mesa, Overton, NV, USA
Collection of the Museum of Contemporary Art,
Los Angeles, www.moca.org
Getting there Overton is 1 hour north of Las Vegas via
Interstate 15. Take exit 93 (Nevada Highway 169) towards
Logandale/Overton. It is 11 miles to Overton from the exit.
Follow signs to Overton airport. (Let someone at the
airport know where you are going in case of emergencies.)
After the airport main gate, turn right onto Mormon Mesa
Road. At the cattle grid at the top, take the middle road
for 2.7 miles. Just before the second cattle grid, turn left
off the main road. Follow this smaller road north for
1.3 miles. Park and walk east where you should be able
to see Double Negative. Keep in mind that unpaved roads,
walking on rocky, sandy terrain and high temperatures
may all be involved, so prepare accordingly – good
shoes, water and a four-wheel-drive vehicle are all
recommended.
Further reading J. Brown (ed.), Michael Heizer: Sculpture
in Reverse (Museum of Contemporary Art, 1984)
E. Hogan, Spiral Jetta: A Road Trip through the Land Art of
the American West (University of Chicago Press, 2008)

DWAN LIGHT SANCTUARY p. 206
United World College, Montezuma, NM 87731, USA
Tel: + 1 505 454 4200 Fax: + 1 505 454 4274
www.uwcaw.uwc.org

EAST SIDE GALLERY p. 203
Mühlenstraße 45–80,
10243 Berlin-Friedrichshain, Germany
Tel: + 49 (0)30 251 7159
www.eastsidegallery.com

EUROPOS PARKAS p. 152
Joneikiskiu k., 15148 Vilnius r., Lithuania
Tel/Fax: + 370 523 77 077
www.europosparkas.lt
Opening hours Daily, 10am–sunset
Admission €5. Guided tours available in English,
Russian and Lithuanian. Advance booking required
Getting there By car Europos Parkas is a 20-min drive
from the centre of Vilnius: go north along Kalvariju or
Gelezinio Vilko street to Santariskes roundabout, turn
right in the direction of Green Lakes/Zalieji Ezerai (the
road sign indicates: Europos Parkas 11 km) and follow
signs for Europos Parkas. By bus From Vilnius Bus/Train
Station or Vilnius town centre, take trolleybus 5 (towards
Zirmunai) until Zalgirio stop, then take a bus or minibus
to Europos Parkas (marked Skirgiskes). See bus schedule
at www.europosparkas.lt – visitor information.
Further reading Gintaras Karosas and Europos Parkas,
in English and Lithuanian (Vilnius, 2005)

FARNSWORTH HOUSE p. 82
14520 River Road, Plano, IL 60545, USA
Tel: + 1 630 552 0052 Fax: + 1 630 552 8890
www.farnsworthhouse.org
Admission $20 Advance reservations required

**FATTORIA DI CELLE: THE GORI COLLECTION
OF SITE-SPECIFIC ART** p. 199
Via Montalese 7, 51030 Santomato di Pistoia, Italy
Tel: + 39 0573 479 907 Fax: + 39 0573 479 486
www.goricoll.it
Opening hours May–Sept, weekdays, by appointment
only. Write or fax at least 6 weeks in advance. Tours
involve a 3–4-hour hike through the grounds.

FIELD OF CORN (WITH OSAGE ORANGE TREES) p. 205
Sam & Eulalia Frantz Park, 4995 Rings Road, Dublin,
OH 43017, USA

THE FIELDS SCULPTURE PARK p. 209
1405 County Route 22, Ghent, NY 12075, USA
Tel: + 1 518 392 4747
www.artomi.org

FIETS & STAL (BICYCLE STABLE) p. 265
The Hague, Netherlands
www.stroom.nl

FIGURENFELD (FIGURE FIELD) p. 85

Directions from the Eichstätt Tourist Office:
Domplatz 8, 85072 Eichstätt, Germany
Tel: + 49 (0)8421 6001 400
Fax: + 49 (0)8421 6001 408
www.eichstaett.info

FLEVOLAND p. 114

Observatorium, Swifterringweg (N307 to Swifterbant),
Lelystad, Netherlands
Aardzee, Vogelweg (N706), Zeewolde, Netherlands
Sea Level, De Wetering Landschaftspark, Zeewolde,
Netherlands
De Groene Kathedraal, Tureluurweg, Almere, Netherlands
Polderland Garden of Love and Fire, Pampushavenweg,
Almere, Netherlands
Museum de Paviljoens, Odeonstraat 3, 1325 AL Almere
Tel: + 31 (0)36 5450400 Fax: + 31 (0)36 5450800
www.depaviljoens.nl
Opening hours Wed, Sat–Sun, 12–5pm; Thurs and Fri,
12–9pm
Getting there *By train* Almere is a 20-min train journey
from Amsterdam (see www.ns.nl). The Museum de
Paviljoens is a 5-min walk from Almere Centrum train
station. Directions to all the Land Art pieces and a guide
to the outdoor sculpture in the region available at the
museum. The museum has bicycles that you can use to
visit the 2 works nearby – *De Groene Kathedraal* and
Polderland Garden of Love and Fire. The other works aren't
accessible by public transport. *By car* All 5 works can
be visited in a day. A circular route starts in Almere at
Polderland Garden of Love and Fire, then on to *Observatorium*,
down to *Aardzee*, which is on the way to *Sea Level* and
Art Route Zeewolde, and finishes with *De Groene Kathedraal*
back in Almere. *By bus* Bus tours with a guide can be
arranged for groups of 20–50 people through
the Museum de Paviljoens.
Further reading J. Bremer & A. de Vries, *Piet Slegers*
(Arnhem, 2004)
The Flevoland Collection, in Dutch and English
(Museum de Paviljoens, 2007)
D. Libeskind, *Daniel Libeskind: The Space of Encounter*
(Thames & Hudson, 2001)

FOREST OF DEAN SCULPTURE TRAIL p. 201

Royal Forest of Dean, Coleford, Gloucestershire, England
Tel: + 44 (0)1594 833057
www.forestofdean-sculpture.org.uk

LA FRÉNOUSE p. 86

Maison des Champs, 53230 Cossé-le-Vivien, France
Tel: + 33 (0)2 43 98 80 89 Fax: + 33 (0)2 43 98 78 89
www.musee-robert-tatin.org

THE GARDEN OF EDEN p. 46

Kansas and Second Street, Lucas, KS 67648, USA
Tel: + 1 785 525 6395
www.garden-of-eden-lucas-kansas.com

GIARDINO DEI TAROCCHI (TAROT GARDEN) p. 126

Pescia Fiorentina, Capalbio, GR 58100, Italy
Tel: + 39 0564 895 122 Fax: + 39 0564 895 700
www.nikidesaintphalle.com
Opening hours Apr–mid-Oct, daily, 2.30–7.30pm;
Nov–Mar, open the first Sat of each month, 9am–1pm
Admission Adults € 10.50, 7–16 year olds, students
and senior citizens € 6.00, children under 7 and
disabled persons free. Free Nov–Mar
Getting there See the website for detailed instructions.
Further reading S. Groom (ed.), *Niki de Saint Phalle*
(Tate Publishing, 2008)
U. Krempel & R. Jackson, *Niki's World: Niki de Saint Phalle*
(Prestel, 2004)
C. Schulz-Hoffmann & P. Restany, *Niki de Saint Phalle:
My Art – My Dreams* (Prestel, 2003)

IL GIARDINO DI DANIEL SPOERRI p. 190

58038 Seggiano, GR, Italy
Tel: + 39 0564 950 457
www.danielspoerri.org
Opening hours Easter–Jun, Tues–Sun, 11am–8pm;
Jul–15 Sept, daily, 11am–8pm, 15 Sept–Oct, Tues–Sun,
11am–7pm; open other times by appointment
Admission Adults €10, concessions €8, under 8 free
Getting there Directions and maps available on website.
Further reading T. Levy (ed.), *Daniel Spoerri: Coincidence
as Master* (Kerber Verlag, 2004)
A. Mazzanti (ed.), *Il Giardino di Daniel Spoerri*, in Italian
and German (Gli Ori, 2003)

GOLDENER VOGEL (GOLDEN BIRD) p. 203

Kölnisches Stadtmuseum, Zeughausstraße 1–3,
50667 Cologne, Germany
Tel: + 49 (0)221 221 25789 Fax: + 49 (0)221 221 24154
www.museenkoeln.de

GOLDWELL OPEN AIR MUSEUM p. 148

Nr Rhyolite, NV, USA
Tel/Fax: + 1 702 870 9946
www.goldwellmuseum.org
Getting there See the website for detailed instructions.
Further reading *The Death Valley Project: The Making of the
Last Supper*, written, produced and directed by S. Hackett
& C. Morgan, DVD with a booklet and essay by W. L. Fox

GOLEM p. 138

Rabinovitch Park, Kiryat Yovel, Jerusalem, Israel

**LE GRAND RASSEMBLEMENT (THE GREAT
GATHERING)** p. 202

Centre d'art Marcel Gagnon, 564 Route de la Mer,
Saint-Flavie, Quebec G0J 2L0, Canada
Tel: + 1 418 775 2829 Fax: + 1 418 775 9548
www.centredart.net

GRASS MOUND p. 84

The Aspen Institute, 1000 North Third Street, Aspen,
CO 81611, USA
Tel: + 1 970 925 7010 Fax: + 1 970 925 4188
www.aspeninstitute.org

GREENWOOD PARK p. 83

45th and Grand Avenue, Des Moines, IA 50312, USA

GRIZEDALE SCULPTURE PROJECT p. 140

Grizedale Forest Park, Ambleside, Cumbria LA22 0QJ,
England
Tel: + 44 (0)1229 860010
www.grizedale.org

THE GROTTO p. 222

Herrenhäuser Gärten, Herrenhäuser Str. 4,
30419 Hannover, Germany
Tel: + 49 (0)511 1684 7576 Fax: + 49 (0)511 1684 7374
Herrenhaeuser-gaerten@hannover-stadt.de
www.grotte-herrenhausen.de
Opening hours Apr–Sept, daily, 9am–8pm (7pm in
April and Sept); Oct–March, 11am–3.30pm. Groups by
appointment every day. Group tours of *The Grotto* and
of 'Niki de Saint Phalle in Hannover' can be arranged
through the Hannover Tourism Service (Tel: + 49 (0)511
1234 5333)
Admission Adults €4, 14 and under free
Getting there Trams 4 (to Stöcken) and 5 (to
Garbsen) go to the Herrenhausen Gardens from
the city centre Hauptbahnhof or Kröpcke subway
stations in about 10 mins.
Further reading S. Groom (ed.), *Niki de Saint Phalle*
(Tate Publishing, 2008)
U. Krempel & R. Jackson, *Niki's World: Niki de Saint Phalle*
(Prestel, 2004)
Niki de Saint Phalle: The Grotto (Hatje Cantz, 2003)
See also Sprengel Museum Hannover, Kurt-Schwitters-
Platz, 30169 Hannover, Germany
Tel: + 49 (0)511 1684 3875 Fax: + 49 (0)511 1684 5093
www.sprengel-museum.de; www.skulpturenmeile.de

GROUNDS FOR SCULPTURE p. 204

18 Fairgrounds Road, Hamilton, NJ 08619, USA
Tel: + 1 609 586 0616 Fax: + 1 609 586 0986
www.groundsforsculpture.org

HAIZE-ORRAZIA (PEINE DEL VIENTO, XV) (WIND COMB) p. 139
Paseo Peine del Viento, San Sebastián, Spain

HEART OF REEDS p. 269
Lewes Railway Land Nature Reserve, Lewes, East Sussex, England
www.heartofreeds.org.uk

HENRY MOORE FOUNDATION p. 110
Dane Tree House, Perry Green, Much Hadham, Hertfordshire SG10 6EE, England
Tel: + 44 (0)1279 843333
www.henry-moore.org
Opening hours By appointment only Apr–Sept; Tues–Fri, guided tours; Fri–Sun, unaccompanied visits; admission free
Getting there By train Trains from London's Liverpool Street Station to Bishop's Stortford take 40–50 mins (www.nationalrail.co.uk). A taxi from Bishop's Stortford station to Perry Green takes 15 mins. By car Directions and map available from the website.
Further reading D. Mitchinson, Celebrating Moore (Lund Humphries, 2006)
Sculpture in the Open Air at Perry Green: The Henry Moore Foundation (Henry Moore Foundation, 2000)

HERRING ISLAND ENVIRONMENTAL SCULPTURE PARK p. 208
Yarra River, South Yarra, Victoria 3141, Australia
Tel: + 61 (0)3 8627 4699
www.parkweb.vic.gov.au
Opening hours Weekends, 12–5pm, during daylight-saving time
Getting there Herring Island is 3 km upstream from Melbourne city centre and is only accessible by boat. It can be reached by punt from Como Landing.

HIMMELHØJ p. 236
Kalvebod Fælleden, Amager, Copenhagen, Denmark
www.alfiobonanno.dk
Opening hours Daily, 24 hours
Admission Free
Getting there By metro Central Copenhagen to Vestamager Metro Station takes 15 mins. Kalvebod Fælleden (where Himmelhøj is situated) is a 5-min walk.
Further reading J. K. Grande, Art Nature Dialogues: Interviews with Environmental Artists (SUNY Press, 2004)
H. Strelow (ed.), with V. David, Ecological Aesthetics: Art in Environmental Design: Theory and Practice, in English and German (Birkhäuser, 2004)

HIRSHHORN MUSEUM AND SCULPTURE GARDEN p. 138
National Mall, Washington, DC, USA
http://hirshhorn.si.edu

HOLOCAUST MEMORIAL p. 207
Judenplatz, Vienna, Austria

HUNDERTWASSER HOUSE p. 199
Corner of Kegelgasse and Löwengasse, Vienna, Austria
www.hundertwasserhaus.at
Admission Access to outside only

INSIDE AUSTRALIA p. 228
Lake Ballard, via Menzies, Western Australia 6436
www.menzies.wa.gov.au
Getting there Lake Ballard is 55 km west of Menzies and 800 km northeast of Perth.
Further reading H. Brody et al, Antony Gormley: Inside Australia (Thames & Hudson, 2005)
Inside Australia, official booklet (Perth International Arts Festival, 2003)

ISLA DE ESCULTURAS (ISLAND OF SCULPTURES) p. 210
Xunqueira Island, Pontevedra, Galicia, Spain
www.turgalicia.es

LE JARDIN DE NOUS DEUX (THE GARDEN OF THE TWO OF US) p. 139
Chemin de Mazard, 69380 Civrieux d'Azergues, France
Admission Access to outside only as it is a private residence

JOSHUA TREE ENVIRONMENT p. 202
63030 Blair Lane, Joshua Tree, CA 92252, USA
Tel: + 1 213 382 7516
www.noahpurifoy.com

DAS JUNKERHAUS (JUNKER HOUSE) p. 46
Hamelner Str. 36, 32657 Lemgo, Germany
Tel: + 49 (0)5261 667 695 Fax: + 49 (0)5261 213 346
www.junkerhaus.de
Opening hours Apr–Oct, Tues–Sun, 10am–5pm; Nov–Mar, Fri–Sun, 11am–3pm

JUPITER ARTLAND p. 260
Bonnington House Steadings, Wilkieston, Edinburgh EH27 8BB, Scotland
Tel: +44 (0)131 2574170
www.jupiterartland.org
Opening hours May–August, Fri, Sat and Sun. Advance booking for a morning, midday or afternoon session is essential. See website to book. Allow about 1½ hours for a visit and wear appropriate footwear for the woodland areas.
Admission £5
Getting there By car Jupiter Artland is 20 mins from central Edinburgh and 40 mins from Glasgow. See website for directions.

KIKAR LEVANA (WHITE SQUARE) p. 140
Edith Wolfson Park, Tel Aviv, Israel
www.danikaravan.com

KIRISHIMA OPEN-AIR MUSEUM p. 265
220, Koba 6340, Yusui-cho, Aira-gun, Kagoshima Prefecture 899-6201, Japan
Tel: + 81 (0)99 574 5945 Fax: + 81 (0)99 574 2545
www.open-air-museum.org

KRÖLLER-MÜLLER MUSEUM p. 38
Houtkampweg 6, 6731 AW Otterlo, Netherlands
Mailing address: P.O. Box 1, 6730 AA Otterlo, Netherlands
Tel: + 31 (0)3 18591241 Fax: + 31 (0)3 18591515
www.kmm.nl
Getting there By car Follow signs for Park Hoge Veluwe/Kröller-Müller Museum from the A1, A50 and A12. By public transportation Direct trains from Amsterdam Centraal to Apeldoorn and Ede/Wageningen take 1 hour. Direct buses to the park and museum run from both locations and stop outside the museum – look out for the big blue trowel. Once inside the park there are white bicycles to use free of charge.
Opening hours Museum: Tues–Sun and bank holidays, 10am–5pm. Sculpture garden: Tues–Sun and bank holidays, 10am–4.30pm
Admission Combined tickets for the Park and Museum available at the Park ticket office or from the bus driver. Day tickets, group discounts and annual passes also available. Guided tours are available in the museum/sculpture garden by appointment (Tel: + 31 (0)3 18596155 Fax: + 31 (0)3 18590460) or combined through the sculpture garden and the Hoge Veluwe National Park (Tel: + 31 (0)5 53788116).
Further reading Kröller-Müller Museum (Stichting Kröller-Müller Museum, 2008)
Sculpture Garden Kröller-Müller Museum (Stichting Kröller-Müller Museum/NAi Uitgevers, 2007)

KRYŽIŲ KALNAS (HILL OF CROSSES) p. 46
16 km north of Siauliai, just off the A12 Vilnius-Riga highway, Lithuania
www.kryziukalnas.lt

LABERINTO HOMENAJE A BORGES (LABYRINTH IN HONOUR OF BORGES) p. 267
Finca Los Alamos, Calle Bombal, San Rafael, Argentina
Tel: + 54 (0)2627 44 2350
www.fincalosalamos.com

THE LAND OF EVERMOR p. 199
Prairie du Sac, WI 53578, USA
Further reading T. Kupsh, A Mythic Obsession: The World of Dr Evermor (Chicago Review Press, 2008)

LANDFORM UEDA p. 266
Scottish National Gallery of Modern Art, 75 Belford Road, Edinburgh EH4 3DR, Scotland
Tel: + 44 (0)131 6246200 Fax: + 44 (0)131 6237126
www.nationalgalleries.org

LANDMARK p. 204
Ocean Park, junction of East Tyndall Street and Ocean Way, Cardiff, Wales

LAROUCHE p. 214
Foundation CIEL, Town Hall, 709 Rue Gauthier, Larouche, QC G0W 1Z0, Canada
Tel: + 1 418 695 2201 Fax: + 1 418 695 4989
www.villedelarouche.qc.ca
Getting there By car Larouche is 500 km from Montréal and 245 km north of Québec City through the Laurentides park. From Montréal take the Jacques-Cartier Bridge then Autoroute 20 east towards Québec City (206 km). Then take the Autoroute 73 N exit (312-N) towards Pont Pierre-Laporte, Québec City. Take the Autoroute 40 E / Autoroute 73 N exit (142-E) towards Chicoutimi and follow signs to Chicoutimi (Autoroute 73) which becomes Route 175 N for 170 km through the Laurentides park. At the end of Route 175 in Chicoutimi, take Highway 70 W towards Larouche for 40 km. By bus From Montréal, daily departures from the Berri-Saint-Hubert bus station to Chicoutimi. By train From Montréal, daily departures from the Central Train Station to the Saguenay-Lac-Saint-Jean region. By air Daily departures from Pierre-Elliott-Trudeau airport in Montréal to Bagotville (20 mins from Larouche). From the airport, follow Highway 70 W towards Larouche.
Further reading A. Dempsey, *Styles, Schools and Movements: The Essential Encyclopaedic Guide to Modern Art* (Thames & Hudson, 2010)
G. Godmer, *Claude Simard*, in French and English (Musée d'art contemporain de Montreal, 1998)

THE LIGHTNING FIELD p. 106
P.O. Box 2993, Corrales, NM 87048, USA
Tel: + 1 505 898 3335 Fax: + 1 505 898 3336
www.lightningfield.org
Opening hours Visiting season is May–Oct
Admission Visiting fee includes transport from Quemado, overnight accommodation and meals in a cabin at the site and transport back to Quemado the next day. Reservations must be made in advance. See the website for current fees and to make reservations.
Further reading W. De Maria, 'The Lightning Field', *Artforum*, 18 No. 8 (Apr 1980), pp. 52–59
E. Hogan, *Spiral Jetta: A Road Trip through the Land Art of the American West* (University of Chicago Press, 2008)

LITTLE SPARTA p. 70
Dunsyre, Lanarkshire, Scotland
Tel: + 44 (0)1556 640244
www.littlesparta.co.uk
Opening hours Jun–Sept, Wed, Fri and Sun, 2.30–5pm
Admission Entry is £10 (cash only)
Getting there See website for detailed instructions.
Further reading J. Dixon Hunt, *Nature Over Again: The Garden Art of Ian Hamilton Finlay* (Reaktion Books, 2008)
J. Sheeler, *Little Sparta, the Garden of Ian Hamilton Finlay* (Frances Lincoln, 2003)

LOUISIANA MUSEUM SCULPTURE PARK p. 85
Louisiana Museum of Modern Art, Gl. Strandvej 13, 3050 Humlebæk, Denmark
Tel: + 45 4919 0719 Fax: + 45 4919 3505
www.louisiana.dk
Admission Entrance fee, open Tues–Sun

LOUTH ART TRAIL p. 265
The New Market Hall, off Cornmarket, Louth, Lincolnshire LN11 9PY, England
www.louth.org

M8 ART PROJECT p. 205
M8 between Edinburgh and Glasgow, Scotland
www.art-in-partnership.org.uk

LA MAISON PICASSIETTE p. 49
22 Rue du Repos, Saint-Chéron, 27000 Chartres, France
Tel: + 33 (0)2 37 34 10 78 Fax: + 33 (0)2 37 36 14 69
Opening hours Apr–Nov, daily, except Tues and Sun morning
Admission Entrance fee

MÅLSELV VARDE p. 244
Olsborg, Målselv, Troms, Norway
www.malselv.kommune.no; www.alfiobonanno.dk
Opening hours Daily, 24 hours
Admission Free
Getting there *Målselv Varde* is in Olsborg in Målselv (which is 120 km south of Tromsø), close to the junction between the Målselv river and the E6.
Further reading J. K. Grande, *Art Nature Dialogues: Interviews with Environmental Artists* (SUNY Press, 2004)
H. Strelow (ed.), with V. David, *Ecological Aesthetics: Art in Environmental Design: Theory and Practice*, in English and German (Birkhäuser, 2004)

MEMORIAL TO HEROIC SACRIFICE p. 18
Postman's Park, Churchyard behind St Botolph-without-Aldersgate, London EC1, England
Admission Entrances from Aldersgate or King Edward St
Further reading H. Dagnall, *Postman's Park & its Memorials* (H. Dagnall, 1987)
P. Ward-Jackson, *Public Sculpture of the City of London* (Liverpool University Press, 2003)

MEMORIAL TO THE MURDERED JEWS OF EUROPE p. 269
Nr the Brandenburg Gate, Berlin, Germany

MENNESKET VED HAVET (MAN MEETS THE SEA) p. 206
Sædding Strand, 6710 Esbjerg V, Denmark
www.visitesbjerg.dk

MERZBARN p. 82
Hatton Gallery, The Quadrangle, University of Newcastle, Newcastle upon Tyne NE1 7RU, England
Tel: + 44 (0)191 2226059 Fax: + 44 (0)191 2223454
www.ncl.ac.uk/hatton

MILL CREEK CANYON EARTHWORKS p. 141
742 East Titus Street, Kent, WA 98032, USA
Tel: + 1 253 859 3991
www.ci.kent.wa.us
Opening hours Daily
Getting there 15 miles south of Seattle

MILLENNIUM PARK p. 210
Welcome Center, 201 E. Randolph Street, Chicago, IL, USA
Tel: + 1 312 742 1168
www.millenniumpark.org

MONTENMEDIO ARTE CONTEMPORANEO p. 218
Fundación NMAC, Ctra N340, km 42.5. Dehesa de Montenmedio, 11150 Vejer de la Frontera, Cádiz, Spain
Tel: + 34 956 455 134 Fax: + 34 956 455 135
www.fundacionnmac.org
Opening hours Winter, daily, 10am–2.30pm, 4–6pm; Summer, daily, 10am–2pm, 5–8.30pm
Getting there NMAC is located at the 42.5 km mark on the national road that runs from Cádiz to Malaga (N340). It is a 45-min drive from Cádiz or Gibraltar, a 1½-hour drive from Seville and a 2-hour drive from Malaga. Buses from Cádiz to Vejer de la Frontera take 45 mins. The Foundation is a short taxi ride away.
Further reading *Fundación NMAC: Montenmedio Arte Contemporaneo 02 03*, in Spanish and English (Fundación NMAC, 2003)
Sculpture Parks in Europe: A Guide to Art and Nature (Birkhäuser, 2006)
Witnesses, catalogue of 2004 and 2006 projects, in Spanish and English (Fundación NMAC, 2006)

MOUNT RUSHMORE p. 34
Highway 244, Keystone, SD, USA
Tel: + 1 605 574 2523 Fax: + 1 605 574 2307
www.nps.gov/moru/
Getting there See the website above for detailed instructions.
Further reading R. Portell (ed.), *Out of Rushmore's Shadow: The Artistic Development of Gutzon Borglum (1867–1941)* (Stamford Museum & Nature Center, CT, 1999)
R. A. Smith, *The Carving of Mount Rushmore* (Abbeville, 1985)

MUSÉE MORALÈS p. 198
Avenue Pins, 13110 Port-de-Bouc, France
Tel: + 33 (0)4 42 06 49 01
Opening hours Daily, except Tues, 9am–12pm, 3–7pm

MUSEO GUGGENHEIM BILBAO p. 186
Avenida Abandoibarra 2, 48001 Bilbao, Spain
Tel: + 34 944 359 080
www.guggenheim-bilbao.es
Opening hours Sept–Jun, Tues–Sun, 10am–8pm;
Jul–Aug, Mon–Sun, 10am–8pm; closed 25 Dec and 1 Jan
Admission See website for fees
Getting there The Guggenheim is located in the city
centre and can be easily reached by Metro (exit at the
Moyua station), Streetcar (ask for the Guggenheim stop)
or by the numerous buses that service the area (see the
website for further information).
Further reading F. Gehry & J. F. Ragheb, *Frank Gehry,
Architect* (Solomon R. Guggenheim Foundation, 2003)
S. Stich, *art•SITES – SPAIN* (art•SITES, 2001)

MUSEO MURAL DIEGO RIVERA p. 201
Balderas y Colón s/n, Centro Historico, México, DF
Tel: + 52 (55) 5512 5318
www.museomuraldiegorivera.bellasartes.gob.mx
Opening hours Tues–Sun, 10am–6pm
Admission Entrance fee, free on Sundays

NEGEV MONUMENT p. 86
Beersheba, Israel
www.danikaravan.com

**THE NEW YORK EARTH ROOM & THE BROKEN
KILOMETER** p. 122
The New York Earth Room, 141 Wooster Street, New York,
NY 10012, USA
The Broken Kilometer, 393 West Broadway, New York,
NY 10012, USA
Opening hours For both: Sept–Jun, Wed–Sun,
12–6pm (closed 3–3.30pm)
Admission Free
Further reading G. Baker & C. Philipp Muller, 'A
Balancing Act', *October*, Vol. 82 (Fall 1997), pp. 94–118
J. Kastner, 'Alone in a Crowd: The Solitude of Walter De
Maria's *New York Earth Room* and *Broken Kilometer*',
Afterall, No. 2 (2000), pp. 69–73
See also Dia Art Foundation, 535 West 22nd Street,
New York, NY 10011, USA, Tel: + 1 212 989 5566
Fax: + 1 212 989 4055, www.diaart.org

NIMIS AND ARX p. 198
Kullaberg, Skåne, Sweden
www.ladonia.net
Getting there Information and directions from Höganäs
Tourist Office, Centralgatan 20, 26382 Höganäs, Sweden
(Tel: + 46 (0)42 33 77 74 or email turistbyran@hoganas.se)

NOAH'S ARK SCULPTURE PARK p. 266
Tisch Family Zoological Garden, Manahat,
Jerusalem 91008, Israel
Tel: + 972 (0)2 675 0111
www.jerusalemzoo.org.il

THE OPEN MUSEUM p. 200
Tefen Industrial Park, Tefen, Israel
Tel: + 972 (0)4 987 2022 Fax: + 972 (0)4 987 2940

OPEN-AIR ART MUSEUM AT PEDVALE p. 204
Pedvale, Sabile 3294, Latvia
Tel: + 371 6325 2249
www.pedvale.lv
Opening hours Daily

OPUS 40 p. 44
50 Fite Road, Saugerties, NY 12477, USA
Tel: + 1 845 246 3400
www.opus40.org
Opening hours June–mid-Oct, Fri, Sat, Sun and holiday
Mon, 11.30am–5pm; often used for special events so
check website to confirm that it is open for visitors.
Admission Adults fee, children under 6 free
Further reading J. Beardsley, *Earthworks and Beyond:
Contemporary Art in the Landscape* (New York, 1998)

THE OWL HOUSE p. 82
River Street, Nieu-Bethesda 6286, South Africa
Tel: + 27 (049) 841 1733
www.owlhouse.co.za

LE PALAIS IDÉAL p. 14
Le Palais Idéal du Facteur Cheval, 26390 Hauterives, France
TEL: + 33 (0)4 75 68 81 19 FAX: + 33 (0)4 75 68 88 15
www.facteurcheval.com
Opening hours Dec–Jan, 9.30am–12.30pm and
1.30–4.30pm; Feb, Mar, Oct and Nov, 9.30am–12.30pm
and 1.30–5.30pm; Apr–Jun and Sept, 9.30am–12.30pm
and 1.30–6.30pm; Jul and Aug, 9.30am–12.30pm and
1.30–7.30pm. Closed 25 Dec and 1 Jan
Getting there *By car* Hauterives is halfway between
Lyon and Valence at the intersection of the D51 and the
D538. If driving from Lyon, take the Chanas exit off the
A7 towards Hauterives. *By train* Lyon is a 2-hour train
journey from Paris.
Further reading 'The Autobiography of Ferdinand
Cheval', *Raw Vision*, No. 38 (2002)
Raw Vision Outsider Art Source Book (Raw Vision, 2002)

PARADISE GARDENS p. 86
84 Knox Street, Pennville Community, Summerville,
GA 30747, USA
Tel: + 1 423 619 8154 Fax: + 1 205 587 3090
www.finstersparadisegardens.org
Opening hours Sat and Sun, 12–4.30pm

PARC LA CREUTA DEL COLL p. 202
Passeig de la Mare de Déu del Coll, Barcelona, Spain
Tel: + 34 932 076 673
www.bcn.es/artpublic

PARCO PORTELLO p. 269
The park is located between Viale Serra, Viale Scarampo,
Via Traiano and Via Palazzolo, 20149 Milan, Italy

**PARCO SCULTURE DEL CHIANTI
(CHIANTI SCULPTURE PARK)** p. 266
Loc. La Fornace 48/49, Pievasciata, 53010 Siena, Italy
Tel: + 39 0577 357 151 Fax: + 39 0577 357 149
www.chiantisculpturepark.it
Opening hours Apr–Oct, 10am–sunset; Nov–Mar,
by appointment only
Admission Entrance fee

PARK GÜELL p. 22
Carrer d'Olot 7, Vallcarca, Gràcia, 08024 Barcelona, Spain
Tel: + 34 934 132 400
Getting there *By Metro Green Line* to Lesseps then
follow signs – it is a 15-min steep walk. Or take Bus 24
from the Placa de Catalunya which stops close to the
entrance.
Further reading I. De Sola-Morales, *Antoni Gaudí*
(Harry N. Abrams, 2003)
C. Kent & D. Prindle, *Park Güell* (Princeton Architectural
Press, 1993)
See also Casa Museu Gaudí, Park Güell, Carretera del
Carmel, 08024 Barcelona, Spain, Tel: + 34 932 193 811
www.casamuseugaudi.org

PARK IN THE WATER p. 160
Haagse Hogeschool, Johanna Westerdijkplein 75,
The Hague, Netherlands
Getting there *By train* Take a direct train from
Amsterdam Centraal to Den Haag Hollands Spoor
(50 mins) then take the Laakhaven exit and it is a 3-min
walk. From Den Haag Centraal Station, there are trains,
trams or buses to Den Haag Hollands Spoor.
Further reading F. Matzner (ed.), *Public Art* (Hatje
Cantz, 2003)
F. Ward, *Vito Acconci (Contemporary Artists)* (Phaidon, 2002)
See also Stroom Den Haag, Hogewal 1–9, 2514 HA
The Hague, Netherlands, Tel: + 31 (0)70 3658985
Fax: + 31 (0)70 3617962, www.stroom.nl

PARK-MUSEUM OF ALEXEY K. TOLSTOY p. 86
Gagarina av. 38, Bryansk 241000, Russia
Tel: + 7 0832 743 692

**PARQUE ESCULTÓRICO CEMENTERIO DE CARRETAS
(CART CEMETERY SCULPTURE PARK)** p. 264
San Martín 773, Putaendo, Quinta Región, Chile
Tel: + 56 34 502 822 or + 56 34 502 072

PASAQUAN p. 84
Eddie Martin Road, Buena Vista, GA 31803, USA
Tel: + 1 229 649 9444
www.pasaquan.com

PASSAGES – HOMAGE TO WALTER BENJAMIN p. 203
Portbou, Spain
www.danikaravan.com

THE PEOPLE'S GALLERY p. 206
Rossville Street, Derry, Northern Ireland
www.bogsideartists.com

PIRKKALA SCULPTURE PARK p. 266
33950 Pirkkala, Finland
Tel: + 358 (0)3 3684879

LAS POZAS p. 64
Xilitla, Mexico
www.xilitla.org
Opening hours Daily, 9am–6pm
Getting there By car Las Pozas is 2 km outside Xilitla which is a 2-hour drive from Cuidad Valles – south on Highway 85 then west on Highway 120. The nearest airport is in Tampico – a 4½-hour bus ride or 3–4-hour drive from there.
Further reading Edward James: Builder of Dreams, DVD, produced by Avery & L. Danziger (1995)
B. Goldstone, 'Las Pozas: a conservator's nightmare', The Folk Art Messenger, Vol. 12, No. 4 (Fall 1999)
M. Hooks, Surreal Eden: Edward James & Las Pozas (Princeton Architectural Press, 2006)

PULSE SCULPTURE PROJECT p. 252
Harald Saeveruds vei
Råstølen, Bergen, Norway
www.modahl.com, www.rastolen.no

QUEEN CALIFIA'S MAGICAL CIRCLE p. 268
Iris Sankey Arboretum, Kit Carson Park (corner of Bear Valley Parkway and Mary Lane), Escondido, CA, USA
www.queencalifia.org

REED CHAMBER p. 267
WWT Arundel Wetland Centre, Mill Road, Arundel, West Sussex BN18 9PB, England
Tel: + 44 (0)1903 883355 Fax: + 44 (0)1903 884834
www.wwt.org.uk

REFUGES D'ART p. 206
Digne-les-Bains, France
A map and directions in French and English available on www.refugesart.fr

RIETVELD SCHRÖDERHUIS p. 30
Prins Hendriklaan 50, Utrecht, Netherlands
www.rietveldschroderhuis.nl
Centraal Museum, Nicolaaskerkhof 10,
3512 XC Utrecht, Netherlands
Tel: +31 (0)30 2362362 Fax: +31 (0)30 2332006
www.centraalmuseum.nl
Opening hours Unaccompanied tours at fixed times Wed–Sun, guided tours Thurs–Sun. Reservations for both strongly recommended as visitor numbers are limited to 10 per session: Tel: +31 (0)30 2362310 or email rhreserveringen@centraalmuseum.nl
Admission Entrance fee combined with Centraal Museum. The Ticket Office is located at Erasmuslaan 5 (opposite the Rietveld Schröder House under the viaduct).
Getting there By train Direct trains from Amsterdam Centraal to Utrecht Centraal take 30 mins. See www.ns.nl for train schedules and prices (in Dutch and English). In Utrecht, follow signs to the Museumkwartier (Museum Quarter) and to the Centraal Museum (a 10-min walk from the station). By bus From Utrecht Central Station, bus number 2 goes to the Museumkwartier with a stop at the Centraal Museum.
Further reading B. Mulder & I. van Zijl, Rietveld Schröder House (Princeton Architectural Press, 1999)
P. Overy, De Stijl (Thames & Hudson, 1991)

LES ROCHERS SCULPTÉS (THE CARVED ROCKS) p. 46
Chemin des Rochers Sculptés, 35400 Saint-Malo, France
Tel: + 33 (0)6 68 98 23 95
www.saint-malo-tourisme.com

THE ROCK GARDEN p. 56
Sector 1, Chandigarh (U.T.), India
Tel: + 91 172 740 645
www.nekchand.com
Opening hours Apr–Sept, daily, 9am–7pm; Oct–Mar, daily, 9am–6pm
Admission Adults 5 Rs, children 3 Rs
Getting there The Shatabdi Express train runs 2–3 times daily from New Delhi to Chandigarh and takes 3 hours. The Rock Garden is in the north of the city, in Sector 1.
Further reading J. England, Obsessive Visions: Art Outside the Mainstream (England & Co., 2001)
L. Peiry & P. Lespinasse, Nek Chand's Outsider Art, The Rock Garden of Chandigarh (Flammarion, 2005)
Raw Vision Outsider Art Source Book (Raw Vision, 2002)

RUDOLF STEINER HOUSE p. 48
35 Park Road, London NW1 6XT, England
Tel: + 44 (0)20 7723 4400 Fax: + 44 (0)20 7724 4364
www.anth.org.uk/rsh
Opening hours Mon–Sat

RUTA DE LA AMISTAD (FRIENDSHIP HIGHWAY) p. 87
Anillo Periferico, Mexico City, Mexico
www.mexico68.org/ruta

SCULPTURE IN THE PARKLANDS p. 267
Lough Boora Parklands, Teach Lea, Leabeg, Tullamore, Co. Offaly, Ireland
www.sculptureintheparklands.com

SCULPTURE IN WOODLANDS p. 207
Devil's Glen Wood, Ashford, Co. Wicklow, Ireland
Tel: + 353 (0)1 2011132 Fax: + 353 (0)1 2011199
www.coillte.ie

THE SCULPTURE PARK IN THASSOS p. 204
Kallirahi, Thassos, Greece
www.artlogos.gr

SECRET GARDEN p. 266
Walker Botanical Garden, Rodman Hall Arts Centre, Brock University, 109 St Paul Crescent, St Catharines, Ontario L2S 1M3, Canada
Tel: + 1 905 684 2925 Fax: + 1 905 682 4733
www.brocku.ca/rodmanhall

LA SERPARA p. 208
Loc. serpara 1, 01020 Civitella d'Agliano, VT, Italy
Tel/Fax: + 39 0761 914 071
www.serpara.net

SET NORTH FOR JAPAN (74° 33′ 2″) p. 265
Nakasato Village, Niigata Prefecture, Japan
www.echigo-tsumari.jp and
www.richardwilsonsculptor.com

SHEEPFOLDS p. 207
Cumbria, England
www.sheepfoldscumbria.co.uk

SITOOTERIE p. 268
Barnards Farm, Brentwood Road, West Horndon, Essex CM13 3LX, England
Tel: + 44 (0)1277 811262
www.barnardsfarm.eu

SKULPTUR PROJEKTE p. 140
Münster, Germany
www.skulptur-projekte.de
Getting there See map on www.muenster.de/stadt/skulpturen (in German)

SKULPTURENPARK DRAU-ROSENTAL p. 210
Sponheimerplatz 1, 9170 Ferlach, Austria
www.carnica-rosental.at

SKY PARK p. 203
Torvalla, Östersund, Sweden
www.bandolin.se

SLICE OF REALITY p. 210
River Thames, off Thames Path, Meridian Gardens, nr Drawdock Road, Blackwall Point, Greenwich, London SE10, England
www.richardwilsonsculptor.com

SOCRATES SCULPTURE PARK p. 201
32-01 Vernon Boulevard at Broadway, Long Island City, NY 11106, USA
Tel: + 1 718 956 1819
www.socratessculpturepark.org

SOD MAZE p. 138
Chateau-sur-Mer, 424 Bellevue Avenue, Newport, RI 02840, USA
Tel: + 1 401 847 1000

SPIRAL JETTY p. 90
Rozel Point, Promontory Point, Box Elder County, UT 84302, USA
www.spiraljetty.org
Getting there Information and directions available from the Golden Spike National Historic Site – Promontory Summit, UT 84302, Tel: + 1 435 471 2209 (32 miles west of Brigham City, Utah, via Highways 13 and 83). Follow signs to the Visitors Center. Spiral Jetty is a further 15-mile drive along a dirt road with giant potholes. A four-wheel-drive vehicle is recommended.
Further reading S. Boettger, Earthworks: Art and the Landscape of the Sixties (University of California Press, 2002)
L. Cooke & K. Kelly (eds), Robert Smithson: Spiral Jetty (University of California Press, 2005)
E. Hogan, Spiral Jetta: A Road Trip through the Land Art of the American West (University of Chicago Press, 2008)

STAR AXIS p. 92
Chupinas Mesa, New Mexico, USA
www.staraxis.org
Getting there Detailed visiting information will be
available on website once the work is open to the public.
Until then some visitors can be accommodated during
the summer months for a donation of $100 (see website).
Further reading S. Karlin, 'A Sculptor Works Up an
Exposé of the Stars' Secrets', *The New York Times*,
(3 Nov 2002), Arts & Leisure section, pp. 21–28
H. Linton, *Color in Architecture* (McGraw-Hill, 1999),
pp. 169–173

STAR CHAMBER p. 248
Vanderbilt Dyer Observatory, 1000 Oman Drive,
Brentwood, TN 37027, USA
www.dyer.vanderbilt.edu, www.chrisdrury.co.uk
Getting there Directions available on the website.
Opening hours The Observatory grounds are usually
open Mon–Fri, 9am–4pm for self-guided tours of *Star
Chamber*, however the facilities are often used for special
events, so call ahead (+1 615 373 4897) to confirm that
the Observatory is open for visitors.
Further reading C. Drury, *Chris Drury: Silent Spaces*
(Thames & Hudson, 2004)

STEPINAC AND NYERERE p. 226
Dakawa Village, Mvomero District, Morogoro, Tanzania
Tel: + 255 23 262 8740
www.klapez.freeuk.com
Getting there Dakawa is 220 km west of Dar es Salaam
on Highway T3 towards Dodoma. The nearest town is
Morogoro (45 km away).

STIFTUNG INSEL HOMBROICH p. 144
41472 Neuss, Germany
Tel: + 49 (0)2182 2094 Fax: + 49 (0)2182 1229
www.inselhombroich.de
Opening hours Daily, Apr–Sept, 10am–7pm;
Oct, 10am–6pm; Nov–Mar, 10am–5pm;
closed 24, 25, 31 Dec and 1 Jan
Admission Mon–Fri adults €12, concessions €6;
weekends adults €15, concessions €7; combined ticket
with the Langen Foundation, Tues–Fri adults €17,
concessions €10. Weekends adults €20, concessions €11
Getting there *By car* Stiftung Insel Hombroich is 20 mins
from Düsseldorf and 40 mins from Cologne. Take the A57
and exit at Neuss-West onto the A46 towards Aachen.
Exit at Grevenbroich/Kapellen and follow signs to the
Museum Stiftung Insel Hombroich and/or the Langen
Foundation. *By bus* From the Neuss bus station, take
bus 869 or 877 to Museum Insel Hombroich and/or the
Langen Foundation.
Further reading O. Kruse, W. Wang & E. Kob, *Oliver
Kruse: Children Island Hombroich* (Walther König, 2001)
Stiftung Insel Hombroich (Stiftung Insel Hombroich, 2004)
See also Langen Foundation, Rakentenstation
Hombroich 1, 41472 Neuss, Germany
Tel: + 49 (0)2182 5701 20 Fax: + 49 (0)2182 5701 10
www.langenfoundation.de

STORM KING ART CENTER p. 60
Old Pleasant Hill Road, Mountainville,
NY 10953, USA
Tel: + 1 845 534 3115 Fax: + 1 845 534 4457
www.stormking.org
Getting there See website for detailed instructions.
Further reading J. Beardsley, *A Landscape for Modern
Sculpture: Storm King Art Center* (Abbeville Press, 1997)
Earth, Sky, and Sculpture – Storm King Art Center (Storm
King Art Center, 2000)

THE STRATA PROJECT p. 156
Tree Mountain, off Pinsiöntie, Pinsiö, Finland
(Tourist information: Kuruntie 14, 33470 Ylöjärvi, Finland,
Tel: + 358 (0)3 349 5111, www.ylojarvi.fi)
Up and Under, 561 Sasintie, Pinsiö, Finland
(Tourist information: Harjukatu 23, 37100 Nokia, Finland,
Tel: + 358 (0)3 118 8350, www.nokiankaupunki.fi)
Getting there *Tree Mountain* is near Ylöjärvi (a 15-min
drive from Tampere). From Tampere take Highway 3
north towards Ylöjärvi and turn left at the sign reading
'Pinsiö 4 km'. Take Pinsiöntie for 1 km and turn right.
Tree Mountain is in the middle of the gravel pit and visible
from the road. Continue along Pinsiöntie for 3 km to
reach *Up and Under*. If driving from Nokia, take Pinsiöntie
to the end, turn left on Sasintie at the village shop
crossing, then continue for 100 metres to *Up and Under*.
Park and walk to the art works: the land in the quarries
is protected.
Further reading U. Grosenick (ed.), *Women Artists
in the 20th and 21st Century* (Taschen, 2005)
J. Kastner & B. Wallis, *Land and Environmental Art*
(Phaidon, 1998)

SUN TUNNELS p. 100
Great Basin Desert, nr Lucin, Box Elder County, UT, USA
Getting there The *Sun Tunnels* are 5 miles south of
Lucin and 40 miles north of West Wendover, Nevada,
the nearest city with hotel accommodation. It is a
4-hour drive from Salt Lake City. Take Interstate 80
west through West Wendover to Oasis, Nevada. From
there take Nevada Highway 233 through Montello into
Utah, where it becomes Utah Highway 30. Montello,
Nevada, is the last stop for food, water and fuel.
Continue to the Lucin cutoff, which is 42 miles from
Oasis and 10 miles over the state line. Take the dirt
road south for 4 miles to Lucin. Continue heading
south from Lucin for another 2 miles. Turn left at the
post marked 'S.T. 3'. After 2 miles, bear right for 1 mile.
There is also another route which is shorter but is a
gravel road. It runs north from Wendover to Lucin and
is on most maps. There is now a sign on the road to
the *Sun Tunnels*, which is a right turn off the gravel
road, just south of Lucin.
Further reading N. Holt, 'Sun Tunnels', *Artforum*
(Apr 1977), pp. 32–37
J. Kastner & B. Wallis, *Land and Environmental Art*
(Phaidon, 1998)

SZOBORPARK p. 170
Balatoni út – Szabadkai utca sarok, 1223 Budapest,
Hungary
Tel: + 36 (1) 424 7500 Fax: + 36 (1) 337 5050
www.szoborpark.hu
Opening hours Daily, 10am–sunset
Admission 1,500 HUF
Getting there See website for detailed instructions.
Further reading G. Boros, *Statue Park* (City Hall, 2002)
*Statue Park: Gigantic Monuments from the Age of Communist
Dictatorship*, guidebook in Hungarian, English, French,
Italian, Spanish and German

TAAL MONUMENT (LANGUAGE MOMENT) p. 139
Paarl Mountain, Paarl, South Africa
Opening hours Daily
Admission Entrance fee

TIME LANDSCAPE p. 86
Corner of La Guardia Place and Houston Street,
New York, NY, USA
www.nycgovparks.org

TÍR SÁILE – THE NORTH MAYO SCULPTURE TRAIL p. 205
Ballina, Mayo, Ireland
Tel/Fax: + 353 (0)98 45107
www.ballina.mayo-ireland.ie/TirSaile/TirSaile.htm

TIRANA p. 265
Tirana, Albania
www.tirana.gov.al

TORRES DE SATÉLITE (SATELLITE CITY TOWERS) p. 85
Queratoro Highway, Mexico City, Mexico
www.torresdesatelite.org

TOUR AUX FIGURES p. 202
Parc de l'Ile Saint-Germain, 92130 Issy-les-Moulineaux,
France
Tel: + 33 (0)1 41 23 87 00
www.issy.com/tourisme

TOUR D'EBEN-EZER p. 82
Rue Istahelle 9, 4690 Eben-Emael, Belgium
Tel: + 32 (0)4 286 92 79
www.musee-du-silex.be
Opening hours Apr–Oct, Mon–Fri, 1.30–6pm, Sat–Sun,
1.30–7pm; Nov–Mar, Mon–Fri, 1.30–5pm, Sat–Sun,
1.30–6pm

TOUT QUARRY SCULPTURE PROJECT p. 199
Wide Street, Tradecroft, Portland DT5 2LN, England
Tel/Fax: + 44 (0)1305 826736
www.learningstone.org
Opening hours Daily, dawn–dusk
Admission Free

TRAIN p. 208
Morton Park, A66, Darlington, England
www.davidmach.com

TRANEKÆR INTERNATIONAL CENTRE FOR ART AND NATURE (TICKON) p. 164
Tranekær Castle Park, 5953 Tranekær, Langeland, Denmark
Tel: + 45 62 51 35 05 Fax: + 45 62 51 43 35
www.langeland.dk
Opening hours Daily, sunrise–sunset
Admission 25 Danish kroners, free for children under 12
Getting there By car Langeland is a 2–3-hour drive from Copenhagen. Take the E20 from Copenhagen to Odense then the A9 from Odense to Rudkøbing and road 305 from Rudkøbing to Tranekær. By train and bus IC train from Copenhagen Airport or Copenhagen Central station to Nyborg, then bus 910 to Rudkøbing-Tranekær.
Further reading Sculpture Parks in Europe: A Guide to Art and Nature (Birkhäuser, 2006)
TICKON Park Guide (TICKON, 2005)

TYREBAGGER SCULPTURE PROJECT p. 205
Near Aberdeen, Scotland
www.forestry.gov.uk

UNESCO p. 85
7 Place de Fontenoy, 75007 Paris, France
Tel: + 33 (0)1 45 68 03 59
www.unesco.org
Opening hours Mon–Fri, admission free

UNTITLED p. 194
Santa Maria Annunciata in Chiesa Rossa,
Via Neera 24, Milan, Italy
Opening hours Daily, 4–7pm
Getting there From central Milan, take tram 3 from Piazza Fontana, direction Gratosoglio, for 12 stops. Get off at Montegani-Neera and walk 100 metres (25 mins journey).
Further reading T. Bell, 'Dan Flavin, Posthumously', Art in America (Oct 2000)
M. Govan & T. Bell, Dan Flavin: The Complete Lights 1961–1996 (Dia Art Foundation, 2004)
See also Fondazione Prada Exhibition Space, Via Fogazzaro 36, 20135 Milan, Italy, Tel: + 39 02 5467 0515 Fax: + 39 02 5467 0258, www.fondazioneprada.org and Villa Collezione Panza, Piazza Litta, 1, Varese (Biumo Superiore), Italy, Tel: + 39 0332 283960 Fax: + 39 0332 498315, www.fondoambiente.it

URBAN CONFIGURATIONS p. 203
La Barceloneta, Barcelona, Spain
www.bcn.es/artpublic/

VIGELANDSPARKEN p. 48
Kirkeveien, Oslo, Norway
www.vigeland.museum.no

VILLA SAVOYE p. 49
82 Rue de Villiers, 78300 Poissy, France
Tel: + 33 (0)1 39 65 01 06 Fax: + 33 (0)1 39 65 19 33
www.monuments-nationaux.fr
Opening hours Tues–Sun
Admission Entrance fee

VOLLIS SIMPSON'S WHIRLIGIG PARK p. 201
Wiggins Mill Road, Lucama, NC 27542, USA
Tel: + 1 800 497 7398
www.wilson-nc.com
Opening hours Daily
Admission Free

WALDSKULPTURENWEG (WOODLAND SCULPTURE TRAIL) p. 264
Rothaar Mountains, Germany
www.waldskulpturenweg.de

WANÅS FOUNDATION p. 202
Box 67, 289 21 Knislinge, Sweden
Tel: + 46 (0)44 660 71 Fax: + 46 (0) 44 660 18
www.wanas.se

WAT SALA KAEW KOO BUDDHA PARK p. 140
10 Bansamukkee, Mong District, Nong Khai, Thailand
Opening hours Daily

WATTS TOWERS p. 26
1765 East 107th Street, Los Angeles, CA 90002, USA
Tel: + 1 213 485 1795
www.trywatts.com
Opening hours Thurs–Fri, 11am–3pm; Sat, 10.30am–3pm; Sun, 12.30–3pm
Getting there The Towers are 8 miles south of central Los Angeles. Take Freeway 110 south to Century Boulevard then turn right on to Compton Avenue. Go 1 block to 103rd Street. Take 103rd to Graham and turn right. Take Graham to 107th Street. Turn left.
Further reading F. Hernendez, 'Watts Towers', Raw Vision, No. 37 (2001)
J. Maizels, Raw Creation: Outsider Art and Beyond (Phaidon, 1996)

THE WAVE FIELD p. 206
FXB Aerospace Engineering Building, University of Michigan, Ann Arbor, MI 48109, USA
www.umich.edu

THE WHARTON ESHERICK MUSEUM p. 49
P.O. Box 595, Paoli, PA 19301, USA
Tel: + 1 610 644 5822
www.whartonesherickmuseum.org
Opening hours By appointment only, Sat, 10am–5pm; Sun, 1–5pm; Mon–Fri, 10am–5pm for groups of five or more
Admission Entrance fee
Getting there Directions supplied upon making an appointment.

WISCONSIN CONCRETE PARK p. 83
State Highway 13, Phillips, WI 54555, USA
Tel: + 1 800 269 4505
www.friendsoffredsmith.org
Opening hours Daily, admission free
Getting there Phillips is at the intersections of State Highway 13 and County Highways F, W, H and D.

XIANG KHOUAN (BUDDHA PARK) p. 85
About 25 km south of Vientiane, Laos
Opening hours Daily, 8am–6pm
Admission Entrance fee

YORKSHIRE SCULPTURE PARK p. 140
West Bretton, Wakefield WF4 4LG, England
Tel: + 44 (0)1924 832631
www.ysp.co.uk

ZOOM IN/TURN AROUND p. 206
Stadhuis en Bibliotheek, Spui 70, The Hague, Netherlands
www.stroom.nl
Opening hours Daily, except Sun

CONVERSION TABLE
1 hectare = 2.471 acres
1 acre = 0.405 hectare
1 kilometre = approximately ⅗ mile
1 mile = approximately 1.609 kilometres
1 metre = approximately 39⅜ inches
1 yard = 0.9144 metre
1 centimetre = ⅜ inch
1 inch = 2.54 centimetres

While every effort has been made to ensure that the information presented here is correct, it is always advisable to check opening times and admission prices before embarking on your journey. The author and publisher accept no responsibility for loss or damage incurred as a result of information contained in this book.

Please send your comments or any suggestions of other sites to include in possible future volumes, by visiting www.destination-art.org

Index of people

Main entries are in **bold**
References to illustrations are in *italics*

Index of places

Index of sites

Main entries are in **bold**
References to illustrations are in *italics*

List of illustrations

Measurements are given in centimeters, followed by inches, height before width before depth, unless otherwise stated.

The Chinati Foundation, Marfa, Texas. Photo Florian Holzherr, 2004. Art © Judd Foundation. Licensed by VAGA, New York/DACS, London 2006

p. 134 Donald Judd, *The Arena*, 1980–84 (detail). Permanent collection, The Chinati Foundation, Marfa, Texas, USA. Photo Florian Holzherr, 2002. Art © Judd Foundation. Licensed by VAGA, New York/DACS, London 2006

p. 135 t Donald Judd, *100 untitled works in mill aluminium*, 1982–86 (detail). Permanent collection, The Chinati Foundation, Marfa, Texas. Photo Florian Holzherr, 2002. Art © Judd Foundation. Licensed by VAGA, New York/DACS, London 2006

p. 135 b John Chamberlain, 23 variously titled works, 1972–83 (detail). Painted and chromium steel, architectural adaptation by Donald Judd. Permanent collection, The Chinati Foundation, Marfa, Texas, USA. Photo Florian Holzherr, 2004. © ARS, NY and DACS, London 2006

p. 136 t Dan Flavin, *Untitled (Marfa Project)*, 1996 (detail). Permanent collection, The Chinati Foundation, Marfa, Texas, USA. Photo Florian Holzherr, 2001. © ARS, NY and DACS, London 2006

p. 136 b Dan Flavin, *Untitled (Marfa Project)*, 1996 (detail). Permanent collection, The Chinati Foundation, Marfa, Texas, USA. Photo Florian Holzherr, 2004. © ARS, NY and DACS, London 2006

p. 137 Dan Flavin, *Untitled (Marfa Project)*, 1996 (detail). Permanent collection, The Chinati Foundation, Marfa, Texas, USA. Photo Florian Holzherr, 2001. © ARS, NY and DACS, London 2006

p. 138 l Jean Dubuffet, *Closerie Falbala*, 1971–76. Périgny-sur-Yerres, Val-de-Marne, France. Courtesy Fondation Dubuffet, Périgny-sur-Yerres. © ADAGP, Paris and DACS, London 2006

p. 138 c Niki de Saint Phalle, *Golem*, 1972. Rabinovitch Park, Kiryat Yovel, Jerusalem, Israel. Photo Leonardo Bezzola. © 2006 Niki Charitable Art Foundation. All rights reserved. © ADAGP, Paris and DACS, London 2006

p. 138 r Robert Smithson, *Amarillo Ramp*, 1973. Tecovas Lake, Amarillo, Texas, USA. Courtesy James Cohen Gallery, New York. © Estate of Robert Smithson/VAGA, New York/DACS, London 2006

pp. 138–39 Ant Farm, *Cadillac Ranch*, 1974. Amarillo, Texas, USA. © Ant Farm (Lord, Marquez, Michels), 1974. Photo Jules Backus

p. 139 l Mark di Suvero, *Are Years What? (for Marianne Moore)*, 1967. Painted steel, 1219.2 × 914.4 × 914.4 (480 × 360 × 360). Hirshhorn Museum and Sculpture Garden, Smithsonian Institution, Washington, DC, USA. Joseph H. Hirschhorn Purchase Fund and Gift of the Institute of Scrap Recycling Industries, by exchange, 1999.

p. 139 c Charles Billy, *Le Jardin de Nous Deux (The Garden of the Two of Us)*, 1975–91. Civrieux d'Azergues, France. Photo Maggie Jones Maizels

p. 139 r Eduardo Chillida, *Haize-Orrazia (Peine del Viento, CV) (Wind Comb)*, 1976. San Sebastián, Spain. Courtesy Museo Chillida Leku. © Eduardo Chillida/VEGAP, 2006

p. 140 l Barbara Hepworth, *Squares with Two Circles*, 1963. Bronze. Yorkshire Sculpture Park, West Bretton, Yorkshire, England. Photo Jonty Wilde

p. 140 c Dani Karavan, *Kikar Levana (White Square)*, 1977–88. Tel Aviv, Israel.

© Dani Karavan. Photo Avraham Hay

p. 140 r Luang Pu Bunleua Surirat, *Wat Sala Kaew Koo Buddha Park*, 1977–96, Mong District, Nong Khai, Thailand. Photo Julia Wilkinson/Lonely Planet Images

p. 141 t Alannah Robins, *Bean An T-Visce*, 1995. Grizedale Forest Park, Ambleside, Cumbria, England. Photo Julie Coldwell. Courtesy Forestry Commission

p. 141 b Herbert Bayer, *Mill Creek Canyon Earthworks*, 1979–82. Commissioned by the City of Kent, Washington, USA. Courtesy City of Kent Arts Commission. © DACS 2006

pp. 142–43 Andy Goldsworthy, *Untitled*, 1992. Wall of dry rocks, h.160 × l.3800 (63 × 1496⅛). Courtesy Centre international d'art et du paysage, Vassivière en Limousin, France. Photo Jacques Hœpffner

p. 144 t Erwin Heerich, *Orangerie*, 1983. Courtesy Stiftung Insel Hombroich, Germany. Photo Tomas Riehle

p. 144 b Erwin Heerich, *Brunnen (fountain)*, 1985. Courtesy Stiftung Insel Hombroich, Germany. Photo Tomas Riehle

p. 145 t Erwin Heerich, *Seminar und Bürogebäude* (seminar and office building), 2000. Courtesy Stiftung Insel Hombroich, Germany. Photo Tomas Riehle

p. 145 b Erwin Heerich, *Gästehaus* (guesthouse), 2000. Courtesy Stiftung Insel Hombroich, Germany. Photo Tomas Riehle

p. 146 Erwin Heerich, *Schnecke* (snail), 1993. Courtesy Stiftung Insel Hombroich, Germany. Photo Tomas Riehle

p. 147 t Erwin Heerich, Interior of the Zwölf-Räume-Haus (twelve room house), 1993. With paintings by Dutch painter Bart van der Leck (1876–1958). Courtesy Stiftung Insel Hombroich, Germany. Photo Tomas Riehle. Bart van der Leck © DACS 2006

p. 147 b Erwin Heerich, Interior of Fontana Pavilion. Courtesy Stiftung Insel Hombroich, Germany. Photo Tomas Riehle

p. 148 Albert Szukalski, *Ghost Rider*, 1984. Goldwell Open Air Museum, Rhyolite, Nevada, USA. Photo Charles F. Morgan

p. 149 t Albert Szukalski, *Ghost Rider*, 1984. Goldwell Open Air Museum, Rhyolite, Nevada, USA. Photo Charles F. Morgan

p. 149 b Albert Szukalski, *Last Supper*, 1984. Goldwell Open Air Museum, Rhyolite, Nevada, USA. Photo Charles F. Morgan

p. 150 t Dre Peeters, *Icara*, 1992. Goldwell Open Air Museum, Rhyolite, Nevada, USA. Photo Charles F. Morgan

p. 150 bl Sofie Siegmann, *Sit Here!*, 2000 (installed and restored at Goldwell in 2007). Concrete, tile, vintage glass, found materials/objects, 91.4 × 152.4 × 274.3 (36 × 60 × 108). Goldwell Open Air Museum, Rhyolite, Nevada, USA. Photo David Lancaster

p. 150 br Fred Bervoets, *Tribute to Shorty Harris*, 1994. Goldwell Open Air Museum, Rhyolite, Nevada, USA. Photo Charles F. Morgan

p. 151 Hugo Heyrman, *Lady Desert: The Venus of Nevada*, 1992. Goldwell Open Air Museum, Rhyolite, Nevada, USA. Photo Charles F. Morgan

pp. 152–53 Gintaras Karosas, LNK Infotree, 2000. 2903 old television sets, painted wooden construction, polythene, h.270 (106¼). All courtesy Europos Parkas, Lithuania. Photo Gintaras Karosas. © DACS 2006

p. 154 Gintaras Karosas, *Monument of the Centre of Europe*, 1993–96 (detail). Grey polished granite, grass, h.130 (51⅛), circle

d.1700 (669¼). Courtesy Europos Parkas, Lithuania. Photo Gintaras Karosas. © DACS 2006

p. 155 t Magdalena Abakanowicz, *Space of Unknown Growth*, 1998. 22 variously sized concrete forms (steel framework and concrete), natural boulders, h.420 (165⅛). Courtesy Europos Parkas, Lithuania. Photo Gintaras Karosas. © DACS 2006

p. 155 b Gintaras Karosas, *The Place*, 2001–03. 4 steel poles, natural boulders, water pond, 87,000 × 87,000 (3425¼ × 3425¼). Courtesy Europos Parkas, Lithuania. Photo Gintaras Karosas. © DACS 2006

pp. 156–57 Agnes Denes, *Tree Mountain – A Living Time Capsule-11,000 People, 11,000 Trees, 400 Years*, 1992–96. Ylöjärvi, Finland. Photo © Agnes Denes

pp. 158–59 Nancy Holt, *Up and Under*, 1998. Sand, concrete, grass, water, tunnels aligned N, S, E, W, 19202.4 × 792.5 × 6858 (7560 × 312 × 2700). Nokia, Finland. Photo courtesy the artist. © VAGA, New York and DACS, London 2006

pp. 160–63 Vito Acconci & Studio, *Park in the Water*, 1993–97. The Hague, Netherlands. Photos Jannes Linders, © Stroom Den Haag

p. 164 Mikael Hansen, *Organic Highway*, 2004. TICKON, Tranekær International Centre for Art and Nature, Langeland, Denmark. Photo Alfio Bonanno

pp. 164–65 Britt Smelvær, *Place of Silence*, 2002. TICKON, Tranekær International Centre for Art and Nature, Langeland, Denmark. Photo Alfio Bonanno. Smelvær © DACS 2006

p. 165 Alan Sonfist, *Labyrinth of 1001 endangered oak trees within a stone ship*, 1993. TICKON, Tranekær International Centre for Art and Nature, Langeland, Denmark. Photo Alfio Bonanno

pp. 166–67 Steven Siegel, *Squeeze*, 1997. TICKON, Tranekær International Centre for Art and Nature, Langeland, Denmark. Photo Alfio Bonanno

pp. 168–69 Alfio Bonanno, *Between copper beech and oak*, 2001. TICKON, Tranekær International Centre for Art and Nature, Langeland, Denmark. Photo Alfio Bonanno

p. 169 Alfio Bonanno, *Between copper, beech and oak*, 2001. TICKON, Tranekær International Centre for Art and Nature, Langeland, Denmark. Photo Lief Christiensen

pp. 170–71 Detail of the high relief appearing on the base of the Stalin statue, date unknown. Courtesy Szoborpark (The Statue Park), Budapest, Hungary. www.szoborpark.hu

p. 171 bl Istvan Kiss, *Republic of Councils Monument*, 1969. Bronze, 950 (374). Courtesy Szoborpark (The Statue Park), Budapest, Hungary. www.szoborpark.hu

p. 171 br Unknown Soviet artist, *Lenin*, 1958. Bronze, 250 (98⅜). Courtesy Szoborpark (The Statue Park), Budapest, Hungary. www.szoborpark.hu

p. 172 tl Patzay Pal, *Lenin*, 1965. Bronze, 400 (157½). Courtesy Szoborpark (The Statue Park), Budapest, Hungary. www.szoborpark.hu

p. 172 bl Zsigmond Kisfaludy Strobl, *Liberation Monument*, 1947, 1958. Bronze, 600 (236¼). Courtesy Szoborpark (The Statue Park), Budapest, Hungary. www.szoborpark.hu. © DACS 2006

p. 172 c Barna Buza, *Soviet–Hungarian Friendship*, 1975. Pyrogranite, 320 × 700

(126 × 275⅝). Courtesy Szoborpark (The Statue Park), Budapest, Hungary. www.szoborpark.hu

p. 172 br *The Republic of Councils' Pioneers Memorial Plaque*, 1959. Courtesy Szoborpark (The Statue Park), Budapest, Hungary. www.szoborpark.hu

pp. 172–73 Gyorgy Segesdi, *Marx and Engels*, 1971. Mauthausen granite, 420 (165⅛). Courtesy Szoborpark (The Statue Park), Budapest, Hungary. www.szoborpark.hu

p. 174 t Steven Gregory, *Fish on a Bicycle*, 1998. Cass Sculpture Foundation, Goodwood, England. Photo courtesy Cass Sculpture Garden

p. 174 b Eilis O'Connell, *Carapace*, 1999. Cass Sculpture Foundation, Goodwood, England. Photo courtesy Cass Sculpture Garden

p. 175 t Andy Goldsworthy, *Arch at Goodwood*, 2002. Cass Sculpture Foundation, Goodwood, England. Photo courtesy Cass Sculpture Garden

p. 175 bl Tim Morgan, *Cypher*, 2004. Cass Sculpture Foundation, Goodwood, England. Photo courtesy Cass Sculpture Garden

p. 175 br Sean Henry, *Catafalque*, 2004. Cass Sculpture Foundation, Goodwood, England. Photo courtesy Cass Sculpture Garden

pp. 176–77 Stephen Cox, *Catamarans on a Granite Wave*, 1994. Cass Sculpture Foundation, Goodwood, England. Photo courtesy Cass Sculpture Garden

p. 178 l Tony Cragg, *I'm Alive*, 2005. Cass Sculpture Foundation, Goodwood, England. Photo courtesy Cass Sculpture Garden

p. 178 r Tony Cragg, *Bent of Mind*, 2005. Cass Sculpture Foundation, Goodwood, England. Photo courtesy Cass Sculpture Garden

pp. 178–79 Sophie Smallhorn, *No. 43*, 1999. Cass Sculpture Foundation, Goodwood, England. Photo courtesy Cass Sculpture Garden

p. 179 Zadok Ben-David, *Conversation Piece*, 1996. Cass Sculpture Foundation, Goodwood, England. Photo courtesy Cass Sculpture Garden

pp. 180–81 Softroom, *Kielder Belvedere*, 1999. Stainless steel structure. Kielder Water and Forest Park, Northumberland, England. All photos © Keith Paisley 2005

p. 182 t Nick Coome and Shona Kitchen, *Minotaur*, 2003. 10 tons of rock glass and 480 tons of basalt stone contained in wire cages, 2200 × 1800 (866⅛ × 708⅝). Kielder Water and Forest Park, Northumberland, England. Photo © James Morris

p. 182 b Chris Drury, *Wave Chamber*, 1996. 81 tons of rock. Kielder Water and Forest Park, Northumberland, England. Courtesy the artist

p. 185 t. James Turrell, *Celestial Vault/Panorama in the Dunes*, 1996. Photo Gerrit Schreurs Fotografie. Courtesy Stroom Den Haag

p. 185 b James Turrell, *Celestial Vault/Panorama in the Dunes*, 1996. The Hague, Netherlands. Photo Jannes Linders, © Stroom Den Haag

p. 186 Frank O. Gehry, Museo Guggenheim Bilbao, 1991–97. Bilbao, Spain. Photo Erika Barahona-Ede. © FMGB Guggenheim Bilbao Museoa, 2006. All rights reserved. Total or partial reproduction is prohibited

p. 187 t Frank O. Gehry, Museo Guggenheim Bilbao, 1991–97. Bilbao, Spain. Photo Erika Barahona-Ede. © FMGB Guggenheim Bilbao

Museoa, 2006. All rights reserved. Total or partial reproduction is prohibited
p. 187 bl Frank O. Gehry, Museo Guggenheim Bilbao, 1991–97. Bilbao, Spain. Photo Erika Barahona-Ede. © FMGB Guggenheim Bilbao Museoa, 2006. All rights reserved. Total or partial reproduction is prohibited
p. 187 br Jeff Koons, Puppy, 1992. Stainless steel, substrate and flowering plants, 124 × 1240 × 820 (48⅞ × 488¼ × 322⅞). Photo Getty Images
pp. 188–89 Richard Serra, A Matter of Time, 2005. Installation at Guggenheim Bilbao, Spain. Photo Erika Barahona-Ede. © FMGB Guggenheim Bilbao Museoa, London 2006. All rights reserved. Total or partial reproduction is prohibited. Serra © ARS, NY and DACS, London 2006
p. 190 Daniel Spoerri, Chamber No. 13, Hotel Carcassonne, Rue Mouffetard 24, Paris 1959–65, 1998. Bronze, 250 × 300 × 500 (98⅜ × 118⅛ × 196⅞). Il Giardino di Daniel Spoerri, Seggiano, Italy. Photo Barbara Räderscheidt, Köln, Germany. © DACS 2006
pp. 190–91 Daniel Spoerri, Warriors of the Night, 1982. 13 Bronze elements, each 136 × 90 (53¹¹⁄₁₆ × 35⅜), whole installation 800 × 600 (3141¼ × 236¼). Il Giardino di Daniel Spoerri, Seggiano, Italy. Photo Barbara Räderscheidt, Köln, Germany. © DACS 2006
p. 191 l Jesus Raphael Soto, Pénétrable Sonore, 1997. Iron structure with 400 aluminium tubes, 350 × 400 × 300 (137¾ × 157½ × 118⅛). Il Giardino di Daniel Spoerri, Seggiano, Italy. Photo Barbara Räderscheidt, Köln, Germany. © DACS 2006
p. 191 r Dani Karavan, Adam and Eve, 2002. Olive tree, gold leaf. Il Giardino di Daniel Spoerri, Seggiano, Italy. Photo Barbara Räderscheidt, Köln, Germany
p. 192 l Daniel Spoerri, Courtship Display, 1992. 2 bronze elements, female h.196 (77¼ₙ), male h.150 (59⅛₆) Il Giardino di Daniel Spoerri, Seggiano, Italy. Photo Barbara Räderscheidt, Köln, Germany. © DACS 2006
pp. 192–93 Olivier Estoppey, Dies Irae (Judgement Day), 2001. Concrete, drummer h.350 (137¾), geese each 100 × 40 × 95 (39⅜ × 15¾ × 37⅜). Il Giardino di Daniel Spoerri, Seggiano, Italy. Photo Barbara Räderscheidt, Köln, Germany
p. 193 r Daniel Spoerri, Labyrinthic Mural Path, 1996–98. Stones, grass, 6000 × 4000 × 50 (2362⁹⁄₁₆ × 15741¹⁄₁₆ × 19⅝). Il Giardino di Daniel Spoerri, Seggiano, Italy. Photo Barbara Räderscheidt, Köln, Germany. © DACS 2006
pp. 194–97 Dan Flavin, Santa Maria Annunciata in Chiesa Rossa, 1997. Milan, Italy. Courtesy Fondazione Prada, Milano. Photo Paola Bobba. © ARS, NY and DACS, London 2006
p. 198 l Lars Vilks, Nimis and Arx, 1980. Kullaberg, Skane, Sweden. Courtesy the artist
p. 198 cl J. Seward Johnson, The Awakening, 1980. Cast aluminium, 518.2 × 2133.6 × 1402.1 (204 × 840 × 552). National Harbor, Maryland, USA. © 1980 The Sculpture Foundation. All rights reserved
p. 198 cr View of the Parc de sculptures de Vassivière en Limousin, France. © Centre international d'art et du paysage, Vassivière en Limousin. Photo Franck Gérard
p. 198 r Raymond Moralès, Musée Moralès, begun 1982. Port-de-Bouc, France. Photo Deidi von Schaewen

p. 199 l Daniel Buren, Cabane éclatée aux 4 salles, 2004–05. Cement, mirrors, marble stone and acrylic paint, 400 × 878 × 878 (157½ × 345⅝ × 345⅝). The Gori Collection of Site-Specific Art, Fattoria di Celle, Santomato di Pistoia, Italy. Courtesy the Gori Collection, Fattoria di Celle, Italy. Buren © ADAGP, Paris and DACS, London 2006
p. 199 cl Friedensreich Hundertwasser, The Hundertwasser House, 1983–86. View of the staircase. Vienna, Austria. Courtesy Hundertwasser House, Vienna
p. 199 cr Dan Flavin Art Institute, Bridgehampton, New York. Photo Florian Holzherr. Courtesy Dia Art Foundation
p. 199 r Stephen Marsden, Fallen Fossil, 1985. Portland stone, 228.6 × 304.8 × 61 (90 × 120 × 24). Courtesy Portland Sculpture and Quarry Trust, Portland, Dorset, England
p. 200 l George Walbye, High Plains/Wind Song, 1985. Benson Sculpture Park, Loveland, Colorado, USA. Photo VW Designs
p. 200 c Daniel Buren, Photo-souvenir: 'Les Deux Plateau' sculpture in situ, 1985–86 (detail). Cour d'honneur du Palais-Royale, Paris, France. © D.B
p. 200 r Vollis Simpson, Whirligig Park, begun 1985. Lucama, North Carolina, USA. Photo Ted Degener
p. 201 l Leo Villareal, Star, 2002. LED lights, d.45.7 (18). Socrates Sculpture Park, Long Island City, New York, USA. Photo Lisa Quinones
p. 201 c Jean-Pierre Raynaud, 1000 pots bétonnés peints pour une serre ancienne (1000 cemented jars painted for an old greenhouse), 1986. Photo Benoît Mauras. Courtesy Domaine de Kerguéhénnec, France. © ADAGP, Paris and DACS, London 2006
p. 201 r Neville Gabie, Raw, 2001. Oak, 220 × 220 (86⅝ × 86⅝). Forest of Dean Sculpture Trail, Coleford, Gloucestershire, England. Photo Forestry Commission
p. 202 l Marcel Gagnon, Le Grand Rassemblement (The Great Gathering), 1986–96, Sainte-Flavie, Québec, Canada. Courtesy Centre d'Art Marcel Gagnon
p. 202 cl Maya Lin, 11 Minute Line, 2004. Earth drawing, 45720 × 248.9 (18,000 × 98). Wanås Foundation, Knislinge, Sweden. Photo Anders Norrsell
p. 202 cr Eduardo Chillida, Elogio del Agua, 1987. Parc la Creuta del Coll, Barcelona, Spain. Photo © Lluís Casals. © Eduardo Chillida/VEGAP, 2006
p. 202 r Jean Dubuffet, Tour aux figures, 1986–88. Issy-les-Moulineaux, France. Photo CNAP (Centre National des Arts Plastiques), Stanislas de Grailly, Patrick Thumerelle, Musée d'Issy-les-Moulineaux. © ADAGP, Paris and DACS, London 2006
p. 203 l Dani Karavan, Passages – Homage to Walter Benjamin, 1990–94. Portbou, Spain. Photo Jaume Blasi. © Dani Karavan
p. 203 c Various artists, East Side Gallery, 1990, Berlin Wall, Berlin, Germany. Photo © Heiko Burkhardt, Lilano.com
p. 203 r Gunilla Bandolin, Sky Park, Ostersund, Sweden. Photo Stefan Linnerhag/www.fotobyran.se. © DACS 2006
p. 204 l Carlos Dorrien, The Nine Muses, 1990–97. Granite, 335.3 × 609.6 × 914.4 (132 × 240 × 360). Courtesy Grounds for Sculpture, Hamilton, New Jersey, USA
p. 204 cl Pierre Vivant, Landmark, 1992. Aluminium frame and road signs, topiary. Windsor Road Traffic Island, Cardiff, Wales. Courtesy the artist and CBAT The Arts and Regeneration Agency

p. 204 cr Villu Jaanisoo, The Chair, 2003. Metal barrels. Open-Air Art Museum at Pedvale, Latvia. Courtesy Open-Air Art Museum at Pedvale
p. 204 r Per Kirkeby, Beacon, 1992. Artscape Nordland, Norway. Courtesy Municipality of Meloy. Photo Vegar Moen. www.artscape.no
p. 205 l Hektor Papadakis, Untitled, 2001. Marble. The Sculpture Park, Thassos, Greece. Photo courtesy Art Logos, Greece
p. 205 cl David Mach, Big Heids, 1998. Seafreight container plinths, h.609.6 (240) tall with three heads, h. of each approx. 365.8 (144), welded steel. M8 Motorway, North Lanark, Scotland. Courtesy the artist. Photo David Pearce
p. 205 cr Malcolm Cochran, Field of Corn (with Osage Orange Trees), 1994. Precast concrete, osage orange trees, 5 text panels in bronze. 109 elements, each 182.9 × 55.9 (72 × 22). Dublin, Ohio, USA. Courtesy the artist. Photo Chas Krider
p. 205 r Sally Matthews, Bison Sculpture. Peat and sheeps' wool. Tyrebagger Hill, Kirkhill Forest, Scotland. Photo Forestry Commission
p. 206 l Charles Ross in collaboration with Virginia Dwan and Laban Wingert, Solar Spectrum, 1996. 24 acrylic prisms, each 243.8 × 30.5 × 30.5 (96 × 12 × 12) mounted in 2 apse windows and 4 skylights. Dwan Light Sanctuary, United World College, Montezuma, New Mexico, USA. Photo Charles Ross © 1998. © DACS, London/VAGA, New York 2006
p. 206 c l Marin Kasimir, Zoom in/Turn Around, 1995. The Hague, Netherlands. Photo Ernst Moritz. © Stroom Den Haag
p. 206 cr Svend Wiig Hansen, Man Meets the Sea, 1995. Four concrete figures, h. of each 900 (354¼₆). Esbjerg, Denmark. Photo Holger Leue/Lonely Planet Images
p. 206 r Maya Lin, The Wave Field, 1995. Soil, sand and grass, 3048 × 3048 (1200 × 1200). Ann Arbor, Michigan, USA. Photo Bill Woods, U-M Photo Services
p. 207 l Janet Mullarney, Panorama, 2001. Western red cedar, steel frame, 172 × 72 × 7 (67¾ × 28⅛ × 2¾). Sculpture in Woodland, Devil's Glen Wood, County Wicklow, Ireland. Photo courtesy Sculpture in Woodland, Ireland
p. 207 cl Rachel Whiteread, Holocaust Memorial, 2000. Concrete, 380 × 70 × 100 (149⅝ × 27¹⁄₁₆ × 39⅜). Judenplatz, Vienna, Austria. Courtesy of the artist and Gagosian Gallery, London
p. 207 cr Giuliano Mauri, Tree Cathedral, 2001. Wood, whole structure 1200 × 1500 × 8200 (472¼₆ × 590⅛ × 3228¼₆). Arte Sella, Val si Sella, Borgo Valsugana (Tn), Italy. Photo Aldo Fedele. © Arte Sella
p. 207 r Andy Goldsworthy, Cautley Spout Sheepfold, 2001. Cumbria, England. Photo courtesy the artist
p. 208 l Stjepan Skoko, Domagoj's boat, 1997. Bronze, 420 × 500 × 770 (165⅜ × 196⅞ × 303⅛). Vid, Croatia. Courtesy the artist
p. 208 cl Andy Goldsworthy, Cairn and Stone House, 1997. Herring Island Environmental Sculpture Park, Melbourne, Australia. Photo courtesy the artist
p. 208 cr David Mach, Train, 1997. 185,000 engineering bricks, h.914.4 (360) at highest point, l.3657.6 (1440). A66 Darlington, England. Courtesy the artist. Photo Tony Fletcher
p. 208 r Ursula Stalder, Steckenpferd, 2003.

Found objects, glass, wooden plates, iron construction, 45.5 × 45.5 × 412 (17⅞ × 17⅞ × 162¼). La Serpara, Civitella d'Agliano, Italy
p. 209 l Chris Drury, Both Nam Faileas: Hut of the Shadow, 1997. Lochmaddy, North Uist, Scotland. Courtesy the artist
p. 209 cl Anu Patel, Charlton Crescent Subway, 2005. Tork stone and green slate path and façade, galvanised steel fence. Interior: paint, steel lighting bands with LED lighting and glass resin floor with embedded fibre optic lighting. Courtesy London Borough of Barking & Dagenham Service. Photo Douglas Atfield
p. 209 cr Donald Lipski, Dirt Ball, 2001. Rope, nylon straps. The Fields Sculpture Park at Omi International Arts Center, Ghent, New York
p. 209 r Hiroshi Sugimoto, Appropriate Proportion, 2002. Wood, stone, optical glass, concrete. Art House Project, Benesse Art Site, Honmura, Naoshima, Japan
p. 210 l Antony Gormley, The Angel of the North, 1995–98. Steel, 2200 × 5400 × 220 (866⅛ × 2126 × 86⅝). Gateshead, Tyne & Wear, England. © Courtesy the artist and Jay Jopling/White Cube
p. 210 c Richard Wilson, Slice of Reality, 1999. Greenwich Peninsula, London, England. © Richard Wilson
p. 210 r Anish Kapoor, Cloud Gate, 2004. Chicago Millennium Park, Illinois, USA. Courtesy the artist. Photo Peter J. Schluz
p. 211 Tim Curtis, 24 Steps to Heaven, 2003. Steel staircases and tree. Skulpturenpark Drau-Rosental, Drau River, Rosental, Austria. Courtesy Carnica-Region, Rosental, Carinthia, Austria
pp. 212–13 William Furlong, Off the Beaten Track, 2003. 16 Stainless steel cubes, each 90 × 90 × 90 (35⅜ × 35⅜ × 35⅜). Parco Sculture del Chianti, Pievasciata Siena, Italy. Photo Bruno Bruchi
pp. 214–17 Claude Simard, Larouche, begun 2000. Quebec, Canada. Courtesy the artist. All photos Daniel Pedenault
pp. 218–19 Olafur Eliasson, Quasi Brick Wall, 2003. Fired earthenware bricks and polished steel mirrors, 500 × 160 (196⅞ × 63). NMAC Foundation, Vejer, Cádiz, Spain. Photo Gaetane Hermans
p. 220 t Shen Yuan, Bridge, 2004. Iron, cement and ceramic painted by hand, 900 × 250 (354⅜ × 98⅜). NMAC Foundation, Vejer, Cádiz, Spain. Photo Geatane Hermans
pp. 220–21 Marina Abramovic, Human Nests, 2001. Sand and rope ladders, seven holes 100 × 100 × 100 (39⅜ × 39⅜ × 39⅜), excavated in a quarry wall. NMAC Foundation, Vejer, Cádiz, Spain. Photo TheMahler. © DACS 2006
p. 221 t Sol LeWitt, Cinderblock, 2001. Concrete blocks, 40 × 20 × 20 (15¾ × 7⅞ × 7⅞). NMAC Foundation, Vejer, Cádiz, Spain. Photo Eberhard Hirsch. © ARS, NY and DACS, London 2006
p. 221 r Roxy Paine, Transplant, 2001. NMAC Foundation, Vejer (Cádiz, Spain). Photo Gaetane Hermans
pp. 222–25 Niki de Saint Phalle, The Grotto, 1999–2003. 3-roomed grotto, walls covered with a mosaic of mirror and glass. Herrenhäuser Gardens, Hannover, Germany. Photo Aline Gwose and Michael Herling. © ADAGP, Paris and DACS, London 2006
p. 226 Ivan Klapez, Stepinac, 2002–09. Granite. Dakawa, Tanzania. Photo Dr Fabrizio Gennari. Courtesy the artist

p. 227 Ivan Klapez, *Nyerere*, 2002–09. Granite. Dakawa, Tanzania. Photo Dr Fabrizio Gennari. Courtesy the artist
pp. 228–31 Antony Gormley, *Inside Australia*, 2002–03. Cast alloy of iron, molybdenum, iridium, vanadium and titanium. 51 insider sculptures based on 51 inhabitants of Menzies, Lake Ballard, Western Australia. © Courtesy the artist and Jay Jopling/ White Cube
p. 233 Entrance to Dia:Beacon. Photo Richard Barnes. © Dia Art Foundation
pp. 234–35 Michael Heizer, *North, East, South, West*, 1967/2003. Installation view at Dia: Beacon, New York. Collection Dia Art Foundation. Photo Tom Vinetz
pp. 236–37 Alfio Bonanno, *Amager Ark*, 2004. Himmelhøj, Vest Amager, Denmark. Photo Alfio Bonanno
p. 238 tl Alfio Bonanno, *Amager Ark*, 2004. Himmelhøj, Vest Amager, Denmark. Photo Alfio Bonanno
p. 238 b Alfio Bonanno, *Amager Ark*, 2004. Himmelhøj, Vest Amager, Denmark. Photo Alfio Bonanno.
pp. 238–39 Alfio Bonanno, *Insect Forest*, 2004. Himmelhøj, Vest Amager, Denmark. Photo Alfio Bonanno
p. 239 Alfio Bonanno, *Insect Forest* (detail), 2004. Himmelhøj, Vest Amager, Denmark. Photo Alfio Bonanno
p. 240 l James Turrell, *Afrum, Pale Blue*, 1968. Courtesy Chichu Art Museum, Naoshima, Japan. Photo Fujitsuka Mitsumasa
p. 240 r Interior view of Chichu Art Museum, 2004. Courtesy Chichu Art Museum, Naoshima, Japan. Photo Fujitsuka Mitsumasa
p. 241 t Interior view of Chichu Art Museum. Courtesy Chichu Art Museum, Naoshima, Japan. Photo Fujitsuka Mitsumasa
p. 241 b Exterior view of Chichu Art Museum. Courtesy Chichu Art Museum, Naoshima, Japan. Photo Fujitsuka Mitsumasa
p. 242 t Interior view of Chichu Art Museum. Courtesy Chichu Art Museum, Naoshima, Japan. Photo Fujitsuka Mitsumasa
p. 242 b Interior view of Chichu Art Museum, including Claude Monet's Water Lily paintings, 1914–26. Courtesy Chichu Art Museum, Naoshima, Japan. Photo Fujitsuka Mitsumasa
pp. 242–43 Walter De Maria, *Time/Timeless/No Time*, 2004. Courtesy Chichu Art Museum, Naoshima, Japan. Photo Michael Kellough
pp. 244–47 Alfio Bonanno, *Målselv Varde (Malselv Cairn)*, 2005. Olsborg, Målselv (Troms), Norway. Photos Alfio Bonanno
pp. 248–49. Chris Drury, *Star Chamber*, 2006. Cinder block and cement, timber, steel and limestone rock. Spiral chamber, 1200 × 1500 × 300 (472½ × 590½ × 118⅛). Vanderbilt Dyer Observatory, Brentwood, Nashville, Tennessee. Courtesy the artist
p. 250 l Chris Drury, *Star Chamber*, 2006.

Cinder block and cement, timber, steel and limestone rock. Spiral chamber, 1200 × 1500 × 300 (472½ × 590½ × 118⅛). Vanderbilt Dyer Observatory, Brentwood, Nashville, Tennessee. Courtesy the artist
p. 250 r Chris Drury, *Star Chamber*, 2006. Cinder block and cement, timber, steel and limestone rock. Spiral chamber, 1200 × 1500 × 300 (472½ × 590½ × 118⅛). Vanderbilt Dyer Observatory, Brentwood, Nashville, Tennessee. Courtesy Rocky Alvey and Neil Brake, Vanderbilt Dyer Observatory
p. 251 Chris Drury, *Star Chamber*, 2006. Cinder block and cement, timber, steel and limestone rock, spiral chamber: 1200 × 1500 × 300 (472½ × 590½ × 118⅛). Vanderbilt Dyer Observatory, Brentwood, Nashville, Tennessee. Courtesy the artist
pp. 252–53 Finn Eirik Modahl, *SOL*, 2007. Steel and glass, 1500 × 8100 (590½ × 3189). Pulse Sculpture Complex, Bergen, Norway. Photo Lars Svenkerud. © the artist
p. 254 Finn Eirik Modahl, *SOL*, 2007. Steel and glass, 1500 × 8100 (590½ × 3189). Pulse Sculpture Complex, Bergen, Norway. Photo Lars Svenkerud. © the artist
p. 255 t Finn Eirik Modahl, *SOL*, 2007. Steel and glass, 1500 × 8100 (590½ × 3189). Pulse Sculpture Complex, Bergen, Norway. Photo Kjetil Vatne. © the artist
p. 255 b Finn Eirik Modahl, *LIV*, 2007. Earth mound. Pulse Sculpture Complex, Bergen, Norway. Photo Kjetil Vatne. © the artist
p. 256 Jonathan Borofsky, *People Tower*, 2008. Steel, 700 × 700 × 2000 (275⅝ × 275⅝ × 787⅜). 100 Olympic Sculptures, Beijing, People's Republic of China. Photo Jessie Lei Sun
p. 257 l Jonathan Borofsky, *People Tower*, 2008. Steel, 700 × 700 × 2000 (275⅝ × 275⅝ × 787⅜). 100 Olympic Sculptures, Beijing, People's Republic of China. Photo Jessie Lei Sun
p. 257 r Nicolas Bertoux, *The Red Forest*, 2008. Granite, 530 × 120 × 400 (208⅝ × 47¼ × 157½). 100 Olympic Sculptures, Beijing, People's Republic of China. Photo Michael Duozhuang Suh
p. 258 t Huo Boyang, *Memory of Water*, 2008. Steel, 500 × 250 × 280 (196⅞ × 98⅜ × 110¼). 100 Olympic Sculptures, Beijing, People's Republic of China. Photo Wang Yaqi
p. 258 bl Zeng Chenggang, *Torch Relay*, 2008. Fibreglass, 860 × 240 × 600 (338⅝ × 94½ × 236¼). 100 Olympic Sculptures, Beijing, People's Republic of China. Photo Wang Yaqi
p. 258 br Zhang Wenxia, *Joy of Sport*, 2008. Bronze, 160 × 150 × 135 (63 × 59 × 53⅛). 100 Olympic Sculptures, Beijing, People's Republic of China. Photo Michael Duozhuang Suh
p. 259 l Sun Wei, *Joy*, 2008. Stainless Steel, 150 × 150 × 600 (59 × 59 × 236¼). 100 Olympic Sculptures, Beijing, People's Republic of China. Photo Wang Yaqi
p. 259 tr Ralfonso, *Dance with the Wind*,

2008. Stainless steel, 190 × 190 × 700 (74¾ × 74¾ × 275⅝). 100 Olympic Sculptures, Beijing, People's Republic of China. Photo Michael Duozhuang Suh
p. 259 br Sun Wei, *Joy*, 2008. Stainless Steel, 150 × 150 × 600 (59 × 59 × 236¼). 100 Olympic Sculptures, Beijing, People's Republic of China. Photo Michael Duozhuang Suh
p. 260–61 Charles Jencks, *Life Mounds*, 2005–09. Jupiter Artland, Edinburgh, Scotland. Courtesy the artist. © Charles Jencks
p. 262 tl Laura Ford, *Weeping Girls*, 2009. Courtesy Jupiter Artland, Edinburgh, Scotland.
p. 262 tr Shane Waltener, *Over Here*, 2007. Courtesy Jupiter Artland, Edinburgh, Scotland.
p. 262 bl Andy Goldsworthy, *Stone Coppice*, 2009. Courtesy Jupiter Artland, Edinburgh, Scotland.
p. 262 br Anthony Gormley, *Firmament*, 2008. Steel. Courtesy Jupiter Artland, Edinburgh, Scotland.
p. 263 t Marc Quinn, *Love Bomb*, 2006. Height 1200 (472½). Courtesy Jupiter Artland, Edinburgh, Scotland.
p. 263 b Anish Kapoor, *Suck*, 2008. Courtesy Jupiter Artland, Edinburgh, Scotland.
p. 264 l David Černý, *Babies*, 2001. Prague TV Tower Zizkov, Prague, Czech Republic. Courtesy the artist
p. 264 cl Nelson Miranda, *Carretas cordilleranas en vuelo*, 2001. Black iron plates, h.300 (118⅛). Parque Escultórico de Carretas en Putaendo, Chile
p. 264 cr Lili Fischer, *Der Hexenplatz*, 2003. WaldSkulpturenWeg, Rothaar Mountains, Germany. Courtesy Touristiverein Bad Berleburg, Germany. Photo Christa Velten. www.waldskulpturenweg.de
p. 264 r Anish Kapoor, *At the Edge of the World*, 1998. Wijnegem, Belgium. Courtesy the artist
p. 265 l Richard Wilson, *Set North for Japan (74° 33' 2")*, 2000. Echigo Tsumari Project, Niigata Prefecture, Japan. © Richard Wilson
p. 265 cl Les Bicknell and Laurence Edwards, *Solution*, 2002. Bronze and steel. Louth Art Trail, Lincolnshire, England. Courtesy Commissions East. Photo Andrew Weekes
p. 265 cr Keiji Uematsu, *Floating Form – Red*, 2000. Kirishima Open-Air Museum. Yusui-cho, Kagoshima Prefecture, Japan
p. 265 r Jan Snoeck, *Fiets & Stal (Bicycle Stable)*, 2000–05. The Hague, Netherlands. Photo © Stroom Den Haag
p. 266 l Niki de Saint Phalle and Mario Botta, *Seals*, 2001. Noah's Ark Sculpture Park, Tisch Family Zoological Garden, Jerusalem, Israel. Photo Pino Musi. Como. © 2006 Niki Charitable Art Foundation. All rights reserved. © ADAGP, Paris and DACS, London 2006
p. 266 cl Adriano Visintin, *Xaris*, 2002. Iron, 400 × 200 (157½ × 78¾).

Parco Sculture del Chianti, Pievasciata, Siena, Italy. Photo Bruno Bruchi
p. 266 cr Villu Jaanisoo, *Rubberduck*, 2003. Rubber tyres, 330 × 380 × 300 (129⅞ × 149⅝ × 118⅛). Pirrkala Sculpture Park, Finland. Photo Villu Jaanisoo. http://www2.pirrkala.fi/villusoo
p. 266 r Charles Jencks, *Landform Ueda*, 2002. Edinburgh, Scotland. Photo © Adrian Welch. www.edinburgharchitecture.co.uk
p. 267 l Dennis Oppenheim, *Bus Home*, 2002. Transit Center, Ventura, California, USA. Steel, perforated steel, structural acrylic, epoxy paint, concrete foundations, 1097.3 × 3048 × 1524 (432 × 1200 × 600). Photo Donna Granata, Focus on the Masters
p. 267 cl Chris Drury, *Reed Chamber*, WWT Arundel Wetland Centre, West Sussex, England. Courtesy the artist
p. 267 cr Henri Etienne-Martin, *Demeure I*, 1954–58. Bronze, 230 (90½). Noyal-sur-Vilaine, France. Courtesy L'Athanor – Musée Etienne-Martin. © DACS 2006
p. 267 r Eileen MacDonagh assisted by Marc Wouters, *Boora Pyramid*, 2002. Stone. Sculpture in the Parklands, Lough Boora Parklands, Ireland. Photo James Fraher
p. 268 l Antony Gormley, Broken Column, 2003. 23 cast iron bodyforms, each 197 × 48 × 26 (77½ × 18⅞ × 10¼). Stavanger, Norway. © Courtesy the artist and Jay Jopling/ White Cube
p. 268 cl Thomas Heatherwick, *Sitooterie*, 2003. Aluminium cube with a window and door perforated with 4,000 angled holes each holding a hollow aluminium tube capped with orange perspex, 240 × 240 (94½ × 94½). Barnards Farm, Essex, England. Photo Steve Speller
p. 268 cr Li Yinim, *In The Sun*, 2003. Changchun World Sculpture Park, Changchun, China
p. 268 r Niki de Saint Phalle, *Queen Califia's Magical Circle*, 2003. Escondido, California, USA. Photo Masashi Kuroiwa. © 2006 Niki Charitable Art Foundation. All rights reserved. © ADAGP, Paris and DACS, London 2006
p. 268 l Thomas Heatherwick, *Bleigiessen*, 2004. Assemblage of 150,000 glass spheres suspended on 1 million metres of fine stainless steel wire, h.3,000 (1181⅛). Wellcome Trust headquarters, London, England. Photo Steve Speller
p. 269 c Chris Drury, *Heart of Reeds*, 2004–05. Lewes, England. Courtesy the artist. www.heartofreeds.org.uk
p. 269 r Peter Eisenman, *Memorial to the Murdered Jews of Europe*, 2005. c. 2,700 concrete steles arranged in a 19,000 × 19,000 m space. Each stele 95 × 238 (37⅜ × 93¾), varying in height. Berlin, Germany. Photo Getty Images
p. 269 b Charles Jencks, *Parco Portello*, Milan, Italy, 2002 onwards. Courtesy Margherita Brianza. © Charles Jencks

Acknowledgments

Many thanks to all those who helped along the way:

Malin Barth, Hans Biørn Lian, Jimena Blázquez Abascal, Eric de Boer, Gerard de Boer, Alfio Bonanno, Tina Booth, Aliki Braine, Laurence Braine, Margherita Brianza, Joanna Bukowska, Alister Campbell, Bloum Cardenas, Ronald Clark,

Chiara Costa, Jason Dempsey, Joel Dempsey, Carol Dixie, Sean Dixie, Terry Dixie, Sarah Dixon, Chris Drury, Bettina Funcke, Gabriela Gastelum, Sylvia Gentenaar, Julija Giljevic, Lily van Ginneken, Pierre Haibl, Cathy Haruf, Kent Haruf, Nancy Holt, Charles Jencks, Lina Karosiene, Simon Kilmurry, Kaisa Kirkko-Jaakkola, Drazan Klapez, Ivan Klapez,

Tokiko Kume, Rachael Leith, Paula Llull Llobera, Simon Mason, Alexandra McConnell, Viki Mendelssohn, Finn Eirik Modahl, Caroline Morey, Guy Morey, Lewis Morey, Charles Morgan, Jill O'Bryan, Lidia Pardo, Steve Perkins, Kristin Pleasanton, Tom Pleasanton, Mireille de Putter, Barbara Räderscheidt, James Ramsay,

Trudy van Riemsdijk-Zandee, Macha Roesink, Justin Saunders, Kay Saunders, Roger Saunders, Susanne Scheidler, Barbara Schröder, Jack Shainman, Jessie Sheeler, Claude Simard, Daniel Spoerri, Michael Suh, Nick Terry, Adrian Welsh, Jan Wijle and Lori Zippay.